The Care of Prints and Drawings

American Association for State and Local History
Book Series

About the Series
The American Association for State and Local History Book Series addresses issues critical to the field of state and local history through interpretive, intellectual, scholarly, and educational texts. To submit a proposal or manuscript to the series, please request proposal guidelines from AASLH headquarters: AASLH Editorial Board, 1717 Church St., Nashville, Tennessee 37203. Telephone: (615) 320-3203. Website: www.aaslh.org.

About the Organization
The American Association for State and Local History (AASLH) is a national history membership association headquartered in Nashville, Tennessee. AASLH provides leadership and support for its members who preserve and interpret state and local history in order to make the past more meaningful to all Americans. AASLH members are leaders in preserving, researching, and interpreting traces of the American past to connect the people, thoughts, and events of yesterday with the creative memories and abiding concerns of people, communities, and our nation today. In addition to sponsorship of this book series, AASLH publishes *History News* magazine, a newsletter, technical leaflets and reports, and other materials; confers prizes and awards in recognition of outstanding achievement in the field; supports a broad education program and other activities designed to help members work more effectively; and advocates on behalf of the discipline of history. To join AASLH, go to www.aaslh.org or contact Membership Services, AASLH, 1717 Church St., Nashville, TN 37203.

The Care of Prints and Drawings

Second Edition

Margaret Holben Ellis

ROWMAN & LITTLEFIELD
Lanham • Boulder • New York • London

Published by Rowman & Littlefield
A wholly owned subsidiary of The Rowman & Littlefield Publishing Group, Inc.
4501 Forbes Boulevard, Suite 200, Lanham, Maryland 20706
www.rowman.com

Unit A, Whitacre Mews, 26-34 Stannary Street, London SE11 4AB

British Library Cataloguing in Publication Information Available

Library of Congress Cataloging-in-Publication Data
Names: Ellis, Margaret Holben, author. | American Association for State and Local
 History, issuing body.
Title: The care of prints and drawings / Margaret Holben Ellis.
Description: Second edition. | Lanham : Rowman & Littlefield, 2017. | Series:
 American Association for State and Local History book series | Includes
 bibliographical references and index.
Identifiers: LCCN 2016037045 (print) | LCCN 2016037498 (ebook) |
 ISBN 9781442239708 (cloth : alk. paper) | ISBN 9781442239715 (pbk. : alk. paper) |
 ISBN 9781442239722 (Electronic)
Subjects: LCSH: Prints—Conservation and restoration. | Drasing—Conservation and
 restoration.
Classification: LCC NE380 .E45 2017 (print) | LCC NE380 (ebook) | DDC
 740.28/8—dc23
LC record available at https://lccn.loc.gov/2016037045

Printed in the United States of America

Contents

List of Illustrations

Acknowledgments

This second edition of *The Care of Prints and Drawings* is long overdue, but not because of drastic changes in the actual care of prints and drawings. Preservation requirements for them, based upon their inherent visual, physical, and chemical properties, remain pretty much the same. What has changed is an acknowledgment of the greater benefits to be gained by adopting a broader institutional mandate of preventive conservation, a strategic shift, which, I hope, is reflected in this new edition.

I would like to recognize the Institute of Fine Arts of New York University, in particular its current Judy and Michael Steinhardt Director, Patricia Rubin, for granting me a much-needed research leave and sabbatical, and faculty at the Conservation Center, Hannelore Roemich, Michele Marincola, and Norbert Baer. I will always be grateful to the Center's extraordinary librarians, Daniel Biddle and Robert Stacy (now retired), for their invaluable assistance. Kevin Martin and Catherine Lukaszewski cheerfully provided much-needed technological support, with Cat efficiently compiling Appendix 2.

I am also very grateful to the staff of the Thaw Conservation Center, Morgan Library & Museum – Reba Snyder, Maria Fredericks, Frank Trujillo, Lindsey Tyne, and James Donchez – for their sustained support during my two research absences in 2015, which were possible thanks to the Morgan's administration, in particular, Peggy Fogelman, former Director of Collections.

I confess to taking an occasional topical detour during a 2015 visiting scholar's residency at the Getty Conservation Institute (GCI) to delve into several subjects covered in this book, irresistible given the GCI's renowned library resources, not to mention its talented research assistant, Anna Duer. This fortuitous circumstance would not have been possible without the support of the GCI, in particular its Director Timothy Whalen, and the Getty Foundation.

Former student, Katherine Sanderson, readily agreed to author Appendix 1. Despite her current position as a conservator of photographic materials at the Metropolitan Museum of Art, she will forever be the go-to paste-lady. I am grateful for her good-humored assistance.

Saira Haqqi, also a former student, spent a good portion of her summer photographing the illustrations and getting even more familiar with the study collection of the Conservation Center.

My papermaking friend and colleague, Timothy Barrett of the University of Iowa Center for the Book, provided stills from his informative video created by talented filmmaker Avi Michael. Readers are encouraged to watch *Chancery Papermaking* at https://www.youtube.com/watch?v=e-PmfdV_cZU.

I am grateful to my publishers, the Rowman & Littlefield Publishing Group, for persuading me to undertake this revision, in particular, Charles Harmon, whose confidence in the result is appreciated, and assistant editor Kathleen O'Brien.

The first 1987 edition of *The Care of Prints and Drawing* coincided not only with the birth of my sons, but also with the first of many classes of smart and talented paper conservation students. Always intellectually challenging, it is to them – sons and students – that this book is dedicated.

Introduction

The purpose of this revision of *The Care of Prints and Drawings* remains the same as the original 1987 edition – to provide practical, straightforward advice to those responsible for the preservation of prints and drawings, or more broadly, works of art on paper. These works need not belong to a museum, art gallery, library, or historical society, although this book tends to address such collecting institutions. My suggestions here might apply equally to the preservation of a rare "Old Master" pen-and-ink drawing prized by a serious collector, a twentieth-century Pop Art serigraph purchased by a savvy investor, an elaborately decorated family document, such as a *fraktur* or *ketubah*, or to a cherished handmade valentine. Equating them all to "works of art" is, of course, subjective, but, regardless of their status, all are irreplaceable and all deserve the best possible care.

The most noticeable change in this revision is the greater emphasis on preventive conservation as put into practice via a comprehensive Collections Care Program. Chapters 5 and 6, which describe both item- and collection-level approaches to conservation, reflect the growing recognition that scarce resources are best expended on preventing deterioration, rather than on more costly, and often less successful, measures of reversing it. Granting agencies have generally adopted this philosophy, with priority given to programs that assess the conditions of collections, as well as the robustness of the institutional policies that are meant to protect them. By implementing the recommendations found in chapters 5 and 6, you will be better positioned to receive federal and state preservation funds and to make them go farther.

Prints and drawings vary in kind according to the paper – typically called the "support" – or the "substrate" on which their marks appear and to differences in the substance – or medium – and the technique used to create the marks. Consequently, drawings done in a particular medium may be prone to

a specific type of deterioration. Likewise, prints created using one printmaking technique may be more susceptible to a certain kind of damage than those created using a different printing process. All works of art on paper, however, share certain common characteristics, largely dependent upon the physical and chemical properties of paper, and thus are predisposed to the same general – and predictable – problems as they age. Correct maintenance for them and, by extension, a thorough knowledge of optimal conditions and procedures that are required for their preservation, is based upon an understanding of their material characteristics. Ideally, using this approach, most conservation problems will be avoided entirely. At the very least, symptoms of developing trouble can be recognized in good time. Several seemingly inconsequential symptoms are, in fact, early warning signs of potentially more serious dangers. Some conservation ailments, such as deformation – informally called buckling, wrinkling, or cockling – are quite general and can affect almost any type of print or drawing. Other worrisome conditions, such as flaking, are usually associated with specific media and occur in a narrower range of works.

In order to devise the best means to prevent or minimize the conservation problems that can beset works of art on paper, it is necessary to have a clear idea of what prints and drawings are, materially speaking, and the reasons that their physical compositions and structural constructions can make them vulnerable to a range of usually preventable problems.

Some general comments on the nature of prints and drawings follow, with directions to that area of the text where more detailed information on specific topics may be found.

The creative beginning of prints and drawings is much the same: they all came into being when a mark was made by a human being using a tool – finger, brush, pen – or a machine – printing press, laser printer – on a substrate or support. The support could be one of many different materials, although it had from the very beginning consistent characteristics: it was comparatively thin, flat, portable, usually capable of being folded or rolled, and retained the marks on its surface during the item's functional lifetime. The marks could be made with one, medium, or more substances, media, using a variety of techniques.

Throughout the history, different areas of the world developed various kinds of supports on which to write, draw, and print. Some were devised for specific purposes, used only in circumscribed geographic locations, or were short-lived. Because of their materials and method of manufacture they have different characteristics – and conservation needs – than parchment and paper, which, since byzantine times, have been the two kinds of support used most extensively for prints and drawings in the western hemisphere. Anthropological or ethnographic collections today may include artifacts on proto-papers

such as bark, palm leaves, Pacific Island tapa cloth, Mexican amate or amatl, or East Asian rice paper – more properly called "pith" paper since it is made from the flayed pith of *Tetrapanax papyrifer*, called the "rice paper plant" (see Figure 1.1). Comprehensive historical and archeological collections are also likely to include works on papyrus, which was made thousands of years before the Common Era (CE) and used throughout the Mediterranean world for centuries as a support for writing and drawing. Close relatives of paper in their vegetal origins, proto-papers are also flat, foldable, rollable, and portable sheets of material capable of retaining marks made on their surfaces. These supports are mentioned only in passing, here, and in chapter 1. Generally speaking, paper conservators having specialized knowledge and skills treat artifacts on proto-papers.

Chapter 1, *Supports for Prints and Drawings*, discusses the properties of parchment and paper and introduces the general preservation needs and conservation problems shared by all works of art on paper, regardless of their media. It should be noted here that, in this book, the discussion of paper is confined to that made from traditional cellulosic materials, omitting "paper" made from synthetic fibers, such as polyester; not all of the substances, for example, woven silk or birch bark, ever used as supports for prints and drawings are discussed.

Also, absent from this book is a discussion of photographs, which are considered by many people to be works of art on paper. In many collecting institutions photographs fall under the jurisdiction of the prints and drawings department, although independent curatorial and conservation supervision, as well as separate storage rooms and exhibition galleries, are more prevalent today. It has become apparent to conservators of paper that the deterioration processes and preservation needs of photographic materials differ vastly from those of prints and drawings. Consequently, conservation treatments and collections care practices for the housing, storage, and exhibition of photographic materials have changed as well.

Chapter 2, *Conservation Problems Related to the Paper Support of Prints and Drawings*, presents a guide to recognizing the symptoms and diagnosing the causes of damage specific to paper.

Chapter 3, *Conservation Problems Related to the Materials and Techniques of Prints*, also describes ways to recognize the symptoms and diagnose the causes of damage to various kinds of prints, but not those stemming from the paper support on which they appear. Here the reader will find descriptions of those conservation problems that affect specific printmaking materials and arise from specific printmaking processes.

Chapter 4, *Conservation Problems Related to the Materials and Techniques of Drawings*, likewise focuses on the various materials, both dry and wet, used to create marks on paper. It should be mentioned that the category

of drawings, as is typical in the museum community, is expanded to include works done using pastel, watercolor, opaque watercolor, oil paint, and synthetic polymer paint on paper, which in many collections are called paintings on paper.

Chapter 5 discusses typical item-level protective measures taken for works of art on paper so that they can better withstand the ordinary rigors of handling, examination, exhibition, travel, adverse environmental conditions, and general wear and tear.

This is my first opportunity – and I seize it eagerly – to say that *item-level protection of prints and drawings, according to conservation standards, is one of the most effective ways to provide a longer life for these works of art.* It is the conscientious, planned maintenance and deliberate expenditure of energy, time, and money on simple enclosures that can produce effective long-term preservation at minimal cost.

Well-considered preventive conservation in the form of a Collections Care Program integrated into an institutional Collections Management Policy can reduce the need for expensive and risky conservation treatments. Chapter 6, *Preventive Conservation for Prints and Drawings*, considers the quandary of many well-meaning organizations that have pledged to protect cultural heritage collections while at the same time must deal with common hazards such as leaky basements, sun-filled galleries, oven-like attics, insect and animal pests, skimpy shelving, shallow storage bins, make-do mounts, atmospheric pollution, and inadequate humidity control – amid chronic shortages of both space and money.

As an inherent aspect of their mission, conservators consider preventive conservation to be:

> The mitigation of deterioration and damage to cultural property through the formulation and implementation of policies and procedures for the following: appropriate environmental conditions; handling and maintenance procedures for storage, exhibition, packing, transport, and use; integrated pest management; emergency preparedness and response; and reformatting/duplication. Preventive conservation is an ongoing process that continues throughout the life of cultural property, and does not end with interventive treatment.[1]

Chapter 6 may at times be aspirational, but it always strives to be pragmatic.

Chapter 7, *Basic Paper Conservation Procedures*, outlines a number of actions that can be done to stabilize damaged prints and drawings and help retard or prevent further damage.

At the end of each chapter is a list of reading materials that can provide additional information on various topics discussed in that chapter.

The vocabulary used by the curatorial and conservation community to describe works of art on paper can be confusing to nonspecialists. Therefore, a *Glossary* of the terminology used throughout this book has been compiled in order to encourage consistency of usage and foster clearer communication among those responsible for the preservation of prints and drawings.

Appendix 1, *How to Make Starch Paste and Methyl Cellulose Adhesive*, and Appendix 2, *Suppliers of Paper Conservation Materials and Equipment*, are intended to help the reader implement the recommendations found throughout the text.

And I close this introduction with one final observation: the human element, unfortunately, remains the leading cause of irreparable damage to prints and drawings, often brought about with the best of intentions but a lack of reliable information and, too often, time and money. If the reader comes away from this book with only one firm resolve in mind, it should be that, as irreplaceable physical evidence of our civilization's journey, prints and drawings deserve our best efforts for their preservation.

Finally, a word concerning the prints and drawings that are addressed herein: the reader will notice that the items under discussion are variously described as prints, drawings, works of art on paper, documents, artworks, manuscripts, artifacts, and paper-based material culture – but, physically, all of them are simply marks on paper. The distinction between art and artifact or drawing and document is a fine one. Regardless of whether an item is found in an art museum, the Special Collections of a library, an archive, historical society, or family strongbox, emphasis should be placed on its significance and value. Most of the prints and drawings under discussion in this volume have been accorded the imprimatur of "artwork." Nonetheless, it is my hope that caretakers, when faced with the difficult decision of what items to include in a Collections Care Program and its associated annual budget, will broaden societal attitudes toward marks on paper, even those not yet deemed to be "original" artworks, and promote their preservation.

NOTE

1. American Institute for Conservation of Historic and Artistic Works, *About Conservation: Definitions of Conservation Terminology* (2015). http://www.conservation-us.org/about-conservation/related-organizatins/definitions#.VoFgf8ArLpB (accessed 1/14/2015).

Chapter 1

Supports for Prints and Drawings

Beginning a book on the care of prints and drawings by describing the substrate on which they are created follows a chronological approach, as well as a materials approach. The best substance ever found to carry the marks of an artist, printmaker, and scribe, the world over, has traditionally tended to be the most critical and vulnerable component of the work, the part needing the greatest care for the whole to endure. That is why we begin this book by saying that the first step in caring for prints and drawings is to understand the nature of their support, the "surface object or substance that carries a two-dimensional work of art, in particular a painting, drawing, or print."[1] The physical and chemical makeup of the support will determine the way it behaves and will dictate the conditions necessary to best protect and preserve it.

Begin with a quick inventory of the prints and drawings in your collection according to the materials on which they have been created. Depending on their age and place of origin, they may be found on a variety of supports. The majority, of course, will be on paper. However, some may be on parchment, which was made in modern-day Turkey two hundred years BCE and extensively used throughout the Western world for centuries. Alternatively, if truly ancient artifacts are among your holdings, or if your collection is ethnographically focused, papyrus or other proto-papers may be found as supports.

PROTO-PAPERS

Papyrus antedates both parchment and paper. The oldest known manuscripts found well-preserved in arid Egyptian tombs were written on papyrus, the earliest dating from before 3000 BCE; and the extensive body of Greek literature housed in the ancient world's greatest library at Alexandria was written

1

on horizontal sheets of papyrus, adhered end to end and rolled around a central wooden rod to form cylindrical manuscripts. Papyrus was made from a type of sedge that grew abundantly in marshy wetlands. The sedge was an extremely useful plant, not only providing pithy stems, which, when sliced, laminated, and pounded, made a flexible writing surface, but also was the stuff of mats, rope, baskets, and sandals. As a writing material, papyrus was used sporadically throughout the Mediterranean into the eleventh century CE, when it was finally superseded by parchment.

As mentioned in the Introduction, other proto-papers used as support materials, including amate or amatl, tapa cloth, rice or pith paper, bark, and palm leaves, and various paper substitutes, may be encountered in specialized collections.

Amate or amatl, a felt-like sheet of macerated bark, was made in Mexico and Central America in pre-Hispanic times; tapa cloth, made from the soft inner bark of shrubs, substituted for paper in the Pacific Islands; many tropical and subtropical countries used palm fronds; and a popular Asian paper substitute was called "rice paper," which is misleading since the product has no relationship to rice whatsoever, but was – and still is – made from the inner core or pith of an East Asian plant *Tetrapanax papyrifer*, called the "rice paper plant."[2] Decorative works on pith paper, a more accurate term, have their own distinct conservation problems, as seen in Figure 1.1.

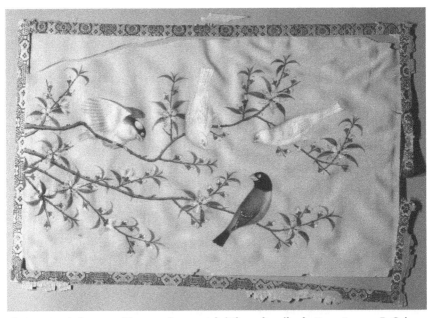

Figure 1.1 As it ages, pith paper becomes brittle and easily shatters. (Image: E. Cohen; courtesy of the Conservation Center, Institute of Fine Arts, New York University).

Used historically as a support for documents and illuminations and, today, sold to tourists as decorative souvenirs, these paper substitutes are sometimes mistaken for paper, and they *are* related to paper in their vegetal origins. Manufacturing processes for each vary greatly, as well as their basic components. Consequently, they exhibit chemical and physical properties that differ from those of traditional Western paper. They are mentioned here a second time, briefly, as interesting sidelights on humanity's long history of making marks on thin, durable, pliable, and portable substrates. If, in surveying your collection, you find support materials that you believe to be neither paper nor parchment (see below), but paper-like substitutes, a major museum having similar holdings may be able to advise on their best care and handling. Generally speaking, their overall preservation needs are similar to those of paper, but treatments involving the direct manipulation of them can differ.

Unless a collection is geographically or historically encyclopedic, or mainly ethnographic in nature, most of the prints and drawings in it are likely to have been executed on one of two kinds of printing and drawing supports that predominated in the Western hemisphere: parchment and paper. Of the two, paper eventually prevailed, especially after the invention of movable type and the printing press in the fifteenth century, which created a sudden and unquenchable demand for a reliable source of an inexpensive substrate with consistent thickness, surface texture, and color.

As they are the two materials most often encountered in Western collections of prints and drawings, parchment and paper are the supports we concern ourselves with, here.

PARCHMENT

A superb material upon which to write, draw, or, less frequently, print, parchment is made of the untanned skins of animals, including sheep, calf, and goat. It has been used for written and illuminated manuscripts, legal documents, public records, and works of art since well before the CE – and still is, although more for its aesthetic appeal and venerable status, than for purely utilitarian reasons. Works on parchment range from the practical and mundane – deeds, diplomas, charters, and certificates – to the most sublime stand-alone works of art and sumptuous illuminated manuscripts, and abound in all types and sizes of collections. Any notion that the care and preservation of parchment is a headache for only rare-book librarians, Old World archivists, or the keepers of the Dead Sea Scrolls is a mistaken notion.

A call to any major artists' supply store today will confirm that parchment is still in demand. Because of its attractive appearance, receptive surface,

reputation for longevity, and sumptuous appeal, it has remained a popular support material for artists and calligraphers. Its devotees have ranged from medieval monks to the sixteenth century's Albrecht Dürer (1471–1528), the seventeenth century's Rembrandt van Rijn (1606–1669), the eighteenth century's Jean Etienne Liotard (1702–1789), the nineteenth century's Winslow Homer (1836–1910), the twentieth century's Pablo Picasso (1881–1973), to artists of today.

As is often the case, political and economic factors hastened the commercial production of parchment and assured its eventual ascendancy over papyrus beginning in the second century BCE. Not only did parchment provide a more smoother and more consistent surface, it was also more durable; its pliability allowed it to be folded into a book, or codex, whose leaves could be turned and flexed. It was these advantages, and political circumstances, which led to its widespread use throughout Europe by the second century CE From then on, it was used in the codex format, as the carrier of pen and ink texts and illuminations created in egg tempera embellished with gold leaf, or in single-sheet form, as the support for documents and stand-alone works of art. Then, in the fifteenth century, movable type and the printing press were invented, which required an unending stream of material on which to print. Parchment could be and was printed on, but as a commodity, it was labor intensive and time-consuming to produce, when compared with paper manufacture. There were intermittent employment crises, not to mention the social stigma suffered by a workforce toiling with foul-smelling, rancid animal skins. In the end, economics once again played a decisive role in shaping parchment's future. It could simply not compete with paper, which eventually displaced it. Nonetheless, parchment or vellum – the two terms are today interchangeable – remains a classic support for works of art and documents of state.

Characteristics of Parchment

The longevity of parchment has been recognized and highly valued for centuries: in 1494, a Benedictine Abbot, Johann Tritheim (1462–1516), suspicious of the newly introduced printing press, exhorted his scribes to choose parchment over paper, with this cautionary challenge, "Truly if writing is set down on vellum, it will last for a millennium. When printing is on paper, however, how long will it last?"[3]

Often the same color as paper, very thin and flexible, although with a more solid "hand," parchment can be easily mistaken for sturdy paper. Like other paper substitutes, however, its chemical and physical properties cause it to behave differently than paper and to require different preservation parameters.

How Parchment Is Made

Parchment production, which endows the final product with its distinctive characteristics, has changed only slightly over the centuries. Flayed animal skins, typically sheep, goat, or calf, are soaked in water baths followed by caustic lime solutions to release the hair. The skins are then scraped repeatedly with a sharp, crescent-shaped blade, to remove the loosened hair and skim away any surface irregularities, such as scar tissue. After further rinsing, the skins are stretched onto a frame, dried, and again scraped for additional thinning and leveling. A final rubbing of the skin with pumice for smoothing and chalk for conditioning completes the preparation. Various finishing solutions can also be applied to the surfaces for color and gloss. Because of the difficulty of identifying the exact animal source after its production, the broader term, animal membrane, is sometimes preferred for describing the support material. Parchment is usually not identified as vellum, unless it is known to have been made from calf.

A finished piece of parchment is the result of simply cleaning and drying an animal skin under tension. It is the simultaneous action of stretching and drying that causes parchment to react differently than leather, which is made from chemically tanned animal skins. As a writing and drawing support, parchment is strong and durable. It is also reusable, since preexisting writing can be scraped away using a sharp knife. The alphanumeric-shaped thinned areas and shadowy ink residues – called "palimpsests" (Figure 1.2), are not damage, but simply evidence of recycling.

Conservation Problems of Parchment

The foremost conservation issue associated with parchment is its tendency to change dimensionally as a result of fluctuations in humidity. Buckling – otherwise known as deformation, cockling, curling, distortion, undulation, or warping – in a sheet of parchment – either bound together with other leaves into codex form or as a single sheet – is a sign that the work has been exposed to a change or recurrent changes in humidity levels. The deformation may be random or may surround an area of the parchment that is held into place and not free to move. Buckling comes about as the animal tissues that constitute the parchment begin to lose the directional orientation imposed upon them when drying under tension; higher humidity levels promote their relaxation and gradual reversion to their original configuration. When the relative humidity returns to lower percentages, the slackened fibers rigidify into their new position (Figure 1.3).

A cautionary note should be inserted, here: some degree of buckling is to be expected as the parchment naturally responds to environmental shifts. In fact, this perfectly natural manifestation is acceptable as long as the

Figure 1.2 **Palimpsests can be evidence of incorrect transcriptions or recycled parchment.** (Image: S. Haqqi; courtesy of the Conservation Center, Institute of Fine Arts, New York University).

item's mat and/or frame has been designed to accommodate such movement. Overzealous measures taken to prevent any dimensional changes, such as mounting the parchment to a stiff paperboard or pressing it directly against glass, should be avoided since these steps have their own detrimental consequences.

Excessive buckling is not only visually displeasing and physically deforming, but it also threatens to disrupt the attachment of the medium, for example, the traditional egg tempera found in medieval manuscripts or the heavily inked lines of Elizabethan indentures. As the parchment expands and contracts, its attachment to the relatively inflexible layer of paint or ink on its surface is compromised. And, if bound into a codex, it rubs against the adjacent page. Taken to an extreme, the medium may simply flake away and be lost entirely. Therefore, it is critical that buckling be monitored closely, with attention paid to the environment that is causing it in the first place (Figures 1.4 and 1.5).

Instances of extreme buckling of parchment should be brought to the attention of a professional conservator (see chapter 7, section *"Finding and Working with a Professional Paper Conservator or Collections Care Specialist"*). Parchment typically falls under the jurisdiction of a paper or book conservator. If the changes are recent, the buckling can often be coaxed back into plane through traditional flattening procedures. If extreme deformation is the result of the parchment being poorly stored or from having been kept folded or rolled for a very long time – such as in historic documents and deeds – the

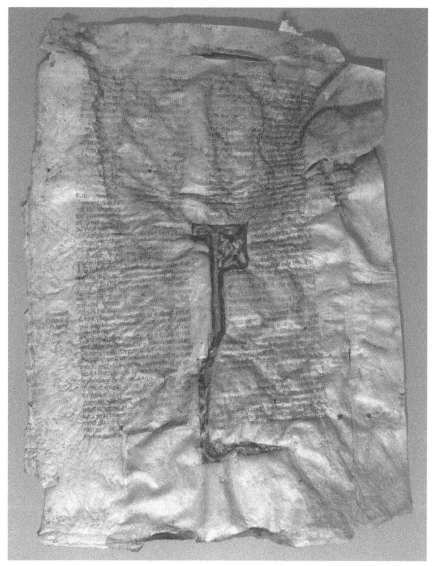

Figure 1.3 Parchment expands and contracts drastically with changes in relative humidity. (Image: S. Haqqi; courtesy of the Conservation Center, Institute of Fine Arts, New York University).

distortion that developed over time may be resistant to normal flattening efforts. Do not attempt to flatten parchment using the paper conservation procedures described in chapter 7.

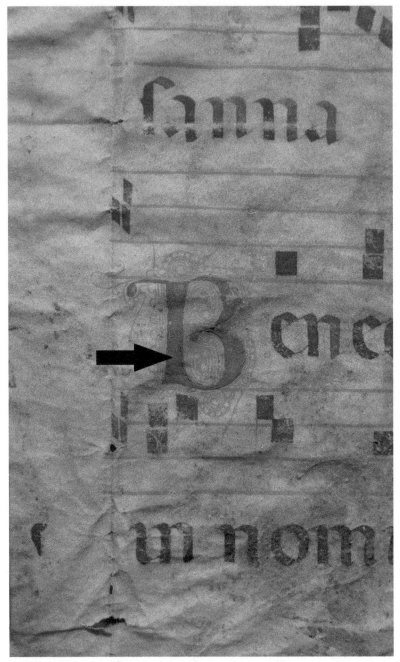

Figure 1.4 Extreme dimensional changes of parchment can cause rubbing against adjacent pages when bound and contribute to eventual disruption of pigment layers. (Image: S. Haqqi; courtesy of the Conservation Center, Institute of Fine Arts, New York University).

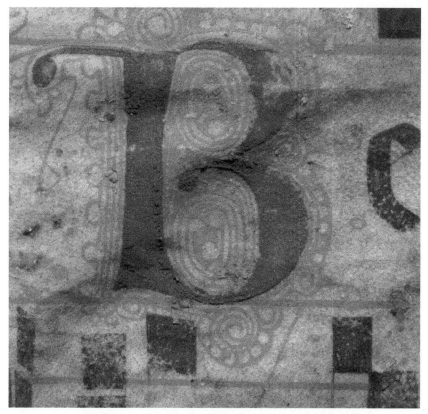

Figure 1.5 Detail of Figure 1.4. Abrasion of pigment in bound manuscript. (Image: S. Haqqi; courtesy of the Conservation Center, Institute of Fine Arts, New York University).

Other typical conservation procedures involving parchment are complicated by its natural reactivity to water and multidirectional expansion and contraction. For example, a simple tear repair on parchment can involve the use of a nonaqueous adhesive and a customized pattern of patches, an approach requiring the expertise of a professional conservator.

Parchment, like the proto-papers described above, and paper, as well, can serve as a nutrient for fungal growth and a food source for insects and vermin (Figure 1.6). Close attention, therefore, needs to be paid to the preventive and conservation measures taken to control conditions in storage facilities. Figure 1.7 shows an unusual purple mold growth on parchment.

Despite its natural vulnerability to high and fluctuating humidity levels, parchment is a strong, resilient material that can withstand much

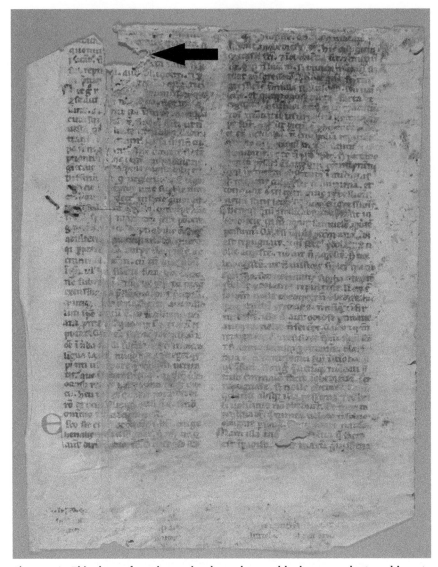

Figure 1.6 This sheet of parchment has been damaged by hungry rodents and insects. (Image: S. Haqqi; courtesy of the Conservation Center, Institute of Fine Arts, New York University).

manipulation. Its marvelous surface texture and color make it an ideal support for writing, drawing, and painting. Given adequate protection, parchment will last for millennia. Evidence of its longevity abounds in archives, libraries, and museums around the world.

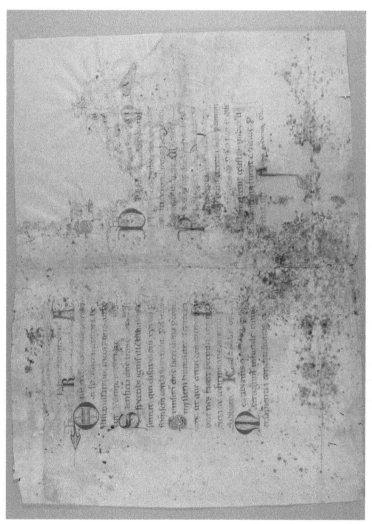

Figure 1.7 **Storage in damp conditions will result in disfiguring mold growth and permanent damage.** (Image: S. Haqqi; courtesy of the Conservation Center, Institute of Fine Arts, New York University).

PAPER

The Chinese invented paper well before the first century BCE. While its exact date and place of invention remain hotly contested and its early technology vague, it is certain that the papermaking process remained a closely guarded secret while paper developed into an advanced and plentiful domestic product. Papermaking remained an exclusively Asian enterprise until the tightly held technology behind it fell into the hands of the Arabs who conquered the Chinese in the eighth century and established in the fabled city of Samarkand (now in present-day Uzbekistan) the first paper mill to be built outside of China. Once the knowledge of papermaking reached Central Asia and the Middle East, it spread rapidly westward and northward – to Egypt with the Arab traders, to Spain with the Moors, into Venice, and gradually into the rest of Europe. Late in the thirteenth century paper mills had been established in Italy; by the end of the fourteenth century in France and Germany; and by the end of the fifteenth century, paper was being made in England and was well on its way to superseding parchment as an excellent surface on which to draw pictures and inscribe legal documents. With the invention of movable type and the great surge of printed materials that took place after the 1450s, paper was recognized as a first-rate printing surface, as well, capable of satisfying the sudden and enormous appetite of the printing presses.

Characteristics of Paper

The word "paper" – derived from papyrus – applies to such a wide and varied range of material that it seems as if this ubiquitous product comes close to being all things to all people. Paper is grocery bags, newsprint, gift wrapping, toweling, magazines, hygienic tissues, book pages, covers and jackets, cardboard, wallpaper, drawing paper, fine stationery, and many more recent innovations, including clothing, dishes, furniture, and building materials, all in addition to being the support for priceless and irreplaceable works of art.

For our working purposes, paper is defined as a dense, evenly deposited layer of long intertwining plant fibers. Figure 1.8, a scanning electron micrograph, depicts a representative sample of paper, which illustrates these physical characteristics.

How Paper Is Made

The basic method of making paper has changed remarkably little over the years and throughout its long odyssey from East to West. Even in today's

high-speed, fully automated commercial paper mill, the process remains, in essence, the same as it was in China, where it all began.

Paper begins with fiber. In Eastern Asia, in centuries past, virgin plant fibers from the inner bark of native shrubs were preferred as the basic raw material of paper. For economic reasons today, wood pulp is used more frequently in Asia, as it is around the world.

In the early years of papermaking in the West, linen, hemp, and, later, cotton rags, cheap and widely available commodities, became the traditional source of fibers. Discarded clothing was not the sole source for rags; a good percentage came from the maritime trades in the form of sails and rigging. Before rags could be used for making paper, however, they had to be broken down by a cumbersome, time-consuming process until they more closely resembled their original plant fibers. As the centuries passed and the demand for paper skyrocketed, the supply of rags grew smaller and smaller. By the nineteenth century, rags had become so scarce in the Western world that Egyptian mummy wrappings were being scavenged to make paper. Regulations stipulated that corpses be entombed in shrouds of wool, rather than linen (wool, an animal product, cannot be used to make paper). Spurred on by the prospect of huge financial rewards, venturesome nineteenth-century entrepreneurs began

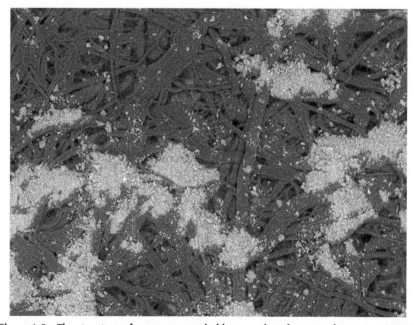

Figure 1.8 The structure of paper as revealed by scanning electron microscopy (X250); the granular powder is chalk. (Image: M. Tan; courtesy of the Conservation Center, Institute of Fine Arts, New York University).

macerating every type of plant in sight. The prophetic observation of ento-
mologist René Antoine Ferchault de Réaumur (1683–1757), who noted that
some species of wasps use digested wood to produce their paper-like nests,
inspired a young Friedrich Gottlob Keller (1816–1895) to design and patent in
1844 a grinding machine that produced papermaking fibers directly from logs.
The technology for producing mechanically processed wood pulp, known
simply as ground wood, transformed commercial papermaking. By the late
1800s inexpensive wood fibers, in the form of ground wood or further refined
using chemical pulping processes, had replaced cotton rags for papermaking.

Wood pulp is an ingredient in more than 90 percent of the paper produced
in America today; and thanks to the work of environmentalists, not to mention
economic incentives, more and more new paper contains significant percent-
ages of recycled postconsumer paper.

It remains true, over two millennia later, that to make paper one must col-
lect a great deal of plant material – soak it, cook it, beat it, and clean it – to
break it down into its essential constituents, because what is needed from the
plant are its long, stringy, thread-like strands of fiber.

Early Western papermakers knew that certain fibers – cotton, linen, and
hemp – made the best paper in terms of strength, durability, appearance,
and longevity, but not why. With the chronic shortage of suitable papermak-
ing fibers in the nineteenth century, every possible fiber, including straw,
nettles, moss, and seaweed, was exploited; few of the resulting products,
however, could rival rag-based paper. The decisive component that made a
difference wasn't given a name until modern times, was not even isolated
as a chemical until 1838, and was not identified by a chemical formula until
1913. It was – and is – cellulose, the chief chemical constituent of the cell
walls of plants.

After the essential fibers (obtained directly from plants or refined from
rags) are cleaned, cooked, and macerated, the pulpy mass is mixed with a
great deal of water, diluting and mixing well, allowing the long strands of
fiber to distribute themselves uniformly. Then a porous flat sieve or screen,
called a "mold," held level and horizontally, is dipped into the suspended pulp
and lifted straight up, bringing with it a dripping layer of swollen fibers. The
water rushes through the mold, leaving behind a dense, evenly deposited layer
of long intertwining fibers. If merely set aside and left to dry, a primitive sheet
of paper is formed. Why and how does this simple procedure make paper?

Cellulose is what makes the whole thing work. Chemically speaking, cel-
lulose exists as atoms of carbon, hydrogen, and oxygen joined together in
arrangements of $C_6H_{10}O_5$ and connected one to another to form long chain
molecules called "polymers." The molecular structure of cellulose makes
it ideal for papermaking, since a mass of long, intertwining fibers orderly
arranged in parallel and stacked sheets of cellulose polymers has great

strength and flexibility. Furthermore, when in proximity with other cellulose molecules, both the polymer itself and its neighbor are stabilized and their attraction further strengthened by an electrochemical property known as hydrogen bonding.

Papermakers empirically deduced that some plants possessed greater quantities of cellulose than others. Raw cotton, they found, had lots of it; flax was good, too; hemp, jute, straw, manila rope, bamboo, sugarcane, and various grasses possessed it, to varying degrees, and were – and still are – constituents of paper pulp.

When cellulose was eventually isolated, modern-day chemists discovered that raw cotton is 91 percent cellulose, which explains its efficacy in papermaking and the current preference for cotton rags – or more commonly today cotton linters, the fuzz left on the cottonseed after ginning – for making fine, high-quality papers, which exhibit durability and permanence. Linen rags were also desirable, because flax, from which linen is made, also is high in cellulose content.

The Four Steps in Papermaking

Because the substances and processes to make paper can have a positive or negative impact on the final product's durability and permanence, it is important to understand the four basic steps of papermaking:

- Preparation of the pulp
- Formation of the sheet
- Pressing and drying
- Sizing and finishing

These four steps apply to paper made both in the Eastern and the Western worlds whether by hand or by machine; machines for making paper had been perfected by 1850.

To make the pulp, as roughly outlined above, the selected fibers are first cleaned, cooked, macerated, and mixed and agitated with water in a vat.

Enough of the suspended fibers to make a single sheet of paper is then scooped up from the vat using a mold, followed by gentle side-to-side shaking which allows the water to drain away, leaving behind an even layer of pulp. The designs of Eastern and Western molds vary, but their function is the same. In industrial papermaking machines, an endlessly moving and vibrating screen replaces individual molds.

Figure 1.9 illustrates the formation of a handmade sheet of paper. The vatman – holding the mold vertically – dips it straight down into the vat, rotates it to a horizontal position, lifts it back up to the surface, and gently rocks it

side to side to distribute the pulp evenly and drain off any excess. A removable wooden frame, called a "deckle," surrounds the mold and prevents the pulp from running off its flat surface entirely. In some simpler papermaking operations, the pulp is poured directly onto the molds.

After the water has drained away, the pulp can be seen evenly deposited across the screen. The newly formed sheet of sodden paper at this point is very thick and contains more than 90 percent water. The long wavy cellulose polymers are hygroscopic – that is, they attract and absorb water. Before the paper can be removed from the screen, the deckle is lifted away.

Figure 1.10 shows the transfer of the newly formed sheet of paper from the mold onto wool felts – the Western practice – or placement directly onto another sheet of damp paper – customary in the East – which is necessary before the paper can be pressed. The transfer is accomplished by couching (pronounced coo-ching from the French verb *coucher*, meaning to lay down) – inverting the mold onto the felts and rocking it firmly from side to side. In one even movement, the paper is released from the mold and attached to the felt below. This step is repeated until enough alternating felts and papers have accumulated to form a post.

A press is then used to squeeze out the tremendous amount of water remaining in the layers of paper that make up the post (Figure 1.11).

In the East, where felts are not used, the screen onto which the paper is formed is flexible. It is simply inverted and rolled away from the paper as it is

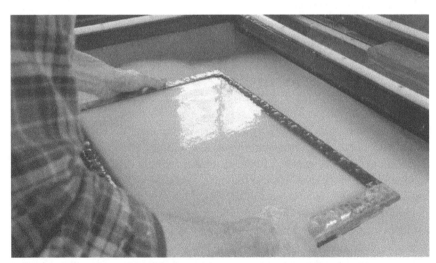

Figure 1.9 Forming a sheet of paper using a porous wire-surfaced mold. (Image: Avi Michael, Play Right Productions; *Chancery Papermaking at the University of Iowa Center for the Book*, 2013).

stacked onto the one below; as in the West, a post is formed and placed in a press.

Presses vary in sophistication from the simplest stone stacks to precisely controlled hydraulic machines. After an initial pressing, the layman separates the paper from the felts to form a pack, which is pressed again. This step can involve many pressings until the paper has lost most of its water.

The sheets are finally hung in small gatherings, called "spurs," in ventilated drying rooms or lofts for curing periods of varying lengths, depending upon the type of paper to be produced, the season of the year, and subsequent finishing processes (Figure 1.12).

Imparting to the paper various specific properties, such as water resistance or a surface receptive to printing, is the final step in papermaking. It can involve the addition of sizing, which renders the paper less absorbent. All writing papers are sized to prevent feathering of the ink used in writing. Sizing – or size – may be mixed directly into the pulp, as is usually done with modern papers, producing a paper that is internally sized. If the sheet of paper has been already formed, pressed, and dried, it is dipped into a tub of a sizing solution, typically dilute gelatin, a process called "external" or "tub" sizing (Figure 1.13). Other forms of finishing include burnishing the surface with smooth stones, an Eastern practice; or glazing or calendering in the West. Papers intended for specific uses such as in magazines are often coated or otherwise further processed.

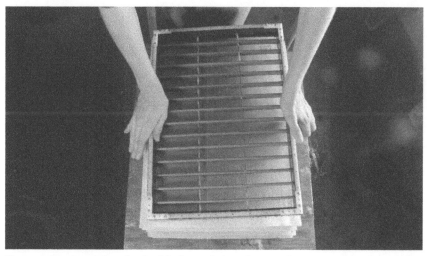

Figure 1.10 Removing the freshly formed sheet by pressing or *couching* it against a damp felt; another felt goes on top and the step is repeated until a stack or *post* of fifty sheets is built up. (Image: Avi Michael, Play Right Productions; *Chancery Papermaking at the University of Iowa Center for the Book*, 2013).

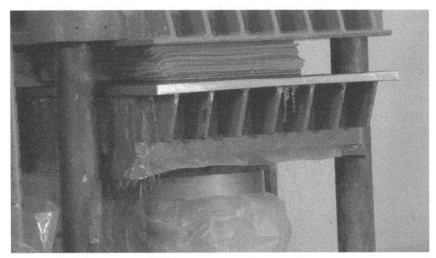

Figure 1.11 The entire post is squeezed under fifty tons of pressure to expel most of the remaining water in the sheets. (Image: Avi Michael, Play Right Productions; *Chancery Papermaking at the University of Iowa Center for the Book*, 2013).

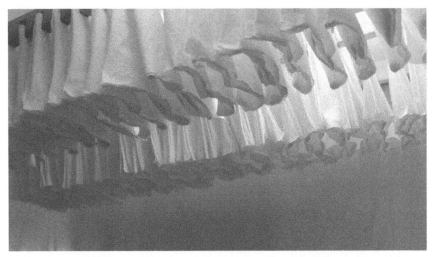

Figure 1.12 The still damp sheets are separated from the felts and hung to dry. (Image: Avi Michael, Play Right Productions; *Chancery Papermaking at the University of Iowa Center for the Book*, 2013).

Quality control is essential in any papermaking mill. Every sheet is examined and graded (Figure 1.14). Knots, shives, and other inclusions, which interrupt the paper's surface, will impede writing with a pen; likewise

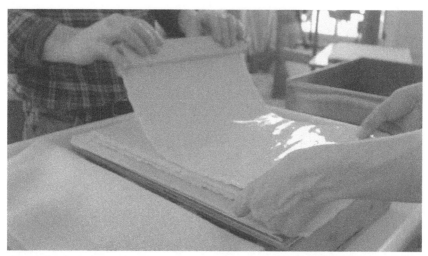

Figure 1.13 If a less-absorbent paper is needed, one intended for writing ink, the paper is dipped into a warm bath of gelatin size. (Image: Avi Michael, Play Right Productions; *Chancery Papermaking at the University of Iowa Center for the Book*, 2013).

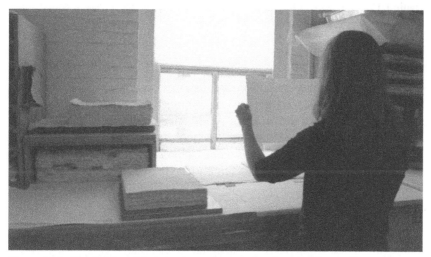

Figure 1.14 The finished dried sheets are inspected and graded for quality. (Image: Avi Michael, Play Right Productions; *Chancery Papermaking at the University of Iowa Center for the Book*, 2013).

differences in thickness can disrupt the evenness of a printed impression and the solidness and smooth operation of the textblock in a book.

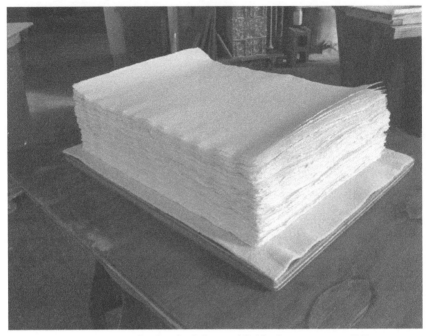

Figure 1.15 One ream or five hundred sheets of finished paper. (Image: T. Barrett; courtesy of the University of Iowa Center for the Book).

Ask papermakers about their product and their response can border on the spiritual. And for good reason: any material that has borne the history, philosophy, art, literature, and music of nation after nation, year after year, must be imbued with magic. Its origins may be modest, but paper's physical power of durability and permanence, plus its metaphysical power of transmitting the meaning of the marks it carries, must surely qualify as miraculous (Figure 1.15).

NOTES

1. Jonathan Stephenson. "Support." *Grove Art Online. Oxford Art Online.* Oxford University Press. http://www.oxfordartonline.com/subscriber/article/grove/art/T082371 (accessed 1/14/2015).

2. Rice paper is also frequently – and incorrectly – used as a generic term for Japanese and Chinese papers made from long fibers – *kozo*, *mitsumata*, and *gampi* – harvested from various shrubs. Only *kozo* belongs to the mulberry species; hence, another popular term – mulberry paper – is also a misnomer for many Asian papers. None of these papers is derived from rice.

3. Curt F. Bühler. *The Fifteenth-Century Book: The Scribes, the Printers, the Decorators.* Philadelphia: University of Pennsylvania Press, 1960, 35.

FURTHER READING

Baker, Cathleen. *From the Hand to the Machine: Nineteenth-century American Paper and Mediums: Technologies, Materials, and Conservation.* Ann Arbor: Legacy Press, 2010.

Balston, John N. *The Whatmans and Wove (Velin) Paper, Its Invention and Development in the West.* West Farleigh: J.N. Balston, 1998.

———. *The Elder James Whatman: England's Greatest Papermaker (1702–1759).* Vols. I, II. West Farleigh: J.N. Balston, 1992.

Barrett, Timothy. *Japanese Papermaking: Traditions, Tools, Techniques.* New York and Tokyo: John Weatherhill, Inc., 1983.

———. *Paper Through Time: Nondestructive Analysis of 14th- through 19th-century Papers.* 2012. http://paper.lib.uiowa.edu/index.php (accessed 3/14/2016).

Basbanes, Nicholas. *On Paper: The Everything of Its Two-Thousand-Year History.* New York: Alfred A. Knopf, 2013.

BBC Two Domesday. *How Parchment Is Made.* https://www.youtube.com/watch?v=2-SpLPFaRd0 (accessed 3/14/2016).

Bloom, Jonathan M. *Paper before Print: The History and Impact of Paper in the Islamic World.* New Haven: Yale University Press, 2001.

Blum, André. *On the Origin of Paper.* New York, NY: R.R. Bowker Company, 1934.

Centre de Recherche sur la Conservation des Collections. *Khartasia.* http://khartasia-crcc.mnhn.fr/en (accessed 3/14/2016).

Clapperton, Robert H. *Paper: An Historical Account of its Making by Hand from the Earliest Times Down to the Present Day.* Oxford: Shakespeare Head Press, 1934.

Clarkson, Christopher. "Rediscovering Parchment: The Nature of the Beast." *The Paper Conservator.* Institute of Paper Conservation 16, (1992): 5–26.

de Hamel, Christopher. *Medieval Craftsmen: Scribes and Illuminators.* Toronto: University of Toronto Press, 1992.

Fitzwilliam Museum. *The Making of a Medieval Manuscript.* http://www.fitzmuseum.cam.ac.uk/pharos/sections/making_art/manuscript.html (accessed 3/14/2016).

Haines, Betty M. "The Manufacture of Parchment." In *The Conservation of Leather and Related Materials*, Oxford: Butterworth-Heinemann, (2006): 198–199.

Harris, Theresa Fairbanks, and Scott Wilcox. *Papermaking and the Art of Watercolour in 18th Century Britain: Paul Sandby and the Whatman Paper Mill.* New Haven: Yale Center for British Art and Yale University Press, 2006.

Holcombe, Melanie. *Pen and Parchment: Drawing in the Middle Ages.* New York: Metropolitan Museum of Art, 2009.

Hughes, Sukey. *Washi–The World of Japanese Paper.* Tokyo: Kodansha International, 1978.

Hunter, Dard. *Papermaking. The History and Technique of an Ancient Craft.* New York, NY: Dover Publications, 1978.

International Association of Paper Historians. *Paper History.* http://www.paperhistory.org/index.php (accessed 3/14/2016).

J. Paul Getty Museum. *Making Manuscripts.* www.getty.edu/art/collection/video/399904/making-manuscripts/ (accessed 3/14/2016).

Karabacek, Joseph von. *Arab Paper.* London: Archetype, 2001.

Krill, John. *English Artists' Paper: Renaissance to Regency.* New Castle, DE: Oak Knoll Press, 2002.

Labarre, E.J. *Dictionary and Encyclopedia of Paper and Paper-making.* Amsterdam: Swets and Zeitlinger, 1952.

Loeber, E.G. *Paper Mould and Mouldmaker.* Amsterdam: Paper Publications Society, 1982.

Loveday, Helen. *Islamic Paper: A Study of the Ancient Craft.* London: Don Baker Memorial Fund, 2001.

Pan, Jixing. "Papermaking and Printing." In *The History of Science and Technology in China,* Vol. 2, Beijing: Cultural Relics Publishing House, (1979): 47–51.

Reed, Ronald. *Ancient Skins, Parchments and Leathers.* London: Seminar Press, 1972.

Sansom, Ian. *Paper: An Elegy.* New York: William Morrow, 2012.

Sutermeister, Edwin. *The Story of Papermaking.* Boston: S.D. Warren Co., 1954.

Thomson, Roy. *Conservation of Leather and Related Materials.* Amsterdam: Elsevier Butterworth-Heinemann, 2007.

Chapter 2

Conservation Problems Related to the Paper Support of Prints and Drawings

CONSERVATION PROBLEMS OF PAPER

Contrary to popular belief, paper is not necessarily short-lived. Many Western papers made in the fourteenth century are in excellent condition today and still flexible 2000-year-old papers have been excavated in China. The life span of a piece of paper is determined by its method of manufacture and, more significantly for caretakers, by its subsequent handling, factors identified in Box 2.1 as *Sources of Deterioration in Paper*. Internal sources of paper deterioration result from the papermaking process itself and include poor-quality pulp, residual processing substances, and unstable sizing and additives. If this category is expanded to include the materials and techniques of printmaking and drawing, as discussed in chapters 3 and 4, then the internal causes of damage grow to encompass what is popularly called "inherent vice," whereby the very materials used, or the way in which they were used, will inevitably deteriorate. Internally generated deterioration can be significantly retarded through the provision of item-level protection and preventive conservation, whereby surroundings and practices that foster preservation are implemented and maintained.

In the absence of such proactive stewardship, external sources of deterioration will proliferate. Dangerous environmental conditions such as high and fluctuating temperature and humidity levels, particulate and gaseous air pollution, and prolonged exposure to bright, full-spectrum light, or more accurately termed radiant energy, all act as external agents of change. Another threat coming from the outside is a phenomenon popularly known as acid migration, wherein paper deteriorates as a result of contact with, or even proximity to, acidic materials such as poor-quality wrapping paper, leather book bindings, stiff corrugated cardboard, and wood-derived products like Masonite® and plywood, which emit volatile organic compounds (VOCs).

Box 2.1 Sources of Deterioration in Paper

Internal Sources	*External Sources*
Poor-quality pulp	Acidity
Residual processing substances	Air pollution
Unstable sizing and additives	Temperature levels and fluctuations
	Humidity levels and fluctuations
	Light
	Insects and rodents
	Emergencies
	Careless handling

Internal sources of deterioration in paper are a result of the papermaking process. Proper housing, storage, and exhibition can lessen or retard the rate of the damage they can cause.

External sources of deterioration in paper result from poor housing, storage, exhibition, and handling. Establishing and enforcing strict collections care practices can eliminate or counteract deterioration.

Other external sources of deterioration include insects and rodents, emergencies, and thoughtless human actions.

Internal Sources of Paper Deterioration

Poor-Quality Pulp

Cellulose is essential for making good-quality paper. Cellulose itself is almost neutral (pH 6.6) and is chemically stable when maintained in that state. Once exposed to acidity, however, the long chain molecule of cellulose begins to break apart through an aggressive reaction known as acid hydrolysis. The greater the amount of acidity, along with necessary moisture and oxygen, the faster the scission of the cellulose bonds. The long flexible polymer of cellulose, so vital to the health of a sheet of paper, is reduced to shorter and shorter segments, its strong side-to-side, layer-by-layer arrangement disrupted. Scientifically, this is known as a decrease in the degree of polymerization (DP) or a loss in DP. The outward physical and visual symptoms of acid hydrolysis are overall embrittlement and darkening of the paper.

Always destructive to the final sheet of paper, acid can enter the pulp in several ways. First, it may be present in the fiber used to make the paper. Wood pulp, while a plentiful and cheap papermaking fiber, contains lignin, usually described as the amorphous cement that binds together and stiffens the bundles of cellulose molecules in wood. Lignin is chemically unstable; it becomes acidic as it breaks down and attacks the cellulose around it. At the same time, it also produces that "old book" odor reminiscent of vanilla. Because of its instability, chemically unrefined wood pulp or ground wood is used only to

produce papers for which durability and permanence is not required.[1] Newsprint, for example, may contain 80 percent unrefined wood pulp by weight. Because many artists have used newsprint in artworks ranging from the wood engravings by Winslow Homer (1836–1910) reproduced in *Harper's Weekly* to Cubist collages by Pablo Picasso (1881–1973), we need to understand the deterioration process of paper made from ground-up wood that has not been chemically treated to dissolve and remove its ligneous components.

Often demonized, wood pulp, in and of itself, does not necessarily produce a short-lived paper, just as the use of rags as ingredients in paper does not guarantee a permanent paper. Advances in refining wood pulp to extract high-quality alpha cellulose have resulted in the availability of conservation-grade papers and boards that are less expensive alternatives to rag-based paper products, confusingly specified as "museum-grade," for housing collections of prints and drawings.

Residual Processing Substances

Chemicals left over from many processing processes used on low-grade rags and non-rag fibers used for pulp can also be an internal source of acidity in the final sheet of paper. Almost all of the bleaches developed during the nineteenth century contained some form of chlorine, which often remained within the paper as a residue. Even traces of chlorine are highly reactive to moisture and can form small amounts of hydrochloric acid. Once again, the long cellulose polymer is cleaved by acidity generated within the paper itself. Other non-chlorine bleaching mechanisms have been found that are less destructive and also have a less negative impact on the environment.

Tiny metal particles, typically iron and copper, can also find their way into pulp during processing, either from equipment or the local water supply. Once trapped within the sheet of paper, they are very reactive to high levels of humidity and can catalyze oxidation reactions, which degrade cellulose molecules. The presence of bleaching residues and metallic impurities is difficult to detect.

Unstable Sizing and Additives

Gelatin sizing, traditionally used in hand papermaking in the West until the nineteenth century, seems to have had no deleterious effects on the aging of paper despite it being inherently acidic. This lack of adverse effect is probably due to the relatively small amount of gelatin deposited onto the surface of the paper and its inhibiting influence on moisture absorption by the paper. Used externally in tub sizing and hardened by the use of potassium aluminum sulfate, or alum, research indicates that traditional gelatin tub-sized rag papers have excellent aging properties. In the nineteenth century, however, with the introduction of unrefined wood pulp, a different sizing substance – rosin or

finely powdered pine pitch – was discovered to have a better affinity with the naturally acidic pulp. The rosin was precipitated evenly throughout the wood pulp by the addition of aluminum sulfate, confusingly called "papermaker's alum." Unfortunately, the combination produced a virtual internal combustion reaction of sulfuric acid hydrolysis. The introduction of neutral or alkaline sizing agents in the mid-twentieth century, typically alkyl ketene dimer (AKD), to decrease absorbency, has resulted in improvements in the lifetime of paper.

The introduction of inferior rags and wood pulp required more chemical and mechanical processing in order to produce a satisfactory pulp. To meet the never-ending demand for paper, nonfibrous fillers, often of clay, were added to the pulp to increase the paper's weight and opacity, but which also served to disrupt fiber-to-fiber bonding. Coatings applied after sheet formation imparted slicker surfaces for printing and a variety of color options, but had their own drawbacks. As a result of all of these factors, paper permanence can be reduced significantly by internal sources of deterioration.

External Sources of Paper Deterioration

The life span of a piece of paper is also affected by conditions to which it is exposed postmanufacture. Box 2.1 lists the external sources of paper deterioration, such as contact with acidic materials, air pollution, high and fluctuating temperature, high and fluctuating relative humidity, light, insects and vermin, emergencies, and careless handling. These external causes of deterioration in paper can be eliminated entirely or their negative impact counteracted by establishing and maintaining a rigorous Collections Care Program as described further in chapter 6. Typically, an institution's collections care practices are specified within its general Collections Management Policy.

Acidity

Acidity appears at the top of the list of external sources of paper deterioration, as it did for internal sources. This time, it is shown as a threat from the outside, through a process popularly called "acid migration." Cellulose, because it is highly absorbent, takes in any vapor or liquid that surrounds it. As a result of simple contact or even proximity, acid can travel from a source, usually poor-quality framing materials or storage enclosures, into the paper support of a print or drawing. This movement of acidity into the artwork, like internally generated acidity, results in deterioration of the paper, usually manifested by embrittlement and discoloration.

Air Pollution

Both forms of air pollution – gaseous and particulate – are known to damage paper. The corrosive effects of gaseous air pollution on paper and pigments

have been known for some time; we know, for example, that books in urban libraries deteriorate faster than their counterparts stored in the country. Common industrial pollutants, for example, sulfur dioxide, combined with humidity within the paper, are converted to sulfuric acid, with devastating results. It is important to recognize that pollutants can also be generated from unstable materials used in the construction of storage furniture and display cases. Gases destructive to organic substances like paper and parchment can accumulate in high concentrations in closed spaces, produced by paints, adhesives, and woods, especially freshly cut plywood and Masonite®. Office equipment, such as copiers, and certain kinds of air purifiers, can produce ozone, a powerful oxidizing agent, which also attacks cellulose. Particulate pollution deposits thin, intractable films of oily dust and dirt onto the surface of prints and drawings, which can be disfiguring, abrasive, and a source of nutrients for insects and fungi.

Temperature Levels and Fluctuations

The temperature in which it is kept is a critical factor in the overall preservation of paper. Although lower temperatures are ideal, a range of 60 to 70°F is the most practical temperature to maintain, due to typical types of building construction in the United States and Europe and human accessibility needs. Both paper and parchment can adjust to temperature variations, as long as the change is gradual and as narrow in range as possible. Ideally, both temperature and humidity levels in collection areas should fluctuate as little as possible. Because of its simultaneous impact on humidity, sudden and repeated episodes of fluctuating temperatures can cause serious damage to prints and drawings. Suffice it to say that attics and basements are not suitable storage areas for works on paper, without the installation of sophisticated heating and ventilation systems, which have their own risks and sustainability issues. Faced with escalating energy costs and carbon-footprint reduction mandates, many collecting institutions now accommodate seasonal shifts in temperature. Chapter 6 will discuss approaches to achieving suitable and sustainable climatic conditions.

Humidity Levels and Fluctuations

When works of art on paper are exposed to high levels of relative humidity – above 68 percent – they quickly become vulnerable to harm from two sources: mold growth and the consequences of dimensional changes. As noted above, levels of both temperature and humidity should be as steady as possible in all areas where prints and drawings are kept. Since both paper and parchment readily absorb moisture from the atmosphere around them and expand in response, high and fluctuating levels of relative humidity – perhaps as a result of malfunctioning equipment or inadequate climate control – can be harmful if

they continue over long periods of time. One recommended range of relative humidity for prints and drawing is 45 to 55 percent (see chapter 6); if the area's equipment makes it impossible to maintain that range, it is more prudent to keep the humidity as close to that as possible, and it is essential to keep it steady, with as little "spiking" as possible. Allowable drifts are typically ±5 percentage points. Again, the impact of seasonal shifts that naturally occur in some systems or historic buildings can be minimized in other ways. Because temperature and humidity are both key ingredients in initiating and sustaining chemical reactions – an increase in temperature or thermal energy will correspondingly increase the speed of a chemical reaction, both need to be kept within safe limits.

Light

Because light – or more accurately radiant energy – supplies the energy required to break chemical bonds, papers exposed to full-spectrum, bright, and prolonged daylight will often change color – becoming darker or lighter – and become brittle rapidly. The adjectives – full-spectrum, bright, and prolonged – are used intentionally and reflect three lighting variables that can be controlled in order to reduce the damage. Likewise, when works on paper are hung over radiators or next to heat-producing lighting fixtures, they change both visually and physically. Light and heat (thermal energy) hasten the aging of paper – in fact, in combination with humidity, these extremes of environment are sometimes used to artificially age paper for scientific analysis. Light can also cause fading of light-sensitive, or fugitive, colorants in the paper.

Insects and Rodents

In addition to providing nutrients for fungal growth, paper is also attractive to hungry insects and rodents. Simple good housekeeping can prevent infestations, but more effective is the establishment of an Integrated Pest Management (IPM) program as part of an overall Collections Care Program, whereby regular checks are carried out to identify, monitor, and limit conditions that allow for pest access and survival. These days, low or no oxygen, anoxic, and subzero freezing techniques for killing insect pests are preferred to toxic and potentially damaging chemical insecticides.

Emergencies

Although no one can prevent natural disasters or malfunctioning equipment, including a Disaster Preparedness and Emergency Response Plan in an institution's Collections Care Program can minimize damage from such unfortunate events. Emergency preparedness need not apply to only major

catastrophes – mini-disasters and calamities, such as broken pipes or leaky roofs, are much more likely to strike with unsettling suddenness, surprisingly often. Before predictable mischance occurs, prepare and assign a plan of action for each member of staff with clear directions on the best response for each situation and easy access to supplies, such as absorbent toweling, flashlights, and plastic sheeting. Well-designed and maintained storage facilities will go a long way in keeping damages from fire and flood to a minimum.

Careless Handling

Careless handling, perhaps the greatest cause of damage to works of art on paper, is one of the most persistent and difficult external source of deterioration to banish. More unnecessary damage is caused by ignorance and impatience than by any other factor listed in Box 2.1. While we may have no control over internal causes of paper deterioration, we can work toward establishing collections care practices that include enforceable standards of behavior on the part of all staff and visitors.

So far, chapter 2 has focused on the chemical and physical nature of the paper support of prints and drawings and the internal and external causes of its deterioration. By learning to recognize the symptoms of paper deterioration, its causes can be promptly addressed.

RECOGNIZING THE SYMPTOMS AND DIAGNOSING THE CAUSES

Deterioration of the paper support of a print or drawing is manifested by telltale changes in its physical, chemical, and visual properties that, correctly diagnosed, can indicate their causes and whether they happened in the past or pose an ongoing threat. All the human senses, perhaps with the exception of taste, can be used when gauging the relative "health" of paper.[2] For example, the senses of touch and sound suggest that a now flaccid gelatin-sized paper once had a satiny surface and a crisp rattle. Smell can detect time spent in a dank basement, either by the lingering musty odor of mildew or by the pungent prophylactic fumes of thymol. Occasionally, there is no need for such empirical evidence to gauge the changes that have transpired in an artwork's original condition – hypotheses can be immediately confirmed by an untouched companion print fortuitously stored in an album or substantiated by the pristine perimeter of a watercolor protected from light by an overlapping window mat.

In order to take prompt and effective action in addressing the causes of conservation problems, symptoms must be carefully evaluated. A severely

darkened paper can be the result of prolonged exposure to light, acid migration from contact with poor-quality storage or framing products, unrefined wood pulp with alum-rosin sizing, previous bleaching with potassium permanganate (now an outdated procedure), or the paper may have been chocolate-brown to begin with. Each symptom points to a different cause, some prompting a closer look at collections care practices, some requiring a call to a conservator for remedial treatment, and others no action at all. Some signs of wear and tear seemingly calling for repair – fingerprints, folds, and creases – may, in fact, endow a work on paper with "authenticity" or evidence of past use. Hence, certain stains and ragged edges may not be candidates for treatment. Relevant examples include cultural artifacts salvaged during the Holocaust, didactic prints having interactive functions, or many kinds of ephemera.

Below are some signs and symptoms of typical damage to paper whose detection can indicate that the internal and external sources of paper deterioration listed in Box 2.1 are at work. Quick and accurate diagnosis of a conservation problem can help in a timely rectification of its cause; more information on actions to be taken can be found in subsequent chapters. Included in each category of damage are other commonly encountered terms used for its description.

Overall Darkening and Embrittlement of Paper

As seen in Figure 2.1, general darkening, not confined to one particular side of the paper, its recto or verso, or in one location and usually accompanied by a marked decrease in flexibility and strength, is evidence that destructive internal sources, such as poor-quality pulp, residual processing substances, or unstable sizing agents, are breaking down the paper's long flexible cellulose molecules into shorter and shorter lengths. With time, the paper becomes weaker and weaker until it can hardly support its own weight when lifted. At that point, the brittle paper can rupture with even the slightest handling and cannot tolerate being curled or flexed.

The deterioration of paper caused by internal chemical factors can be slowed down, but not prevented entirely, by ensuring that the works are stored, preferably individually, in neutral or alkaline enclosures – mats, folders, or envelopes, which provide auxiliary support and mediating protection against surrounding environmental conditions. An enforced Collections Care Program, one component of a comprehensive Collections Management Policy, as described in chapter 6, provides optimal conditions for paper that is inherently unstable. Various options for item-level protection are described in chapter 5.

The vulnerability of paper that is deteriorating from internally generated causes can be lessened through conservation treatments that raise the pH, a measure of relative acidity or alkalinity of the paper, by washing it in alkaline

Figure 2.1 **Poor-quality pulp is an internal source of the overall deterioration of this paper.** (Image: S. Haqqi; Private Collection).

solutions, applying nonaqueous deacidification sprays and solutions, or through the provision of auxiliary structural support, that is, lining. Clearly such highly interventive and individualized treatments require careful deliberation beforehand, since some degree of risk is always involved, and their cost-effectiveness, in terms of providing broader benefits for the entire collection, is minimal.

Papers displaying chronic all-over, all-out symptoms of internal deterioration are frequently singled out as candidates for deacidification, sometimes called "acid neutralization" or "buffering." This process, while effective when applied strategically to collection items before they deteriorate, is not always appropriate for works of art on paper; see chapter 7.

Other terms: degradation, decomposition, degeneration, disintegration, fragility, instability, weakness, yellowing, embrittlement.

Localized Discoloration of Paper

A work of art on paper changes color in one particular area almost certainly because it is in contact with a deleterious substance, such as corrugated cardboard, newsprint, labels, tapes, glues, and other materials routinely used in inventorying, framing, and repairing prints and drawings. Acidity generated by these chemically unstable materials migrates into the naturally absorbent paper support of the art; sometimes only proximity to an acid-producing substance can cause darkening – direct contact is not necessary. Figure 2.2 illustrates one common form of localized contact discoloration called "mat burn." For framing, this work was put into a window mat made from inexpensive wood pulp mat board. Poor-quality mat board is fabricated by simply laminating a layer or layers of unrefined wood pulp between two sheets of heavier facing paper (see chapter 5). The bevel, or angled cut edge of the mat's window opening, exposes the compressed mass of wood pulp. Acid produced by the decomposing wood pulp sandwich migrates from the mat bevel into the work of art, forming a continuous band of discoloration, which corresponds with the dimensions of the window opening.

Depending upon the quality of the facing paper, a band of discoloration may correspond to the entire reverse side of the window mat, in which case, a distinct darker line from the bevel may or may not be present. A flat band of discoloration, as opposed to a distinct stand-alone line, is sometimes called "silhouetting."

Poor-quality mat board can also darken the reverse – or verso – of a print or drawing when used behind it as a supporting back mat board or backing board. Even worse than inexpensive mat board, however, is the use of corrugated cardboard, which creates severe darkening in a characteristic striated

Figure 2.2 A poor-quality window mat caused the line of discoloration that surrounds the platemark of this print. (Image: S. Haqqi; courtesy of the Conservation Center, Institute of Fine Arts, New York University).

pattern (see Figure 2.3). Other acid-producing boards made from reconsti-
tuted wood products include plywood and Masonite®, which are not suitable
for use in frames (see Figure 2.4). Often, the lingering odor of formaldehyde
indicates the use of these boards in frames. The gases emitted from plywood
and Masonite® often cause drastic oxidation reactions in certain pigments,
especially lead white and red lead (see Figures 4.5 and 4.6).

**Figure 2.3 Corrugated cardboard causes a characteristic striated pattern of discolor-
ation when placed in contact with the verso of a work of art on paper.** (Image: M. Ellis;
Private Collection).

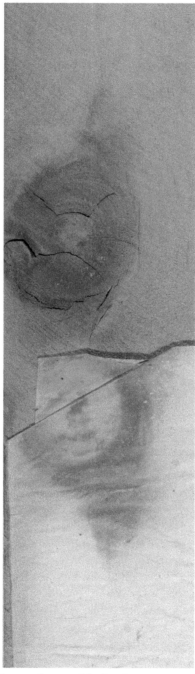

Figure 2.4　Wood products, often used in framing, cause severe discoloration when placed in proximity to paper. (Image: S. Haqqi).

Figure 2.5 Rubber cement not only causes severe staining when applied to paper, but also loses tackiness as it ages. (Image: S. Haqqi; courtesy of the Conservation Center, Institute of Fine Arts, New York University).

Other materials typically used in mounting and framing prints and drawings can cause localized discoloration with devastating chemical and visual effects. Adhesives, such as rubber cement, can attack the paper and cause irreversible damage. Figure 2.5 shows the verso of a drawing that was mounted using rubber cement. The adhesive discolored, stained the paper, dried out, and lost its tackiness, so that in addition to damaging the work, it failed to accomplish its original purpose. Reduction and removal of stains caused by rubber cement and other household glues, as seen in Figure 2.6, should be left to a professional conservator.

If a print or drawing is attached using an adhesive or double-sided tape to another piece of paper or mat board, *never try to peel them apart.* Inevitably, some of the support of the artwork will be left behind – a surface defect called "skinning" (see Figure 2.35). Generally speaking, if an unframed item cannot be easily disassembled from its mat or mount because of the manner in which it has been secured, a conservator should be contacted despite the

Figure 2.6 Common household adhesives can cause discoloration when applied to paper. (Image: S. Haqqi; courtesy of the Conservation Center, Institute of Fine Arts, New York University).

strong temptation to proceed. The urge to search for a signature hidden on the verso of a work is not worth the damage that the artwork will potentially sustain, as shown in Figure 2.7.

Pressure-sensitive (also called self-adhesive) tape can also cause severe localized staining. A host of time- and labor-saving sticky tapes – both single- and double-sided – even Band-Aids® and modern peel-away postage stamps – have been used to secure prints and drawings into mats, to repair tears and punctures, and to reinforce folds – invariably with disastrous results. Figures 2.8–2.12 illustrate the staining caused by the original "cellophane" tape and masking tape.

No pressure-sensitive tapes currently available for purchase can be recommended for hinging or repairing works of art on paper; and only a professional conservator should carry out the removal of those mistakenly applied. The solvents necessary for dissolving aged synthetic adhesives are very strong (polar), are toxic, and can adversely affect both papers and media. Furthermore, specialized equipment and tools are usually required.

Some pressure-sensitive cloth- or paper-backed tapes having a tacky acrylic adhesive are advertised as archival and are very popular for their convenience. A word of caution however: while the chemical stability of their adhesive is a significant improvement over earlier "Scotch" tapes, whose adhesive was rubber based, these tapes cannot be removed with water even a short time after their application. Without the use of solvents – and often, even then – their removal invariably results in skinning, as the adhesive does not dissolve entirely, but only gels. As the gummy mass of adhesive is rolled back upon itself and off the paper, it takes with it paper fibers. The real problem with archival tapes is one of semantics and the definition of archival, which should include the characteristic of reversibility. Chapters 5 and 7 describe materials and procedures for hinging and repairing works on paper.

Figure 2.7 Pulling off a window mat adhered directly to a work of art on paper inevitably results in damage. Sections of the margins of this print have been pulled away. (Image: M. Ellis; Private Collection).

Figure 2.8 Handy self-sticking tapes may save time, but usually cause damage to works of art on paper. (Image: S. Haqqi; courtesy of the Conservation Center, Institute of Fine Arts, New York University).

Gummed brown kraft paper tape, glassine or stamp tape, linen tape, and other water-activated tapes, can also cause localized staining due to the poor quality of the carrier or the unknown formulation of the adhesive, which can

Figure 2.9 Aged "cellophane" tape darkens and dries out. (Image: M. Ellis; Private Collection).

Figure 2.10 The "carrier" of the original "cellophane" tape shrinks as it ages. (Image: M. Ellis; Private Collection).

Figure 2.11 Double-sided masking tape disfigured the recto of this print. (Image: M. Ellis; Private Collection).

Figure 2.12 Rolled-up pieces of pressure-sensitive tape stained this drawing where they were attached on its verso. (Image: M. Ellis; Private Collection).

contain clay fillers, casein, sugars, called "humectants," and salt. For removal, many water-activated tapes require the application of hot water, steam, or poultices to soften the adhesive, a procedure that can easily cause tidelines and staining of the work. Often, the risks and expense of removing extraneous materials affixed to prints and drawings outweigh the degree of damage these materials are causing or will eventually cause – an assessment to be made by a professional paper conservator.

Labels and other extraneous means of identification affixed directly to prints and drawings can also cause localized discoloration, Figure 2.13. Not only because of their adhesives, but also because of their poor-quality paper carriers, stickers, seals, and bar-code labels should be applied to the mat or frame, and never directly to the work itself. The most safe, effective, and time-tested means of identifying works on paper remains a simple inscription or numbering system written in graphite pencil on a verso corner. Improved security measures prevent theft, not indelible and potentially disfiguring marks.

Other terms: burn, acid migration, color shift, darkening, yellowing, corrosion.

Common office fasteners, such as staples and paper clips, easily corrode under damp conditions and should, if possible, be replaced. Rust stains are seen in Figures 2.14 and 2.15.

Other sources of localized discoloration may result from simple ordinary, accidents – spills and drips from water, oil, coffee, candles, and the likes as seen in Figures 2.16–2.18. As mentioned, certain stains may appear to be accidental, but can provide important clues about an artwork's significance

Figure 2.13 **Identification labels and stickers can cause staining from either their adhesives or their carriers or both.** (Image: M. Ellis; Private Collection).

and past use; hence, they may need to be preserved. Likewise, historic and decorative mounts and old repairs should not be indiscriminately disposed of, due to their potential evidentiary significance.

Other terms: stain, tide line, spot, drip, splash.

Darkening of Paper Exposed to Light

Light – or more accurately, radiant energy – catalyzes the breakdown of cellulose and chemical residues contained in some papers. Because it happens gradually, light staining, or time toning, often escapes notice until the print or drawing is removed from its mat. Then it is discovered that the area of the work that remained protected from light under the border of the mat retains its original color, whereas that exposed to the light has darkened or otherwise shifted in tonality. Sometimes, the degree of darkening corresponds to the angle of light hitting the surface of the work while on prolonged display. Figure 2.19 illustrates light staining of an etching. The contours of the darkening correspond exactly to the perimeter of the opening of a window mat previously on the print. Light staining, especially in black-and-white prints, decreases the lively and essential contrast between

Figure 2.14 Rust stains result from common metal fasteners, in this case, a tack.
(Image: S. Haqqi; courtesy of the Conservation Center, Institute of Fine Arts, New York University).

Figure 2.15 In humid conditions, paper clips and staples easily rust and stain paper.
(Image: S. Haqqi).

Figure 2.16 Liquids absorbed by paper often leave telltale tidelines in their wake.
(Image: M. Ellis; Private Collection).

Figure 2.17 Tidelines result from the absorption and movement of water in paper. (Image: S. Haqqi; courtesy of the Conservation Center, Institute of Fine Arts, New York University).

Figure 2.18 A tideline often follows the configuration of the absorbed water. (Image: S. Haqqi; Private Collection).

light and dark. Very simple precautions that will prevent or retard light damage should be taken when works of art on paper are displayed. Damage from exposure to light is cumulative; each hour, day, and month takes its toll. Putting the art in storage will neither reverse damage nor prevent it in the future. Works of art on paper do not benefit from a period of "rest and recuperation" in the dark. Responsible caretakers establish and abide by light exposure standards as specified in their Collections Care Program (see chapter 6). This usually involves difficult choices about whether to exhibit or lend popular works of art, which are often the "stars" of a collection, as well as thinking selflessly about future requests and expectations for access. If a major anniversary of an artist's birth is approaching or the reopening of a local historical society, beloved or iconic works will be expected to be on display. Preplanning allowable exposure times can prevent disagreements and disappointment.

Light damage as manifested through the darkening of exposed paper can often be reduced by conservation treatment, but only after undergoing extensive testing to insure that both the medium and the paper itself can tolerate the rigors of the treatment. While the lessening of discoloration to some degree can be rationalized as beneficial for the physical and chemical well-being of the paper, further measures taken to reduce or eliminate the discoloration on purely aesthetic grounds cannot be seen as conservation, but as restoration.

Other terms: light staining, time toning, darkening, yellowing, sunburn.

Fading of Colored Paper

Like light staining, the fading or color shift of colored paper from exposure to light happens so gradually that it may pass undetected by the casual observer. The colorant in many colored papers is created using an organic dye, not discrete pigment particles, dispersed throughout the paper pulp. Early synthetic dyes, developed after 1856, created never-before seen colors, but were, due to their molecular structure, extremely fugitive or sensitive to light. The family of basic dyes, among the first to be formulated, is the brightest tinctorially and happens to have an affinity for ground wood and unbleached pulps – two quite common – and acidic – constituents of modern, inexpensive papers. The two types most familiar to everyone, the telephone company's Yellow Pages (although rapidly becoming scarce) and children's construction papers, are colored with basic dyes and, not surprisingly, they will fade very quickly. Unfortunately, no treatment can restore lost color.

Other terms: bleaching, lightening.

Figure 2.19 Long-term exposure to light has caused the paper of this print to darken. (Image: S. Haqqi; Private Collection).

Mold Growth

Mold spores are always present in the air. They remain dormant in drier environments (below 68–70 percent relative humidity), but with elevated humidity will readily colonize and grow on paper, its surface coating, various media, and even the cellulose itself. Using these substances as nutrients, mold will grow and spread, invading the paper structure and causing patchy discoloration. Eventually the strong network of paper fibers is broken down, and the sheet becomes limp and spongy. Certain media, especially pastels and watercolors, contain natural gums that are attractive to mold. Mold growth in pastels and watercolors is sometimes easy to overlook, because it blends in with the work's colors and design; in fact, its dappled appearance is sometimes mistaken as intentional.

Mold growth is often difficult to detect early, because it appears in many subtle forms and colors, even pinks and greens. At times, the mold itself is invisible, but its musty odor indicates that the work of art has spent some time in a damp place. Figure 2.20 shows how paper can be affected by long-term storage in a damp environment. In this instance, mold penetrated so deeply into

the structure of the paper that the paper's internal strength has been severely compromised. In some cases, when mold growth has not progressed too far and is resting lightly on the surface of paper, a very soft brush or mini-vacuum, the type used to clean computer keyboards, can be used gently to dislodge it. This solution is obviously not prudent when the mold has attacked powdery media or when removal of the mold would otherwise disturb the image or alter the surface texture of the paper support. Furthermore, *extreme caution* must be taken not to breathe or otherwise ingest airborne mold spores through the skin or eyes, which can occur if mold spores are unintentionally scattered into the workspace by brushing and sweeping. When dealing with conditions in which mold proliferates, for example, after a flood, only vacuums fitted with High Efficiency Particulate Arrestance or Air (HEPA) filters should be used, as well as face masks and gloves, at a minimum. A mold remediation respirator with full body protection including goggles, may be required in extreme circumstances. A Disaster Preparedness and Emergency Response Plan is an important part of the Collections Care Program; see chapter 6.

Mold can take a variety of forms, from small, scattered black spots to feathery white strands or an inconspicuous fuzzy haze. When mold growth is found or suspected in a framed print or drawing, it should be unframed immediately, to dissipate any humidity trapped inside. This is sufficient to stop or prevent mold growth, since mold simply cannot survive in humidity less than 68–70 percent relative humidity. Keep in mind, however, that microclimates of high humidity are easily formed and maintained by water-loving paper. When mold growth has entered into the structure of the paper itself, interferes with a friable medium, or has left disfiguring stains, consultation with a professional conservator is necessary. The use of fungicides, such as thymol, to kill active mold is not advisable; nor do fungicides provide protection against future mold growth.

Other terms: mildew, rot, microbiological attack, contamination, limpness, degeneration.

Foxing

The term foxing refers to the small circular patches of reddish-brown discoloration that mysteriously appear on both old and modern papers for no apparent reason, Figures 2.21 and 2.22. Despite years of scientific investigation, the causes for this unsightly manifestation have not been determined with absolute certainity. For some time, it was thought that iron particles, deposited within the paper matrix during the course of its manufacture, were rusting; in some historic literature, foxing is called "rust." Iron specks can occasionally cause similar stains. Iron inclusions, as they are called, typically have a black speck

Figure 2.20 Storage in damp conditions will result in disfiguring mold growth and permanent damage. (Image: S. Haqqi; courtesy of the Conservation Center, Institute of Fine Arts, New York University).

at their core and do not fluoresce when viewed under ultraviolet radiation – or black light. The most recent, and generally accepted, theory concerning the cause of foxing identifies it as a form of selective microbiological attack, with the waste products of the fungal colonies causing the stains. This is supported by the observation that the paper's absorbency in the foxing spots is drastically increased, probably from a decrease in sizing as also occurs from mold growth. The particular species of microorganisms believed to cause foxing requires very specific humidity conditions, yet to be identified, for its growth. It is not surprising, then, that foxing is often found in books, where humid microclimates can easily develop and persist due to the natural tendency of paper to hold onto water – its hygroscopicity. Sometimes other factors, such as animal glues, printing inks, or acid-producing cardboard, seem to have catalyzed or encouraged foxing. Foxing in and around these areas is sometimes more densely spaced, bizarrely patterned, or different in color. Often, incipient foxing is not visible at all, but fluoresces intensely under ultraviolet radiation. Regardless of the host of potentially contributing factors, it seems safe to conjecture that had they remained in a nonhumid environment, prints and drawings would have been spared this disfigurement.

Figure 2.21 Foxing, as well as a mat burn, disfigure this print. (Image: S. Haqqi; courtesy of the Conservation Center, Institute of Fine Arts, New York University).

Figure 2.22 The term foxing refers to the small circular patches of reddish-brown discoloration that mysteriously appear on both old and modern papers for no apparent reason. (Image: S. Haqqi; courtesy of the Conservation Center, Institute of Fine Arts, New York University).

When kept in a stable environment, foxing will not spread. Only a conservator who can determine the effect of the treatment on the medium and the paper support should attempt the removal or reduction of stains caused by foxing.

Other terms: rust, mildew.

Extreme Overall Deformation of Paper

As noted above, paper is naturally hygroscopic – it loves water. And water, in the form of high and fluctuating humidity, causes the paper to expand and contract. The cellulose molecules of paper will absorb water vapor until they reach equilibrium with the relative humidity of the surrounding atmosphere. As the air around paper becomes less humid, the cellulose molecules give up moisture, but at a much slower rate. As can be expected, variations in moisture content are accompanied by dimensional changes. As the cellulose expands with the intake of water, the whole sheet of paper expands across its "grain," the lengthwise orientation of its paper fibers. When the paper dries out, it shrinks. Different papers expand and contract at different rates and in different ways, depending upon their fiber content and the way the sheet was formed.

Generally speaking, the movement of paper does not present a problem; it is a natural phenomenon and should not be interfered with through attempts to prevent it, like dry-mounting the artwork to a stiff cardboard or pressing it between glass (*passe-partout*). Paper has a life of its own; its subtle contribution to the overall aesthetic of the work of art comes from its liveliness and "body." Keep in mind that the artist chose a particular paper for working on, with its surface in mind. (Paper actually has two distinct sides: the felt side and the wire side resulting from its formation process. Traditionally, the felt side is the "correct" or preferred side.) Drastic measures taken to stop deformation – ironing, dry-mounting, excessive flattening – usually alter the personality of the paper, resulting in a change of the look and feel of the work of art. Correctly hinged, matted, and framed, most works of art on paper will not seriously buckle if kept in a stable environment. When deformation becomes an aesthetic issue, the work can be gently flattened, provided that no flaking of the medium is present.

Deformation is a serious conservation problem in some specific instances. Sometimes, overall pronounced buckling can be a sign of repeated and drastic fluctuations in relative humidity. This distracting characteristic is often seen in works kept in houses by the ocean or in tropical climates. Modifications to the frame "package" can often mitigate such changes; however, attention should be paid to the possibility of mold growth caused by trapped humidity within the frame.

Deformation is particularly dangerous when it warps the paper to the extent that its undulations touch the glass or acrylic sheet that serves as the "glazing" in the frame. A whitish haze of condensation gradually forms in the intimate microclimate that exists between the paper of the artwork and the glazing. Luckily, the haze is usually adhered to the glazing and can be readily wiped away.

Friable media are threatened by extreme overall buckling, since a layer of pigment must move if the support below it moves. Brittle layers of media, such as poster paint or India ink, will often develop flaking. A reminder: parchment is very susceptible to dangerous degrees of deformation (see Figure 1.3). It is no surprise, then, that the illuminations in medieval manuscripts are prone to flaking and powdering.

Other terms: buckling, distortion, undulation, cockling, curling, warping.

Localized Deformation of Paper

Localized deformation is the distortion of paper in one discrete location or in a specific direction, as opposed to the overall buckling described above. Usually, localized buckling is the result of something – a repair, sticker, or hinge – that impedes the natural expansion and contraction of the paper in that particular area. When a work of art on paper is correctly hinged into a mat, it is free to move in response to climatic changes. While it can exhibit severe overall deformation with wide fluctuations in relative humidity, under normal conditions no undue tension will be exerted by its method of attachment. Such was not the case for the drawing shown in Figure 2.23. Because this work was glued or "tipped down" around its entire perimeter, it could not move as the humidity rose and fell. Expansion and contraction of the support led to pronounced rippling or washboard buckling. The result is not only visually distracting, it is also dangerous since the paper will eventually rupture from being stretched so tightly. This defect is also called "drumming," since the paper responds to the tension exerted around its edges like the head of a drum.

Figure 2.23 When paper is prevented from expanding and contracting freely, buckling results. (Image: M. Ellis; Private Collection).

Figure 2.24 A large label on the reverse side – or verso – of this print has caused buckling. (Image: S. Haqqi; courtesy of the Conservation Center, Institute of Fine Arts, New York University).

Localized deformation can also result from the constrictions produced by a label, tape, hinge, or old repair that restricts the natural movement of the paper of a print or drawing. The paper simply expands and contracts around the material that impedes it. The print shown in Figure 2.24 exhibits localized buckling caused by a large label on the reverse side – or verso – of the print.

On occasion, unusual patterns of distortion are a result of the creative process and should be left alone.

Other terms: draw, tension, bulge, warping, pucker, distortion, rippling.

Extreme Overall Flatness of Paper

It may seem paradoxical that, after the discourse on planar distortions just delivered above, flatness of paper can also be seen as a defect. Extreme flatness,

Figure 2.25 The overall adhesion of works of art on paper to poor-quality board can result in embrittlement and eventual breakage. (Image: S. Haqqi; courtesy of the Conservation Center, Institute of Fine Arts, New York University).

Figure 2.26 A corner of this watercolor has been lost as a result of mounting it to cardboard that became brittle over time. (Image: C. Lukaszewski; courtesy of the Conservation Center, Institute of Fine Arts, New York University).

however, is a symptom that the work has been mounted overall to a heavy cardboard – ill-advisedly – to expedite framing, eliminate buckling, or facilitate handling. One downside of this practice can be seen in Figures 2.25 and 2.26. The mounting process is either done wet – using a water-based paste or glue or a solvent-based adhesive such as rubber cement – or dry, using heat and a natural or synthetic resin film or coated tissue. While mounting a work on paper to a stiff cardboard – often called a "secondary" support – seems to solve the problem of distortions and simplifies, to some extent, handling, in reality it poses many more serious threats to the artwork. First, the cardboard to which the work is mounted is often made of wood pulp and causes severe staining of the paper due to acid migration. Second, chemically unstable adhesives often contribute to the discoloration, as they age, as well. Finally, inexpensive cardboard, as it deteriorates, becomes brittle. A sharp blow, sudden jolt, or uneven pressure, such as can occur when a framed piece falls from the wall or a mounted work is picked up by a corner, will snap the cardboard mount – and the artwork – in two. From an aesthetic viewpoint, prints and drawings that have been mounted overall appear dull and lifeless, because the subtle surface textures of their paper, crisp platemarks, as seen in Figures 3.4 and 3.5, and media have been compromised.

Only a professional conservator should attempt the removal of wet- or dry-mounted prints and drawings from aged paperboards. Like localized attachment,

Figure 2.27 Insect larvae create characteristic tunnels as they feed on paper. (Image: S. Haqqi; courtesy of the Conservation Center, Institute of Fine Arts, New York University).

Figure 2.28 "Grazing" is caused by small insects, which feed on the surface of paper. (Image: S. Haqqi; courtesy of the Conservation Center, Institute of Fine Arts, New York University).

gangen
er zugebracht hatten. Am 9ten kam das
Schiff in den Dünen vor Anker, und noch
an eben demselben Tage landete ich zu Deal
und reisete nach London ab.

Ende des vierten Bandes.

Figure 2.29 Rodent droppings can be brushed away; however, their urine stains will remain in this book. (Image: S. Haqqi; courtesy of the Conservation Center, Institute of Fine Arts, New York University).

never try to peel away a work of art on paper that has been firmly affixed to its mount, even though a curled-up corner makes it look as if the entire sheet would lift away at a touch. Chances are that it will not and by the time the damage is discovered, a hefty and irreplaceable layer of the original paper support will have been peeled away, a type of damage called "skinning" (see Figure 2.35). Because of the gradual desiccation of the adhesive, the edges of wet- or dry-mounted works have often begun to delaminate naturally, while the center remains firmly attached. If a conservator detaches a work of art from a secondary support, the mount should not be disposed of without consideration of its potential aesthetic and historical significance, since sometimes they have been inscribed or decorated by the artist or previous owner.

Other terms: laid down, mounted, marouflage (sic).

Insect and Rodent Damage

In addition to providing nutrients for fungal growth, paper is attractive to hungry insects and rodents. Good housekeeping, as part of a comprehensive Integrated Pest Management (IPM) program, can help prevent infestations (see chapter 6). That which they take away, grazing or erosion (Figures 2.27 and 2.28) and that which they leave behind, flyspecks or droppings (Figure 2.29) can signal the presence of pests. The culprit can usually be identified by the configuration of the damage it has inflicted.

Figure 2.30 A loss is a missing portion of the paper support, in this case caused by prolonged and repeated folding. (Image: S. Haqqi; Private Collection).

Other terms: flyspeck, insect residue, frass, organic residue, grazing, erosion, dropping, rodent damage.

Structural and Surface Damages

The necessity to describe structural and surface damages to paper is frustrating, since in almost all cases they are entirely avoidable and caused by human ignorance and impatience. French conservator Robert Lepeltier (1913–1996) states it more strongly: "The principal and indomitable enemy of all works of art – and by far the most destructive – remains man himself. He is responsible

Figure 2.31 A rupture is a break in the paper resulting in severed fibers in either a straight line (cut) or an irregular pattern (tear). (Image: S. Haqqi; courtesy of the Conservation Center, Institute of Fine Arts, New York University).

in one way or another for the conditions in which paper is kept and cared for. He is the villain behind every crime committed on works of art, either directly or by allowing the damage to be done."[3]

Ranging from completely detached and lost pieces of paper to slightly roughed up fibers, the following defects share a common trait: they did not need to occur.

Paper loss: a missing portion of the paper support caused by insects or mishandling (Figure 2.30). Depending on their extent, location, and degree of disfigurement, losses can be filled by a professional paper conservator or stabilized in-house.

Other terms: loss, hole, perforation, gap, lacuna(e).

Paper rupture: a break in the paper resulting in severed fibers in either a straight line (cut) or an irregular pattern (tear). Conscientious caretakers can often repair minor tears and cuts in-house before they get worse.

Other terms: tear, fracture, puncture, crack, cut, incision, break, fissure, separation, breakage, slit, scar, rupture, rip.

Figure 2.32 A "dog ear" is a diagonally folded corner of paper. (Image: S. Haqqi; courtesy of the Conservation Center, Institute of Fine Arts, New York University).

Figure 2.33 Dents are a result of rough handling and poor storage. (Image: S. Haqqi; courtesy of the Conservation Center, Institute of Fine Arts, New York University).

Figure 2.34 Fold and creases interrupt the central area of this design and also weaken the paper below. (Image: S. Haqqi; courtesy of the Conservation Center, Institute of Fine Arts, New York University).

Figure 2.35 Skinning removes only a layer of the paper leaving it vulnerable to tearing or creasing in that area. (Image: S. Haqqi; Private Collection).

Figure 2.36 The gradual accumulation of surface dirt and grime on this print is a symptom of poor handling. (Image: S. Haqqi; courtesy of the Conservation Center, Institute of Fine Arts, New York University).

Planar defects: an interruption of the continuous surface of the paper, sometimes accompanied by breakage of paper fibers (see Figures 2.32–2.34). Folds and creases can sometimes be gently lessened in-house either through local or overall flattening procedures.

Other terms: fold, crease, ding, dent, crimp, wrinkle, dog ear, pleat, crinkle.

Surface defects: disturbances affecting the surface texture or finish of paper usually caused by insects or careless handling. Lightly adhered dirt and dust can often be reduced in-house; however, vulnerable media and sensitive paper finishes can prohibit such procedures. Skinning, as seen in Figure 2.35, and other distracting surface damages or dirt embedded into the paper, as seen in Figure 2.36, are best addressed by a professional conservator.

Other terms: dirt, grime, fingerprints, smudge, soiling, dulling, trace, smear, insect grazing, erosion, organic residue, skinning, thinning, abrasion, scratch, gouge, scrape, nick, scuff, wear.

Today, conservators, collections care professionals, curators, and other caretakers have assumed prominent roles in the long-term preservation of works on paper through the design, implementation, and administration of in-house Collections Care Programs (see chapter 6). By working together, damage to prints and drawings can be prevented or minimized.

NOTES

1. A paper's durability differs from its permanence. Durability refers to the degree to which a paper performs its intended function, for example, paper towels are manufactured to retain their strength and not disintegrate when wetted. But because of their composition, paper towels are not permanent.

2. Printers traditionally touched paper with their tongues to detect alum, an acrid compound used to harden gelatin sizing, and also to determine if the paper had been sufficiently soaked prior to printing.

3. Robert Lepeltier, *The Restorer's Handbook of Drawings and Prints*, trans. Anne Ward. New York: Van Nostrand Reinhold, 1977, 34.

FURTHER READING

American Paper and Pulp Association. *The Dictionary of Paper.* 4th. New York: American Paper Institute, 1980.

ANSI/NISO. *ANSI/NISO Z39.48-1992 (R2009) Permanence of Paper for Publications and Documents in Libraries and Archives.* ANSI/NISO, Baltimore: National Information Standards Organization, 2009, 22.

Banik, Gerhard, and Irene Brückle. *Paper and Water: A Guide for Conservators.* Oxford: Butterworth-Heinemann, Elsevier, Ltd., 2011.

Browning, B.L. *The Analysis of Paper.* New York: Marcel Dekker, 1969.

Holik, Herbert. *Handbook of Paper and Board.* Weinheim: Wiley-VCH, 2006.

Kolseth, Petter, and J. Bristow. *Paper Structure and Properties.* New York: M. Dekker, 1986.

Pulp and Paper Resources and Information Site. http://www.paperonweb.com/index. htm (accessed 3/14/2016).

Rance, H.F. *The Structure and Physical Properties of Paper.* Amsterdam, New York: Elsevier Scientific, 1982.

Scott, William E., James C. Abbott, and Stanley Trosset, ed. *Properties of Paper: An Introduction.* 2nd. Atlanta, GA: TAPPI Press, 1995.

Slavin, John, ed. *Looking at Paper: Evidence and Interpretation: Symposium Proceedings, Toronto, 1999.* Ottawa: Canadian Conservation Institute, 2001.

Spencer Museum of Art. *Print Connoisseurship; Conservation Issues.* http://www. spencerart.ku.edu/collection/print/connoisseurship/conservation.shtml (accessed 3/14/2016).

Chapter 3

Conservation Problems Related to the Materials and Techniques of Prints

RECOGNIZING THE SYMPTOMS AND DIAGNOSING THE CAUSES

Just as the paper support of a print or drawing deteriorates as a result of the internal or external sources listed in Box 2.1, so do printmaking and drawing media change in characteristic ways as they age. Whether printed or drawn, it is necessary to first learn to recognize what the marks are – physically and chemically – in order to identify the causes of their conservation problems. Only then can appropriate preservation strategies be developed for them.

Classification System

Printing processes have traditionally been categorized by the relationship of the printed image to the surface of the paper on which it appears – the ink layer is either raised above it, pressed into it, or as one with the paper surface. The caretaker of print collections, therefore, needs to scrutinize the intimate connection between paper and ink, in order to classify the print as one of three types: relief, intaglio, or planographic, each category having unique visual and physical properties and, by extension, its own conservation issues. To aid in accurately identifying and consistently recording print processes, the reader is encouraged to consult *Descriptive Terminology for Works of Art on Paper: Guidelines for the Accurate and Consistent Description of the Materials and Techniques of Drawings, Prints, and Collages*, a free online resource for collections care managers, curators, registrars, and conservators.[1] Because of the growing popularity of online collection cataloging software and proprietary in-house computer programs, it is important that terms be used consistently.

Considered solely in terms of their medium and methods of manufacture, prints are inherently free of conservation problems – relatively speaking. The fact that a number of fifteenth-century specimens are in excellent condition today is evidence of their durable nature, especially when one considers that the earliest prints, many of which dealt with devotional subjects, were meant for frequent contemplation and handling. And, of course, printed inspirational or informational texts were intended to be read. Early prints, in and of themselves, were not historically accorded the status of and, by extension, the careful handling of fine artworks. Although most conservation problems associated with prints have to do with their paper support, a few arise solely from what the prints were made with and how they were made. A practiced eye can distinguish these unintentional defects from the distinctive aesthetic attributes that each printmaking technique produces; these latter characteristics must not be altered either through careless handling or conservation treatments.

All Western printmaking processes use printing ink, which traditionally is a combination of an oil, such as linseed oil, and finely ground pigment. The exact composition of printing inks differs, depending on the technical requirements of the printing process. The proportion of oil to pigment determines the viscosity, density, and tack of the ink and the presence or absence of additives, such as heavy metal driers, which make the ink dry – through the mechanism of oxidation – more rapidly. Excess oil in a printing ink will sink into the paper, often staining the verso of the sheet and any adjacent papers. This phenomenon, as any librarian will attest, is quite common in printed books, where heavily printed pages are pressed firmly against others within the textblock for long periods of time. Figure 3.1 is an example of the striated pattern of discoloration caused by long-term contact with an unstable printing ink.

Technological advances in their formulations have led to more versatile, water-based, brightly colored, and less toxic, but less robust from a conservation point of view, inks.

Relief Prints and Processes

The simplest kind of print to make and, hence, among the oldest still in existence is the relief print. Examples include woodcuts, linoleum cuts or linocuts, and wood engravings – the latter a confusing term further explained below. The relief print began to appear in Europe during the fifteenth century, about the time when a reliable supply of paper had been established. The earliest relief prints date to the eighth century CE in China.

The technology behind relief prints is simple. A design is drawn upon or transferred onto the surface to be carved – called the "matrix" – typically a

Figure 3.1 Oxidation of the linseed oil binder in the printing ink of a text caused the striated pattern of discoloration on this adjacent page. (Image: C. Lukaszewski; courtesy of the Conservation Center, Institute of Fine Arts, New York University).

block of wood sawn parallel to its grain or a linoleum block. Practically any flat "carve-able" surface can be used. The areas around the design lines are cut away. These lower negative spaces will receive no ink and, thus, will not print. A special sticky printing ink, sufficiently viscous to sit on the raised parts of the block without running into the hollows, is necessary. The edges of design lines produced by the relief process often appear – for lack of a better word – squishy, as thick excess ink oozes out around the embossed block as it presses into the paper.

Prior to the mid-nineteenth century, the inks used for relief prints were generally stable, pigmented, oil-based inks that had excellent aging properties. With the introduction of dye-based colors and new synthetic binders, printing ink's reliable behavior in response to light and contact with water became more unpredictable.

Relief prints are simple to print, as well. Printing presses were not always utilized; many prints were made simply by placing the paper support – often dampened – against the inked block and rubbing evenly by hand with a smooth tool, such as an agate burnisher or even the back of a spoon. The shiny striations and three-dimensional indentations left by the tool, especially

noticeable if the paper has been dampened, are considered an important attribute of the print and are especially prized by collectors of Japanese *ukiyo-e* prints. The web of loopy lines that correspond to rubbing each separate block of color using a *baren* can be seen in Figure 3.2.

This is the first mention of the three-dimensionality of prints, which, as is the case for drawings, imparts liveliness to the work and should not be lessened.

Woodcuts historically offered an advantage in that the blocks could be mounted into a press together with printing type, offering the possibility of simultaneously printing and illustrating a text. But, because of the constraints of the technology – a dense, hard wood that required exceedingly sharp blades wielded with absolute control, woodcuts could produce images having only limited detail and fluidity. Perhaps, that explains their decline in popularity in the sixteenth century in the face of newer printmaking technologies. Later artists, such as Edvard Munch (1863–1944), Paul Gauguin (1848–1903), and the German Expressionists working in the 1920s exploited the raw, emotive effects of a splintered and angular wood grain.

In the late eighteenth century, wood again began to be used for printmaking, specifically as illustrations. It was discovered that extremely fine detail could be obtained by carving a block of wood cut *across* its grain rather

Figure 3.2 The use of a *baren* to rub the back of *ukiyo*-e prints during their production creates characteristic scribbly marks. (Image: S. Haqqi; courtesy of the Conservation Center, Institute of Fine Arts, New York University).

than *with* its grain. A block of fine-grained boxwood, preferable because it is harder than copper engraving plates, so carved could then be printed onto the newly available smooth-surfaced wove papers and imported East Asian papers that reproduced images in greater detail. Wood engraving, as the new process came to be called, was used almost exclusively for commercial illustration. The term engraving can be misleading when used in this context since it normally is considered to be an intaglio process as discussed below. Wood engravings are in fact relief prints. The blocks were made "type high" and were printed simultaneously with the text of books. The illustrations of *Alice's Adventures in Wonderland* were made from metal-faced wood engraving blocks after drawings by John Tenniel (1820–1914); Winslow Homer's (1836–1910) drawings of contemporary Civil War scenes were translated into hundreds of wood engravings published in *Harper's Weekly*.

Wood engravings were frequently printed on extremely thin tissues of East Asian origin, particularly a Japanese *gampi* paper of extraordinary silkiness and sheen – first imported into the United States in the 1880s, which showed the detailing of the design and the skill of the carver to greatest advantage. These delicate prints were often tipped into luxury books as illustrations. Stand-alone, highly detailed prints in all processes were also made on this delicate paper, which requires special handling. As is the case with mounting prints and drawings to rigid secondary supports in mistaken attempts to protect them, these delicate tissues have often been pasted down or otherwise improperly mounted with disastrous results. The effort to achieve printing of the highest refinement, while lessening the vulnerability of the support, led to the development of the *chine collé* printing process, discussed below.

Intaglio Prints and Processes

The category of intaglio prints, from the Italian word *intagliare*, which means to incise, includes engravings, mezzotints, etchings, aquatints, and drypoints, as well as photogravures, blind embossed prints (or inkless intaglio), and countless variations of all these processes. As with the relief printing process, each intaglio technique produces distinctive visual and physical features, which are highly prized by print enthusiasts and vulnerable, to varying degrees, to change with aging, mishandling, and inappropriate conservation treatments.

In the intaglio process, the lines to be printed are incised into the matrix, usually a copper or zinc plate, by means of a burin or rocker held in the hand (engraving or mezzotint), through the corrosive action of acid (etching and aquatint), or scratched directly into the metal (drypoint). When the heated metal plate is inked, the recessed lines fill with the ink, which is thinner than

that used in relief prints. The excess is wiped away, and the plate is then put on the moving bed of an intaglio press. A damp sheet of paper is positioned on top of it, followed by thick felts. The plate, paper, and felts are then pulled under a heavy roller, which exerts such tremendous pressure on the soft absorbent printing paper that it is forced into the grooves of the plate and takes up the ink deposited in them. The paper is literally molded into, over, and around the metal plate and mirrors in three dimensions its topography and outline. This embossed line, corresponding to the dimensions of the plate, is known as the platemark, another attribute of intaglio prints scrutinized by collectors. Figure 3.3 shows how the texture of the paper of an intaglio print has been pressed smooth by the plate, while, beyond the platemark, the paper retains its texture. Notice the depth of the platemark and the way it delineates rough and smooth expanses.

The history of engraving, the oldest intaglio process, goes back nearly as far as that of woodcuts. Etching followed soon after, in the sixteenth century. The etching process, like engraving, was used much earlier for decorating metal utensils and armor. Engraving and etching both afforded much greater detail than was possible by relief processes, and possibly for that reason intaglio prints were soon preferred as more refined successors to relief prints. Other variations of intaglio prints, such as aquatints, mezzotints, and dry-points, are made following the same principle as etchings and engravings. They differ in the manner in which the image is incised into the metal plate. They all share the characteristics of platemarks and raised inked lines.

In the intaglio process, because the paper support is squeezed into the plate's grooves, its design lines stand in relief. In contrast, the lines of a woodcut design are sunk or pressed into the paper. To a print connoisseur, the three-dimensionality of a printed line to a great extent determines the quality of that one impression. In aesthetic terms, the height or depth of a printed line can make the difference between a design that is rich and vibrant and one that is faint and lifeless, and, not surprisingly, a print having more or less financial value. Those responsible for overseeing print collections need to recognize the topography of these works of art; dry-mounting, stretching, and other extreme flattening procedures can easily alter a print's texture. A heightened sensibility to the three-dimensionality of prints is a prerequisite to mastering safe flattening techniques and is indispensable for the care and handling of all prints, even the so-called planographic ones. The point is brought up here because the surface texture of both paper and ink is quite an evident and a prized attribute of intaglio prints.

The platemark is one of the most noticeable and valued three-dimensional traits of intaglio prints. It is difficult to determine the reason for its impor-tance since in early examples the platemark was trimmed away or gradually cut down during remounting campaigns. To some, the platemark is proof

Figure 3.3 This embossed line, corresponding to the dimensions of the plate, is known as the platemark, an attribute of intaglio prints scrutinized by collectors. (Image: S. Haqqi; courtesy of the Conservation Center, Institute of Fine Arts, New York University).

that the print is original – a misconception insofar as a platemark is sometimes embossed upon high-quality photomechanical reproductions. Today, the platemark is considered to be integral to the field of the artist's design. Furthermore, the platemark provides information about the print's creation – the paper that was selected, its "hand," its dampness when pressed, and the amount and evenness of pressure exerted. A platemark can also indicate whether the print was correctly "pulled," and whether the printer was meticulous or careless. The platemark manifests an action that requires both artistic skill and technical expertise. As such, it should remain unaltered.

Because of the tremendous pressure that produces platemarks and the hard edge of the metal plate, the resulting embossed line is sometimes weaker than the surrounding paper. The paper fibers along the platemark may actually

have been partially severed. Fragile or cracked platemarks may indicate that the printing pressure was excessive, the plate poorly beveled and filed smooth, or that the paper selected could not tolerate that degree of deformation. Under no circumstances should a platemark be lessened through destructive mounting to a secondary support, as seen in Figures 3.4 and 3.5.

Cracked platemarks can be reinforced on the verso using strips of feathered, very thin Japanese tissue applied with starch paste. Such reinforcement will bring the separated parts together and will add extra strength to the platemark.

Despite the initial observation that prints tend to be relatively tough and durable, printing inks, in fact, can be damaged by repeated rubbing or surface abrasion. Surface abrasion frequently goes unnoticed; however, it is particularly conspicuous on some types of prints, specifically mezzotints, because of their method of manufacture. To produce a mezzotint, thousands of densely packed, microscopic pits are first gouged into the metal plate using a "rocker." After the entire plate is covered with an evenly distributed pattern of tiny pits, areas of the image that are to be white are burnished down, which creates smooth areas that cannot hold ink. The plate is inked and the excess ink wiped away; each cavity remains filled with ink. Upon printing, a rich velvety layer of ink, made from thousands of pinpoint specks of ink, is deposited across the surface of the paper. The design emerges from a rich, inky black background. The unsized papers on which mezzotints are printed are super-absorbent and soft-surfaced. Before printing is even begun, the paper may be lightly brushed to increase its nap. As is true for all intaglio processes, the design stands out from the support – in this instance, on raised felt-like paper fibers. But too often these inky shadows have paled from rubbing or from prolonged sliding across other sheets of paper in a storage box or portfolio.

Other types of prints having vulnerable ink layers include those produced by stenciling procedures, such as silkscreen and pochoir prints, wherein abrasion is especially apparent in broad passages of flat color.

The surface of all works of art on paper is susceptible to abrasion and should be protected continuously by either the glass or rigid acrylic sheet in a frame – the glazing – or with smooth interleaving papers or "slip sheets" inserted into mats when unframed (see chapter 5). Unprotected prints and drawings should never be stacked and left to slide over each other, for instance, in flat file drawers, since surface abrasion of the design layer will occur gradually, but inevitably.

Planographic Prints and Processes

Lithographs are products of the planographic printing process, so called because the design is neither raised above, nor pressed into the paper support. In the final print, the ink is deposited evenly across the surface of the paper.

Figure 3.4 **The platemark of this soft-ground etching has been flattened out entirely by mounting the work to cardboard.** (Image: C. Lukaszewski; courtesy of the Conservation Center, Institute of Fine Arts, New York University).

Figure 3.5 **The crisp platemark of this etching has been flattened and has ruptured as a result of mounting it to cardboard.** (Image: C. Lukaszewski; courtesy of the Conservation Center, Institute of Fine Arts, New York University).

In lithographs, the paper is not deformed to the same extent as it is from relief and intaglio matrices; however, it may be slightly indented from the printing matrix, that is, the lithographic stone or plate. In this sense, lithographs can have marks that correspond to the platemarks in intaglio prints. They are not nearly as sharp as intaglio platemarks, nor are they always distinguishable, but they usually appear as a smoother delineated area where the paper has been pressed against the lithographic stone or plate. While lithographs may not have appreciable platemarks, they do have dimensionality, which needs to be preserved.

Lithography, which is based on the principle that water and oil do not mix, was discovered in the late eighteenth century by Alois Senefelder (1771–1834), who as the story goes, jotted down his mother's laundry list on a slab of Bavarian limestone on which he ground printing inks. The inspiration to etch, ink up, and then print using the heavy stone as a matrix remains a mystery. The process, which was soon perfected and spread quickly into France and England, involves drawing a design on a scrupulously clean, fine-grained limestone with a grease pencil or ink called "tusche." A very light acid wash fixes the image and opens up the stone's pores. Next the entire surface is coated with water. Because the greasy lines or oily washes have penetrated into the stone's pores, they remain unchanged. After the porous stone is saturated with water, it is inked. The oil-based ink sticks to the greasy design lines and is repelled by the waterlogged stone. The stone, already positioned in the moving bed of a lithographic press, with a damp sheet of paper placed over it, followed by a flexible metal sheet, is passed under a scraper bar, which forces the ink from the stone onto the paper. Sheets of mechanically grained zinc and aluminum can be used instead of lithographic limestone, which is today scarce. The variety of lithographs is enormous and the process, due to the large print runs that were possible, was one of the most popular printing techniques. Today, lithography and other processes are quickly losing out to computer-driven printing techniques, such as ink jet and laser printing, among others. Advances in colored printing inks have resulted in inexpensive color reproductions that do not stand up well to light, as seen in Figure 3.6.

Monotypes can be produced via a number of printing techniques; however, they are generally classified as planographic because their ink layer is in plane with their paper support. In making a monotype the artist paints the image directly onto a matrix, usually but not always a glass or metal plate, from which the print is made with or without a press. Because most of the medium is transferred onto the paper support, usually only one or two impressions of the print can be made from any one plate, and these will differ drastically. Monotypes, while modern in conception, existed as early as the seventeenth century by the Italian printmaker Giovanni Benedetto Castiglione (1609–1664), who appreciated the creativity afforded by the process. Edgar

Degas (1834–1917) is well known for exploiting the process. Their spontaneity can sometimes lead to the use of unusually formulated printing media, most often inks that have been thinned down in order to achieve more painterly effects, but sometimes oil paints are used. Diluted oil paints or oil-based inks, when applied to paper, often can be identified by haloing, which occurs as the oil component is wicked away from the design lines into the surrounding absorbent paper. The process was probably invisible at first, but the oil eventually darkens through oxidation, a natural aging process for linseed oil. Oxidized oil, however, is not only dark in color, it causes embrittlement of the paper. Consequently, prints saturated with oily inks should be handled as little as possible. Haloing, which occurs when excess oil wicks out by the absorbent surrounding paper, can also be observed in drawings made with oil pastels, wax crayons, and paint sticks.

Stencil Prints and Processes

Often categorized as planographic, but in a class by themselves, are stencil prints and their related processes, silkscreen prints, serigraphs, and pochoir. These prints are considered planographic in the sense that their design layer is in plane with their paper support. Generally speaking, silk screens – they are also known as serigraphs, in order to differentiate fine art from commercial silk screens, and the other stencil process of pochoir, which employs flexible metal foil masks through which inks are daubed, suffer from problems associated with the specific inks used. In the case of Henri Matisse's (1869–1954) *Jazz* series – probably one of the most famous examples of a masterpiece executed in pochoir, opaque watercolors were used rather than printing inks to create the highly saturated matte colors. Hence, the surface of the stencil prints from *Jazz* is extremely susceptible to abrasion; and their brilliant colors are sensitive to light. It is sad that the original closed album format of *Jazz*, which protected the colors, has been too often destroyed in order to display the pages individually, sharing their exuberant message to be sure, but hastening their fading in the process.

Conservators are wary when treating silkscreen prints because of the difference in absorbencies between the recto and verso of the paper. Because the flatly printed nonabsorbent inked passages on the recto tend to be large and continuous, the paper support can only absorb water – and expand – through its verso. Hence, washing and flattening these prints can be unpredictable.

Digital Prints and Processes

Digital printing uses computer software to direct the flow of ink via four modes of application: impact (dot matrix), ink-jet (thermal or piezoelectric), electrostatic (electrographic or electrophotographic), and thermographic

Figure 3.6 **Prolonged exposure to light resulted in fading of the yellow and red, leaving only the blue printing ink of this off-set lithographic poster.** (Image: M. Ellis).

(direct thermal transfer or dye diffusion). Many of these processes use proprietary materials and equipment and are known by specific names, such as Giclée® and IRIS®. As a general rule, it can be said that the inks needed to produce digital prints need to be extremely fluid and are therefore usually dye-based or composed of newly developed nanoparticulate pigmented inks. Furthermore, because inks for digital printing tend to be translucent, the papers on which they are printed tend to contain optical brightening agents, which are also known to be sensitive to light. For these reasons digital prints must be considered highly vulnerable to overexposure to light. The reader is encouraged to consult Martin Jürgens, *The Digital Print: Identification and Preservation*, The Getty Conservation Institute, 2009, to aid in their identification.

Printed Chine Collé

Another subcategory of printmaking techniques is the *chine collé* method. As previously noted, printmakers frequently chose to print on thin tissues, because their smooth surfaces produced clear, crisp detail. However, the handling of these fine, but wispy and delicate, papers was difficult. Developed in the nineteenth century, the *chine collé* process, which can be roughly translated as "glued China paper," simultaneously printed and mounted a thin tissue called *Chine* using the pressure exerted by the press; both intaglio and lithographic presses can be used. A tissue was dampened, its back was brushed with a diluted paste, and the sheet was positioned, pasted side up, over an inked metal plate or lithographic stone. A heavier, absorbent "plate" paper, also moistened, was placed on top of the pasted tissue. The whole package was then passed through the press, which printed and adhered the tissue to the heavier plate paper. At one time, the process was so popular that prepasted tissue papers, which required only dampening, were commercially available.

Prints made according to the *chine collé* process present unique conservation problems, hence their mention here. Frequently, they are not recognized as consisting of two distinct layers of paper and are treated as one sheet with disastrous results, especially when moisture is applied to their recto, as might occur with washing or flattening. Works printed using *chine collé* can be difficult to recognize since the tissue layer is often purposefully the same color as the supporting plate paper. As seen in Figure 3.7, the tissue's smooth surface and barely detectable edges, often corresponding with the platemark, make it easy to overlook.

Sometimes air pockets form between the tissue and the plate paper onto which it is mounted, probably a result of uneven pasting or a drying out of the paste with age. Often, the tissue will begin to lift around the edges, again a

result of the desiccation of the paste over time. The adhesive, probably starch or gum arabic, is often so thin and transparent as to be invisible. Nonetheless, *chine collé* prints do seem to be susceptible to foxing; possibly fungus uses paste as a nutrient. Some unstable glues and tissue papers used for the *chine collé* process may yellow with age and exposure to light.

It should be noted that the secondary support or plate paper of a *chine collé*, therefore, is to be considered an inherent component of the work: it is just as much a part of the work as the tissue on which the image has been printed. It should therefore never be trimmed, taped, written upon, or otherwise mutilated. In most composite artworks on paper, the outside dimensions of the secondary support are significant for presentation purposes. Only a professional conservator should treat *chine collé* prints having any of the problems discussed here.

Color Prints versus Colored Prints

The difference between a color print and a colored print is noteworthy, although the two are sometimes difficult to tell apart. For the conservator, the differentiation between them (or a combination of the two techniques) is

Figure 3.7 The delicate tissue on which this etching is printed *chine collé* is difficult to discern. (Image: S. Haqqi; courtesy of the Conservation Center, Institute of Fine Arts, New York University).

critical when designing conservation treatments. The enforcement of exhibition lighting restrictions might be considered, as well. A color print is one in which all the colors have been printed using colored printing inks; printed colors appear flat and evenly deposited across the surface of the paper, as seen in Figure 3.8. Depending on the printing technique, a regular pattern of dots or specks of color will be apparent under magnification. Often one color will be uniformly out of register across the entire design, that is, the red of a firefighter's coat might be out of alignment to the same degree and direction as the red of the fire engine. Alternatively, the printing matrix – plate, stone, or block, could be inked up by hand using different colors applied to specific areas – called *à la poupée*. Nonetheless, the colors are still printed and the medium is still oil-based printing ink.

A colored print, conversely, has colors that have been applied individually and by hand, usually using a brush and transparent or opaque watercolor. The paper area to be colored was first brushed with a surfactant, typically a solution of ox gall, in order to make the paper receptive to a water-based ink or paint, followed by a wash of color. The color sometimes is unevenly applied and extends beyond the printed design lines. Pools and tide lines can form, where accumulated pigment particles have come to settle. The flag in Figure 3.9 has been colored by hand. Stencils were also used as time-savers when coloring in certain passages, in which case, there is often a thicker accumulation of paint where it runs up against the mask. Colors on prints can be both hand-applied and printed, as is evident, for example, in some Currier and Ives lithographs. These prints, in fact, serve as a good case study: many of the deciduous trees in Currier and Ives prints today look more like blue spruces, because the green with which they were originally colored by hand was composed of a mixture of Prussian blue and gamboge, the latter an extremely fugitive organic yellow pigment. Hence, from a conservation standpoint, hand-colored prints should be considered as sensitive to light as watercolor.

Often prints were not only colored by hand using watercolor, but were further enhanced by "glazing" selected colors, that is, applying a thin layer of gum, said to be cherry gum, to certain colors, particularly reds, in order to saturate them or make them look richer. This practice was often done on English sporting prints, as seen in Figures 3.10 and 3.11, and botanical prints.

Generally speaking, color prints resist light more than watercolors applied to a print by hand, with the exception of two important families of prints – Japanese woodblock *ukiyo-e* prints and nineteenth-century commercial lithographs, such as posters by Toulouse-Lautrec (1864–1901). In *ukiyo-e* prints, the printed colors are extremely sensitive to light and may quickly fade away entirely. Fading is so common and rapid that many people are under the impression that Japanese prints have a pale tonality when, in fact, they often were once garishly colored. *Aigami* blue, from the dayflower, and *beni*, a rose

pink from the safflower, are just two among many other fugitive plant-derived colorants. Stringent restrictions are usually placed on the exhibition of Japanese woodblock prints due to the sensitivity of their colors to light.

The other kind of colored printing inks that are sensitive to light in unpredictable ways are the dye-based inks developed in the nineteenth century following the discovery of aniline dyes. In 1856, William Perkin, then a young medical student, isolated aniline purple in his quest to synthesize quinine for the treatment of malaria. By 1866, its popularity as an artists' color had spread throughout Europe and America. The French named the new purple *mauve* and enthusiastically adopted the other never-before-seen colors that quickly followed. Posters printed around this time are particularly sensitive to light. Their blacks have frequently shifted to a muddy brown, while other colors have virtually disappeared, to the despair of collectors who have paid dearly for what was intended only as ephemera. Regardless of the inks used, these posters must be protected from light because their paper support is of poor-quality wood pulp. The darkening of the paper from its exposure to light only further distorts the color balance. Popular posters, political broadsides, and the like, particularly those in the late nineteenth and early twentieth centuries, were purposefully made using the most inexpensive materials – hence, their lack of permanence is no surprise. For conservators, these inks vary in their response to water and solvents, as well.

Figure 3.8 This color lithograph is printed entirely using colored printing inks. (Image: S. Haqqi; courtesy of the Conservation Center, Institute of Fine Arts, New York University).

Figure 3.9 A "colored" print has water-based colors applied to certain areas by hand after printing, in this case, the flag. (Image: S. Haqqi; courtesy of the Conservation Center, Institute of Fine Arts, New York University).

Figure 3.10 This aquatint was hand-colored using watercolors and then the horses and red jackets were "glazed" with gum for further color saturation. (Image: S. Haqqi; courtesy of the Conservation Center, Institute of Fine Arts, New York University).

Figure 3.11 Detail of Figure 3.10. "Colored" prints are usually sensitive to both light and water. (Image: S. Haqqi; courtesy of the Conservation Center, Institute of Fine Arts, New York University).

NOTE

1. www.philamuseum.org/doc_downloads/conservation/Descriptive Terminology-forArtonPaper.pdf (accessed 3/14/2016).

FURTHER READING

Antreasian, G.Z., with C. Adams. *The Tamarind Book of Lithography: Art and Techniques.* New York, Los Angeles, NY: Harry N. Abrams, Tamarind Lithography Workshop, 1971.

Ayers, Julia. *Printmaking Techniques.* New York: Watson-Guptill Publications, 1993.

Ballinger, Raymond. *Art and Graphic Reproduction Techniques.* New York: Van Nostrand Reinhold, 1977.

Bann, Stephen. *Parallel Lines: Printmakers, Painters and Photogrpahers in Nineteenth-century France.* New Haven: Yale University Press, 2001.

Biegeleisen, J.I. *Screen Printing: A Contemporary Guide to the Technique of Screen Printing for Artists, Designers and Craftsmen.* New York: Watson-Guptill Publications, 1971.

Brown, Kathan. *Ink, Paper, Metal, Wood: How to Recognize Contemporary Artists' Prints.* San Francisco: Crown Point Publications, 1992.

Brunner, Felix. *A Handbook of Graphic Reproduction Processes.* 6th. New York: Visual Communications Books, 1984.

Cape Fear Press. *Photo Intaglio definitions.* www.capefearpress.com/photointaglio-def.html (accessed 3/14/2016).

Catanese, P., and A. Geary. *Post-Digital Printmaking: CNC, Traditional and Hybrid Techniques.* London: A & C Black, Publishers, 2012.

Cate, Phillip, and Sinclair Hamilton Hitchings. *The Color Revolution: Color Lithography in France 1890–1900.* New Brunswick, NJ: Rutgers University Art Gallery, 1978.

Chamberlain, Walter. *The Thames and Hudson Manual of Etching and Engraving.* London: Thames and Hudson, 1972.

Colbourne, Jane, and Reba Fishman Snyder, ed. *Printed on Paper: The Techniques, History, and Conservation of Printed Media.* Newcastle upon Tyne: Arts and Social Sciences Academic Press, Northumbria University, 2009.

Curwen, Harold. *Processes of Graphic Reproduction.* 3rd. London: Faber and Faber, 1963.

D'Arcy Hughes, Ann, and Hebe Vernon-Morris. *The Printmaking Bible: The Complete Guide to Materials and Techniques.* San Francisco: Chronicle Books, 2008.

Devon, M., with B. Lagattuta, and R. Hamon. *Tamarind Techniques for Fine Art Lithography.* New York, NY: Harry N. Abrams, 2008.

Digital Art Practices and Terminology Task Force. *Glossary of Digital Art and Printmaking.* http://www.dpandi.com/DAPTTF (accessed 3/14/2016).

Dyson, Anthony. *Pictures to Print: The Nineteenth-century Engraving Trade.* London: Farrand Press, 1984.

Gasgoigne, Bamber. *How to Identify Prints: A Complete Guide to Manual and Mechanical Processes from Woodcut to Inkjet.* Revised Edition. New York: Thames and Hudson, 2004.

Getty Research Institute. *Art and Architecture Thesaurus Online (AAT).* www.getty.edu/research/tools/vocabularies/aat/ (accessed 3/14/2016).

Goldman, Paul. *Looking at Prints, Drawings and Watercolours: A Guide to Technical Terms.* London: British Museum Publications, 1998.

Grasselli, M.M., I.E. Phillips, K. Smentek, and J.C. Walsh. *Colorful Impressions: The Printmaking Revolution in Eighteenth-century France.* Washington, DC: National Gallery of Art, 2003.

Griffiths, Antony. *Prints and Printmaking: An Introduction to the History and Techniques.* Los Angeles: University of California, 1996.

Heller, Jules. *Printmaking Today: An Introduction to the Graphic Arts.* New York: Holt, Rinehart and Winston, 1958.

Hind, Arthur M. *A History of Engraving and Etching.* 3rd. New York: Dover Publications, 1963.

Image Permanence Institute. *Graphics Atlas.* www.graphicsatlas.org (accessed 3/14/2016).

Ivins, William M. *How Prints Look: Photographs with Commentary.* Edited by Marjorie B. Cohn. Boston: Beacon Press, 1987.

———. *Notes on Prints.* New York: Da Capo Press, 1967.

———. *Prints and Visual Communications.* New York: Da Capo Press, 1969.

Jürgens, Martin. *The Digital Print: Identification and Preservation.* Los Angeles: Getty Conservation Institute, 2009.

Jussim, Estelle. *Visual Communication and the Graphic Arts: Photographic Technologies in the Nineteenth Century.* New York: R.R. Bowker, 1983.

Lambert, Susan. *Printmaking.* London: Her Majesty's Stationery Office, 1983.

———. *The Image Multiplied: Five Centuries of Printed Reproductions of Paintings and Drawings.* London: Trefoil Publications, 1987.

Landau, David, and Peter Parshall. *The Renaissance Print 1470–1550.* New Haven: Yale University Press, 1994.

Lengwiler, Guido. *A History of Screen Printing–How an Art Evolved into an Industry.* Cincinnati: ST Media Group International, 2013.

Lumsden, E.S. *The Technique of Etching.* New York: Dover Publications, Inc., 1962.

Mayor, A. Hyatt. *Prints and People: A Social History of Printed Pictures.* New York: Metropolitan Museum of Art, 1971.

Museum of Modern Art. *Printmaking Techniques.* http://moma.org/explore/collection/ge/techniques/index (accessed 3/14/2016).

Mustalish, Rachel, and C. Ackley. *PhotoImage: Printmaking 60s–90s .* Boston: Museum of Fine Arts, 1998.

Nadeau, L. *Encyclopedia of Printing, Photographic, and Photomechanical Processes.* New Brunswick, CA: Atelier Luis Nadeau, 1994.

National Gallery of Art. *Gemini G.E.L. Glossary.* www.nga.gov/gemini/glossary.htm (accessed 3/14/2016).

Nichols, Kimberley. "Physical Qualities of Early Prints." In *Altered and Adorned: Using Renaissance Prints in Daily Life.* Chicago: Art Institute of Chicago, (2011): 99–105.

Oxford University Press. *Oxford Art Online.* www.oxfordartonline.com/subscriber/ (accessed 3/14/2016).

Primeau, Thomas. "The Materials and Technology of Renaissance and Baroque Hand Colored Prints." In *Painted Prints: The Revelation of Color in Northern Renaissance and Baroque Engravings, Etchings and Woodcuts.* University Park, PA: Pennsylvania State University Press, (2002): 49–78.

Print Wiki. *The Free Encyclopedia of Print.* http://printwiki.org (accessed 3/14/2016).

Rhein, Erich. *The Art of Printmaking: A Comprehensive Guide to the Graphic Techniques.* Translated by Neil and Roswitha Morris. New York: Van Nostrand Reinhold, 1976.

Ross, John, and Clare Romano. *The Complete Printmaker.* New York: The Free Press, 1972.

Saff, Donald, and Deli Sacilotto. *Printmaking: History and Process.* New York: Holt, Reinhart and Winston, Inc, 1978.

Salter, Rebecca. *Japanese Woodblock Printing.* Honolulu: University of Hawai'i Press, 2002.

Simmons, Rosemary, and Katie Clemson. *The Complete Manual of Relief Printmaking.* New York: Knopf, 1988.

Sotriffer, Kristian. *Printmaking: History and Technique.* New York: McGraw-Hill, 1968.

Spencer Museum of Art. *Print Connoisseurship.* http://www.spencerart.ku.edu/collection/print/connoisseurship/ (accessed 3/14/2016).

Stijnman, Ad, and Elizabeth Savage, ed. *Printing Color 1400–1700: History, Techniques, Functions and Receptions.* Leiden, Boston: Brill, 2015.

Stijnman, Ad. *Engraving and Etching, 1400–2000: A History of the Development of Manual Intaglio Printmaking Processes.* London: Archetype Books, 2012.

Suzuki, Sarah. *What is a Print? Selections from the Museum of Modern Art.* New York: The Museum of Modern Art, 2011.

Tallman, Susan. *The Contemporary Print from Pre-Pop to Postmodern.* New York and London: Thames and Hudson, 1996.

Institute, Tamarind. *What is Lithography?* http://tamarind.unm.edu/about-us/20-what-is-lithography (accessed 3/14/2016).

Thompson, Wendy. *The Printed Image in the West: History and Techniques.* Metropolitan Museum of Art. www.metmuseum.org/toah/hd/prnt/hd_prnt.htm (accessed 3/14/2016).

Tyler, Kenneth. *Printmaking Collection, Glossary.* 2013. www.nga.gov.au/InternationalPrints/Tyler/Default.cfm?MnuID=9 (accessed 3/14/2016).

University of Iowa. *The Atlas of Early Printing.* http://atlas.lib.uiowa.edu (accessed 3/14/2016).

Wax, Carol. *The Mezzotint: History and Technique.* New York: Harry N. Abrams, 1996.

Zorach, Rebecca, and Elizabeth Rodini. *Paper Museums: The Reproductive Print in Europe, 1500–1800.* Chicago: The David and Alfred Smart Museum of Art, 2005.

Chapter 4

Conservation Problems Related to the Materials and Techniques of Drawings

RECOGNIZING THE SYMPTOMS AND DIAGNOSING THE CAUSES

In chapter 3, we saw examples of the unique ways that some prints respond to internal and external sources of deterioration, with special attention paid to the visual attributes of each kind of print that can be altered by incorrect mounting and careless handling. The same approach can be taken when considering the materials and techniques of drawings. However, the sheer variety of drawing media and the kind of marks they make result in a greater diversity of symptoms and their causes. Like prints, the ability to differentiate between certain characteristics inherent to the medium and defects caused by deterioration can be difficult. And finally, the expertise required to identify accurately the broad range of media – dry and wet – used to create drawings takes time to master, especially today when new and unusual drawing media abound.

Ironically, the symptoms of ongoing degradation and the way in which a drawing ages can sometimes be used to verify its original materials: a blackened crust on the white opaque watercolor, sometimes called "heightening," in an "Old Master" drawing is a sure indication of a lead white pigment, brownish halos surrounding green colorants confirms the copper-containing pigment verdigris, a white crystalline efflorescence or "bloom" supports the presence of a wax-containing medium, such as Crayola® crayon or Paintstik®, and ruptured paper below brown ink writing in a manuscript signals the use of iron gall ink.

The changes undergone by media as they age can also point to causes of deterioration. Before they were exposed to excessive light, the now blue trees on a hand-colored Currier and Ives lithograph were once green and

the cadaver-like cheeks of a pastel portrait began life as a robust rose. Since many drawing media display idiosyncratic shifts in their appearance – and chemistry – as they react to internal and external sources of deterioration, early detection can prevent or lessen damage. Furthermore, damage can be avoided entirely, if a medium's predisposition to certain kinds of decomposition is anticipated. For example, the rapidity with which many modern dye-based inks fade, for example, Dr. Ph. Martin's Synchromatic Transparent Watercolors®, or disappear entirely should preclude their prolonged display from the moment they enter a collection (see Figure 4.3).

Classification System

Unlike printing techniques that are traditionally categorized according to the relationship of the printed line to the paper, drawing media have been classified in many ways – dry versus wet, oldest to newest, and broad versus fine. It should be mentioned that, in this publication at least, the category of "drawings," as is typical in the museum community, is expanded to include pastel, watercolor, and oil paintings made on paper, which, in many collections, are called paintings on paper. Because a materials-based approach is the best way to understand the physical and chemical properties of drawing media and, by extension, the causes of their deterioration, the dry versus wet classification system is adopted here. This also corresponds to the categories and terminology found in the online resource, *Descriptive Terminology for Works of Art on Paper: Guidelines for the Accurate and Consistent Description of the Materials and Techniques of Drawings, Prints, and Collages.*[1] Because of the growing popularity of online collection cataloging software and other in-house collection databases, it is important that terms for drawing media be used consistently.

Dry Drawing Media

Metalpoints and Drawings on Prepared Papers

The conservation problems associated with drawings on prepared paper affect not only rare fourteenth- and fifteenth-century masterpieces in metalpoint, but many modern and contemporary drawings as well – that is, all papers that have been made smooth by the application of a thin, opaque, often colored liquid ground. In Europe and America, prepared papers were, and still are, used for a variety of artistic purposes. Regardless of their age or scarcity, drawings on prepared supports require special handling to avoid fingerprints, oil and water stains, and abraded and flaking ground layers.

Metalpoint is historically one of the earliest dry drawing media and one typically found on a prepared support. A stylus – or styli, plural

– having a thin rod of soft metal was used for routine mechanical purposes, for example, ruling out the lines for text in the making of illuminated manuscripts. Sheets of parchment and, later, paper were prepared by brushing them with a liquid ground, usually lead white, finely powdered bone, or shell (calcium white), often mixed with a small amount of colored pigment. A binder, most often animal glue, was also necessary. Once the ground dried, it was burnished with a smooth stone or bone. The purpose of the ground was to provide a surface with sufficient tooth or friction to pull microscopic particles of metal from the stylus, which could be fabricated from lead, tin, silver, brass, copper, gold, and their alloys; only the metal lead is soft enough to make marks on unprepared paper and parchment. Because the lines of metalpoint drawings, especially after aging, can give only subtle clues to their original elemental composition, the generic designation of metalpoint is preferred over silverpoint or goldpoint, unless the exact metal used is known or identified through multispectral imaging or instrumental analysis.

While isolated accidents and long-term abrasion can both cause a loss of ground, the problem may be inherent in the preparation layer itself. The binder may have gradually dried out and the ground's attachment to the paper below may have weakened as a result. The problem can be aggravated by wide fluctuations in relative humidity as the paper support below the ground layer expands and contracts. The ground layer cannot always accommodate such dimensional changes and may eventually cleave away from the paper, especially if flexed. Losses of the ground or preparation layer are often seen along creases and around the edge of the support. Actively flaking patches can easily worsen as the surrounding edges are nicked or scraped.

Paper is naturally absorbent; prepared papers are even more so and are consequently often disfigured by fingerprints and oil and wax stains. Because liquids or abrasion easily disturbs the ground layer, embedded stains cannot be easily reduced. Both metalpoint and prepared papers enjoyed popular revivals, so examples may be found in diverse collections.

Charcoal, Chalk, Graphite, and Pastel

The four drawing media grouped together here share similar conservation problems attributable to their powdery and friable tendencies. As a result, careless handling, incorrect framing, and inept restoration attempts, often carried out because the nature of these media is misunderstood, have irreparably damaged many works of art executed in charcoal, chalk, graphite, and pastel. Such drawings constitute a major portion of many collections and include some of the most significant works from every artistic era. It is, therefore, worthwhile to consider their particular conservation problems.

All four media can be easily smudged and abraded, characteristics caus-
ing the most consternation among collectors. Insects or fungi do not attack
charcoal, chalk, and graphite, nor are their colors altered by light, since they
are inorganic minerals. The gum binders used in pastel, however, are attrac-
tive to insects and will sustain mold growth because they naturally attract and
hold onto water vapor creating suitable microclimates. Also, because many of
the colors used in pastel are derived from organic substances, they are quite
sensitive to light damage. Because of their physical and chemical properties,
therefore, drawings created in these four media may require extra consid-
eration and effort due to their storage, framing, exhibition, and transport
requirements. One caveat should be inserted here – the susceptibility of these
four media to smudging or to static electricity is dependent upon the relative
amount of the medium present; an underdrawing in black chalk or a graphite
pencil notation should not cause undue concern, whereas a drawing having
heavy lines of unfixed charcoal deserves extra precaution.

As might be expected, charcoal sticks made from twigs heated slowly
in airless ovens were among the earliest drawing materials. Pliny the
Elder (23–79) was the first writer to mention them, and designs using char-
coal as underdrawings have been found on the walls of Pompeian dwellings.
On paper, charcoal sticks produce dry black lines that can easily be wiped
away with traditional erasers such as a piece of chamois, a feather, or bread
crumbs. By using a blending stump, *torchon*, or *tortillon*, the dusty lines of
charcoal could be blended to produce delicate and naturalistic modeling of
three-dimensional shapes. To intensify the powdery lines, some artists soaked
the sticks in linseed oil. As we know today, charcoal can produce drawings
ranging from the most refined and lifelike to raw and expressive.

Like charcoal, natural chalks are ancient drawing materials first used for
the humble task of outlining or transferring wall designs. Large and scat-
tered earthy mineral deposits supplied natural black, red, white, and yellow
chalks. Because they contain varying amounts of clay, natural chalks produce
denser, softer lines that are less likely to smudge. The clay acts as a binder,
improving the malleability of the chalk, while adhering the pigment particles
to each other and also to the paper. Lines drawn with natural chalk are more
cohesive than dusty charcoal lines, whose particles, under magnification,
have a splintery morphology, denoting their woody origins. Natural red chalk,
sometimes called *sanguine*, has a property of interest to artists and of con-
cern to conservators – it is soluble in water and can be made into washes or
locally wetted to modify its hue. Like charcoal, more consistent and reliable
fabricated sticks of chalk eventually replaced naturally occurring chalks in the
late eighteenth century. One example is conte crayon (the generic is preferred,
with a lowercase "c" and no accent), a man-made drawing stick available in
black, red, white, and yellow.

Graphite pencils, as we know them, are of a fairly recent vintage. They were not officially invented until 1794, when Jacques Nicholas Conté blended clay and powdered graphite into a cylindrical mass that could then be fired in a kiln and encased in wood. Until that time lumps of natural graphite, the best quality was *wad* from Borrowdale, England, or rods of the soft metal lead were inserted into a holder or *porte crayon*. Graphite is composed of pure carbon and, therefore, has the same composition as a diamond, but the carbon atoms are not locked into a crystal lattice as they are in the diamond. When we write or draw with graphite, its plate-like particles slide over each other and are deposited into the paper by friction, producing a characteristic metallic sheen. Thus, the physical properties that contribute to its usefulness also create problems with smudging and smearing, which are dependent upon the percentage of clay in the graphite/clay mixture in fabricated graphite pencils. Because of its atomic structure, pure powdered graphite can be used as a lubricant.

Pastel sticks and their derivatives, formulated from natural and, later, synthetic dyes or minerals combined with fillers and binders, offered a more versatile drawing medium than charcoal and natural chalks. The degree of hardness or softness could be controlled in their production; more or less binding medium and coarser or extra-fine kaolin pigment particles resulted in a denser or fluffier line. And combining pigments and adding fillers could easily obtain an infinite variety of hues and shades. Pastel sticks, as we know them, had their heyday in the eighteenth and nineteenth centuries, although cruder processed sticks of compressed pigments were fabricated much earlier. Today, pastel sets having over five hundred sticks of color are available. A wide range of colors is necessary because the colors cannot be mixed but are rather laid down in thin strokes side by side. A stump, *torchon*, or *tortillon*, made from tightly rolled chamois or paper, is used to create flawless color gradations.

An early twentieth-century variant, oil pastel, produces a soft, slow-drying layer that can be more easily manipulated; the medium was first intended for children. Over time, oil halos may form around the medium or under it where the oil is preferentially absorbed by the paper. A whitish crystalline haze called "efflorescence" or "bloom" may also eventually form on its surface. Because of its binder and conservation issues related to it, oil pastel is often considered a variant of wax crayon, which it also closely resembles.

Because of its vulnerable surface, pastel has suffered from the popular misconception that it is not permanent. The fresh, velvety surface of an eighteenth-century portrait by the Swiss pastelist Jean Etienne Liotard (1702–1789) or a Degas (1834–1917) ballerina should dispel this belief. Although some unusual binders (sugar, whey, beer, and oatmeal) have tended to deteriorate, and many organic colorants have faded, pastel are intrinsically no less permanent than watercolors. Once again, it is the care that they receive after their creation that, by and large, will determine their longevity.

Figure 4.1 When dry, a copy or indelible pencil line resembles graphite. When the slightest moisture is applied, its aniline dye component bleeds a brilliant purple. (Image: C. Lukaszewski).

The binders historically used in manufacturing pastel have, however, proved attractive to mold. Gum tragacanth and gum arabic, used traditionally as binders, provide nutrients for mold spores that will grow within the pastel layer when relative humidity exceeds 68–70 percent. Lower levels of relative humidity will prevent mold from growing. Pastel sticks are made today with more resistant binders (methyl cellulose or similar cellulose ethers).

A Word About Copy Pencils

It may seem unnecessary in this day of high-speed copying machines to make mention of a once commonplace means of duplication – the copy pencil. They are included here because copy pencils, also known as indelible or hectograph pencils, were, even in the mid-twentieth century, commonly found – and still used – in offices and retail establishments. The implement itself closely resembles a graphite pencil in form. Its line when drawn dry is almost indistinguishable from a graphite line. However, when subjected to even a small amount of moisture the aniline purple dye component contained in its graphite lead bleeds a brilliant purple color. First patented in 1874 in

England, these pencils were intended to make copies of all transactions of a business day. Receipts and memos written in copy pencil would be interleaved with damp papers and left in a small copy press overnight. In fact, the copy press was also a ubiquitous feature of turn of the century offices, just like our Xerox® copiers of today. Because these pencils were found across the United States and Europe and were frequently interspersed among ordinary pencils and pens, it is not at all surprising that a copy pencil would have been used by an artist for a signature, inscription, or even a sketch itself. For this reason it is imperative that all pencils marks, whether graphite or colored, be scrutinized before any form of water – mist for flattening or liquid for bathing – is applied.

Fixatives

Many people – artists, as well as subsequent caretakers – spray charcoal, chalk, graphite, and pastel drawings with a fixative in the belief that it will arrest or prevent smudging. The practice is not a new one. European fine art academies in the eighteenth century taught artists to use mouth atomizers to apply fixatives between each layer when making charcoal drawings. Artists known for their works in pastel, including Edgar Degas (1834–1917) and Mary Cassatt (1844–1926), had their own favorite fixative formulas and techniques for their application. Today, artists use fixatives with great frequency and, because of the large size of some contemporary works and the preference for no protective glazing, have few other options. The decision to apply a fixative in these cases is made by the artist and must, therefore, be respected. The artist is presumably aware of the aesthetic, chemical, and physical effects of the fixative on both the look and the well-being of the work.

Throughout history, artists themselves have warned that fixatives cause colors to become unevenly saturated and dull. Calcium carbonate whites become transparent and disappear, while titanium whites retain their opaqueness. The delicate matte surface of soft pastel is interrupted and the fine blending of colors is muddied. The color and the texture of the paper, if visible, also change as the fixative is absorbed. In short, fixatives alter the character of the medium; even manufacturers of fixatives warn that their application may cause unwanted changes. Loosely adhered charcoal particles can coalesce into distracting circles as droplets of fixative dry and solvent-sensitive dyes in pastel can bleed through the paper.

The long-term conservation consequences of the application of fixatives are no more reassuring. The fixative itself can yellow depending upon its formulation and rivulets of fixative can become apparent as it ages. Simply stated, chemical instability, color changes, tackiness, and other poor aging characteristics make most commercially available fixatives undesirable – from

a conservation point of view. Some acrylic-based fixatives have better overall aging properties than the so-called "workable" fixatives, which usually contain cellulose nitrate, or earlier fixatives made from diluted natural varnishes, shellac, casein, or fish glue. Our predictions are based upon conjecture and empirical observations. Halos of yellowed fixative surround charcoal lines or a smoggy cloud envelops an entire image. How can anyone responsibly apply a fixative, given that its ingredients are often unknown, its future life uncertain, and its aesthetic, chemical, and physical effects irreversible? Ironically, several spray fixatives on the market are not only called archival by their manufacturers, but are said to prolong the life of paper by protecting it from the atmosphere. Again, aimed at scrapbooking enthusiasts, such a claim is unproven, but almost irresistible to well-meaning compilers of these popular mementos.

Spray fixatives do not prevent papers from aging and they are not the magic solution to protect collection items from rubbing. Caretakers should search for less interventive approaches. Does the problem result from careless handling or inadequate protection? Could reframing or rematting in a different format prevent smudging? Is the damage continuing or does it indicate a past incident? Such questions often suggest simple reversible steps to address persistent problems while preventing new ones from occurring.

A Word About Framing Charcoal, Chalk, Graphite, and Pastel Drawings[2]

Due to their potentially vulnerable surfaces extra care must be taken when preparing drawings in charcoal, chalk, graphite, and pastel for storage, exhibition, and travel, especially when matting and framing them.

Depending on the work's dimensions and the degree to which its surface is susceptible to abrasion, it is often prudent to opt for an 8-ply window mat and mat backboard for its housing. This thicker mat board provides extra space if the item is framed and also extra support for the item, which will inhibit accidental flexing. If a slip sheet is to be provided during storage, it is best to select neutral glassine, which has a smooth and slick surface. Clear polyester film (Melinex®) slip sheets should never be used against powdery pigments due to their static charge. If the surface of the work is extremely powdery, nothing should be put on its recto. Instead, the work can be stored in its mat in a solander box by itself. Or the mat can be fitted with a protective portfolio cover which is hinged to and rotated completely around and behind the back mat board. Drawings having unfixed powdery surfaces are generally not overmatted in a manner that will abrade their delicate surfaces; either the works are floated within the areas of the window mat or an extra layer of mat board is inserted between the window mat and around the perimeter of the work to prevent direct contact of the window mat to the work of art.

Finally, it might be best if the drawing is kept in its frame stored horizontally on a shelf on a permanent basis. Drawings stored horizontally in their frames should have light-blocking covers provided for them to reduce unintentional exposure to light; Tyvek® polyethylene sheeting is available in black and can be easily cut to shape; or mat board cut to shape can be used. The accession number, bar code, or other identification should be adhered to the surface of this light cover to reduce unnecessary handling of the framed work. Obviously, works having insecure or powdery surfaces should not be suspended on movable wire screens, which are often used for storing framed paintings.

If framed, it is important to insure that the drawing is provided with adequate space between its fragile surface and the glazing. This is not only to prevent abrasion, but also, in the case of works in pastel, to discourage condensation of moisture and mold growth. Fortunately, it is no longer necessary to only use glass as glazing. Thanks to the development of a static-free rigid acrylic sheet, a lighter weight, less breakable alternative is available that also filters out unwanted ultraviolet radiation. Since a good percentage of the colorants used to fabricate pastel sticks are sensitive to light, it is preferable, if funding permits, to select such a glazing product (see chapter 5). If glass is used, it is important to clearly indicate its presence on the backboard of the frame and to tape it prior to any travel.

Ironically, even though drawings with vulnerable surfaces are provided with optimal protection when stored in their frames, the feasibility and, thus, temptation for their more frequent and prolonged display is greater. Therefore, it is easy to inadvertently counteract the protection afforded by these frames by subjecting their contents to undue light exposure and travel.

Colored Pencil

Related to graphite pencils in their format and fabrication, colored pencils, available in a full palette of colored dyes and pigment mixtures, generally have more cohesiveness and subsequently better adhesion to paper. They usually contain a waxy binder, which also creates a slightly lustrous sheen in heavily drawn passages. Close cousins to colored pencils are watercolor pencils, sometimes called "aquarelle" pencils, which contain surfactants that cause drawn lines to dissolve when water is applied to them. Regardless of which type of colored pencil is used, its dye-based colors are probably sensitive to light. Because dry watercolor pencil lines appear virtually identical to standard colored pencil lines, thorough testing of each and every color must always precede the application of water vapor for flattening or wet starch paste for tear repair.

Wax Crayon

Technically, the term crayon refers to the size and shape of a stick of compressed drawing medium and not necessarily its exact constituents.

Therefore, a crayon could be chalk, pastel, or the wax-based version, Crayola®, so beloved today. The term is generally now used to refer to stick made from mixing pigment and dyes with fillers and an oily, waxy, or greasy binder. The line made by such a crayon is smooth and consistent, called its "lay down," with a satiny luster. Sometimes, the heat caused by the friction of the crayon dragging against the paper results in "puttying" or clumping of the heat-sensitive binders or even "spalling" whereby bits of crayon fall away. Included in this broad category are grease pencil, wax crayon, conte crayon (with a lowercase "c" and no accent), lithographic crayon, and oil pastel.

Paint Stick

Paint stick (two words, no hyphen) is a pigmented, oil-based fabricated drawing stick. Paint sticks were formulated to resemble, as closely as possible, oil paints in solid form. Therefore, they contain a higher concentration of drying oil; a tough skin may form on the surface of the medium as it slowly dries; it may remain tacky indefinitely. When paint sticks are heavily applied to paper, they can create extremely thick and weighty layers of medium, which will require firm adhesion to the paper below. Oily halos may form around the drawn medium over time, and whitish efflorescence or bloom may develop on its surface. Paint stick is also called oil stick; the proprietary name is Paintstik® by Shiva.

Wet Drawing Media

Ink

The term ink is used here to mean an aqueous suspension of ultrafine particles to which a binder, such as gum arabic, has been added to improve the ink's flow.

Inks are generally available in liquid form, although Asian *sumi* inks come in solid bars that are wetted up for each use. Small and uniform particle size are necessary qualities for an ink, especially if used for writing purposes, since the standard implement – a pen – requires these physical characteristics for its smooth operation. Density and evenness of color is also desirable for optimal legibility.

Inks that artists have traditionally used alone or in combination include carbon black ink, iron gall ink, bister, and sepia. Inks have also been made from berries, bark, licorice, tobacco, and other, often secret, ingredients. Inks as used in drawings have been incorrectly identified for centuries, each inaccuracy based upon another and passed along. Likewise, books on artists' materials have simply perpetuated the misinterpretation of old recipes, adding to the difficulty of precise identification.[3] Consequently, we are left with

volumes of conflicting descriptions of the inks used in traditional drawings. Often the terms sepia and bister are used to denote a specific brown color and not the actual chemical composition of the ink used. The confusion continues with modern drawings. The inks used by one twentieth-century artist, generally thought to consist of washes of carbon black ink, were actually made using hair dye. As already mentioned, with the increasing use of collection databases for the entry and retrieval of media descriptions, the use of consistent terminology is critical.

Generally, inks are classified by color: black (carbon ink) and brown (iron gall ink, bister, and sepia). Carbon black ink, lampblack, India, or Chinese ink as has been called in the past, is a truly black ink. One of the oldest of inks, carbon black ink was used by the ancient Egyptians for writing hieroglyphics on papyrus and also by the Chinese for characters on silk and the earliest paper. The ink was historically made from candle soot or charcoal, which consists of almost pure carbon, mixed with water, and a bit of gum arabic or other binder. Carbon black ink in solid form, called *sumi* ink, was available from Asia and was always highly regarded by Western artists. What we today call India ink is generally a waterproof carbon black ink, recognizable by its deep black color and by the slight sheen produced by the shellac added to render impervious to water. Because of its deep black color, India ink was traditionally used in art that was meant to be photographically reproduced, for example, commercial illustration.

Drawings done in carbon black ink have few conservation problems specifically related to the ink. Carbon black inks do not cause discoloration of paper and will not fade. This can be misleading, however, since today many blacks have yellow or red dyes added to them to make them appear blacker to our eyes. The actual components of these inks can often be seen under magnification along the edges of the lines where the dyes have been wicked up preferentially by the paper fibers. True carbon black ink lines should appear uniformly black, rich, and opaque. Many drawings from the latter half of the nineteenth century and the first half of the twentieth century were made with blue-black ink, a writing ink resulting from advancements in the commercial dye industry. Because the ink is very sensitive to light, many of these artworks have faded to blue gray or pale brown.

Occasionally, works done in modern India ink can exhibit cracking or flaking, especially if it has been thickly applied, applied to a highly polished paper, or both. The ink becomes inflexible and can shrink from its shellac component. When this is observed, a conservator may consider consolidation as a treatment.

The brown inks – iron gall, bister, and sepia – are the most difficult to differentiate, because they can be similar in appearance. Of the three, iron gall ink is the most common. Its color, which was almost black when freshly

made, invariably lightens to brown or even to pale yellow. The name iron gall refers to its method of manufacture from ferrous sulfate, in the form of iron filings, combined with oak galls, which contain tannic and gallic acid. The color of the ink is produced by a chemical reaction between these two ingredients and oxygen. The formulation for iron gall ink is ancient; the ink was used in Roman times and in medieval *scriptoria* before the production of European paper. Although it was not made specifically as an artist's material, its ready availability made it a natural choice for artists. It was cheap to manufacture in large quantities and could easily be made at home or in a workshop. In America, iron gall ink was used as a writing and drawing ink well into the nineteenth century. Its simple chemical reaction mechanism is still used as a basis for certain ink formulations.

Two conservation problems are commonly associated with marks made using iron gall ink: fading and corrosion of the ink and the paper below the ink. The writing on countless numbers of diplomas, deeds, and letters has faded to the point of illegibility. Depending upon the proportions of the ingredients in their original recipe, iron gall inks will change color, some more than others, but the reaction can be lowered considerably by protecting the ink from light. For this reason, strict measures should be taken when displaying historic drawings and documents written in brown ink. The United States Charters of Freedom (the Declaration of Independence, Constitution, and Bill of Rights), all written in iron gall ink, are not only protected from light, but are also housed in an inert atmosphere of argon, which further disrupts the fading mechanism. There is no safe method for restoring the legibility of faded inks.

Scientific research into the conservation problems of works created using iron gall ink is ongoing, but has intensified in the late twentieth century. As a result, its deterioration mechanism is much better understood. The chemistry of iron gall ink gives it another bothersome characteristic as it ages: the production of sulfuric acid and "Fe^{++}" or "iron two" ions. The symptoms of the development of these substances include a gradual darkening of the ink and the area of the paper immediately below and around it and a crusty appearance of its surface. As the chemical reaction continues, via acid hydrolysis and oxidation, the paper affected by the ink can rupture and disintegrate entirely – resulting in intact paper around what was once a stroke of ink as seen in Figure 4.2. Chemical mediations have been developed to arrest both deterioration mechanisms as they occur – deacidification for the acid hydrolysis process and chelation for the oxidation process. Because of the highly interventive nature of these treatments, however, and the visual changes undergone by the artifact, some conservators have opted for no treatment. It should be noted that not all iron gall inks will produce Fe^{++}; a microchemical spot test is required to confirm its presence, although the visual symptoms

Figure 4.2 Depending upon its original formulation, iron gall ink can become corrosive as it ages, weakening the paper below it. (Image: M. Ellis; Private Collection).

described above are usually positive evidence. Many factors influence the extent of damage caused by these reactions – the exact formula used to make the ink, the concentration of the ink on the paper, the absorbency of the paper, and variations in environmental conditions, specifically relative humidity, over the lifetime of the drawing or document.

Bister and sepia, also brown inks, are so frequently misidentified that it is difficult to confirm them without instrumental analysis. Often, the two terms are used to denote brown colors, not the substances that create those colors. Bister derives its rich brown color from the wood resins produced by the tarry chimney soot from which it was made. Bister has larger pigment particles than iron gall ink, which is a solution, not a suspension; therefore, bister is more of an artist's medium than a writing ink. Artists have used bister as an ink since the fourteenth century; bister-colored watercolor is still available.

Genuine sepia was made from the ink sac of cuttlefish and is only occasionally encountered as a drawing medium; not surprisingly its use was confined to specific locales and artistic movements. As with bister, the term more often refers to a specific color, a cool brown-black, which is still available as a watercolor. Sepia and bister do not have the corrosive tendencies of iron gall ink, but both inks should be assumed to be sensitive to light.

Many new varieties of inks are available to artists today. As mentioned, colored dye-based inks, preferable due to their lack of particles that can clog pen nibs and disrupt the flow of porous-point pens or markers, are notoriously sensitive – or fugitive – to light. One brilliantly colored ink – Dr. Martin's Synchromatic Transparent Watercolors®, popular among commercial illustrators and pop artists such as Andy Warhol (1928–1987), is notoriously sensitive to light as seen in Figure 4.3. Newly developed nanoparticulate inks have largely solved this problem.

Watercolor

The term watercolor is used here to mean thin, transparent washes of finely powdered pigment applied with water. The binder is a water-soluble gum, such as gum arabic, with a humectant, such as glycerin, added to retain moisture. The white paper below the watercolor reflects light and can, if used alone, serve as pure white highlights. The pebbled texture of many watercolor papers increases their reflectivity. The transparency of watercolor differentiates this medium from other water-based paints, such as opaque watercolor (gouache, poster paint) and tempera.

Although watercolor was used as early as the fifteenth century, as an artist's medium, it was generally reserved for landscapes, genre scenes, and other popular subject matter. In the eighteenth century, watercolor painting

Figure 4.3 Dr. Martin's Synchromatic Transparent Watercolors® have not faded where they have been protected from light by a window mat. (Image: M. Ellis; Private Collection).

matured as artists, particularly in England, perfected the use of veils of color, a technique more suited to its natural properties. Powerful and dramatic effects were possible, and soon watercolor as a stand-alone medium competed with the more elevated status of oil paint. Artists in France also evolved disciplined techniques for exploiting the inherent characteristics of watercolor.

Shortly after the medium had established itself on the art scene and watercolor works were hung in galleries lit by skylights, rumors circulated about

their fading tendencies. The ensuing outcry from artists and, more so, from their patrons resulted in one of the first scientific investigations of artists' materials.[4] The reports of these late nineteenth-century experiments are still of great significance to conservators. Possibly of even more consequence, however, were the truth-in-advertising policies to which they gave rise. Today, most manufacturers of paints and pigments acknowledge their responsibility to inform artists of the composition and stability of their products and adhere to volunteer labeling standards. Their websites often provide light sensitivity charts and other technical data about their products. While useful in particular for artists, the primary customers, once a watercolor enters a collection it should be assumed to be sensitive to light, regardless of what colors are present or, sadly, what colors remain.

The fact that certain colorants are sensitive to light has thus been recognized for some time. Fading affects the organic rather than the inorganic colors in an artist's palette, due to their molecular structure.[5] Some examples of organic colorants are gamboge, sap green, van dyke brown, madder, and alizarin. The rate at which such colors will fade is influenced by humidity, temperature, and air quality, as well as light or, more accurately, radiant energy. Chapter 6 further describes the lighting restrictions that should be instituted in order to minimize the fading and other color shifts in watercolors.

Other conservation problems associated with the watercolor medium are dependent upon technique. Occasionally, high proportions of gum arabic added to watercolors during or after application, as a glaze, can crack and darken, obscuring the image. Nothing can be done to reverse this condition, which should be closely monitored and stabilized if necessary by consolidation.

Opaque Watercolor

The category of opaque watercolor includes the traditional medium of gouache, called "body color" in Europe, and the modern medium of poster paint. Because of the broad range of time and substances spanning the two media, it is better to use a more general term, which describes their defining characteristic of opacity, which is due to the large percentage of inert filler or white pigment used as an ingredient. Like watercolor, opaque watercolor is composed of finely ground pigment, water, and a binder, traditionally gum arabic, but today other substances are used. The filler, which may or may not lighten the actual shade of the paint, causes the more viscous medium to sit on the surface of the paper, forming an opaque layer with a matte finish; watercolor, which penetrates the paper, remains transparent. Because the typical conservation problems that develop with opaque watercolor resemble those of tempera, their discussion will follow below.

Tempera

Tempera is generally differentiated from opaque watercolor in that the pigment is suspended in an emulsion rather than simply mixed with water and a binder. Egg tempera, as used in medieval manuscript illumination, is cited as a traditional example of tempera. The emulsion, whether made with egg yolk, gelatin, gum and oil, or a synthetic gel, creates a design layer that is resistant to water, with darker, more saturated colors than opaque watercolor and a tougher, satiny finish. Tempera paints are marketed today that bear little resemblance to egg tempera in their formulation, but share these visual and physical traits.

Together with opaque watercolor, tempera is prone to flaking. Flaking occurs in works of art regardless of their age or origin, but the problem almost always involves a too-thick paint layer containing a desiccated or aged binder, on top of a too-thin, smooth-surfaced paper or parchment that flexes or moves easily. It has also been observed that certain pigments seem to naturally have poor adhesion to the ground or paper below them. The first warning sign is often a network of fissures that develops over time. As the paint film ages, its attachment to its support weakens. Figure 4.4 is an example of the flaking of inexpensive poster paints. The thicker and more inflexible the paint layer, the more likely that flaking will develop. The likelihood of flaking also increases in proportion to the flexibility and smoothness of the support. It frequently occurs in illuminated medieval manuscripts made from parchment, which expands and contracts as relative humidity fluctuates. Flaking of tempera in bound manuscripts is further exacerbated when the paper or parchment pages are turned or as a result of rubbing when the book is carelessly handled.

The establishment of handling and storage procedures for opaque watercolor and tempera should take into account that works done in these media have a tendency to flake, as should the decision to make them available for loan. Flaking problems will worsen if the work is jarred, shaken, or subjected to rapid fluctuations in relative humidity, situations more likely to be encountered in transit. If any evidence of active or potential flaking is observed, the object should not travel, nor should it come into proximity with static-producing rigid acrylic sheets or flexible polyester film (Melinex®) used as glazing in frames or slip sheets in mats.

A conservator should examine works in which flaking is observed or suspected. It may prove possible to stabilize and strengthen the loosened paint layer through consolidation, a treatment procedure. The substances used and their methods of application can cause visual changes, such as darkening or glossiness, so this treatment may not be an option. In this situation, there are few remaining options except to store the piece horizontally and restrict its movement entirely.

Figure 4.4 Opaque watercolor, in this case poster paint, is prone to flaking, especially when applied to a smooth-surfaced paper. (Image: S. Haqqi; Private Collection).

One curious phenomenon that sometimes affects older opaque watercolors and tempera is the blackening of a white pigment, or colors containing that white pigment, when the drawing is exposed to air pollution. Lead white carbonate is an ancient pigment that has been used in medieval manuscript illumination, oil paintings, as grounds, and in heightened drawings. Hydrogen sulfide, a common ingredient of smog, changes the lead white carbonate into lead sulfide, a metallic gray substance. Gradually the white areas of the design darken to gray or black (see Figure 4.5), causing an odd turnabout in tonalities – white clouds are suddenly dark and areas that look to be in relief are suddenly recessed. This color change can happen gradually, as seen in drawings that experienced the Industrial Revolution in England or suddenly as can happen if drawings having lead white carbonate are displayed or shipped in freshly constructed plywood containers, which produce formaldehyde. It is sometimes possible to convert the black lead sulfide into another lead compound that happens to be white in color, lead sulfate, a process to be undertaken only by a conservator. Lead white, due to toxicity concerns, was replaced by zinc white – also called Chinese white, and by titanium white.

This phenomenon is also characteristic of other lead-based pigments such as red lead or vermilion as seen in Figure 4.6.

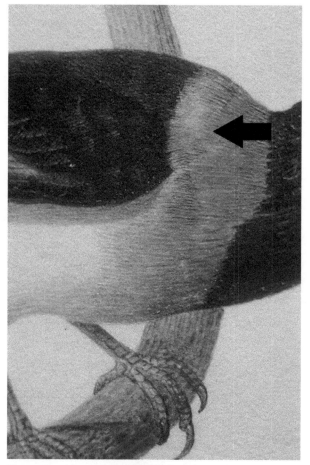

Figure 4.5 These painted lead white highlights on the neck of a bird have turned black as a result of exposure to air pollution. (Image: M. Ellis; Private Collection).

Oil Paint

Instability may be a problem when artists combine media and papers that respond adversely to each other. This is often the case when oil paint is used directly on paper, rather than prepared canvas. Oil paint is composed of ground pigments typically combined with linseed oil (other seed-derived drying oils can be used). Additional ingredients in commercially available oil paints include bulking agents and stabilizers. Used undiluted on paper, oil paint forms a slightly glossy film; however, it is usually thinned down or otherwise altered when used on paper due to its sheer weight as a medium.

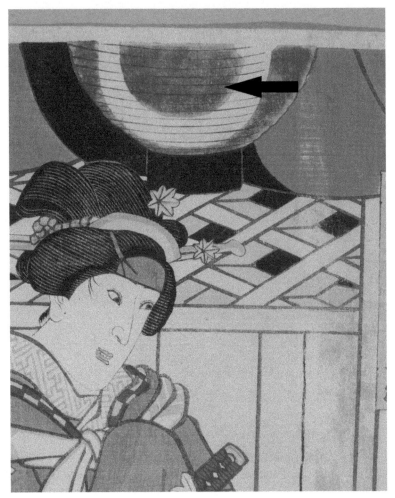

Figure 4.6 Red lead, used here in a *ukiyo*-e print, has darkened in response to exposure to air pollution. (Image: S. Haqqi; courtesy of the Conservation Center, Institute of Fine Arts, New York University).

Stiff paper boards are the usual supports when using undiluted oil paint. As mentioned in chapter 3 when discussing oil-based printing ink, the absorption of oil by an unprepared paper support leads to embrittlement and darkening under and around the oil-saturated paper. Artists have been aware of this undesirable development; Edgar Degas (1834–1917) perfected a method of painting in oil called *à l'essence*, by reducing the percentage of oil in the paint using blotting paper, and others have reduced absorption by preparing their papers with a ground or by selecting a heavily sized and nonabsorbent

paper. Works done with oil paint on paper should be provided with adequate support, due to their weight or lack of flexibility of their support.

Synthetic Polymer Paint

Acrylic dispersion paint is the most typical kind of synthetic polymer paint found on paper, although many new synthetic resins were introduced in paint form during the twentieth century. Acrylic dispersion paint generally combines well with paper, because it is water-based, alkaline, has good long-term aging characteristics, and forms a flexible film, which can thereby withstand the natural movement of paper. Most conservation problems associated with synthetic polymer paint on paper arise from a heavy impasto on a weak or thin paper with little tooth. As with oil paint, synthetic polymer paint is often diluted for use on paper.

A Word About Unusual Drawing Media

Life might be easier for curators and conservators if artists confined their creative endeavors to the traditional media and techniques with which we are well acquainted and prepared to preserve. Nonetheless, for centuries, the invention and development of new writing, drawing, and painting substances and implements, usually intended for commercial use, served to expand the repertoire of artists' materials and means. Head-shaking and finger-wagging over the adoption of unusual materials has continued with every generation of artists and their patrons. It is not surprising then that artists immediately responded to twentieth-century innovations such as BIC® pens, Magic Markers®, Day-Glo® paints, and Crayola® crayons. Generally speaking, commercial products have not been subjected to rigorous quality control and aging tests, nor do their manufacturers feel compelled to provide such information. It is impossible to foresee what new media or combinations thereof will come our way in the future, just as it is impossible to describe all the unorthodox ones already in our collections. Ideally, an artist should be aware of the possible consequences of using unstable media or incompatible combinations of materials. But we, as subsequent caretakers, cannot second-guess an artist's selection, and must assume that the medium, as well as its paper support, conveys an intent. Whether the result of artist's intent, experimentation, or ignorance, unusual media will jeopardize the longevity of some works. Some artists, especially those who do not regard their creations as precious commodities, may deliberately create their works with the visual and physical consequences of disintegration in mind. Intentional or not, deterioration stemming from unusual drawing media can be significantly retarded through the institutional policies and practices introduced in chapters 5 and 6, whereby a protective environment for collections is created and maintained.

NOTES

1. www.philamuseum.org/doc_downloads/conservation/DescriptiveTerminology-forArtonPaper.pdf (accessed 3/14/2016).
2. These framing recommendations also apply to drawings having active flaking or surfaces particularly vulnerable to abrasion and static charges.
3. The classic fifteenth-century book on artists' techniques, Cennino Cennini's *Il Libro delle'Arte*, has been retranslated and annotated by Lara Broeke, London: Archetype Publications, 2015.
4. Marjorie B. Cohn's *Wash and Gouache* is recommended for its account of the development of watercolor as an artists' medium.
5. For a detailed description of the fading mechanism of organic colors, see Thomas B. Brill, *Light: Its Interaction with Art and Antiquities.* New York: Plenum Press, 1980.

FURTHER READING

Ambers, J., C. Higgitt, and D. Saunders. *Italian Renaissance Drawings: Technical Examination and Analysis.* London: British Museum in association with Archetype, 2010.

Bambach, Carmen. *Drawing and Painting in the Italian Renaissance Workshop: Theory and Practice 1300–1600.* London: Cambridge University Press, 1999.

Brommelle, Norman. "The Russell and Abney Report on the Action of Light on Watercolours." *Studies in Conservation* 9, no. 4 (1964): 140–145.

Burns, Thea. *The Luminous Trace: Drawing and Writing in Metalpoint.* London: Archetype, 2012.

———. *The Invention of Pastel Painting.* London: Archetype, 2007.

Burns, Thea, and Philippe Saunier. *The Art of the Pastel.* London: Abbeville Publishers, 2015.

Chapman, Hugo. *Italian Renaissance Drawings.* London: British Museum Press, 2010.

Cohn, Marjorie. *Wash and Gouache: A Study of the Development of the Materials of Watercolor.* Cambridge, MA: Fogg Art Museum, 1977.

Cultural Heritage Agency of the Netherlands (RCE). *Iron Gall Ink Website.* www.irongallink.org (accessed 3/14/2016).

Dube, L. "The Copying Pencil: Composition, History, and Conservation Implications." In *AIC Book and Paper Group Annual*, Vol. 17. American Institute for the Conservation of Historic and Artistic Works, (1998): 45–52

Ellis, M. Holben. "Drawings in Fibre-Tipped Pen: New Conservation Challenges." In *Modern Works, Modern Problems?* The Institute of Paper Conservation, (1994): 114–121.

Ellis, M. Holben, and B. Yeh. "The History, Use, and Characteristics of Wax-Based Drawing Media." *The Paper Conservator* 22 (1998): 48–55.

Fuga, Antonella. *Artists' Techniques and Materials.* Los Angeles: Getty Conservation Institute, 2006.

Getty Research Institute. *Art and Architecture Thesaurus Online (AAT).* www.getty. edu/research/tools/vocabularies/aat/ (accessed 3/14/2016).

Goldman, Paul. *Looking at Prints, Drawings and Watercolours: A Guide to Technical Terms.* London: British Museum Publications, 1998.

Gottsegen, Mark. *The Painter's Handbook: A Complete Reference.* New York: Watson-Guptill Publications, 2006.

Harris, Theresa Fairbanks, and Scott Wilcox. *Papermaking and the Art of Watercolour in 18th Century Britain: Paul Sandby and the Whatman Paper Mill.* New Haven: Yale Center for British Art and Yale University Press, 2006.

James, C., C. Corrigan, M.C. Enshaian and M.R. Greca. *Old Master Prints and Drawings: A Guide to Preservation and Conservation.* Edited and translated by Marjorie B. Cohn. Amsterdam: Amsterdam University Press, 1997.

James, Carlo. *Visual Identification and Analysis of Old Master Drawing Techniques.* Florence: Olschki, 2010.

Kolar, Jana, and Matija Strlic. *Iron Gall Inks: On Manufacture, Characterisation, Degradation, and Stabilisation.* Ljubljana: National and University Library, 2006.

Lambert, Susan. *Reading Drawings: An Introduction to Looking at Drawings.* New York: Pantheon Books, 1984.

Lussier, Stephanie M., and Gregory D. Smith. "A Review of the Phenomenon of Lead White Darkening and its Conversion Treatment." *Reviews in Conservation* 8 (2007): 41–53.

Mayer, Deborah, and Pamela Vandiver. "Red Chalk: Historical and Technical Perspectives. Part 2: A Technical Study." In *Drawings Defined*, edited by Walter Strauss and Tracie Felker. New York: Abaris Books, (1987): 171–180

Mayhew, T.D., M. Ellis, and S. Seraphin. "Natural Yellow Chalk in Traditional Old Master Drawings." *Journal of the American Institute for Conservation of Historic and Artistic Works* 53, no. 1 (2014): 1–18.

———. "Steatite and Calcite Natural White Chalks in Traditional Old Master Drawings." *Journal of the American Institute for Conservation of Historic and Artistic Works* 51, no. 2 (2012): 175–198.

Mayhew, T.D., S. Hernandez, P.L. Anderson, and S. Seraphin. "Natural Red Chalk in Traditional Old Master Drawings." *Journal of the American Insttitute for Conservation of Historic and Artistic works* 53, no. 2 (2014): 89–115.

Museums Boijmans van Beuningen. *Iron Gall Ink Corrosion: Proceedings European Workshop on Iron Gall Corrosion June 16–17, 1997.* Rotterdam, 1997.

Nickell, J. *Pen, Ink, and Evidence: A Study of Writing and Writing Materials for the Penman, Collector and Document Detective.* New Castel, DE: Oak Knoll, 2000.

Oxford University Press. *Oxford Art Online.* www.oxfordartonline.com/subscriber/ (accessed 3/14/2016).

Petherbridge, Deanna. *The Primacy of Drawings: Histories and Theories of Practice.* New Haven: Yale University Press, 2010.

Petroski, H. *The Pencil: A History of Design and Circumstance.* New York: Knopf, 1993.

Philadelphia Museum of Art. *Drawing Materials.* www.philamuseum.org/collections/22-394-217.html (accessed 3/14/2016).

Schenck, Kimberly. "Drawings under Scrutiny: The Materials and Techniques of Metalpoint." *In Drawing in Silver and Gold: Leonardo to Jasper Johns*. Princeton: Princeton University Press, (2015): 9–24.

Seymour, P. *The Artist's Handbook*. London: Arcturus Publishing Ltd., 2003.

Stratis, Harriet, and Britt Salveson, ed. *The Broad Spectrum: Studies in the Materials, Techniques and Conservation of Color on Paper*. London: Archetype, 2002.

Strauss, Walter, and Tracie Felker, ed. *Drawings Defined*. New York: Abaris Books, 1987.

University of Northumbria. *The Iron Gall Ink Meeting, September 4th and 5th, 2000*. Edited by A.J.E. Brown. Newcastle upon Tyne: University of Northumbria, 2000.

Watrous, James. *The Craft of Old-Master Drawings*. Madison, WI: The University of Wisconsin Press, 1957.

Weekes, Ursula. *Techniques of Drawings from the 15th to the 19th Centuries*. Oxford: Ashmolean Museum, 1999.

Wehlte, Kurt. *The Materials of Painting*. New York, NY: Van Nostrand Reinhold, 1975.

Winsor and Newton. *Winsor and Newton Archive of 19th Century Artists' Materials*. http://www-hki.fitzmuseum.cam.ac.uk/archives/wn/ (accessed 3/14/2016).

Chapter 5

Item-Level Collection Protection

Envelopes, Sleeves, Folders, Enclosures, Mats, Boxes, Frames, and Furniture

PURPOSE

Item-level protection, that is, placing an individual work, or what is defined as a unit, for example, a letter having several pages, into a protective enclosure is one of the most effective ways of preserving prints and drawings chemically and physically. Enclosures can help lessen, but not prevent, the negative effects of temperature and humidity fluctuations and provide protection against particulate and gaseous air pollution. Options for such protection range from simple inexpensive prefabricated folders to very expensive custom-made decorative mats and frames. Ultimately, the determination of what kind of enclosure to select is informed by the nature of the collection and its format, its condition and frequency of use, along with budgetary, space, and environmental considerations. Usually several formats of item-level protection are provided for a collection, carefully calculated to work together. For example, even the best level of protection is useless, if folders do not fit into boxes, boxes onto shelving, or frames into bins and slots.

A Word about Standard Sizes

Perhaps, one of the most important decisions to make regarding item-level enclosures is not so much what materials to choose, but what sizes of them will best serve your collection. The more the dimensions of the envelopes, folders, mats, interleaving sheets, storage boxes, frames, and even the furniture in which they are kept can be standardized, the more time, labor, and money will be saved. And ultimately, the day-to-day handling of the collection will be safer and more efficient. For this reason, the determination of dimensions should come early on in planning. Once standard sizes

have been decided upon, mat board and other framing materials, including acrylic sheets and backing boards used in framing, can be precut to reduce waste. Many companies will do this work for a "cutting charge," and the service is generally worthwhile, as it saves on labor and wastage. Often the cut-off strips are delivered with the order; these can be used for other storage purposes, such as filling out partially empty boxes with leftover acid-free corrugated cardboard. Unfortunately, suppliers have not coordinated the sizes of all the materials that you will need, so, for example, it may be necessary to have the folder stock precut to fit into the boxes and the mat board precut to fit into the frames. Prefabricated frames, one of the more costly expenditures for an institution, are usually available in the following standard sizes:

8 × 10 inches
11 × 14 inches
12 × 16 inches
16 × 20 inches
18 × 24 inches
20 × 24 inches
22 × 28 inches
30 × 40 inches

Polyester Envelopes and Sleeves

If a collection is regularly handled, irregularly shaped, double-sided, or in a poor or weakened condition the use of clear flexible polyester[1] envelopes and sleeves is sometimes the most practical storage option. Uncoated polyester film called Melinex[®2] is available in 0.003 inch to 0.005 inch thicknesses or mils (one one-thousandths of an inch equals one mil, one point, or one thou). Two to three mil polyester will provide sufficient support for most works; thicker four to five mil films can be used for oversized posters and maps. Because the film is transparent, the item can be viewed on both sides without actually opening the enclosure. A characteristic of polyester film is that is has a static charge, which can be both an advantage and a disadvantage. A work that is in such a weakened state that it could not normally be handled can be safely lifted and turned over when placed between polyester films, because the static charge keeps the piece firmly in place. On the other hand, drawings down in friable media such as charcoal, chalk, graphite, and pastel cannot be safely stored in polyester enclosures. Finally, polyester enclosures can quickly became ponderously heavy as they accumulate – something to keep in mind when determining how high or how far away a box of such items will be stored. Storing in polyester film is not always desirable for prints and drawings because its glossy surface can interfere with the viewer's

examination of the enclosed artwork and, due to its static charge, fragile items may then be damaged when pulled out from the sleeve or envelope. Documents and other archival materials are usual candidates for storage in polyester sleeves and envelopes or collections that are frequently accessed by researchers. Polyester sleeves and envelopes provide a great deal of protection with the least equipment and expertise required.

Archival supply companies offer a variety of polyester film envelopes and sleeves in standard sizes. These are useful for large collections of similarly sized items, such as postcards or record albums. For many items a design that is welded along two adjacent sides in the shape of an "L" is best. The joined sides should be aligned consistently, usually along the longest and bottom edge. Most companies will also produce custom-cut sizes for a minimum quantity order. The film is generally more expensive than paper folders.

Encapsulation

Encapsulation refers to a polyester sandwich, whose perimeter has been entirely sealed either by using 3M #415® double-sided tape or welded together either using heat (radiofrequency welding) or high-frequency low-amplitude vibration (ultrasonic welding). The static electricity of the two sheets of polyester holds the artwork firmly in place and allows the item to be flexed and curled.

Because only large-scale operations have welding equipment, these instructions use double-sided tape. Care must be taken that the contents of an encapsulated item do not come into contact with the double-sided tape.[3]

Supplies

- 3 or 4 mil polyester (Melinex®) film
- 3M #415® double-sided tape (1/4 inch wide)
- Bone or Teflon® folder
- Lint-free microfiber cloth
- Squeegee
- Utility knife
- Metal straightedge
- Ruled cutting mat
- Small weights
- Precut blotter squares (3 × 3 inches)
- Corner rounder

To encapsulate a work, first cut two pieces of polyester film about one inch larger all around than the item to be encapsulated. Cutting the film is easiest

with a tabletop paper cutter, but a utility knife and heavy straightedge will work as well. Polyester film can be purchased by the roll and is also available in standard size or custom sheets. Place one piece of polyester film onto a ruled self-healing cutting mat. Then clean it with a lint-free microfiber cloth. The resulting static charge will attract any dust in the immediate area, so the workspace must be kept scrupulously clean. Next, place the print or drawing on the film and align it along the grid lines so that it is centered on the plastic. Put a small weight on top of it, protecting the artwork's surface with a blotter square. Carefully apply narrow 3M #415® double-sided tape around the item, leaving a least 1/8 inch between the tape and the edge of the item. Use this tape only for encapsulation; never permit it to touch the print or drawing. Remove the weight and the blotter square and place the other precut sheet of polyester film on top of the artwork. Once again, weight the center of the artwork to prevent shifting. Working in a clockwise manner, or counterclockwise if you are left-handed, peel the release paper covering from the tape at the top and right side. Using the lint-free cloth or a squeegee, smooth the layers of polyester film, stroking away from the two attached sides. Pull the release paper covering away from the final two strips of tape and smooth out the entire package with the cloth or squeegee. With a paper cutter or knife and straightedge, trim the excess polyester film to within 1/16 inch of the tape. Round the corners, using scissors or a special device available from archival supply companies, so that the corners cannot cut other papers – or the handler's fingers.

Continuing research indicates that very acidic items do not benefit from encapsulation, that is, in a closed system, the mechanism of acid deterioration is accelerated. Leaving a small gap for air exchange, as was once suggested, is not effective. For highly acidic items, partial encapsulation is a better choice, in which the item is placed against a sheet of buffered mat board or heavy folder stock and then faced with polyester film or a sheet of buffered paper is included in the encapsulation package. Another option is to deacidify highly acidic items beforehand – a decision to be made with and a procedure to be carried out by a paper conservator. Encapsulated items or those slipped into sleeves and envelopes are best stored in acid-free folders, so that their surfaces cannot scratch and dull one another.

Encapsulation must not be confused with lamination, which heat-seals an item more or less permanently in between cellulose acetate film. Lamination is not recommended for works of art and important documents under any circumstances. Only pure polyester film is acceptable for storing prints and drawings; any unidentified plastics should be avoided. Do not use cellulose acetate, which can lead to "vinegar syndrome" as it chemically deteriorates, or polyvinyl chloride, which is also chemically unstable. Clear plastic film for food storage, such as cellophane or Saran Wrap®, is also not acceptable.

Selecting Storage Papers, Folder Stock, and Mat Board

The selection of paper-based materials for storing prints and drawings is not for the fainthearted! Papers in North America are described by various units of thickness or caliper (e.g., mil, point, thou, and ply), by weight (e.g., basis weight in pounds), or by grades (e.g., bond, cover, index, and tag). European-sourced papers are usually described in metric units (e.g., grammage and millimeters). Descriptions of the paper's purity, for example, lignin-free or having a *kappa (κ)* number less than five, are meaningless to nonspecialists. Overused words like "acid-free" mean several things: acid-free can apply to papers having a neutral pH (7.0) at the time of their manufacture and also to papers containing an alkaline reserve, typically 2–3 percent calcium carbonate ($CaCO_3$) by dry weight of the paper, added to maintain a neutral pH. In other words, a paper may be acid-free today, but not tomorrow thanks to residues from sizing and bleaching compounds, gaseous air pollution, kraft paper wrappers, or corrugated cardboard containers. Rag board is not necessarily made from rags, nor is it necessarily of conservation quality. Even the word "archival" is vague; "archival quality" is a nontechnical term that suggests that a material or product is permanent, durable, or chemically stable, and that it can, therefore, be used safely for preservation purposes. The phrase is not quantifiable.[4] Archival-quality interleaving papers, folder stock, and mat board can be made of rag fibers (usually cotton remnants purchased from underwear knitting mills or linters, the fuzz left on the cottonseed after ginning) or from highly purified alpha cellulose derived from wood pulp. Chemically speaking, both kinds of fibers are acceptable. The difference between conservation board and museum board is their price, not their preservation capability. While there is no standard that spells out what papers, folder stock, and mat boards are acceptable for storage enclosures, there are references that provide helpful information for evaluating individual products. One of these is *Permanence of Paper for Publications and Documents in Libraries and Archives ANSI/NISO Z39.48-1992 (R2009)*, which states emphatically, "Publishers and paper manufacturers, take note! This standard sets the basic criteria for coated and uncoated papers that will last several hundred years under normal use. It covers pH value, tear resistance, alkaline reserve and lignin threshold. Recycled papers will meet the criteria specified." Another resource for evaluating paper-based storage materials is *Guidelines for Information about Preservation Products, ANSI/NISO Z39.77-2001*; unfortunately, this standard is currently inactive; however, the information remains useful. For these reasons, it is important to be conversant with paper specifications when shopping for archival-quality supplies and to deal consistently with a reliable company. Many archival supply companies now have informative websites and staff, which can help you to select the materials that best meet your budget and collection needs.

Take note if your collection includes certain types of photographic materials. In particular, it has been found that storage papers and mat boards having a higher pH content are not suitable for albumen prints, cyanotypes, dye transfer, and chromogenic color prints. Special types of storage materials have been produced for collections of photographic materials. These materials are often described as having passed the *Photographic Activity Test (PAT)*. This is an international standard test developed by the Image Permanence Institute that evaluates storage and display products. For more information about the PAT, visit the Image Permanence Institute at https://www.image-permanenceinstitute.org/testing/pat.

Folders, Enclosures, and Storage Portfolios

Folders can be made from heavy archival-quality folder stock available in thickness from 10 to 20 points. A 10-point paper would be equivalent to a typical office file folder; 20-point folder stock would be appropriate for supporting larger or heavier items; 40-point folder stock requires scoring or even cutting and taping for a smooth crease, but would be a good choice for items needing extra support. Folder stock is available in rolls or in sheets.

A folder is typically a sheet of sturdy folder stock folded in half with the fold along the longest dimension. Many archival supply companies have precut folders in a variety of weights and sizes. Like polyester envelopes and sleeves, many companies have specially designed folders for specific types of items, for example, standard 8½ × 10 inch letter size papers. Also, folders can be easily custom-made in larger quantities.

Folders can be arranged in boxes, either horizontally or vertically, or placed directly into flat or vertical file drawers. Slip sheets or interleaving papers may or may not be used in folders, depending on the nature of the item being stored. Generally speaking, folder stock has a very smooth surface. Folders can have many different formats, just like mats, so for safety's sake they should all open from the same direction, if possible.

How to Make a Folder

Supplies

- Ruled cutting mat
- Ruler
- Metal straightedge
- 10- or 20-point folder stock
- Bone or Teflon® folder
- Small weights
- Corner rounder (optional)

Determine the exterior dimensions of opened folder. Divide longest edge in half either using a ruler or the ruled cutting mat as a guide. Score along fold line using a bone or Teflon® folder and straightedge. Curl the folder in half and align the two outer corners on top of each other; secure with small weights. Fold along the scored line and burnish lightly. The outside corners of the folder may be rounded using a corner-rounding device if desired.

Enclosures come in many different designs but generally include side flaps that fold up and over the contents to provide additional protection. For enclosures made of sturdy folder stock, each fold line needs to be scored with a bone or Teflon® folder for greater flexibility. A piece of thin mat board or slightly heavier folder stock can be slipped into the enclosure for rigidity and extra support. Two designs are described below.

How to Make a Four-Flap Enclosure

Supplies

- Ruled cutting mat
- Ruler
- Metal straightedge
- 10- or 20-point folder stock
- Bone or Teflon® folder
- Small weights
- Hard graphite pencil
- Velcro® dots or white cotton twill tape
- Corner rounder (optional)

Onto a sheet of the folder stock transfer the outside dimensions of the item to be enclosed, adding 1/8 inch around all the edges (see Figure 5.1). You can also simply place the original onto the folder stock and mark its four corners, adding 1/8 inch all around. Replicate this shape around each side of the original rectangle. The corners of the flaps may be rounded or angled if desired, with the exception of the upper or lower flap that will be in direct contact with the item inside. These flaps may be shorter than the height of the piece. Score and fold all four flaps upward. The order of folding the flaps is generally upper and lower first followed by right and left. Press both the loops and hooks of one Velcro® dot firmly together, peel off the backings, and adhere the fastener to the inside of the outer flap or tie with twill tape to secure. Figure 5.1 illustrates a four-flap enclosure in which the right flap is angled to be inserted into a vertical cut slot in the left flap. Library and archive supply companies have similar four-flap enclosures in standard sizes.

Four-flap Folder

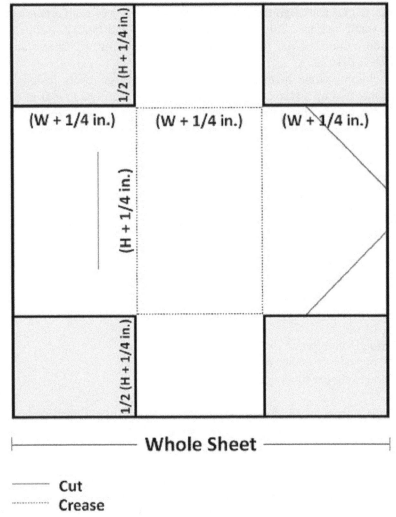

Whole Sheet

------ **Cut**
·········· **Crease**

Figure 5.1 Steps in making a four-flap enclosure. (Drawing: S. Mulshine).

How to Make a Storage Portfolio

Supplies

- Ruled cutting mat
- Ruler

- Metal straightedge
- 10- or 20-point folder stock
- Two- or four-ply mat board; 60-point archival board
- Bone or Teflon® folder
- Gummed linen (Holland or Dutch) tape or pressure-sensitive (archival) cloth tape (Filmoplast SH®)
- 1/4 inch 3M #415® double-sided tape
- Small weights
- Hard graphite pencil
- Corner rounder (optional)

This enclosure is more elaborate to make than a standard four-flap enclosure. It consists of a folded heavy acid-free paper enclosure that contains the item, and an outer cover, or portfolio, made of two pieces of heavier folder stock or even two- or four-ply mat board hinged along the longest edge. The two components are made separately and then are joined together using the double-sided tape on the back of the folded enclosure. Onto the folder stock transfer the outside dimensions of the item to be stored, increasing them by about 1/8 inch all round. Replicate this shape on three sides of the original rectangle – to its top, right, and below – to form the flaps. The corners of all three flaps should be either rounded or trimmed diagonally. The top and bottom flaps do not need to be the full height of the item; however, the flap to the right should be of the same dimensions, since this is the flap that will completely fold up and over and cover the item inside the folio. Rule and score the fold line on each flap. Fold along each line and burnish lightly. To make the outer folio, measure the heavier folder stock or two- or four-ply mat board 1/8 inch larger than the envelope just constructed. On a flat surface align and weight each half so that it does not shift with a small gap between the sheets equivalent to the thickness of the item being stored. Using gummed linen tape – either water activated or pressure sensitive

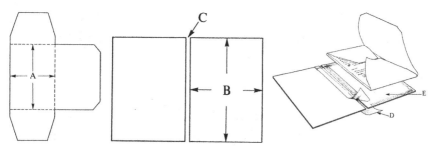

Figure 5.2 Steps in making a storage portfolio. (CCI *Notes* 11/1 How to Make a Storage Portfolio).

(archival quality) attach the outer cover boards to each other along the spine, on both sides, maintaining the narrow gap. Cover and allow to dry if necessary. Attach the assembled envelope to the back cover using 3M #415® double-sided tape around its edges on the back. Figure 5.2 shows the assembling steps.[5] Library and archive supply companies have similar portfolios in standard sizes.

Mats

Today, mats are used almost universally, both to present and to protect prints and drawings. Standard format (see Figure 5.3) for them is two pieces of stiff laminated mat board, joined with a length of strong tape, usually along the longest side, either the upper horizontal edge or the left vertical edge. For safety in handling matted works of art, the mats for a collection should open consistently in the same direction. The outer window mat should not be glued or taped around its edges to the back mat board since this prevents easy access to the artwork inside.

The bottom back mat board of the two-board folder is left whole, for overall support of the art, while the top sheet has a window opening cut into it through which the artwork can be seen. (An exception is made for double-sided works, in which case a window is cut in the back mat board as well to reveal another drawing, inscription, signature, or other detail; depending on the size of this second opening additional support may need to be provided.)

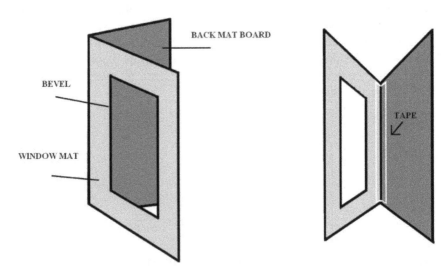

Figure 5.3 A standard window mat. (Drawing: E. Ellis).

Mats play an aesthetic role in the presentation of an artwork by setting it off in a field of neutral color or by surrounding it (in the case of "French" mats) with decorative bands of pastel, grays, or thin strips of gold foil. Mats also serve a variety of beneficial protective functions; in addition to providing physical support and an acid-free enclosure, they can prevent the artwork from pressing against the glazing material – glass or rigid acrylic sheet – used in a frame. The breathing space between the artwork and the glazing lessens the danger of condensation and mold growth by allowing trapped humidity to dissipate more rapidly than it could otherwise. The extra space also reduces the chance that, under certain circumstances, some works of art could stick to the glazing; certain substances in watercolors or pastels may cause the medium to become sticky in elevated humidity, and the breathing space provided by the mat gives the art some protection, in that event. Also, as paper-based prints and drawings respond to fluctuations in temperature and humidity, they expand and contract. The resulting undulations may come into contact with the glazing, leading to condensation in that particular location.

The British Museum can lay claim to inventing the design for our present-day mat in the mid-nineteenth century, when the curator at the time, Mr. W. M. Scott, noticed that prints kept in portfolios were subjected to rubbing. Called "sunk mounts," mats have become the traditional storage and presentation format for prints and drawings.[6] And for good reason: mats go a long way in lessening or retarding the rate of damage caused by internal sources of deterioration in paper and can eliminate or counteract external sources of deterioration as listed in Box 2.1.

Mats are cut from stiff paper-based mat board whose composition varies significantly. The ideal materials – museum board – rag board, buffered rag board – and conservation board both contain almost pure alpha cellulose derived from different sources. All three types are suitable for matting prints and drawings, although they have slight differences. All three have a neutral or alkaline pH (a pH of 7 or more). As the name implies, rag board is made from cotton fibers and usually has a neutral pH. If it has been improperly sized, however, even 100 percent rag board can become acidic. Buffered rag board is alkaline because calcium carbonate ($CaCO_3$), usually 2 to 3 percent by dry weight of the paper, has been added. These types of mat board are often called "museum" board and are available in a limited number of colors.

Conservation board, also called "archival" or "acid-free" mounting board, is made from wood pulp that has been chemically refined to contain only alpha cellulose. This board is also available as buffered with calcium carbonate. Buffered board lasts longer because its alkaline reserve maintains a higher pH as it neutralizes acid from its environment or even from the artwork

it protects. Mat board that contains no alkaline reserve quickly becomes acidic under poor storage conditions, for example, if it is stored in plywood drawers or wrapped with brown kraft paper or corrugated cardboard. Conservation board is now available in a wide range of colors and even has a choice of black or white cores.

Wood pulp mat board – a stiff, bonded sheet of bleached ground wood compressed between two sheets of facing paper – should be avoided at all costs. The outer facing paper is often decorative in texture and color and may even be of better quality. The inner paper, the side that will be in contact with the artwork, is generally thin and smooth. Although it is attractive for matting inexpensive reproductions, it should never be used to mat valued prints and drawings. If silk mats or decorative "French" mats are used, the side of the mat that touches the artwork should be lined with suitable mat board or paper.

Archival-quality mat board is not always available at framing establishments nor is it automatically used by framers unless specified. There are several ways of determining whether a high-quality board or cheap wood pulp board has been used to mat a print or drawing. The characteristics described below might help you to determine if an item is properly matted when it enters your collection.

Damage to the artwork. Acidic mat board can cause a gradual weakening and embrittlement of the artwork where it has come into contact with it. Thin, dark lines of discoloration, or mat burn, quite often appear, following the contours of the window opening. Acid migration from the beveled edge of the window can cause mat burn even when the mat has been faced with acid-free paper (Figures 2.2 and 2.21).

The presence of plies. Examining the beveled edge of the window or the edge of the mat itself, you should be able to detect two, four, eight, or even twelve distinct layers or plies of laminated paper. In contrast, the edge of a wood pulp board will usually show two thin facing papers enclosing a compressed mass of what looks like sawdust – this is called a "filled" board in the industry. The thicker the board, the more "sawdust" is in the sandwich filling.

The color of the board's exposed edge. With time, the inner core of a wood pulp mat board usually discolors, so that the edge exposed to air and light in the window opening becomes tan or brown. The interior of museum or conservation mat board remains the same color as the outer layer of paper. Today, there are archival-quality mat boards on the market, which have a different color core, usually black or white; however, the boards are still plied and not filled with unrefined wood pulp.

General discoloration. Papers containing unrefined wood pulp can discolor rapidly in strong light, whereas conservation and museum mat boards are

more resistant to light. More colors are now available in conservation boards; these should be lightfast.

Tear direction and strength. Wood pulp board even a few months old will break easily in a straight line, becoming even more brittle as it ages. Conservation and museum mat boards tear unevenly and peel along the planes of their component plies.

pH. For someone actively involved with matting a collection, the determination of pH (the measurement of relative acidity or alkalinity) of mat board is important. pH is measured on a scale of 14; measurements below 7 are considered acidic, and measurements above 7, alkaline. It should be kept in mind, however, that a neutral or even alkaline pH does not necessarily indicate that a mat board is of conservation quality, since newly manufactured wood pulp board can be alkaline. pH measurements should be used to monitor incoming or stored supplies of mat board. Since the term acid-free is loosely applied to all sorts of materials and cannot be defined with precision, it is prudent to find out exactly what materials were used to make any board or paper you may consider using. Contents should always be clearly indicated on the wrapper, which should be made from polyethylene film or archival-quality wrapping paper, or written on the carton supplied by the manufacturer.

The simplest way to measure pH is with an inexpensive archivist's pen or pencil (Lineco pH Testing Pen®, Abbey pH Pen®), which uses a reactive dye, typically chlorophenol red, to measure acidity. The paper to be tested is marked with the pencil and is then moistened with distilled water. After 15 seconds, the color is compared to a color chart. pH indicator strips, available from chemical supply companies, can also be used but involve more water. They are coated with a range of reactive substances, which react when pressed against a droplet of water applied to the sample paper. To use these strips, place the sample paper on a clean piece of glass. Moisten a small area with a drop of distilled water. Place the colored portion of the strip face down on the wetted area, cover with a small piece of glass, such as a microscope slide, or small square of polyester film, and add a weight. After 5 minutes remove the pH strip and compare it with the accompanying color chart. For the sake of accuracy the water must actually penetrate the sample rather than simply sitting on its surface. If the water remains as a bead for several seconds, lightly scratch the surface of the paper to facilitate absorption before proceeding. For greatest accuracy repeat the test in a variety of areas of the mat board, for example, on both the recto and the verso, along the edges and in the center. Then calculate the average pH reading. *Do not use pH pencils or pens directly on a print or drawing, since they will cause permanent stains.* Only a qualified paper conservator can determine if and when to measure the pH of a work of art on paper.

Price. Museum (rag) mat board costs more per sheet than conservation (alpha cellulose) mat board. Both provide equal protection. Buffered boards are the best choice in terms of longevity. Many institutions prefer the look of museum mat board, which has been described as having a "richer" appearance with smoother crisper cut edges. Four-ply mat board is the usual choice for most items; however, for a large collection, two-ply board is less expensive and more matted items can be fitted into each storage box. Care should be taken to support larger artworks adequately when they are in two-ply mats, since this lighter weight board can sag and wobble. Besides being more attractive, four-ply mats provide deeper breathing spaces for framed prints and drawings. A particularly heavy or fragile piece would obviously require greater support, perhaps an eight-ply mat or two "stepped" four-ply mats.

How to Make a Mat

Supplies

- Utility knife
- Ruled cutting mat
- Mat cutter
- Metal straightedge
- Ruler
- Hard graphite pencil
- White vinyl eraser
- Bone or Teflon® folder
- Fine emery paper
- Gummed linen (Holland or Dutch) tape or pressure-sensitive (archival) cloth tape (Filmoplast SH®)
- Two- or four-ply mat board
- Scrap mat board
- Small weights
- Precut blotter squares (3 × 3 inches)

The first step in making a mat is to measure the greatest outside dimensions of the artwork – meaning the entire sheet on which the design appears. Prints and drawings often have small images and relatively large margins. Failure to take the artwork's overall measurements beforehand has sometimes led to the trimming or folding over the edges of the artwork in order to fit it into a mat that is too small.[7] Always record dimensions by height followed by width, that is, a vertical rectangle (portrait format) would measure 12 × 10 inches and the same horizontal rectangle (landscape format) would be 10 × 12 inches. It is useful to use a mat measurement template, as seen

Mat Measurement Template

Date:

Charge to:

Artist/Accession Number:

		Height	**Width**
Outside dimensions of mat	A	_____	_____
Outside dimensions of window opening	B	_____	_____
A – B =	C	_____	_____
Width of margins (C divided by 2)	C/2	_____	_____
Raise bottom by ¼" or ½"? +/-	_____		
+/-	_____		

Format: Portrait Landscape Color _____

2-ply _____
4-ply _____
8-ply _____
Other _____

Figure 5.4 A suggested mat measurement template.

in Figure 5.4, to record dimensions, especially if several different people are ordering mats for different purposes or if mat orders need to be tracked, for example, when expenditures are charged to a specific exhibition budget line or department.

Next, determine the outside measurements of the mat. The dimensions of the mat will depend on the size of the storage box, the size of the standard frame, or the size of an existing frame into which the piece is going. If a custom mat (one made to order, not of standard size) is to be made, a three-inch margin around all sides of the image to be shown in the window is a good amount to try first, unless of course, the margins of the image exceed three inches! Generally speaking, the overall effect of a mat will be aesthetically more pleasing if its margins are a bit wider than narrower. Too much margin is better than not enough. If standard sizes must be used

and you need to choose between two sizes, always opt for the larger size; the results are likely to be more visually satisfying and wider margins offer better protection.

Many institutions save time and expense by using mats that fit into standard frame sizes or commercially available storage boxes or both. As mentioned it is worthwhile to have mat board, backing boards, glazing, and interleaving sheets all precut for convenience.

The next step in mat preparation is to determine the size of the opening in the window in the front of the mat "folder." The dimensions of the window opening (or window) are determined by how much of the image is to be displayed. Will the item be "overmatted," with a window smaller than the outside dimensions of the artwork? This is sometimes called an "overlay" mat. Or will the item be "floated" within the window opening, that is, touching none of the window's borders? Generally speaking, if a drawing or print is to be overmatted, at least 1/8 to 1/4 inch of its perimeter should be held down by the window mat. Otherwise, the artwork might pull from under and curl out of the window mat. This can happen when paper expands in high humidity. In such situations, tears and creases can easily occur especially if the window mat is quickly opened and catches the edge of the item.

Drawings and prints with slight buckling are often overmatted to prevent them from curling forward and touching the glazing – the glass or rigid acrylic sheet – in the frame. When overmatting etchings, engravings, and other intaglio prints, never cover the platemarks; these are important parts of the design. Modern graphics and drawings that extend to the very edges of the sheet, as well as irregularly shaped drawings and Old Master prints that have been cropped to their platemarks are usually floated.

To determine the dimensions of the window opening, first place the item to be matted in front of you on a clean blotter or other suitable working surface. Then measure the height and the width of the design area that will appear in the window. If the artwork is to be floated, simply add 1/2 inch to the height and the width of the entire piece, which you have already measured and recorded on the template. Avoid resting the ruler on the artwork itself. Record all measurements on the template, perhaps, using a small diagram for better visualization. Never write down measurements or indicate placement using arrows or V-shaped "carets" directly on the artwork – a surprisingly common practice that is too frequently discovered when unframing prints and drawings.

To calculate the width of all four margins, subtract the window's vertical measurement from the mat's overall vertical measurement and divide by two. Do the same with the horizontal measurements. It is claimed that, because our eyes naturally fix on a point slightly above the geometric center of a picture, it is traditional, when matting works of art on paper, to add a bit more width

(approximately 1/2 inch) to the bottom border, a practice called "raising" or "bottom-weighting." Whether or not this belief is based on fact is open to debate. If the bottom margin is to be raised, add approximately 1/2 inch to it and subtract the same amount from the upper margin. It is helpful to record other information, such as color choices and ply on the template in order to guard against inadvertent mistakes.

Unless the mat board has been precut in the standard sizes used in your collection, you will need first to cut two pieces of it to the outside dimensions indicated on the template. To cut the window opening, lay one piece of the cut board face down on a clean working surface. Most people prefer to measure and mark the mat board on top of several layers of clean kraft paper or large blotter to avoid slippage. The actual cutting of the window is always done with the mat board lying right side down on top of long scrap pieces of mat board (the cut ends saved from precutting) to protect the blade and the table surface. To determine which side of the mat board is the right side, hold the board up in raking light that exaggerates its surface texture. One side will usually appear rougher than the other and that side is generally preferred as the "right" side, due to its richer effect. The difference between the two is slight, but will be noticeable if works are displayed side by side. Using a pencil with a hard lead and a sharp point, mark out the margins on the back of the board. With increasing proficiency, you will no longer need to rule out the lines – only the locations that indicate the corners of the window.

Mat cutters can be tools as simple as a utility knife or a handheld cutter (Dexter®) to an elaborate table top model with tracks and a sliding blade holder, a wall-mounted vertical model, or a fully automated computerized mat cutter. Many models fall between those two extremes. However the window is cut, the edge should have a bevel or slant of approximately 45 degrees. As you cut, the knife should follow the ruled lines, with the blade angled toward the center of the mat board. Because you are holding the blade at an angle, you will need to extend the cut about 1/8 inch beyond each corner of the window opening to compensate for the thickness of the mat board. Exert even pressure on the knife and make each cut in one continuous motion. If you are using a utility knife or a handheld cutter, you will need a heavy metal straightedge to guide your blade. Squares of sand paper attached to the back of the straightedge will help prevent slippage. When all four cuts have been made, flip the mat over.

If the center cutout, sometimes called the "fallout," does not immediately drop away, carefully extend each incomplete cut with a sharp utility knife, scalpel, or razor blade. The tool must be held in the same position as the cutter so the 45 degree angle of the bevel is continued all along the cut. Flip the mat face down again and use a soft white eraser to remove any pencil

marks remaining on the back (colored erasers sometimes leave stains). Using a bone or Teflon® folder, gently smooth down any sharp edges along the window opening. Extremely fine grade emery paper can also eliminate rough edges.

Place the window mat face down and align it, usually along its long edge, with the back mat board, face up. Secure each board with small weights or beanbags placed on top of blotter squares so that it cannot shift during taping. Attach the two mat boards along their butted edges using either wet linen (Holland or Dutch) tape or a cloth pressure-sensitive tape designed to sustain repeated folding (Filmoplast SH®). The tape should be at least 1 inch wide. If wet linen tape is used, it must be covered with blotters, glass, and weights while drying. The pressure-sensitive tapes need only to be burnished. Linen tape is the strongest type and lasts the longest, but many people avoid using it because of the extra time and effort required, or they do not have access to water in the workspace.

Instructions for cutting double-sided mats, "sink" mats designed to accommodate very thick or heavy artworks, and other sorts of customized matting formats are best left to mat-cutting specialists who can work with a conservator to design a mat that protects and presents an artwork to its best advantage. Many ingenious item-level solutions exist to protect prints and drawings having unusual conservation requirements. The more the final protective enclosure can be integrated into an existing storage system, however, the safer it will be. A one-of-a-kind cumbersome protective enclosure left propped up against a wall can be more dangerous than lesser protection provided by a flat file drawer. Several entries included under Further Reading can suggest alternative protective measures for prints and drawings.

Securing the Artwork

The means by which a print or drawing is secured to its back mat board is the most critical step of the entire framing process. Typically, artworks are attached to the back mat board using hinges, which permit the viewer to examine the back of the artwork and also allow the paper to expand and contact safely with fluctuations in temperature and humidity. Works of art on paper should never be restrained around all four edges; this prevents their natural movement in response to the environment and results in tension "draws" or "washboard" buckling (see Figure 2.23). Informed choices need to be made along every step of the hinging process – from the selection of the carrier and adhesive, to the hinge's configuration, and its placement on the work of art.

Hinges

Four factors will determine the success or failure of a hinge:

The carrier. The carrier (the paper, plastic, or fabric that "carries" the adhesive) must be the correct thickness, color, opacity, and strength for the paper it is to secure. It must also have, and retain over time, a neutral pH. It should be chemically stable and not lose its strength, flexibility, or change color.

The adhesive. The adhesive must be selected with consideration given to the weight, absorbency, and dimensional stability of the artwork to which it is applied. It, too, must have a neutral pH and be chemically stable. As it ages it cannot darken, lose adhesion, or become more difficult to dissolve. This latter characteristic – reversibility – is of utmost importance and will be discussed below.

Hinge design. Many different configurations of hinges have been devised in order to adequately support works of art on a variety of papers. While lengthwise, horizontally folded hinges of Japanese tissue applied to the verso (reverse) of the artwork are the most common, pendant hinges have been found to offer better support for particularly heavy artworks or those that expand and contract with changes in ambient temperature and humidity.

Hinge location. Hinges must be located where they can offer optimal security while not interfering with the visual enjoyment of the artwork. Typically, hinges are placed in the upper corners of the verso of the work; however, other arrangements may be in order if the work has irregular dimensions, is oversized, buckled, or destined to travel.

Correctly applied hinges allow the work of art to be seen to its best advantage, while providing adequate support during display, storage, and transport. Hinges can fail due to any one of the above factors. When this happens, the artwork can fall away completely or is left dangling from one still-affixed corner. Conversely, when the hinge is too strong, the weaker artwork can shear away from it, leaving a corner behind.

Hinges should be made from Japanese paper (*washi*), which is available in many weights, fiber types, and opacities so can be selected to suit best the characteristics of the artwork to be hinged. For example, sheer lightweight papers can be used for hinges behind translucent papers. Japanese paper is also extremely strong and long-fibered so adheres well to even slick, smooth-surfaced papers. Most importantly, Japanese papers made in the traditional manner using pure bast fibers and nonchemical processing are still readily available, albeit expensive. Although wood pulp and chemical refining has

been introduced into this segment of the papermaking industry, high-quality *washi* is still distributed widely in the United States through conservation and library and archive supply houses.

A word about the names of Japanese papers may be helpful. Most often, the name given to a is the name of the region where it was traditionally produced or the use for which it was historically intended. Over the years, that name has become synonymous with that particular paper. Therefore, while *mino-gami* is usually thought of as being a medium- to light-weight paper, it is available in heavier grades. The Japanese names can only be used as general guides. Most Japanese papers used for hinging purposes are made from *kozo* fibers, the most dimensionally stable of the three bast fibers typically used in Japanese papermaking. The most important factor to consider when choosing a for hinging is the weight and thickness of the item being hinged. Heavy-weight papers include *okiwara*; among medium-weight papers, *sekishu* and *kizukishi* are frequently selected. For very thin papers, *tengujo* might be appropriate. Hinges should never be so heavy that they emboss the item, nor should they create an opaque area behind it. On the other hand, they should be strong enough to support the weight of the piece. The idea is that if the artwork is subjected to a sudden jolt, the hinge will tear, rather than the artwork surrounding it.

It is useful to keep an assortment of Japanese papers on hand, an idea that has been packaged into samplers by some conservation material suppliers. In no case should an artwork be glued or taped into a mat; if hinging is not possible, a variety of other safe options exist that are described below.

Two hinges at the top edges of the artwork will be sufficient to hold most art on paper, but larger pieces – wider than 24 inches – may require three or more hinges evenly spaced across their top edges. On occasion, hinges can be attached around all four sides to more evenly distribute heavier weights. Prints and drawings should not be hinged on one vertical edge unless there is a special reason for this format – a page from an Islamic manuscript might be hinged along its right edge, for example, to preserve its identity as part of a book. Any unusual hinging configurations should be indicated by small pencil marks on the inside of the mat.

If a print or drawing on very thin paper is not overmatted, and if a rigid acrylic sheet is used instead of glass in the frame, the art can be easily pulled forward into contact with the glazing by static electricity. Antistatic solutions applied to the glazing beforehand can prevent this to some extent as can antistatic "guns," which dissipate the buildup of static charges. Sometimes, there is no choice but to add a small folded hinge to each lower corner of the artwork to prevent it from being pulled forward. As mentioned above, if hinges are applied to the artwork in any location other than its upper corners, indicate their placement by penciling small arrows on the back mat board. Otherwise,

one can easily tear the piece by attempting to lift an attached corner. Fortunately, there is now available a nonstatic variety of rigid acrylic sheet for use in frames.

Preparing a Folded Hinge

Supplies

- Japanese papers in assorted weights
- Ruled cutting mat
- Ruler
- Metal straightedge
- Forceps
- Starch paste, strained and thinned to proper consistency
- Small, flat (3/8 to 1/2 inch wide), stiff bristle brush
- Distilled water/brush/pen applicator
- Precut blotter squares (3 × 3 inches)
- Glass squares (3 × 3 inches)

ARTWORK
VERSO

ARTWORK
VERSO

FEATHERED EDGE

Figure 5.5 A folded hinge and a pendant hinge. (Drawing: E. Ellis).

- Precut polyester web (4 mil Reemay® or Hollytex®) squares (3 × 3 inches)
- Small weights
- Bone or Teflon® folder
- Scrap paper

A folded or "V" hinge, as shown in Figure 5.5, is simply a strip of Japanese tissue folded lengthwise in not-quite-equal portions. The narrowest portion is applied to the verso of the artwork; the remaining wider strip is folded back and applied to the back mat board, forming a pivot. A work that floats in its window mat (art that is not overmatted) requires folded hinges.

To make the hinge, spread a suitable tissue on a clean blotter. With a heavy straightedge and a bone or Teflon® folder, score long strips of tissue between 1 and 1½ inches wide, following the grain of the paper (the direction in which it tears most easily). Holding the straightedge in place, fold back along the scored line. Apply a thin line of water along the scored line, using a brush or a portable watercolor pen (resembling an empty felt-tipped marker filled with water). Pressing the straightedge firmly down with one hand, gently pull the tissue away from it, tearing along the moistened line. Fold the tissue not quite in half lengthwise and tear off the number of desired hinges about 1½ to 2½ inches long, again by scoring. Sometimes water is not needed for tearing, but the moisture helps create a feathered edge, which is softer, bonds more smoothly to the paper, and is less visible from the front. Thin tissues that have pre-watermarked tear lines are available for purchase; however, these papers are generally used for paper repair.[8] For smaller prints, shorter and narrower hinges are in order, as long as they adequately support the weight of the artwork.

Starch paste, cooked up using purified wheat or rice starch, is the usual choice for applying hinges to works of art on paper. It is the most versatile paste available and can be modified, made thicker or thinner, or mixed with other adhesives, to produce different properties. Most importantly, it has stood the test of time and does not discolor, become acidic, lose adhesion, or become more difficult to reverse as it ages. These aging properties are not just anecdotal – they have been scientifically proven through rigorously controlled aging experiments. While conservators have also used synthetic resins that are solvent- or heat-activated, acrylic emulsions, and other adhesives with great success, starch paste remains the most dependable, especially as it ages. Appendix 1 describes how to make paste.

An alternative adhesive is pure methyl cellulose, the main ingredient in wallpaper paste, which does not require cooking. Generally speaking, it is not as strong as starch paste nor is it as versatile. Instructions for its preparation are also included in Appendix 1.

The following procedure for applying folded hinges requires relatively little maneuvering, once the artwork has been positioned, and it reduces the chance

of misalignment. Place the item to be hinged face down on a clean working surface with its top edge closest to you. Under the spot where the first hinge will be placed, slide a small square of blotter covered with a small square of polyester web (4 mil Reemay® or Hollytex®). Insert a square of waste paper, scraps of leftover folder stock, for example, into the folded hinge and place its narrowest side up onto a small glass plate away from the artwork, holding it in place with forceps. Using a small, flat, stiff bristle brush apply a thin, even coat of paste to the upper side brushing away from its folded edge. Remove and discard the waste paper that acted as a mask. Then, still holding the folded hinge with forceps, attach the hinge to the back of the artwork so that its folded edge is aligned exactly with or slightly away from the top edge of the art. Unfold the hinge.[9] Place a small square of polyester web over the unfolded hinge and lightly burnish using a bone or Teflon® folder. Replace this polyester square with a clean one, followed by a square of blotting paper, a square of glass, and a small weight. Repeat this procedure for each hinge.

After 5 minutes, remove the weights and glass squares and flip the blotter squares to speed the drying process. Replace the glass squares and weights. Allow to dry from 20 to 30 minutes. When thin, delicate papers are being hinged, blotters should be changed often to prevent cockling. Remove the weights, blotters, and polyester squares, and turn the artwork face up. Place it in the mat and position the image within the window opening. Secure the artwork with one or two weights placed on blotter squares. Using scrap pieces of folder stock to support them, the extended edges of the unfolded hinges are then pasted up. Paste away from the fold, being careful that excess paste is not deposited onto the front of the artwork. If it does, quickly roll it off with a swab or lightly tamp with a clean blotter square. Fold the extended half of the pasted hinge under the artwork and affix to the back mat board below. Cover with a polyester square, blotter square, glass, and weight. Flip the blotter after 5 minutes and allow the paste to dry for at least 30 minutes. Repeat for the remaining hinges. While the hinges should open freely after drying, always lift the artwork with caution to insure that the two sides of the hinge are not stuck together. If they are, the paste may have been too thick, the tissue too thin, or the drying times insufficient.

Preparing a Pendant Hinge

Supplies

- Japanese papers in assorted weights
- Ruled cutting mat
- Ruler
- Metal straightedge
- Forceps
- Starch paste, strained and thinned to proper consistency

- Small, flat, (3/8 to 1/2 inch wide) stiff bristle brush
- Distilled water/brush/pen applicator
- Precut blotter squares (3 × 3 inches)
- Glass squares (3 × 3 inches)
- Precut polyester web (4 mil Reemay® or Hollytex®) squares (3 × 3 inches)
- Small weights
- Bone or Teflon® folder
- Scrap paper

Pendant, tab, hanging, or "T" hinges (see Figure 5.5) are made from rectangles of Japanese paper measuring approximately 1 × 2 inches with feathered edges along the descender of the "T." The size of the hinge can be modified according to the dimensions and the weight of the item being matted. Pendant hinges are stronger than folded hinges, because the entire hinge carries the weight of the artwork rather than pulling along the spine of the folded hinge. Folded hinges, if not strong enough, can slip. Pendant hinges, however, can only be used with items that are overmatted since they are visible above the top edge of the artwork.

Place the artwork face down on a clean working surface with its top edge closest to you. Place blotter squares covered with polyester web squares under the locations where the hinges will be placed. Paste out the hinge on a piece of glass by covering two-thirds to one half of the hinge crosswise with a piece of scrap paper that will act as a mask during pasting. Apply paste to the exposed portion. Pick up the pasted hinge with forceps and carefully align the pasted edge along the top edge of the artwork. Place a square of polyester web over the hinge and gently burnish with a bone or Teflon® folder. Replace the polyester web square followed by a blotter square, a glass square, and a weight. After 5 minutes, change or flip both the blotter squares. Repeat this procedure for each hinge. Wait for at least 30 minutes. Turn the artwork over, place it in the mat, and position it in the window opening. Secure the artwork in place using one or two weights on top of blotter squares. Apply paste entirely over another rectangle of Japanese paper, slightly larger than the first one. Place this piece over the extended hinge – the top part of the "T." It should be close to, but not touching, the top edge of the artwork. Cover with a polyester web square and firmly burnish. Replace the polyester web square and cover with a blotter square, glass, and weight. Flip the blotters after 5 minutes and allow to dry for at least 30 minutes. Repeat for the remaining hinge(s).

Sometimes the results of hinging a work of art into a mat are less than satisfying. Symptoms such as staining through to the recto of the artwork, tide-lines, curling of the hinge, and puckering of the artwork around the hinge are evidence of too much paste, uneven application of paste, lumpy paste, a too-heavy

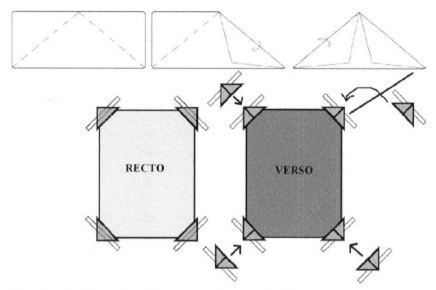

Figure 5.6 Making and applying corners. (Drawing: E. Ellis).

hinge paper, insufficient drying time, or not enough blotter changes. Hinges that pull off easily or slip indicate too little paste or paste that is too old. Weak hinges may also be caused by a work of art with a smooth or nonabsorbent surface, or one whose weight is too heavy for the number of hinges provided.

Occasionally, works have been hinged directly to the window mat rather than to the back mat board. This is dangerous for the art, because, when the mat is opened, the art is pulled along with it, often resulting in creasing and tearing.

Corners

When a print or drawing is sufficiently overmatted, corners made from acid-free paper or clear polyester film (polypropylene, a softer, more flexible film, can also be used) can be used. Corners are available in many sizes, materials, and adhesive (moisture-activated, pressure-sensitive) options commercially. These corners are usually preferable because no adhesive is put directly onto the work of art, eliminating possible problems of curling or staining and the future task of hinge removal. Corners should not be used on very weak or brittle papers that cannot support their own weight. Furthermore, the size of the corner must be appropriate to the size of the artwork. Many commercially available corners intended for photo albums are too small to support larger items sufficiently nor are they of archival quality.

Removing an artwork secured with corners is an easy operation. One must remember, however, that the corners are removed from the mat first and slid away from the artwork; the artwork should not be curled up and pulled away from the corners. If the corners are firmly adhered to the back mat they can be carefully cut away.

Corners are easy to make from scraps of polyester film, lightweight folder stock, or acid-free paper, such as Permalife®. To make an average-size photo corner, cut a strip of either material approximately 2 inches long and 1 inch wide (length should measure twice the strip's width). With the strip horizontally in front of you, fold over the upper corners at 45 degrees, so that they meet along the centerline of the resulting triangle (see Figure 5.6). The side of the triangle where the edges meet goes below the artwork when it is slipped over the work's corner. The corner is secured into place applying a strip of gummed linen (Holland or Dutch) tape, gummed archival paper tape, or pressure-sensitive (archival) cloth tape (Filmoplast SH®) diagonally across it.

Edge Strips

Recently archive and library supply companies have offered stiff strips made from clear polyester film that can be used to support prints and drawings in their mats, acting rather like very shallow cleats. They are available in different configurations and lengths that can be cut down as needed; some actually act like a clamp, exerting slight pressure when they are slipped around the top and bottom edges of the artwork. The strips are generally self-adhesive. Like corners, no adhesive ever comes into contact with the work of art and the strips are completely reversible. Once again, the strips must be carefully evaluated to insure that they can support the weight of the item or that it does not slump under its own weight. Edge strips and "cleats" can also be made by hand scoring and sharply folding strips of lightweight folder stock.

Many other innovative solutions have been devised for securing works of art on paper into mats. Sometimes a combination of hinges and corners is employed, reducing the amount of time and effort involved in preparation and increasing the ease of reversibility. Rather than hinging its vertical sides or bottom corners, "hair silk," practically invisible stands of natural silk, can be stretched across an item horizontally to keep it from bowing forward. The ends of the strand are simply taped down out of sight under the window mat. Most recently the use of rare earth magnets has been explored. The magnets are now available in flat disks, but the mat board still needs to be excavated around them and their metal "targets" to which they are attracted. In a closed

mat or frame, dirt is usually not an issue; however, these magnets will attract metallic dust and debris if left out in the open.

"Archival" Pressure-sensitive Adhesive Tapes

In the 1970s, a number of pressure-sensitive or self-adhesive "archival" tapes for hinging works of art on paper were introduced. They are popular since they require no preparation, little experience or skill to handle, and can be applied in only seconds, vastly reducing the most time-consuming step in the framing process. While these tapes do have better aging characteristics than the old-fashioned "scotch" tape or masking tape, their acrylic-based adhesives are not easily removed, especially after a few years. Also, in looking at the factors listed above that can affect the success or failure of a hinge, the paper of these tapes, typically an optically brightened white short-fibered bond wove paper, is not as versatile, although recently a thinner paper carrier as well as a matte plastic carrier have been introduced for use on lighter weight papers. Plus the configurations one can make with these tapes are limited: a tape can be flat, folded, or rolled up like a sausage. Both aesthetically and mechanically these tapes may not be as attractive or effective when used for hinging.

It is claimed that pressure-sensitive hinges can be easily removed with heat or hot water. The question of the ease of reversibility of these tapes is a highly controversial issue among conservators. Shortly after application, while the adhesive is still sticky, these tapes can usually be rolled away using a "crepe" square made from hard porous rubber, provided the artwork's surface is abrasion resistance and nonfibrous. In general, these tapes are reversible with water within the first year or so of their application. But, it is important to note that water does not dissolve the adhesive – it "gels" or partially solubilizes it, so that it can be gently rolled away. If the paper to which it has been applied is not heavily sized, has a fibrous, nappy, surface, or is a deteriorated wood pulp, skinning or thinning of the paper can easily result, since the gelled acrylic adhesive remains extremely sticky. Over time, however, hot water or "stronger" (more polar) organic solvents are required to soften the adhesive. The application of hot water and solvents can easily result in staining and the formation of "tide lines," especially when dealing with older, yellowed, or absorbent papers. Heat can be applied to soften the adhesive, but unless the exact melting point of the adhesive is achieved, the heat will often drive the adhesive into the artwork, leaving behind a tenacious sticky residue that is even more difficult to eliminate.

The carriers of these tapes are generally better-quality papers, sometimes buffered with calcium carbonate. As mentioned above, a translucent carrier has been introduced for use on thinner papers. Ironically, the risks involved in

its removal are increased when used on the very type of paper it was designed to repair.

Like the carriers, acrylic-based adhesives do indeed age significantly better. They generally do not darken and retain their tack and neutrality. They do, however, contain plasticizers that can cause dye-based inks to bleed.

If the term "archival" means completely reversible, then the tape's claim is not accurate. It should be acknowledged that these tapes work very well when reversibility is not an issue, for example, for repairing books in a circulating library collection or nonunique documents destined to be copied or saved in another format. There is a huge scrapbooking movement in America today, for which these tapes might be suitable; however, it is important to keep in mind that some ephemera from the past is treasured today. It should be said that these tapes are excellent when used appropriately – that is, when reversibility is not a consideration.

Hinging to a Secondary Support Sheet

In many collections, prints and drawings are hinged to heavier archival-quality papers (Bristol weight), two-ply mat board, or light folder stock, rather than hinged directly to the back mat board. The secondary support sheet is attached to the mat with the same kind of tape used to bind the mat together; or it would be a good use for the pressure-sensitive "archival" tapes described above. The separate sheet of paper makes it possible to transfer the print or drawing from one mat to another without rehinging. This reduces the wear and tear on the artwork. In addition, the back of the artwork can be more easily examined by curling the secondary support, which should measure slightly larger than the work itself. Hinging to a secondary support sheet is highly recommended for study collections, significantly reducing the direct touching of collection items.

Interleaving Papers (Slip Sheets)

When prints and drawings are to be kept stored in mats, a sheet of interleaving paper, sometimes called a "slip sheet," should be inserted between the artwork and the window mat. The two most important properties of slip sheets are their chemical neutrality and their smoothness followed by transparency and wrinkle resistance. Many collections opt to use polyester sheets, the same kind used for storage sleeves and encapsulation. Its transparency is a definite plus, since the artwork within each mat can be quickly confirmed when sorting through a box. The disadvantage of using polyester sheets for interleaving, however, is their weight, sharp corners, and static

charge. Polyester film should never be used against charcoal, chalk, graphite, or pastel drawings. For this reason, most collections care specialists opt for paper-based slip sheets. These include neutral glassine, tissue, and paper. Glassine is neutral, that is, nonbuffered, is smooth, slick, and translucent. It does not wrinkle easily. It will not age as well as acid-free tissue, especially if the work it covers is highly acidic. In most cases, this is not a problem. If a precut stack of interleaving paper is kept in the storage area or vault, replacing it regularly is not a problem. Note that glassine is not household wax paper – its translucency results from highly beaten and super-calendered fibers and not a coating.

Acid-free tissue is available in several weights and both buffered and nonbuffered. Tissue creases more easily and has a slightly rougher surface. Because it is less translucent, or opaque, the mat needs to be opened and the sheet pulled away in order to confirm that the correct item has been located. Acid-free tissue is ideal for many protective purposes in addition to interleaving; it can also be used for wrapping and packing textiles and other artifacts often found in storage. "Silk" tissue, a Japanese tissue containing a high percentage of *gampi*, is silky, translucent, and neutral. Because it is so thin, however, the tissue tends to fly away and wrinkle easily; it is also expensive.

Lightweight, highly purified paper, such as Permalife® and similar brands, is also available, both buffered and nonbuffered. It is stronger than most tissues and glassine and has a smooth surface. Its drawback is that it is opaque.

How frequently neutral glassine and nonbuffered interleaving papers need to be rotated is difficult to state categorically. Obviously, if a slip sheet is covering a print with a pH of 4, the slip sheet will become acidic faster than one against a print with a pH of 7. A good rule of thumb is always to keep a supply of precut slip sheets on hand and to change them whenever any sort of discoloration is noted on the interleaving paper itself. This practice, however, does little for the unpopular print that never sees the light of day. Any signs of brittleness or darkening of the slip sheet is proof that it is doing little to protect the artwork within the mat. Such a slip sheet should be replaced immediately. A pH indicator pencil can also be kept nearby, to test papers used as slip sheets – a corner snipped off can serve as a sample.

Storage Boxes

One of the most common and adaptable methods of storing prints and drawings involves the use of print storage boxes arranged along open shelving (discussed further under Storage Furniture).

Print storage boxes – often called "solander" boxes – after their inventor, Daniel Charles Solander (1736–1782), a pupil of Carl Linnaeus (1707–1778) – are

made from sturdy pressboard, binders' board, or other stiff paper laminates, usually attached to interior wooden frames. Solander boxes are available in several sizes and vary in price according to their components and degree of craftsmanship. Over the years, with growing interest in their use for archival storage, there have been many improvements in the materials used to make them. Major manufacturers are now using a buffered acid-free folder stock or an impermeable synthetic Tyvek® lining for the boxes. Traditional starch-filled cloth outer coverings (attractive to vermin and not very durable) have largely been replaced with acrylic coated cloth. Adhesives are now chemically improved and stronger.

When selecting a storage box for prints and drawings, it is important to consider these points:

- Is the box rigid and durable? A box that cannot adequately support its contents or one that falls apart after a few years of handling is useless.
- Is the box lining acid-free or an inert material like Tyvek®? Will it act as a barrier against environmental fluctuations or gaseous pollution in the storage area? Manufacturers should always provide specifications about all the components in a storage box, including the internal frame.
- Does the box open and close easily? Does it close snugly? Too loose a top allows dust and vermin to penetrate; too tight a top makes the box difficult to open.

When costs must be curbed, there is no simpler, more practical solution than boxes made from acid-free corrugated cardboard. Boxes made from acid-free corrugated cardboard are precut and are delivered flat; extra containers can be stored until ready to be assembled. Such boxes, however, weigh less than solander boxes, are less durable, and are less suitable for heavy use in print study rooms or libraries. Their corners, lacking rigid supports, adhesives, or metal fasteners, tend to fold inward; therefore, they do not always close smoothly. In larger sizes, cardboard boxes can torque. While homemade or prefabricated boxes can be economical, the difficulty in opening and closing them can be dangerous for their contents.

No adhesives are needed in boxes made from archival-quality board with metal clips providing strong corner support. Because of their lighter weight and no internal wooden framework, paperboard boxes lack the rigidity of solander boxes and the larger sizes tend to wobble. They also may be awkward to open and close; and because their parts do not always fit snugly they are not as dust proof as solander boxes. By and large, however, their archival-quality materials and low cost make these paperboard boxes, as well as those made from acid-free corrugated cardboard, an

economical solution for safely storing large collections of paper-based items.

In general, the more neutral and chemically stable its adhesives, boards, linings, coverings, and the more it can withstand years of use, the better the box is for conservation purposes. Its price will increase in relation to quality and craftsmanship. Several less expensive boxes that can easily accommodate a collection are better than one premium-priced model crammed to overflowing. Apart from the item-level protection options described above, these boxes are one of the best conservation investments, in terms of the protection they afford.

Standardized dimensions of folders, enclosures, mats, interleaving papers, and storage boxes are more economical and provide greater safety in handling. The dimensions of the storage enclosures should be the same as the box in which they are placed to minimize movement of the items within the box. For example, 16 × 20 inch folders or mats should be put into a 16 × 20 inch storage box. Commerically available folders are automatically "scaled down" to fit into standard sized boxes. Even when different-sized items are stored together in one box, their enclosure dimensions should be the same and large enough to cover fully the largest item in the box. Purchase standard-sized boxes and enclosures in a range of dimensions to fit your storage needs. If custom dimensions are the best option for your collection, purchase as many associated storage materials, that is, folders, slip sheets, mat board, and boxes as possible in those sizes beforehand. Not only will this be more economical, change in the global paper industry is fast-paced; companies switch hands and products are discontinued seemingly overnight. Whether they are in envelopes, sleeves, folders, enclosures, or mats, prints and drawings so protected should be the appropriate size for the box or drawer they are out into. A small item in an oversized container can be damaged by sliding around inside. When paper items are to be stored in flat files, for economy of space you may designate drawers to be used for full drawer-size enclosures or subdivide other drawers to accommodate half-size or even quarter-size enclosures. When possible, drawings and prints should be stored horizontally within a storage box to distribute their weight evenly. The fold of the mat or enclosure should follow the spine of the box.

It is a fact, however, that horizontal storage boxes take up more space. Some institutions have adopted vertical storage systems for boxed prints and drawings, making sure that the drawings are oriented correctly within the box and the box is padded out to prevent shifting of its contents. Vertical storage in document boxes is common for archival materials, which often have paper of similar weight and size; extra space in the box needs to be filled in with spacers made from acid-free corrugated cardboard or Ethafoam® blocks or strips to prevent slumping and curling. Bubblewrap® should not be used in long-term storage.

Frames

Not until the eighteenth century, when the technology for manufacturing smooth sheets of glass improved, were prints and drawings framed and used as interior decoration. Before that time, prints and drawings were normally kept in albums or portfolios for private enjoyment, with the exception of devotional or popular allegorical prints, which were simply tacked to the wall. Etched reproductions of popular paintings were among the first works of art meant to be glazed – covered with glass – framed, and displayed. It has been recorded that the estate of the artist Charles Germain de Saint-Aubin (1721–1786) included 70 prints framed behind glass.[10] Writing in 1751, a certain Mrs. Mary Delaney, noted for her startlingly realistic paper collages of flowers and equally accurate social commentary, observed this new trend in interior decoration, "Mr. Vesey has a room filled with prints and they look very well."[11] Folk art – such as *frakturs* and silhouettes – was intended for display. Itinerant artists often provided frames, so that satisfied customers could immediately show off their purchases. Such frames are important components of these artworks and should not be thoughtlessly disposed of when they are damaged or go out of fashion.

Because they had no precedent for framing, prints and drawings were often framed in the manner of paintings – both visually, with heavy gilt molding and deep linen-covered fillets, and also structurally. They were often lined with canvas, wrapped around stretchers, and left without glass, a procedure

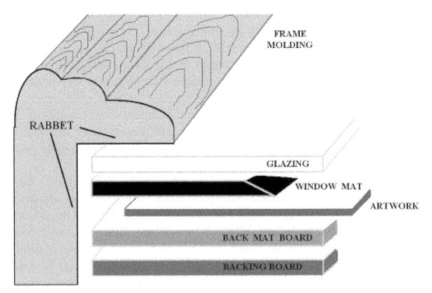

Figure 5.7 The frame package. (Drawing: E. Ellis).

also described by Mrs. Delaney quoted above. Today, many works of art of paper, especially paintings on paper, are still aggressively framed as if they are simply smaller paintings, a practice that is somewhat cynically claimed to increase their price because they are closer in appearance to more high-priced paintings.

Conservators consider the primary function of framing to be protective as well as aesthetic, providing additional physical protection for prints and drawings when they are on display or in storage. Therefore, it is important that all components of the frame "package" be selected with conservation consideration in mind. Figure 5.7 is a cross section of a typical frame package. Each component will be discussed below.

Molding

The strips of rigid wood or metal that make up a frame are called "molding." Often the molding is made in a particular historical style or profile and can be painted, gessoed, gilded, and carved. Usually the style or profile of the molding is selected to complement the work that it is intended to showcase. Regardless of its decorative attributes, however, it is important to evaluate how much protection the molding provides. Firstly, is it physically able to support the weight of the frame's contents? Flimsy molding that is too narrow can sag and the contents – luckily sometimes just the glass or rigid acrylic sheet (glazing), but also the matted work of art itself can pop out the front. Secondly, are the corners securely fastened? Are the miters (the diagonal joint where the corners meet) tight or are they uneven and spreading? Have they been welded, mortised and tenoned, keyed or splined, or reinforced in some manner? Finally, is the molding profile deep enough to accommodate the glazing, window mat, back mat board, backing board, and hanging hardware – all without protruding from the back. Vintage or period frames are often cut down for reuse. And, the same considerations come into play – are the miters secure and is the frame deep enough to contain all components of the frame package? Their nonstandard dimensions often complicate the reuse of period frames and the special handling required to protect vulnerable gilding and ornamental protrusions. To provide variety and to complement various historical contexts, many institutions select two or three styles of molding available in a range of standard sizes.

Fillets and Spacers

When prints and drawings are framed it is important that they not come into contact with the glass or acrylic sheet used for glazing. A standard four-ply mat board window is usually sufficient for this purpose; however, if the

drawing is buckled, a thicker mat made from eight-ply or two pieces of four-ply may be necessary. Spacers or fillets fitted around the "rabbet" the groove into which and the lip onto which the glazing rests, also called the "rebate," can provide a breathing space for unmatted or "floated" prints and drawings. This breathing space is crucial for the dissipation of trapped humidity. In areas where the drawing is in contact with the glass or rigid acrylic sheet, moisture can easily condense and foster mold growth, seen at first as hazy whitish efflorescence.

Contemporary prints and drawings are often framed by simply hinging the artwork onto four- or eight-ply mat board and placing it directly into a frame fitted with a "fillet" or "spacer" to prevent the work from touching the glazing. A fillet is a strip of wood, plastic, or mat board inserted around the perimeter of the frame and hidden from view by the rabbet of the molding. The resulting airspace protects the work from condensation and the extra depth can be aesthetically attractive. Framespace®, an easy-to-cut clear plastic spacer marketed in strips that are S-shaped in cross-section, snaps around the glazing in a frame and rests against the mat. If thin wood strips are used as spacers, they must not rest directly against the artwork itself. They can be faced using strips of mat board attached with a purified white glue (polyvinyl acetate, such as Jade 403®).

It is especially important to insure that adequate space is provided for drawings done in powdery media such as charcoal, chalk, graphite, and pastel. Furthermore, glass or a rigid nonstatic coated acrylic sheet must be used in their proximity, rather than an uncoated acrylic sheet.

Glazing

Glass. Common "soda lime" glass continues to be a popular choice as a glazing material because of its wide availability and low cost. Glass used for glazing purposes is "float glass," a term that refers to its method of manufacture – the molten glass is "floated" across liquidized tin, resulting in an almost perfect surface.

Older glass, found in "period" frames, may be particularly greenish and wavy, and may contain numerous particulate inclusions and air bubbles. It is often desirable to retain this old glass when used in a recycled frame, as its uneven surface and its distortion of the image may be historically or aesthetically appropriate. For ultraviolet (UV) protection, a sheet of UV-filtering rigid acrylic can be placed between the original glass and the artwork, close to, but not in direct contact with, the artwork. This may require some modification of the existing frame in order to accommodate the extra thickness and weight of the glass and acrylic together. A word of caution, however, when recycling old glass – glass becomes brittle as it ages and can shatter unexpectedly.

"Weeping" glass results from a chemical imbalance of its constituents. It is characterized by droplets of moisture, which form on its surface in humid surroundings. If then moved to an environment with lower humidity, it can also appear as a white, crystalline haze on the surface of the glass. Occasionally, weeping glass is found in cased miniatures and daguerreotypes. Such glass should be removed and stored separately with a desiccant.

Glass has several disadvantages when used in frames: it breaks easily, is inflexible, is heavy in larger sizes, and provides no protection against UV radiation, present in natural and fluorescent lighting. Some glass has a greenish cast, the result of iron impurities in the sand from which the glass was made or from iron oxide added intentionally to reduce air bubbles and distortions. The greenish tint actually filters out a very small amount of UV radiation.[12] Absolutely colorless "water white" glass is also available. Thicker water white glass is often used in display vitrines due to its crystal clear clarity.

Many specialized types of glasses have been developed, which can be used in framing works of art on paper. Designed to reduce distracting glare, two types of nonreflecting glasses are available. They are known in the industry as "nonglare" and "antireflective." Although the two terms are often used interchangeably, the products are very different. "Nonglare" glass is acid-etched on one or both sides, which causes incident light to be scattered. "Antireflective" glass has a metallic oxide, optical interference coating applied to one or both sides. This is the type of glass found in eyeglasses and camera lenses. Other specialty glasses include UV-filtering glass and laminated varieties. These products are generally expensive and, while effective, are still heavy and breakable.

Acrylic. Available since the early 1930s for industrial use, rigid acrylic sheets were first used for airplane windows. Developments in manufacturing technology, particularly in the 1970s and later in the 2000s, have resulted in high-quality sheets of polymethyl methacrylate suitable for use in framing. Rigid acrylic expands and contracts with changes in temperature and humidity to a greater degree than glass. In most instances, this is not a serious problem. In larger sizes the amount of movement increases proportionately, which can lead to popping out or bowing of the acrylic with climatic extremes. Usually, adjusting the frame molding can accommodate these changes. Direct lighting with incandescent fixtures, causing localized heat buildup within the acrylic as well as the rest of the frame package, can exacerbate this phenomenon. Nonetheless, rigid acrylic glazing has several advantages to glass, thanks to recent technological developments that have resulted in acrylic glazing which can filter out UV light, and eliminate unwanted reflections and static charges.

UV-filtering acrylic is produced by dispersion of an UV absorber throughout the substrate. There is no coating, so static electricity is still generated

and reflections from light sources appear. This type of rigid acrylic glazing is susceptible to scratching.

Nonreflective acrylic glazing, like glass, may be produced by either etching or optically coating its surface. The etched version must be placed in direct or extremely close contact with the item being glazed in order to be effective. This type, like etched glass, is not suitable for conservation framing. In contrast, the coated version is effective from any distance from the item being glazed, and therefore is suitable for conservation framing.

Perhaps, the ultimate in glazing products, UV-filtering nonreflective acrylic is an abrasion-resistant acrylic sheet coated on both sides with a nonreflective coating. In addition to its exceptional clarity, good light transmission, and negligible static charge, this product's lightness and overall durability make it an ideal option; however, its high cost may prevent it from being universally used.

Recently, an optically coated acrylic has been introduced that has a negligible static charge, but is not nonreflective, hence, it is less expensive. This product would be an excellent choice for glazing drawings done in powdery pigments.

Polystyrene. Polystyrene is a clear, colorless plastic that is available with an UV filter and a nonglare finish. It is easier to cut than glass, has a low cost, and is available in large sizes. While similar to acrylic, polystyrene is less chemically stable and tends to yellow with age. This product is not widely used in the framing industry.

Polycarbonate. Available since the late 1950s, polycarbonate is not widely used for glazing purposes. Its impact resistance, however, makes it a natural choice for high traffic or public areas, where the possibility of accident or vandalism is high.

A Word about UV-Filtering Products

Given the vagueness of the term "UV-filtering" and the variety of glazing materials to choose from, it can be difficult to determine which product is the most effective. Unhappily, comparison between brands and materials, that is, glass versus acrylic, from different manufacturers can be confusing for the layperson. The most accurate means of evaluation are the products' transmission curves, sometimes, but not always, provided by the manufacturer. In general, when comparing transmission curves, the consumer should select the product that transmits the least amount of radiation below 400 nanometers, indicated by a curve and measured off by percentage points, usually on a vertical axis.

If transmission curves are unavailable for the material under consideration, or if it is unidentified, its filtering capacity can be measured with a UV meter. The easiest meter to operate, and one designed specifically for museums and

galleries, is the Elsec Environmental Monitor Type 765 or the Elsec Universal Light Monitor Type 775.[13] These meters detect both UV radiation and visible light, then generate the ratio of intensities of the two in units of microwatts (of UV radiation) per lumen (of light). When using these meters to check the amount of UV radiation filtered out by glazing, be sure to use a light source rich in UV, such as daylight from an unfiltered window. Make a reading of the light source (typically you will measure between 300 and 700 microwatts per lumen). Then place the glazing in front of the meter's sensor and check that it drops to very low values (less than 75 microwatts per lumen).

A second type of meter is available which measures absolute or incident UV in microwatts.[14] Used together with a standard light meter, the proportion of UV (microwatts per lumen) can be calculated. Instructions for converting one measurement to another are provided by the manufacturer.

Even with 100 percent filtration of UV radiation, other measures should be taken to minimize damage from light. There are described further in chapter 6.

Glazing material, whether glass or rigid acrylic, should fit properly in the molding. If tension is too great or uneven, glass can snap and acrylic can bow. A loose fit will allow dust and gaseous air pollution to penetrate. For this reason, the glazing is often taped onto the rabbet upon which it rests, creating an effective dust shield. A variety of tapes can be used, such as Tyvek® tape, Foil Back Frame Sealing Tape®, or 3M Preservation Tape (887)®.

After the molding and the glazing have been assembled and cleaned, the frame is ready to receive the matted artwork. Old frames being rehabilitated should be thoroughly cleaned. Old tape and adhesive should be removed; corners should be reglued if necessary or reinforced using metal straps. "Canned" or compressed air can be used to eliminate tiny splinters inside of old moldings. This is also an opportunity to look for the presence of active woodworm – keep an eye out for fresh frass or new tunnels. Handheld vacuum cleaners also do the job quickly and efficiently. Stiff wide and flat brushes are also handy for cleaning debris trapped in old frames.

Since the introduction of nonstatic rigid acrylic glazing, there is no reason for a framed work of art on paper to travel with glass used as a glazing material. However, if a work is to be shipped under glass, the glass should be taped to contain splinters and shards in case of breakage. Wide strips of masking or blue painter's tape should be applied side by side to the surface of the glass – not to nonreflective optically coated glass – with their ends doubled over for pull tabs. To remove the tape, pull it slowly back upon itself (so that the tape forms a V). Pulling it straight up (so that the tape forms an L) exerts strain that can make old and brittle glass snap. The tape should not extend over the glass on the frame, because it can damage some

finishes. Any residues left by the tape can be removed by wiping with glass cleaner or benzine.

When cleaning the glazing, either during the framing process or when on display, the appropriate solution should be applied to the cloth used rather than sprayed directly onto the frame picture. Liquids can accumulate at the bottom lip of the molding and are quickly wicked up into the mat if present, or worse, into the artwork itself, if it extends to the perimeter of the frame. Always dampen the cloth with the solvent before wiping; never pour liquids directly onto the glass. Rigid acrylic sheet should never be taped.

Backing Boards

To insert a matted drawing into the frame, hold the frame upright and tip the mat into it, keeping an eye on the artwork. Gently close the package, like a book, keeping both upright. Then lower the frame face down to insert a backing board. The purpose of the backing board is to provide additional physical and chemical protection for the artwork. Today several rigid materials are available for use as backing boards, each having advantages and disadvantages. This is a great advantage over cedar shingles, commonly used in the eighteenth and nineteenth centuries for backing boards, which cause distinctive staining (see Figure 2.4).

Acid-free corrugated cardboard, available in double-wall (thick) and single-wall (thin), is lightweight and easy to cut. It is usually light blue or white. Because of its versatility, it can be used for a variety of other purposes from constructing protective enclosures, dividing flat file drawers and boxes, to providing supplemental horizontal support to items as they are transported. Because it is buffered, it will retain its alkalinity.

Coroplast® is a translucent or white corrugated polypropylene plastic sheet that is lightweight, waterproof, easy to cut, and, of the three backing board materials, the most difficult to puncture. Coroplast® is the most expensive option of the three backing boards, but not disproportionately so. Its edges can be sharp and because it is a plastic, it attracts dust.

Fome-Cor® Board is a lightweight board, comprised of extruded polystyrene foam with clay-coated white facing papers. It is easy to cut, sturdy, and lightweight. The polystyrene core becomes brittle over time. The clay coating on the facing paper is alkaline and nonabsorbent. While not of archival quality, it is a satisfactory alternative for use as a backing board on frames. It should not be used to construct enclosures or used within storage boxes.

Brads, Points, Turn Buttons, and Strainers

The backing board is held into place with small steel nails, called "brads," or with flat diamond-, triangular-, or pin-shaped glazier's "points." Brads

are inserted using a fitting tool or brad setter. As the handles of the tool are squeezed together, a rubber-tipped head gently presses the brad into the frame molding. This does not jar the frame like a hammer would. Glazier's points are shot into place by a spring action driver or compressed air gun. This can cause quite a forceful blow on the frame, its finish, and its contents. "Turn buttons" are small clamps that rotate around a screw and can be swiveled back or forth to secure or release the mat and backing board. Because they are only attached once around the perimeter of the frame, they are often preferred for use on antique frames or for frames whose contents are frequently rotated. For frames with metal molding or to provide extra support, a rectangular wooden frame called a "strainer" is often inserted and screwed into predrilled holes in the molding. Frames having strainers are structurally more secure and are recommended for traveling shows. Frames exceeding 22 × 28 inches should have strainers to prevent torqueing. Strainers are helpful for collections than are rotated frequently, because they make framing and unframing faster and easier.

Dust Covers and Taping

For long-term framing, a sheet of acid-free wrapping paper is stretched over the back of the frame and adhered to the edge of the molding around all four sides with a white glue, polyvinyl acetate adhesive Jade 403®, or a pressure-sensitive adhesive film. This paper acts as a dust shield. On it can be noted the date the artwork was framed, the kind of glazing material used, inscriptions, hinging information (if out of the ordinary), and any other pertinent information – exhibition dates, exposure times, display restrictions, and so forth. A dust cover is not necessary if the item is to be unframed and returned to storage after an exhibition, but the edges of the backing board should nonetheless be sealed with either gummed linen tape or brown gummed paper tape to keep out dust and insects and to help mediate climate fluctuations. If the item is going out on loan, taping can indicate if the frame has been opened, which is usually not permitted.

Hanging Hardware and Bumpers

Framed prints and drawings can be installed in a variety of ways. Most museums prefer to use flat metal "mirror" plates, which are screwed into the back of the frame, with an extended flange that is screwed to the wall and painted over; any tampering with the painted plates is easily detectable. Mirror plates provide the greatest structural support and, at the same time, discourage theft. Often screws that require the use of a special high-security screwdriver are used which further thwarts theft. Screw eyes or flat D-rings holding a length of braided or twisted galvanized steel wire are used in most home and office

situations, but are often inadequate for heavy or large frames. A security "tether" can be added to the wire to deter theft. Never put screws into existing holes in a wooden frame as they can easily pull out under stress. Framed prints and drawings can also be suspended from ceiling molding hooks using nylon or copper wire. Several other hanging systems, which incorporate cleats or hanging devices, can speed up installation times. Security personnel should review the ease of too convenient deinstallation!

Handmade circles of cork or rubber "bumpers" attached to the bottom two corners of the back of the frame lift the frame away from the wall and increase air circulation behind it. This ventilation is especially important if items are hung on cool exterior walls. Bumpers that come with a sharp shaft, resembling tacks, can be put on the back corner; bumpers are also available with pressure-sensitive adhesives.

Sealed Frames

Proponents of sealed framing, which uses sheets of polyester film, metal foil, or other impermeable material to seal the sides and backs of frames, with or without the inclusion of a sheet material containing conditioned silica gel to maintain its interior relative humidity of approximately 50 percent, argue that the frame contents are thereby protected from extreme fluctuations in humidity. The frame "package," which includes the glazing, window mat, artwork, back mat board, backing board, and impermeable film, is taped around its edges using an impermeable foil-backed or clear polypropylene tape, which has been "counter-taped," that is, a strip of the same tape, but narrower, has been applied along the centerline of the wider tape onto its adhesive side – adhesive to adhesive. Thus, no adhesive sticks to the mat board edges, making disassembly easier.

A frame package, as shown in Figure 5.7, will be at equilibrium with the environment, but its moisture absorbing contents will tend to absorb water vapor in preference to giving it up. In other words, a matted and framed drawing will retain moisture long after the relative humidity in a gallery drops. In most instances, standard framing is adequate for protecting prints and drawings.

Sealed frames would be appropriate in situations when artworks might encounter short periods of unstable conditions – for example, a traveling exhibition; or when exposure to humidity would be exceedingly dangerous for supersensitive contents, such as stretched pastels on parchment. Nonetheless, sealed frames are no excuse for unsafe environmental conditions. Even with these precautions, sealed framing is not 100 percent airtight.

Anoxic Frames

Based on the theory that chemical reactions, such as the fading of colors and the breakdown of iron gall ink, are dependent upon the presence of water and oxygen, anoxic or oxygen-free framing, in which oxygen is replaced by the inert gas argon, has been designed for works of art on paper that are on permanent display, such as the United States Charters of Freedom on view in the National Archives and the Waldseemüller Map at the Library of Congress. A few commercial variations of anoxic frames have been marketed, but with limited success to date due to weight and expense. Questions have also been raised about the ability of certain colorants to change even in the absence of oxygen.

Commercial Framing

Depending on the number of items to be framed, the talents of in-house staff, and the size of your budget, you may decide to have some artworks framed by a commercial establishment. You should not assume that a framer will automatically follow the procedures recommended here. The ever-rising costs of quality materials, the introduction of some materials with dubious conservation claims, and the labor involved in correctly applied hinges and careful mat cutting, means that you must be prepared to specify and be prepared to pay for framing that meets conservation standards. When you have ordered special materials, you will also want to verify that they have been used. Do-it-yourself or online framing services will sometimes provide conservation quality materials for an extra charge. The Professional Picture Framers Association, an industry trade group, has gone a long way in educating commercial framers about conservation framing standards, but, ultimately, it is up to the informed consumer to work closely with the framer in making the best choices.

By the time a conservation problem becomes apparent in a framed artwork, the damage has probably worsened. Make a periodic inventory of framed prints and drawings, with close inspection of mat bevels, hinging locations, if visible, and backing boards, to detect problems early. Be on the lookout for hazy glass, areas of contact between the art and the glazing, wobbly window mats or backing boards, rusty hanging hardware, and musty odors.

Unframing Procedures

From time to time, works of art on paper must be unframed, for example when a piece enters a collection. The most important principle to keep in mind, especially if the framing was not done in-house, is to *take nothing for granted*. Many prints and drawings seems to have been framed in ways

designed to confound those who must unframe them. First, cover a table with a soft material, such as felt, toweling, carpet remnants, or several blotters, to protect the finish of the frame from being chipped or scratched. When moving a framed item, hold it firmly by its vertical sides with both hands in its proper orientation if possible. Do not trust the strength of the hanging wire or the attachment of the screw eyes or D-rings.

Place the framed item on the table and examine it carefully from the front to see whether any conditions might make unframing risky. Has the item slipped out of its mat along one edge? Does a localized buckling pattern indicate where each hinge is? Is the artwork so flat that it might have been dry-mounted to a board that has itself become brittle? Do you see flaking paint? Is the artwork in contact with the glass and, if so, is it stuck to it? Is the glazing material old glass or a rigid acrylic sheet?

After learning as much as possible about how the picture has been inserted into the frame, turn the frame face down on the padded table. First remove any screw eyes, D-rings, and hanging wire. Resist the temptation to simply slide the artwork out from under the hanging wire. Cut the hanging wire completely away so that loose ends cannot fly around and cause scratches and cuts. Throw it away! With a soft brush, gently clean the back of the frame, taking care not to catch and tear any peeling labels.

Next, cut away the dust cover, being sure to save any inscriptions or labels that you find on it. As you do, look for water stains, dirt, insects – any clues regarding the probable condition of the frame's contents. Note them on a separate sheet of paper, so that they can be considered when the artwork is later examined. Do not discard anything until you know with certainty that it has no archival significance. If the back of the frame has not been covered with paper, cut away the tape covering the brads or glazier's points and carefully pull them out with pliers. You may need to dig with a sharp knife in order to get a firm grip on the head of each nail with the pliers. Glazier's points must often be bent upward with a blunt knife to pull them out. They can often be rotated out with a flat-head screwdriver by pushing on one edge of the lozenge shape. Be sure to remove all the points and nails, so that the backing board will not catch on any left behind when it is lifted away.

When the backing board has been fully exposed, lift the frame upright with one hand and tilt it slightly backward to see whether the contents will fall out gently into your other hand. Push very gently on the glazing. If the contents remain firmly packed into the frame, coax the backing board, gently and lightly, with a thin flexible metal spatula inserted along the upper edge. Avoid prying the board; if it is brittle, it may suddenly crack in half when pulled out under pressure. And you may inadvertently damage the artwork itself. Prints and drawings are sometimes simply dropped into frames with no backing board at all. Check for this possibility beforehand, and avoid

peeling away or otherwise damaging backing boards while they are still in the frame.

If your observations suggest that the item was dry-mounted to a brittle board or that some other risks are involved, turn the entire frame package face up, holding the contents firmly in place with your hand or a piece of cardboard. Place it on the table and lift the frame molding away from the glazing. Then pick up the glass or rigid acrylic sheet. Remember that glass becomes brittle as it ages. Two people may be needed for this step. Always lift up a piece of glass by two adjacent corners at the shortest ends and never torque the sheet.

If possible, separate the backing materials from the artwork and from anything to which it is directly adhered. The artwork, its window mat, and back mat board, labels, and other materials removed from the frame should be stored in a large acid-free folder pending examination, documentation, or treatment. If the work has been adhered to brittle backing board provide it with supplemental support – acid-free corrugated cardboard, for instance, while it is in storage.

Discard old framing materials, unless they are to be reused or duplicated, such as decorative mats. Wrap and label the frame, after placing cardboard against the glass and cushioning its corners. Store the ensemble together until it is needed again.

Oversized Works on Paper: Framing and Handling

While many collectors consider dimensions of 30 × 40 inches to define an oversized work of art on paper, in reality, any item whose dimensions exceed your framing and storage accommodations can be considered oversized. Works of art whose large format makes then difficult to handle include posters, maps, architectural drawings, contemporary graphics, and wallpaper. Not only are these objects difficult to manipulate, often requiring advance planning and coordination between handlers, the costs of framing them are higher as well.

Oversized works of art also require more storage space, often at a premium in collecting institutions. The need for special allowances that must be made in storing large works of art – a formidable problem, sometimes – is discussed under *Storing Oversized Works on Paper*, which suggests types of storage containers, shelving, and organization for these special items. Such works are usually in deplorable condition when they are acquired, because they often served a practical function prior to becoming part of a collection. Many deteriorated from neglect, simply because of their large, unwieldy size. As an example, today only one complete map survives of the original 868 Mercator wall maps engraved in 1554 on six joined sheets of paper.[15]

Speaking generally, vintage posters and broadsides were never intended to be works of art. Consequently, they were often printed on papers of the poorest quality (durability was a more important property than permanence), as were those by Toulouse-Lautrec (1864–1901). More often than not, posters were actually used as advertisements, sometimes outdoors. They are likely to be found rolled, crushed, and tattered; or worse, they may have been patched with scotch tape, dry-mounted, or lined with heavy canvas for easier handing.

Maps, likewise, lead a hard life before they come to rest in a collection. Old ones that were usually rolled up for use and transport were often lined with fabric for extra strength and were bound with a separate strip of ribbon or fabric at the edges. Wooden dowels were attached to the top and bottom edges for ease of rolling. To create a map of the desired size, several sheets of paper were frequently joined or attached end to end. Maps were also varnished, sometimes many times, to render them waterproof. Today, the varnish has darkened and the maps have stiffened from their linings. They are typically soiled and torn from long and heavy use.

Architectural drawings and prints can come in many sizes and shapes, the most common being preliminary sketches, more complete studies, presentation drawings for clients, and detailed construction drawings. Architectural drawings were done on many types of supports, including commercial illustration boards for display and linen-lined tracing paper for rolling. Copied architectural plans, such as blueprints, have special conservation requirements that relate to the copying technique used. Like maps, architectural drawings were made to scale and were used specifically to illustrate details. Consequently, they can reach massive proportions.

Wallpaper is often the largest work on paper to be found in a collection. Historic wallpapers are now being preserved *in situ* and also as separate sheets in museum collections. Preservation *in situ* has many limitations, since the wall behind the wallpaper is often the source of its deterioration. A more complete procedure – and one considerably more expensive, is to remove the wallpaper from the wall, carry out the conservation treatment required, and reinstall the paper on panels that are archivally sound and easily removable. Many historical societies have chosen to replace their wallpapers with reproductions while saving the originals in storage. Extensive planning is obviously needed when considering all the options for dealing with wallpaper preservation.

Wallpaper sections that enter collections are very often in need of conservation treatment. They are dirty or torn and bits of lathe and plaster often still adhere to their backs, which are frequently made up of many layers of older wallpapers. Flaking paint, frequently a problem, is aggravated by rolling the paper. Odd sizes are especially difficult to handle and store.

Oversized objects often require conservation treatments, such as flattening, tear repair, washing, or lining before they can be put into storage. This puts a premium on work spaces and personnel. Because treatment of large format items does require greater space, many private conservators simply cannot accept them. Generally, regional conservation centers are better equipped to handle oversized works. Some have even become known for their treatment of maps and posters.

Lining with canvas is often recommended for large format items, but it is often badly done and the canvas is too heavy for the poor-quality paper of the piece. Also, the adhesive is often too strong for the short-fibered and weak paper. Most conservators prefer to use Japanese tissue for lining because of its lighter weight and better compatibility with the paper of the work – a woven fabric expands and contracts differently than paper. For very large works such as billboard advertisements, linen or other cloth may be the only practical lining materials; a range of lightweight polyester cloth has recently been found to be suitable; since it is a synthetic material, it is dimensionally stable. If fabric is used, an inner lining of Japanese tissue is often added which will facilitate removal of the cloth if that becomes necessary in the future.

Large format works on paper should be framed and stored with the same care as smaller prints and drawings. Whenever possible, lightweight materials should be chosen for ease of handling and safely. Traditional framing is ideal, budget and space permitting, with the same framing guidelines described above applying. A rigid acrylic sheet is preferable to glass because of its lighter weight. An optically coated acrylic sheet has no static charge, plus it is also available in an UV-filtering version. Since the possibility that a framed work of art will touch its glazing increases with its dimensions, the use of a deeper breathing space or additional hinges is prudent for larger works as is a deeper and heavier molding.

Framers often suggest dry-mounting large items to keep them flat, but this is not recommended. If necessary, place several hinges around the edges and bottom of the piece to keep it flatter. Several hinges may be necessary to support the greater weight of large objects. Hinges can be slotted through the back mat board for greater support or the item can be "strip lined" by making extended edges from strong Japanese tissue that is wrapped around a lightweight honeycomb paperboard.

Clips, which clamp a piece of rigid acrylic together with the artwork and backing board, are convenient and eliminate the need for expensive and heavy frame molding. Although these clips are easy to use and attractive for contemporary posters, they are recommended for use for only a short time. Dust and other contaminants can easily enter all sides of the package, left behind in the air currents, which crisscross across the surface of the work. Furthermore, the clips leave no breathing space, encouraging condensation and mold growth over time.

Less costly alternatives are possible by eliminating the need for glazing and molding. Encapsulation – sandwiching the piece between transparent polyester films – is a practical solution for large format pieces. The items can be easily handled and readily identified. Encapsulation should not be confused with lamination, which is permanent sealing between plastic sheets. Lamination is not recommended for any work of art. Obviously, encapsulation is not appropriate for artworks having powdering media or insecure paint layers. Directions for encapsulation are found above.

Partial encapsulation is another inexpensive method for storing large format graphics and is preferable if they are acidic. In this method, the artwork is sandwiched between a transparent polyester sheet and a rigid piece of acid-free corrugated cardboard or eight-ply mat board to which the work has been secured. If partial encapsulation is done neatly, the object can often be displayed as is.

"Shrink-wrapping," often done to protect posters for sale, stretches a thin sheet of thermoplastic film around the item and a rigid backing board, and seals it with a heat gun that shrinks the film. Shrink-wrapping is not recommended for works of art on paper.

Posters, maps, architectural drawings, and other large format items should be stored and displayed under the same environmental conditions as other works of art on paper (see chapter 6).

STORAGE

The selection of storage furniture will vary according to what other functions occur in the collection storage area. Ideally, the room can be dedicated solely to storage, but in many institutions the collection storage area also needs to be used for examination, photography, and research, not to mention for offices and exhibition preparation. The furniture described below is really an extension – chemically and physically – of item-level protection, and is not intended to fulfill other nonstorage functions of collection storage rooms. Museum-quality storage furniture – shelving, flat files, and cabinets – is preferably constructed out of steel that is powder-coated with an epoxy, acrylic, or polyester finish. Anodized or powder-coated aluminum, often too lightweight for furniture, is also an acceptable material. Wooden storage furniture is sometimes unavoidable, in which case, item-level protection is especially important. If possible, a program for replacing wooden storage shelving and furniture with newer steel units should be planned. Chapter 6 will describe other conditions ideal for storage areas. An excellent resource that addresses a variety of storage issues is *Storage Techniques for Art, Science and History* (http://stashc.com).

Shelving

Open shelving has proved to be the most cost- and space-effective option for storing prints and drawings that have been provided with item-level protection described above. Readymade metal shelving units, suitable for a wide range of available storage space and budgets, are available through office furniture supply and industrial storage manufacturers. Wood should be avoided for constructing shelving units. The bottom-most shelf must be several inches above the floor both for cleanliness and for protection against flooding. Store the largest and heaviest boxes on the lower shelves and the smaller ones higher up. If boxes are placed beyond easy reach, use a sturdy step stool to get to them. Storage shelving should be set up in well-ventilated rooms, preferably climate controlled, and steel shelving should be regularly checked for signs of rust. Do not place any shelving directly against exterior walls, which can be cold and damp.

Factors to consider when designing shelving include the height between shelves for maximum storage space, pullout shelves to temporarily rest boxes and folders on, and modular capabilities for future expansion or conversion to compact shelving. In earthquake-prone locations, shelving can be tilted back or fitted with strapping. Open shelving units need to be provided with some sort of opaque shade for light control and in storage areas with fire suppression systems, for protection from water in case of accidental discharge. "Gutters" designed to divert water from fire suppression systems are a prudent design feature to consider.

Flat Files

When lack of space must be considered, flat files, also known as plan chests or map cases, can accommodate many more drawings in a given amount of space than framed storage would safely allow. Flat print files, available from office, library, and archive furniture companies, are commonly constructed of either wood or coated metal.

Wood is not a suitable material for constructing storage or display furniture to be used for art on paper. This is a particular problem in historic homes and period rooms, and reinforced by the tradition of storing documents and linens in oak or cedar containers. If wooden cabinets are the only storage option available, the cabinets should be painted with several coats of polyurethane and allowed to air-dry for several months to a year before being put into use. Each wooden shelf should be lined with acid-free paper. Artworks stored within wooded cabinets should be surrounded by item-level acid-free enclosures and preferably put into solander boxes. Ventilation for the cabinet should be provided; the cabinet's wooden back might be replaced with screening. Unfortunately, the composite wood products used within

millwork – Masonite®, plywood, and medium-density fiberboard (MDF) emit the highest levels of volatile organic compounds (VOCs), a form of gaseous air pollution (see chapter 6).

Metal flat files should be of sturdy welded steel construction with inner frames for additional stacking support. The drawers should open and close smoothly – money for a good suspension and roller system will be well spent. Care should be taken to avoid overloading flat files drawers; cramming in more pieces of art than a drawer can accommodate will result in a crumpled artwork lodged in the back of the cabinet. Each drawer should be arranged to prevent its contents from sliding back and forth when the drawer is opened and closed, which could result in abrasion or other damage. As mentioned, each drawer can be subdivided into smaller standard sizes beforehand using acid-free corrugated cardboard or Coroplast®. Flat file units should be set onto a plinth, which raises the lowest drawer several inches from the floor – important for cleanliness and protection in case of flood.

Cabinets

Custom-designed storage cabinets of emission-free powder-coated steel are now available commercially that can accommodate prints and drawings, but are designed more for collections of three-dimensional objects. Closed cabinets containing drawers and pullout trays are acceptable and are highly secure; however, less expensive options are available for efficiently storing works of art on paper. Of course, if security is an issue, these locking systems might be preferable, but for large collections of prints and drawings, these cabinets are an expensive approach. They would, however, be an excellent choice for collections of smaller, highly valuable or sensitive materials such as portrait miniatures on parchment or ivory.

Storing Framed Artworks

By far the best method of storing prints and drawings is in their frames, provided that they have been correctly hinged and matted using materials of conservation quality. There are two important caveats to this statement:

1. It assumes that all cataloging information, including media identification and dimensions, is accurate and that the recto and the verso of the artwork have been digitally photographed.
2. It assumes that the work will go into a designated storage area and not simply relocated to another location, such as in an office or hallway. As mentioned in chapter 4, it is easy to offset the protection afforded by

framed works by overexposing them due to ease of display. See chapter 6 for a fuller description of a suitable storage facility.

The frame protects the picture itself from careless handling. The clear glazing material allows the work to be quickly examined, protects it from dust, and to some extent helps to prevent damage from gaseous air pollution. Pastel, chalk, and charcoal drawings, which have a natural tendency to smudge, are always best stored in their frames, as are other especially fragile or frequently accessed drawings. This approach to storage, however, assumes adequate space and an adequate budget – two frequently scarce commodities in collecting institutions.

The ideal way to store framed works of art on paper is horizontally – placed face up in shallow drawers or on shelving. In this way, the works are protected from rough handling and are easily identifiable and accessible. For protection from unnecessary light, a shade can be suspended in front of the shelving unit, or rectangles of cardboard or black Tyvek® can be placed over each frame with identifying information on them. Both shelving and flat file drawer units can be mounted onto tracks to operate as compact units.

Framed works on paper can also be stored vertically, that is, slid into narrow slots. Within each slot, they should be separated from each other with sturdy pieces of Coroplast® or acid-free corrugated cardboard. The disadvantage of this system is that the frames are not as easily accessed. They need to be slid in and out of the slot to identify them; there is always the temptation to squeeze yet one more frame into the narrow slot or to rotate their proper orientation for a better fit. The bottom of each slot should be padded with carpet strips or cardboard to prevent damage, especially to ornate decorative frames. The bottom of vertical bins should stand with their bottoms several inches above floor level for cleanliness as well as protection against water, in case of flood. Framed objects should never be propped up directly on the floor. If framed items must be pulled out and temporarily examined in a storeroom, they should always be elevated either on a padded viewing shelf equipped with a generous lip or at least placed on blocks of Ethafoam® on the floor. A block of Ethafoam® should also be inserted behind the top of the frame to prevent it from resting against a wall – especially an exterior one.

An alternative storage method – less satisfactory than vertical bins – is to hang framed works on wire screens, either stationary or moving along tracks on the floor. Such screens are frequently used in paintings storerooms. Pastel, charcoal, chalk drawings, or drawings having matte painted surfaces prone to flaking should not be hung on movable screens, due to the vibration caused by rearranging the screens. If hung on screens, the

front of each framed piece needs to be covered with an opaque paper, black Tyvek®, or cloth to protect the work from excess light. Furthermore, in storerooms equipped with fire suppression systems, the framed items must be protected in case of accidental discharge of water. Generally, hanging a collection of framed prints and drawings on screens is not an efficient use of space.

Storing Oversized Works on Paper

As mentioned, special allowances must be made for size and weight when the storage of oversized items is being planned. A critical consideration before deciding on a system, however, is frequency of access. Flat storage for oversized works of art is preferable. Horizontal metal flat files with shallow drawers are best for storing large items and are available from library, archive, and office furniture supply companies. All works going into storage should first be encapsulated or enclosed in sturdy acid-free folders or enclosures. It is advisable to put encapsulated items into acid-free folders and wrappers as well to prevent surface scratches. Placing the folders in the drawers with their spines facing out will encourage anyone handling the art to remove the entire folder from the drawer rather than extracting the item itself. Encapsulated objects and acid-free folders can also be stored in flat map boxes, although these boxes are awkward to handle and usually require two people to lift and carry them safely. Map storage boxes can be stacked on study metal shelving.

Oversized items can also simply be stored on wide metal shelving. This option is the least satisfactory one, but it can be safe if the objects are held securely in folders, interspersed with lightweight rigid supports, and not stacked too high. The more items in a pile, the more rummaging is necessary to find and extract a specific one. Clear labeling, bar codes, handy oversized rigid folios, and nearby viewing tables are crucial for trouble-free storage and transport of oversized items. Aisles and passageways must be measured beforehand to insure that large items can be maneuvered safely around corners.

Artworks should be rolled up only temporarily or in situations of extreme necessity. If rolling is unavoidable, the artwork should be wrapped, face out, around the exterior of a tube that is as large in diameter as possible and is acid-free or if not, wrapped in an impermeable material such as Marvelseal®, an aluminized polyethylene/polypropylene and nylon barrier film. The art itself should then be wrapped around the outside of the tube, perhaps using interleaving, followed by heavy acid-free wrapping paper. Rolls can be tied with cotton twill tape and wrapped with plastic sheets as further protection against dirt and moisture. Obviously accessibility is hindered by such protective measures. Rolled items can be supported by

interior hanging rods or by carved Ethafoam® blocks placed at their ends. Triangular storage tubes made from acid-free corrugated cardboard are now available and are easier to stack, but with triangular tubes, the rolled artwork is place inside the tube. Heavily painted historic wallpapers should never be rolled.

NOTES

1. Polyethylene terephthalate (PET). Other plastics suitable for storage enclosures are polypropylene and polyethylene.

2. Melinex is a registered Trademark of Dupont Teijin Films.

3. While 3M #415® double-sided tape is frequently used in the fabrication of enclosures, it is not safe to use in direct contact with prints and drawings.

4. Definition taken from ANSI/NISO Z39.77–2001, *Guidelines for Information About Preservation Products*, 3.

5. CCI (Canadian Conservation Institute) *Notes* 11/1 series 11 (paper and books).

6. Alfred Whitman, *Print-Collector's Handbook*. London: George Bell and Sons, 1903, 106.

7. The issue of trimming down artworks deserves serious attention. Too often, it is not recognized that the placement of an image on the sheet reflects the decision of the artist and is not accidental. In modern graphics, especially, the entire sheet is often intended for display, and its proportions in relation to the image are aesthetically meaningful. The sheet that carries the design may also indicate the item's provenance and method of manufacture. Stone marks or platemarks, deckle edges, and tacking edges are often removed when edges are trimmed. If an item has been torn from a book (not recommended), intact edges will provide that evidence through sewing holes or adhesive. Artworks whose edges have been trimmed decrease in value, as well. This same prohibition against trimming also applies to secondary supports when they are inherently related either historically or artistically to the print or drawing.

8. This lightweight *kozo* repair paper is watermarked in regularly spaced striations, which make it easy to tear into repair strips. Made by the University of Iowa, Center for the Book, it can also be purchased from conservation material suppliers.

9. Aligning the "spine" of a folded hinge precisely along the top of the artwork will allow for it to be rotated 180° in order to inspect its verso. Many collections do not allow for this.

10. A. Hyatt Mayor, *Prints and People: A Social History of Printed Pictures*. New York: Metropolitan Museum of Art, 1971, no. 91.

11. Merle Hughes, *Prints for the Collector*, New York: Praeger, 1971, 29. See also Mark Larid and Alicia Weisberg-Roberts, *Mrs. Delany and Her Circle*. New Haven: Yale University Press, 2009.

12. Yellow glass is also a very effective filter of UV radiation. Its use or the use of yellow shades was recommended for museum windows as early as 1924, while the use of blue or violet fabrics for blinds was discouraged. Lucas, A. *Antiques – Their Restoration and Preservation*. London: Edward Arnold, 1924, 25.

13. Elsec Monitors are available from Littlemore Scientific Engineering, Dorset, UK; http://www.elsec.co.uk; these meters are also available through distributors of conservation supplies.

14. Meters which measure absolute UV levels are available from Meaco, Staffordshire; http://www.meaco.co.uk; J.S. Holdings, Stevenage Hertfordshire, UK; http://www.jsholdings.co.uk; and are available through distributors of conservation supplies.

15. Mayor, *Prints and People*, no. 180.

FURTHER READING

Bachmann, Konstanze, ed. *Conservation Concerns: A Guide for Collectors and Curators.* Washington, DC: Smithsonian Institution Press, 1992.

Boston Museum of Fine Arts. *Conservation and Art Materials Encyclopedia Online (CAMEO).* http://cameo.mfa.org/wiki/Main_Page (accessed 3/14/2016).

British Library. *Collection Care.* http://www.bl.uk/aboutus/stratpolprog/collection-care/conservetreat/ (accessed 3/14/2016).

Canadian Conservation Institute. *CCI Notes.* http://www.cci-icc.gc.ca/ (accessed 3/14/2016).

Canadian Heritage Information Network. *Canadian Heritage Information Network.* http://www/chin.gc.ca (accessed 3/14/2016).

Clapp, Anne. *Curatorial Care of Works of Art on Paper.* New York: Nick Lyons, 1987.

Collections Trust. *Collections Link.* http://www.collectionstrust.org.uk/ (accessed 3/14/2016).

Conte, Lisa, and Lisa Nelson, Katherine Sanderson, Eliza Spaulding, Margaret Holben Ellis. "Achieving Clarify: Glazing Solutions for Works on Paper." *Museum Management and Curatorship* (Routledge) 25, no. 4 (December 2010): 399–422.

Foundation of the American Institute for Conservation of Historic and Artistic Works. *Connecting to Collections Care Online Community.* www.connectingtocollections.org (accessed 3/14/2016).

Getty Research Institute. *Art and Architecture Thesaurus Online.* www.getty.edu/research/tools/vocabularies/aat/ (accessed 3/14/2016).

Minnesota Historical Society. *Minnesota Historical Society.* http://www.mnhs.org/preserve/conservation/ (accessed 3/14/2016).

National Archives and Records Administration. *National Archives and Records Administration.* http://www.archives.gov/preservation/formats/ (accessed 3/14/2016).

National Archives of Australia. *National Archives of Australia.* http://www.naa.gov.au/collection/family-history/family-archive/indes.aspx (accessed 3/14/2016).

National Center for Preservation Technology and Training. *National Center for Preservation Technology and Training.* http://www.ncptt.nps.gov (accessed 3/14/2016).

National Committee to Save America's Cultural Collections. *Caring for Your Collections.* New York: Harry N. Abrams, 1992.

National Park Service. *Conserve-O-Gram.* http://www.nps.gov/museum/publications/conserveogram/cons_toc.html (accessed 3/14/2016).

National Trust for Historic Preservation. *National Trust for Historic Preservation.* http://www.preservationnation.org (accessed 3/14/2016).

———. "4.9 Storage Solutions for Oversized Paper Artifacts." *Northeast Document Conservation Center Preservation Leaflets.* https://www.nedcc.org/free-resources/preservation-leaflets/4.-storage-and-handling/4.9-storage-solutions-for-oversized-paper-artifacts (accessed 3/14/2016).

———. "7.4 How to Do Your Own Matting and Framing." *Northeast Document Conservation Center Preservation Leaflets.* https:www.nedcc.org/free-resources/preservation-leaflets/7.-conservation-procedures/7.4-how-to-do-your-own-matting-and-hinging (accessed 3/14/2016).

Ogden, Sherelyn. *The Storage of Art on Paper.* Urbana-Champaign: Graduate School of Library and Information Science, University of Illinois at Urbana-Champaign, 2001.

Rayner, Judith, and Joanna Kosek, Birthe Christensen, ed. *Art on Paper: Mounting and Housing.* London: Archetype Publications in association with the British Museum, 2005.

Saving Your Treasures. *Saving Your Treasures.* http://www.netnebraska.org/extras/treasures/index.htm (accessed 3/14/2016).

STASH (Storage Techniques for Art, Science & History Collections). 2014. http://stashc.com/ (accessed 3/14/2016).

Chapter 6

Preventive Conservation for Prints and Drawings

In order to understand the pervasive role of conservation in museum operations, it is useful to be familiar with the range of institutional activities and the "best practices" that govern them. The American Alliance of Museums (AAM) identifies five core documents as fundamental for demonstrating an institutional commitment to professional procedures:

- Mission Statement
- Institutional Code of Ethics
- Strategic Institutional Plan
- Collections Management Policy
- Disaster Preparedness and Emergency Response Plan

Conservation concerns – both philosophical and practical – are reflected in each one of these documents, for example, most Mission Statements clearly articulate the preservation of the collection as a primary goal. Likewise, the improvement of a storage facility might be part of a Strategic Institutional Plan or the number and distribution of disaster response carts specified in the Emergency Response Plan. In general, conservation procedures and policies are considered in greatest detail in the Collections Management Policy and the Disaster Preparedness and Emergency Response Plan.

THE COLLECTIONS MANAGEMENT POLICY[1]

The Collections Management Policy is a written document approved by a ruling authority, usually the Board of Trustees or government entity that specifies the institution's policies concerning all collections-related issues including:

- Acquisitions/accessioning
- Deaccessioning/disposal of collections/use of proceeds from the sale of deaccessioned collections for "direct care"
- Loans, incoming and outgoing
- Collections care; risk assessment and management
- Inventories and/or documentation and tracking of collections
- Access to and/or use of collections

In general, a Collections Management Policy addresses the development, uses, and preservation of collection items; increasingly the economic and environmental sustainability of these programs is also considered. Once again, conservation concerns are reflected throughout the Policy. For example, preventive conservation standards need to be assured when lending or exhibiting works on paper; the proceeds from the sale of deaccessioned objects are designated for "direct care,"[2] and risk assessment informs the Collections Care Program. In sum, all actions impacting collection items are viewed through the lens of preventive conservation.

WHAT IS PREVENTIVE CONSERVATION?

Preventive conservation is defined as

> the mitigation of deterioration and damage to cultural property through the formulation and implementation of policies and procedures for the following: appropriate environmental conditions; handling and maintenance procedures for storage, exhibition, packing, transport, and use; integrated pest management; emergency preparedness and response; and reformatting/duplication. Preventive conservation is an ongoing process that continues throughout the life of cultural property, and does not end with interventive treatment.[3]

Many aspects of preventive conservation may not be at first obvious, for example, the importance of maintaining up-to-date insurance policies, accurate catalog records, reliable tracking systems, regular condition surveys, continued professional development for staff, or specific housekeeping or building maintenance procedures, such as weed control around building foundations. A proactive attitude of preventive conservation should be thoroughly integrated into every operation from human resources to gift shop personnel, but, in particular, it actively involves facility managers, curators, registrars, art handlers, security staff, exhibit designers, architects, maintenance workers, and conservators.

The goals of preventive conservation are:

- To extend the life of cultural property.
- To reduce the risk of catastrophic loss of cultural property.
- To defer, reduce, or eliminate the need for interventive treatment.
- To extend the effectiveness of interventive treatment.
- To provide a cost-effective method for the preservation of collections.
- To maximize impact of the conservation professional.
- To encourage the conservation professional to employ the broadest range of preservation strategies (e.g., risk management, long-range planning, site protection).
- To encourage the conservation professional to collaborate with others who have responsibility for the care of collections and cultural property (e.g., security and fire prevention personnel, facilities or site managers, collections managers, maintenance staff).
- To encourage the participation of others in the preservation of cultural property.[4]

A COLLECTIONS CARE PROGRAM FOR PRINTS AND DRAWINGS

Found within an institution's Collections Management Policy is a comprehensive Collections Care Program, which specifically describes how preventive conservation is incorporated into all activities involving works of art on paper, that is, whenever prints or drawings are moved, lent, displayed, examined, or treated. Every institution will require a different kind of Collections Care Program depending upon the nature, size, and function of its collections. What follows are preventive conservation recommendations specific to prints and drawings. In chapter 5, we saw the effectiveness of item-level protection for works on paper. A Collections Care Program is generally less item-specific and emphasizes broader steps to be taken to prevent or minimize damage.

Risk Assessment

Risk assessment is the foundation of a sound Collections Care Program. Only by identifying specific threats to a collection and putting them into relative perspective can priorities be set for expending limited resources in the most effective way. Because collections vary so widely along with the risks to them, risk assessments are unique to each collecting institution. For example, if your collection is stored off-site, security may be a greater risk than environmental control; or if you are located in a coastal region, potential

flooding may need to receive extra attention in storage room design and location. Guidelines and templates for conducting a risk assessment may be found under Further Reading.

Routine Handling of Prints and Drawings

All staff, new employees, and volunteers should be familiar with safe handling procedures for prints and drawings. Because items are frequently requested for viewing by nonstaff members, printed or electronic copies of study or storage room handling procedures need to be provided or, even better, required to be reviewed prior to granting access. As any supervisor of an actively used collection can attest, the observation of these procedures can prevent unnecessary wear and tear of prints and drawings. The following rules establish basic precautions; each institution should compile and enforce additional rules appropriate to its collection and study room situation.

- Dangling necklaces, bracelets, and ID cards should not be worn when examining unframed prints and drawings. Neckties and scarves should be tucked inside shirts or taken off.
- Remove one matted or otherwise enclosed work from the storage box at a time. Place on a clean, uncluttered table. Do not pull one matted item from out of a heavy stack of other matted items. Do not shuffle groups of items, loose or matted, in order to align their edges. Mats should be fitted into a storage box with their spines along the spine of the box.
- Mats should be opened only from the upper or lower right corner, not by reaching through the mat window. Remove the interleaving paper by grasping its corner and sliding it sideways; close the window mat.
- For viewing, the mat should be held with both hands and tilted upward. Viewers should look *across toward*, not directly *down on*, an unprotected print or drawing to minimize the chances of damage in the event of coughs or sneezes or eyeglasses falling. Small tabletop easels and bookstands are useful for viewing matted prints and drawings at a safe distance.
- Touching of the original should be kept to a minimum. When direct handling is necessary, hands must be frequently washed. Hand cream and colored nail polish should be avoided. Some print study rooms prohibit the wearing of colored nail polish altogether, because it is easily abraded by and transferred onto mat board.
- Only alcohol-based oil-free hand wipes are allowed for cleaning hands.
- Before lifting or turning over a print or drawing, the stability of its medium should be ascertained.
- Begin lifting or turning over a print or drawing by inserting a smooth thin tool, such as a microspatula, or a small piece of clean paper or flexible plastic flim below it.

- Overall support for a loose print or drawing should be provided using a clean sheet of mat board or blotter. If necessary, lift a loose sheet by the corners of its longest edge or by diagonal corners.
- If an unprotected print or drawing is to be turned upside down in order to examine its verso, place it between two sheets of clean blotter or mat board for additional support while turning.
- Matted prints and drawings must have interleaving papers or "slip sheets" at all times. Creased, torn, or discolored slip sheets should be replaced, ensuring that they are centered and smooth before closing the mat.
- When turning a hinged print or drawing to examine its verso, always insure that the hinges rotate freely by 180 degrees. Position the interleaving paper so that when the item is flipped, it will rest on the interleaving sheet, not on the window opening. If not, the print or drawing can fall partially through the window opening. Many hinges will not accommodate a 180-degree rotation.
- Only graphite pencils should be used in proximity to works of art on paper. Never point or gesture toward an artwork with a pen or pencil.
- Food and drink are not allowed in areas where items are stored or examined.
- Self-adhesive Post-It® notes should not be adhered to works of art or to their protective enclosures.
- All sharp objects, screw eyes, wires, and nails should be kept at a distance from unframed drawings.

As a safety measure in handling matted artworks in a collection, the mats should all open in the same direction. Most often, for vertical prints and drawings, this is an opening from the right to left, as in the pages of an ordinary occidental book. For horizontal formats, opening a mat by lifting its bottom edge is standard. Similarly, all prints and drawings should be consistently hinged in the same manner. If hinges are placed in a location where they may not be expected, small arrows penciled inside the mat should so indicate.

The Glove Question

Many people inquire about the advisability of wearing white cotton gloves when examining prints and drawings. Generally speaking, wearing white cotton gloves is unnecessary provided that hand-washing facilities are conveniently located and regularly used. When designing study room facilities, sinks are often sited adjacent to lockers where visitors secure their bags and other belongings. White cotton gloves, especially inexpensive ones, often do not fit properly or are themselves dirty from repeated use. They make it difficult to handle individual sheets of paper with precision and can easily slip when handling heavy storage boxes. Disposable nitrile gloves can be used; these are latex- and powder free, but must be discarded after every use. They are

available in various sizes and should fit snugly. Many people find wearing nitrile gloves uncomfortable because they foster perspiration. If works on paper are becoming soiled as a result of handling (see Figures 2.33 and 2.36), it is better to enforce better housekeeping, not glove-wearing, procedures.[5]

In-House Transport of Prints and Drawings

Any experienced registrar will attest that most damage to prints and drawings results during transport. While thorough and conscientious precautions are usually taken when shipping items to a far-away institution, it is surprising how few precautions are taken in-house. Drawings and prints are casually slid between cardboard or carried in stacks while opening doors, moving through crowds, and pushing elevator buttons, usually due to haste and a lack of conveniently located carts and moving supplies.

• Always transport a matted or loose print or drawing in a stiff portfolio. Holding the portfolio in a vertical position is usually more manageable when passing through doors or along narrow hallways. Items should be suitably protected within the portfolio, whose spine should be downward; loose works on paper can easily slip from opened-sided or upside-down portfolios!
• One or more storage boxes of matted items must be moved flat on a cart.
• Framed items larger than 18 × 24 inches should be moved on a cart; A-frame carts or vertically slotted trolleys for moving framed items in a vertical position are commercially available.
• If hand-carried, a framed item should be held firmly by both vertical sides in its proper orientation, and not suspended by its hanging wire or grasped by the top molding strip.
• If possible, during open hours, avoid transporting collections through public areas, such as galleries and cafeterias.

Lending Prints and Drawings

It should be noted that the following loan procedures principally apply to prints and drawings and do not include all aspects of loan negotiations, for example, indemnities, reproduction rights, and loan agreement terminology. More comprehensive guidelines for lending can be obtained from the Registrar's Committee of the American Alliance of Museums (RC-AAM)[6] or the National Park Service.[7]

Pre-Loan Procedures

Conservation staff should ideally become involved with loan discussions as soon as the request to borrow an item is received and the borrower's proposed

exhibition, from a curatorial point of view, is deemed to be appropriate and will advance the item's study and appreciation. The decision to lend or not to lend is predicated on numerous factors, which are discussed in the 2015 digital edition of *Guidelines for Lending Works of Art on Paper* published by the Print Council of America.[8] Two aspects of the loan request will require input from conservators, registrars, and collections care specialists: a determination of the "fitness" of the borrower and the "fitness" of the item to be lent.[9]

Typically, the credentials of the borrowing institution, including its facilities and staff, are determined through information derived from the *General Facility Report* published by the AAM.[9] This form collects information pertaining to the borrower's building construction and layout, environmental controls, fire detection and suppression systems, security equipment and guardianship, handling and packing staff, insurance, and loan history, and also assesses the risk of natural disasters, such as earthquakes. Generally speaking, the lending institution requires the same "best practices" regarding handling, security, and environment on the part of the borrower as those maintained at home. The processing and evaluation of the *General Facility Report* often falls under the jurisdiction of the registrar's department, but can also involve conservation and collections care staff. Nonetheless, even with the best data available, "The vast network of lending and borrowing between museums and other cultural institutions runs primarily on trust."[10] For this reason, it is important to maintain open and honest communications throughout loan negotiations and to involve conservators as decisions are made.

Because of the risks inherent in any travel, it is also incumbent to carry out a thorough assessment of the item's "fitness" to be lent. This involves not only questions of its physical condition, but also the work's past and future exhibition history. A pre-loan examination will determine if the print or drawing is physically able to withstand the rigors of travel, which can potentially involve dramatic climatic changes, vibration, or worse, serious accidents or complete loss. Obviously, oversized, odd-sized, or very heavy works on paper that require specialized framing, packing, or shipping will incur additional risks and may not be the best candidates for travel. The medium of other works, such as drawings done with unfixed pastel, charcoal, or thick poster paint, may be inherently unstable or prone to flaking. If approved for loan, they may require extra precautions in transport or installation – they can be shipped face-up and can be installed using hand rather than power tools.[11] Occasionally, it is the support of the print or drawing that precludes lending – works on parchment are particularly susceptible to fluctuations in relative humidity and those on severely deteriorated newsprint or mounted to brittle cardboard may be too structurally weak or vulnerable for travel. Other conservation problems, such as tears and losses, which compromise the strength of the overall

sheet or are visually distracting, can be rectified, provided there is sufficient time to carry out the necessary treatment before the departure date. For this reason a lead time of six to twelve months is often required for loan requests.

Finally, the long-term impact of a loan on a work's total exhibition history needs to be carefully calculated and considered, especially for an extended multivenue show, which can add up to twelve or more months of exposure time. Because prints and drawings need to be protected from excessive cumulative light exposure, the projected exposure time of each item needs to be predicted to the fullest extent possible. It is difficult to see into the future, but is critical for works whose "lifetimes" are predictably shorter – works done with felt-tipped markers, colored construction papers, and color ink-jet prints – to name just a few. Conversely, an absolutely pristine watercolor that has escaped overexposure for centuries will be dependent upon its caretakers to mediate its light exposure scorecard. Is the home institution planning an upcoming show for which this artwork is crucial? Does the artist of the work have a significant birth or death anniversary soon, which will increase the chances that it will be requested? Almost every historical society and library has some "greatest hits," beloved by their constituencies, for example, works by a prominent local artist or a portrait of a hometown hero. Despite their good condition today, which would suggest that they are ideal candidates for loan, in fact, these might be the very ones to curtail from lending in order to maintain their good condition into the future. Whatever the final decision, the total exposure time for each print and drawing requested for loan should be recorded in order to inform future decisions. Fortunately, computerized recordkeeping has facilitated the tracking of this data.

Pre- and Post-Loan Documentation

Condition reports, including photographic documentation, completed before the loan, are now standard practice. Electronic or hardcopy images are used; with rapidly developing digital technology, portable devices for recording and sending images are becoming common. Condition reports for loan differ from full-scale conservation examinations in that they make note of only the defects and visual attributes that may change. For example, the presence of a watermark may not be noted, nor the appearance of the margins of a print covered by the mat. A repaired tear or localized buckling, on the other hand, might be described, to prevent the borrower from worrying about the state of the tear, in the first instance, or, in case the buckling worsens and touches the glazing, in the second instance. The structure and finish of the frame should be noted along with its condition and any scratches on the glazing. Ideally, the same person completes both outgoing and incoming condition reports; typically condition reporting is the responsibility of the registrar's office, paper conservator, collections care staff, curator, or designated courier.

Travel Frames

Prior to lending a print or drawing, its frame should be examined to determine if any modifications are necessary. Ornate period frames are often not suitable for travel, especially if their finish is a gilded gesso ground or they have protruding decorative elements. Travel frames should be of sturdy construction, with dowelled or splined corners. Frames fitted with strainers usually torque less than those whose contents are secured using brads or points and are more robust for travel. The molding should be deep enough to contain all the frame's contents without protruding from the back and sufficiently thick to accommodate the attachment of metal mirror plates (during shipment, mirror plates should be rotated inward). Frames are among the most expensive investments for collecting institutions; it may be financially worthwhile to invest in more durable travel frames if collection items travel frequently.

Prints and drawings on loan should be secured directly to the wall using flat metal "mirror" plates, which are screwed into the back of the frame, with an extended flange that is screwed to the wall and painted over; any tampering with the painted plates is easily detectable. Mirror plates provide the greatest structural support for the frame and, at the same time, discourage theft. Often screws that require the use of a special high-security screwdriver are used to further thwart theft. If a hanging wire is used, a security "tether" or electronic motion alarm can be added, as can a mirror plate along the bottom edge of the frame.

Thanks to advancements in glazing technology, it is no longer necessary to transport print and drawings behind glass. Nonstatic, ultraviolet (UV)-filtering, and nonreflective, if desired, acrylic glazing is available and should be used. The type of glazing in the frame should be noted on the back of the frame. Acrylic glazing should never be taped, as was the practice for glass in the past.

If loaned works are particularly sensitive to climatic fluctuations, "sealed" framing may be recommended (see chapter 5). Some institutions routinely prepare items for loan in sealed frames – with or without conditioning materials added – which provide extra protection from water damage and sudden climatic changes.

Packing and Transport of Prints and Drawings

Because of advancements in crating design and packing materials, and new Transportation Security Administration (TSA) regulations, which limit access to TSA-approved personnel, the transport of prints and drawings for loan via ground or air is best left to the expertise of professional fine arts packers, shippers, and custom agents, in consultation with the registrar and conservation staff. Many major museums will have knowledgeable staff in-house.

Generally speaking, prints and drawings travel in frames, which are wrapped in high-density polyethylene sheeting and taped. These wrapped works are then put into vertically slotted crates in proper hanging orientation or stacked horizontally for travel. Unpacking and repacking instructions should be marked on the packing materials, with the location of each item clearly noted so that, when the time comes to return them, the chances of misarranging them are minimized. Crate design and construction is now a highly sophisticated craft, which incorporates precautions against water, air pollution, temperature extremes, sudden shock, and vibration.[12] Small, portable humidity, temperature (HOBOs) and vibration data loggers can also be included in the crate. Typically, the condition reports, compiled in a notebook and put into a designated slot, travel with the artworks. Many lenders require that crates wait twenty-four hours in a controlled gallery or storeroom to acclimatize before being opened. Given the improved effectiveness of the crates' insulation, the necessity of this precaution is debatable for prints and drawings.

Because many prints and drawings can be small and lightweight, at least when unframed, it is often proposed that they be hand-carried. Even a small work on paper becomes surprisingly large and unwieldy when wrapped and suitably protected for travel. Given TSA inspection regulations and restrictions surrounding carry-on luggage, it is safer to transport an artwork in a crate using a professional fine arts shipper.

Couriers

When necessary, couriers, familiar with the object and its correct handling, accompany items on loan. The decision to require an in-house courier is often determined by an ongoing relationship with the borrower or the item's value, condition, or special installation requirements. Couriers are responsible for recording the condition of each piece upon departure and arrival and should be prepared and able to do so. Couriers should be able to confirm that all environmental and display requirements have been met by the borrower, evaluate and approve of any deviations from them, and perform the installation if necessary. The pros and cons of sharing institutional personnel for the oversight of loaned items, a person known as an "accompanier," and even the necessity of couriers is currently being debated in the face of economic, ecological, and security considerations.

Storage Facilities for Prints and Drawings

Good collections storage is a major aspect of preventive conservation and an important component of a Collections Care Program. It is essential to the long-term preservation of the collection. A well-planned and organized

storage space reduces risks to the collection and provides easy and safe accessibility. Conservation issues and concerns need to be included when initially planning either new or expanded storage facilities or when renovating existing ones. The choice of an appropriate storage space for works of art on paper is influenced by several factors: its location and the size, nature, and usage of the collection to be stored.

Because roofs leak and underground areas flood, attics and basements are usually unsuitable for storing prints and drawings without elaborate precautions to prevent or respond quickly to disasters. If there is any possibility of a leak, even from pipes in an adjacent space or several floors above a proposed storage area, water detectors should be installed and be integrated into the central security system. Furthermore, environmental control is often more difficult in preexisting underground or attic spaces. Temperature and relative humidity controls – whether active or passive – are more easily designed and ultimately cheaper when installed into new or fully renovated spaces.

Security considerations should also influence the choice of location for a storeroom for prints and drawings. Even the most secure vault, however, will not protect a collection if it is not convenient for those who will be accessing the collection most often, such as curatorial, conservation, and study room staff. This is because of the irresistible temptation to stash items in interim spaces or to neglect to scan their bar codes or register them into a logbook as they move from secure to less secure spaces. Since damage to museum objects most often occurs during transit, the need to move collection items from room to room, up and down stairs, or from building to building should be minimized. In smaller institutions, the storeroom is often located near the personnel who are responsible for knowing the location of collection items at all times. Tracking the movement of collection items in, out, and around an institution is often accomplished by using a computerized tracking system (see below), but many smaller organizations still use logbooks or a simple, but effective, call slip system.

If possible, it is best to have dedicated storage areas for prints and drawings. The more people entering and leaving a space, the greater the chances for theft, mishandling, environmental fluctuations, unnecessary exposure to light, unnecessary exposure to ozone generated by office equipment, and increased dust, dirt, and insect pests.

Often, due to costs or space shortages, collections are stored off-site. When necessary, this arrangement works well, but it is important to keep in mind that off-site spaces are not usually designed and constructed with art collections in mind. Additional costs may be incurred by the necessity of upgrading environmental or security systems or by retaining an off-site Collections Care Manager. Because off-site locations are often located in underpopulated areas or in different governmental jurisdictions, the Disaster Preparedness and Emergency Response Plan will need revising.

Any room in which prints and drawings are stored should be clean, well ventilated, and equipped with sufficient lighting for safe and necessary everyday operations, such as examination, moving, re-housing, and cleaning. Lighting for general operations should not be dependent upon windows or skylights whose output is uncontrollable; if possible the light transmitted through windows and skylights in storerooms should be blocked entirely or at least UV-filtered and lessened physically (films and screens are available that both filter and physically reduce visible light). While the same lighting concerns apply to prints and drawings while in storage as in exhibition, light sources must be able to accommodate a wide variety of tasks; some, such as cleaning, require higher light levels. Light-emitting diode (LED) lamps or UV-filtered fluorescent lighting are currently preferred. The technology of compact fluorescent lamps (CFLs) has been improved, but they still should be checked for their UV radiation output.

Motion detectors can eliminate unnecessary lighting when the storage space is unoccupied, but they need to be timed so that staff members are not perched on step stools holding storage boxes when the lights go out. There should be a table or cart inside the storage area on which items being moved to or from assigned storage locations can temporarily rest.

In any storage area, everything must be well organized and labeled according to the institution's current tracking system. Cement, plaster, and paints used to construct or renovate a storage area should be completely cured before works of art are moved into the room; volatile organic compounds (VOCs) are produced from a variety of construction materials (see Air Pollution below). This waiting period is especially critical when planning new facilities, which often run over scheduled completion dates. All storeroom shelves, floors, and furniture must be cleanable. Light-colored walls, ceilings, and floors will make detection and elimination of rodents and insects easier. As stated in chapter 5, artworks must be stored in furniture above floor level and not propped up against walls.

Tracking Systems for Prints and Drawings

Many institutions now use bar codes or radio frequency identification (RFID) tags to track the movement of or to conduct inventories of prints and drawings by scanning or otherwise recording self-adhesive printed labels. These tracking labels must be adhered to archival-quality tags, which are, in turn, attached to the artworks, or the labels can be put onto the artworks' enclosures. *Never put pressure-sensitive tracking labels directly onto prints and drawings.* Persons responsible for scanning items whenever they are moved must be clearly designated. Preferably anyone, regardless of position, who moves a collection item, is responsible for tracking it. Scanning equipment must be plentiful and conveniently located; otherwise it will not be used.

Many collections management systems have computerized tracking functions that do not require the use of labels, but, again, in order to be effective, the system is entirely dependent upon humans to enter location information.

Various methods of individually identifying works on paper have been used in the past; in fact, historic collectors' marks and stamps are important evidence of provenance. Generally speaking, however, collectors no longer indelibly stamp their possessions either for security or pride-of-ownership reasons. In fact, security stamps have not been found to deter theft, since they can almost always be eradicated or disguised for nefarious purposes. Most major collecting institutions simply use a graphite pencil to identify items on their versos (see Security Systems below).

Fire Detection and Suppression Systems

Detailed descriptions of the various fire detection and suppression systems are beyond the scope of this book. Nonetheless, some comments pertaining to fire suppression systems for collections of prints and drawings are germane. Museums have traditionally avoided water-supplied sprinkler systems in both storage and galleries because of the threat of accidental or deliberate discharge; indeed sensational news stories reinforce the prevailing prejudice against sprinkler systems. Nonetheless, nearly all Fire Protection Agencies in the United States now require wet protection systems in addition to gaseous systems, which are typically carbon dioxide, or newer mist systems. Wet systems include the so-called "dry-pipe" sprinklers that normally contain pressurized air. When heat is detected the air pressure in the empty pipe is reduced, which opens a valve and allows water to flow through the sprinklers. A wet-pipe system, by contrast, contains water in its pipes at all times. Both wet- and dry-pipe fire suppression systems are reliable and effective – their selection should be guided by each brand's accidental discharge record and the amount of maintenance each model requires. Furthermore, anecdotal evidence suggests that water damage from powerful fire-fighting hoses causes far more damage than sprinklers. Because sprinkler systems are in many cases unavoidable, storage furniture should be designed and arranged to minimize damage from water in the case of discharge. For example, pictures on hanging screens should be protected with plastic covers; a "gutter" system on the top of compact shelving can channel water from overhead sprinklers to the side of the unit. Such measures may not prevent damage, but they can delay or reduce it. Many museums opt for double fire suppression, calibrating a gaseous system to respond first, followed by sprinklers.[13]

Carbon dioxide fire extinguishers are recommended instead of those using liquids or foam. Place the fire extinguisher next to the door, preferably at eye level, and conduct periodic training sessions on their use.

Security Systems

Also beyond the scope of this book, a few words can still be directed specifically to security procedures for prints and drawings. Because prints and drawings can be misplaced so easily, various methods of identifying them have been historically adopted, including invisible inks detectable under UV radiation, indelible collector's stamps, embossed chop marks, blind stamps, and even perforations. While some of these marks, no doubt, reflect pride of ownership, they cannot be justified as preventing theft or vandalism. From a conservation standpoint, the safest method of identifying prints and drawings is to do so with a soft graphite pencil. Small identifying inscriptions can be written in a corner on the reverse of the artwork. Before writing these notations, always place the art face down on a clean hard surface, to avoid embossing the paper. Most thefts of prints and drawings have occurred due to spotty tracking, irregular collection inventories, and lax inspection of bags and briefcases. The Museum Security Network (http://www.museumsecurity.org) reports on some shocking examples of negligence and the steps to be taken to effectively deter theft.

Environment

While you may not be in a position to install a heating, ventilation, and air-conditioning (HVAC) system as technologically sophisticated as those found in major museums, you will still want to give your collection the best possible protection from potential environmental damages. Without being a heating and cooling engineer or a lighting designer, you can determine what the appropriate environmental conditions are for your collection and learn how to measure and monitor them. The adjective *appropriate* is used here to describe the conditions that are best for preservation and, at the same time, achievable and sustainable by your institution. The term denotes suitability and rightness: it represents a compromise between what we know to be optimal and what we recognize as realistic given our facility and our budget.

Equipped with that understanding, one can work with specialists to design and install systems that control air pollution, temperature, and humidity in a practical manner. The selection of lighting systems and integrated pest management will also benefit from expert advice. There is always the question of whether one can afford to consult specialists. In most instances, their expertise will save money; a piecemeal approach to climate control for works of art on paper may actually make the environment worse. For example, turning on a humidifier during a winter day or shutting down air-conditioning on summer nights does little to improve environmental conditions for prints and drawings.

For many institutions, a simple, relatively uncomplicated system is preferable to a more sophisticated arrangement lacking trained operations staff to maintain and monitor it. If you cannot afford total climate control, evolve a long-range plan and start small, working within your financial and technological limitations. You might begin with just one storage area or gallery (an approach called "zoning") or even with one vitrine or cabinet (called a "microclimate"). Or you might start by simply closing curtains, dusting regularly, or applying UV-filtering or light-reducing films to glass entrance doors. Several manuals can serve as more comprehensive guides for "best practices" in museum facility maintenance (see Further Reading).

The first step in improving environmental conditions is to understand how the interaction of air pollution, temperature, humidity, and light causes prints and drawings to deteriorate. Next, one must determine what conditions actually exist in one's own facility. Finally, potential systems – suited to your building, collection, staffing, and budget – that will maintain satisfactory environments can be investigated. Some historic structures, especially those in northern regions of America, cannot withstand elevated humidity levels during winter months; since moister air will always migrate toward drier air, porous brickwork and historic windows can be damaged from condensation. In these cases, a holistic approach to moderate extremes of temperature and humidity is more practical and sustainable. The 2015 *Handbook of the American Society of Heating, Refrigerating, and Air-Conditioning Engineers (ASHRAE)* has a chapter specifically addressing environmental parameters and systems for museums, galleries, archives, and libraries.[14] The National Park Service also has published a *Museum Handbook* with detailed chapters on environmental conditions.[15]

Air Pollution

The deleterious effect of air pollution on prints and drawings has long been recognized. The protection afforded to artworks by glass was noted as early as 1850[16] and *Vibert's Fixatif* was marketed in the 1880s as a brushed or sprayed on product that would theoretically protect watercolors from the pollution produced by gas lamps.[17] The darkening of lead white from exposure to air pollution has also been seen (Figure 4.5). Far more insidious than color change, however, is the physical breakdown of paper from gases such as sulfur dioxide, hydrogen sulfide, nitrogen oxides, and ozone. Probably the most dangerous single pollutant is sulfur dioxide, produced from the burning of fossil fuels. With elevated temperature and humidity levels, sulfur dioxide readily combines with water vapor to form sulfuric acid. Ozone, a powerful oxidant, is prevalent in photochemical smog, produced by the action of sunlight on car exhaust fumes, but office copiers also generate ozone within a building.

Volatile organic compounds (VOCs), including formaldehyde, are produced by many building materials and have adverse effects on cellulose. It seems safe to assume that in any urban area, air pollution exists in levels detrimental to works of art on paper. That is why steps need to be taken to prevent the intrusion of outdoor air pollution and to identify and eliminate indoor sources of it as well. Your local Environmental Protection Agency can assist you in analyzing the air quality within your building. Gaseous air pollution may be present in new construction and can be specifically emitted from carpeting, paints, and insulation. For this reason many newly constructed or renovated museums will plan to operate the ventilation system on full for at least two weeks prior to opening: with a 100 percent fresh air supply and 100 percent air exhaust. A finely tuned HVAC system can also take some time to calibrate.

Air pollution exists in both solid and gaseous forms. Particles of smoke, dust, pollen, lint, and salt all find their way into collection repositories and settle on any unprotected work and the enclosures and furniture that protect them. Tobacco smoke was a prime particulate pollutant in the past and its effects are still evident, but less so on prints and drawings than on furniture, wallpaper, and paintings. Particulate pollution can cause damage through soiling, abrasion, and the introduction of sources of acidity and food for insects.

Most HVAC systems remove particulate air pollution through the use of filters of varying fineness. Filters for removing dust and soot from the air can be fitted into existing systems, but the more effective the filter the more energy is required to force air through it and the more frequently it needs to be changed. While the design and operation of single- or multiple-zone HVAC systems is beyond the scope of this book, there are a few specific sources of indoor pollution of risk to prints and drawings.

Some collectors use electrostatic air cleaners, which are widely advertised for removing dust, pollen, and mold spores from the air. These devices have strongly charged negative plates that draw positively charged particles into a an electronic field and trap them there. While such air cleaners are effective, assuming regular maintenance, they can endanger paper through the production of ozone, which is produced by the electronically catalyzed reaction of air molecules around the machine. Ozone is particularly destructive to cellulose. Since ozone can be destroyed by the use of activated charcoal filters, electrostatic air cleaners should only be used in conjunction with these filters; a household unit should not be placed in a storeroom. Photocopying machines and laser printers also produce ozone and should be kept out of storage rooms.

Some simple and practical methods for reducing particulate pollution are these: seal storage room windows and doors tightly and reduce traffic in and out of the room. If possible create a separate vestibule in front of the entrance door or at least fit it out with a "clean room" mat, a tacky-surfaced mat that traps dirt and dust from shoe surfaces. Regularly clean radiators, fireplace

openings, heating ducts, and chimneys, as well as storage furniture and floors. Microfiber cloths are particularly good for dust control. Avoid waxes or polishes for cleaning purposes in collection areas as these leave behind a sticky film that will only trap more dust. If dust and dirt persist, a HEPA filter air purifier is preferable pending better solutions.

Methods of eliminating gaseous and particulate pollution can be incorporated into sophisticated mechanical systems or dealt with on a local level. But all activities will require some degree of surveillance and periodic maintenance, which requires the establishment of a regular housekeeping program.

The Oddy Test

Gaseous air pollution does not necessarily come from the outdoors or even from the presumably cleaner environment found in a gallery. It may be generated by and accumulate in the display case in which works of art are exhibited. We have seen how carefully the materials for matting, storing, and framing prints and drawings are selected. The same care must be taken to evaluate all the materials used to fabricate an enclosed display case or vitrine. Certain wood-based particle boards, oil-based paints, sealants, foams, plastics, adhesives, and other conventional building products are chemically unstable and produce VOCs as they cure and age. New fabrics may contain mordents and finishes that produce harmful gases or they can corrode metals on contact. Within an enclosed environment, as might easily exist in a display case, appreciable amounts of gaseous pollutants can build up. For these reasons, some display cases intended for metal artifacts are designed to incorporate activated charcoal to absorb corrosive pollutants. Airing out display cases between exhibitions can also decrease dangerous accumulations of pollutants.

With the knowledge that certain common building materials "off gas" or produce VOCs, the design and construction of exhibition furniture has become very sophisticated. Institutions wishing to purchase commercially available furniture will want to carefully review all the material specifications supplied by the manufacturer, including the case's display deck fabric, gasketing material, sealants, and painted surfaces to insure that they do not produce harmful emissions.

One popular method for assessing the suitability and compatibility of materials to be incorporated into an enclosed display case is called the "Oddy test" after its developer Andrew Oddy, a conservation scientist formerly with the British Museum. It involves the artificial aging of a sample of the material in question – fabric, wood, paper, adhesive – and its corrosive effect on indicator "coupons" of lead, which detect organic acids, aldehydes, and acidic gases; copper, for detecting chlorides, oxides, and sulfur; and silver, for detecting sulfur. How the results of the Oddy test are evaluated is a topic of

considerable debate, with the primary complaint being that the interpretation of the relative degree of corrosion of each metal strip is subjective. Nonetheless, the Oddy test, or one of its many variants, remains the standard means of assessing the relative stability of materials intended for display cases. It is used by many collecting institutions and by manufacturers of exhibition furniture as a way to minimize gaseous pollution generated within display cases. Loan agreements will often require that display cases conform to Oddy testing standards.

Temperature

All facets of a museum's environment – pollution, temperature, humidity, and light – are interrelated. For example, the damaging effects of air pollution are multiplied many times over as temperature and humidity increase. Acids are formed as gaseous pollutants combine with available water vapor, a reaction that is speeded up by heat, as are the symptoms of yellowing and embrittlement that result – visible evidence of the aging of works of art on paper. Heat, thermal energy that speeds up chemical reactions, is sometimes used specifically to artificially age paper for analysis. Artworks stored in attics, where temperatures can soar to 120°F, thus undergo a great deal of inadvertent artificial aging. Besides being a catalyst and accelerant for chemical reactions, excess warmth also encourages the establishment of insect and rodent colonies.

In most storerooms and galleries, temperature must be maintained in a range that is comfortable for people, as well as safe for the art objects. Once upon a time, the notion of a museum environment of 70°F with ±2° and 50 percent relative humidity with ±5 points set a simple target for building engineers and conservators who sought to maintain "ideal" conditions. But, given the high costs, both ecological and financial, of maintaining such an environment, the differences in climates across continents, plus the fact that many historic building envelopes cannot sustain such an environment without causing damage to their pointing and window frames, these temperature and relative humidity parameters have rightfully come under scrutiny. While works on paper, especially those made from ephemeral materials, are best stored in lower temperatures, a range of 68–72°F is likely to be easier to maintain and comfortable for humans, as well. Furthermore, depending on the type of paper, poor-quality unrefined wood pulp, for example, lower relative humidity may also be optimal. Much more important than the actual temperature within this range, however, is the prevention of sudden and drastic fluctuations in temperature. Because heat is intimately related to humidity, a sudden drop in temperature can cause relative humidity in a room to reach dangerously high levels in a short time, resulting in condensation. The temperature in

collections storerooms and galleries should be kept as constant as possible. If temperature must fluctuate, it should do so as slowly as possible, to give the reactive paper in the area a longer period of adjustment. Double-glazed windows and extra insulation will help minimize temperature fluctuations and will save energy as well. A suggested allowable range of temperature change is no more than ±5° within a 24-hour period. Seasonal changes can be broader but should occur over a longer period.

It is important to realize that heat within buildings does not come from furnaces alone. Metal halogen spotlights can substantially increase temperatures in galleries, as can crowds of people. A table lamp fitted with an incandescent light bulb can heat up a picture that hangs nearby. Fortunately, LED technology has eliminated the intense heat produced by the small lights designed to be clipped onto picture frames; due to the intense and uneven light they cast on a picture, these are not recommended, in any case. Sunlight striking dark curtains and upholstery produces heat. Electrical equipment generates heat, as does heating ductwork hidden in walls. In most buildings, localized "hot spots" are common. Keeping prints and drawings in proximity to radiators, heating vents, steam risers, or working fireplaces and stoves should be avoided.

It is always instructive to place temperature and relative humidity data loggers throughout the facility and record temperatures throughout the day. The monitors that are connected to the centralized HVAC system will not necessarily pinpoint hotspots. While built-in temperature sensors in an HVAC system will automatically activate heating or cooling equipment as needed, it is quite possible that the heating and cooling distribution is uneven. This is especially true in facilities having several HVAC systems of different vintages. Fans or increased air exchange may be in order, but keep in mind that humidity levels will also be affected in short order. In general, in order to develop an understanding of how temperature and humidity are linked, it is necessary to become acquainted with environmental conditions in every corner of the facility where artworks are located.

Relative Humidity

Regulating humidity is the most difficult technical challenge in climate control. High levels of humidity are particularly troublesome for paper artifacts. Since paper is hygroscopic, when placed in damp surroundings it will absorb water vapor rapidly, only slowly giving it up again. Many of the illustrations in chapter 2 show the effects of high humidity on paper. Drastic dimensional changes brought about by fluctuations in relative humidity can disrupt paint layers and permanently deform paper. Mold growth sustained by prolonged periods of high humidity can stain and weaken paper. Because humidity is

directly affected by temperature, both must be carefully monitored to prevent and respond to fluctuations.

It is important to understand this close relationship. Air can hold water vapor in varying degrees. Simply measuring the amount of water by weight contained in a certain volume of air provides the absolute humidity, but since air can hold varying amounts of water at different temperatures, this is not a meaningful measurement. Relative humidity (RH) is the ratio expressed as a percentage obtained by comparing the amount of water vapor in a given volume of air (m) to the maximum amount that same volume of air could potentially hold, that is, the air is saturated, at that temperature (M); RH = (m/M × *100*).

Just like heat, it is useful to become acquainted with localized areas of humidity that may be potentially dangerous. Since microclimates exist throughout every facility, it is useful to know how to operate and read a hand-held psychrometer, rather than relying upon those built into an HVAC system since their location is fixed. Technological advances have resulted in vastly improved psychrometers that require only occasional calibration.

As with the control of temperature, the objective in controlling humidity is to avoid subjecting works on paper to repeated, irregularly changing levels of humidity. Again, the easiest way to control humidity is with a total climate control system. Since this is not feasible in many situations, freestanding humidifiers or dehumidifiers may look like attractive options. Unfortunately, unless they are used correctly, these devices can easily aggravate interior climates, especially if they are not correctly located, regularly cleaned and maintained, or do not have a large enough capacity for the space they need to condition. Passive approaches such as ceiling fans, added insulation, or even opening windows during certain seasons can be surprisingly effective in the long run.

Having emphasized the close correlation between temperature and relative humidity, what are their optimal ranges for a collection of prints and drawings? Unfortunately, the answer is not straightforward. Today almost everyone agrees that collecting institutions should reduce their energy consumption. Given the issue of museum sustainability, depending on the nature of their collections and their geographic location, many museums have broadened their temperature and relative humidity parameters for exhibition and storage from the original "ideal." It is generally acknowledged that, in order to best protect collections, temperature and humidity levels should be kept as constant as possible within a range of 59–77°F and 40–60 percent relative humidity. Also, it is generally agreed that drastic fluctuations in both are more dangerous than gradual seasonal shifts.

In 2014, three organizations proposed guidelines, which are given below. As has been seen throughout this book, certain types of works of art on paper and parchment are extremely reactive to climatic shifts, either due to their

components or to their condition. While most prints and drawings will withstand the ranges given below, a conservator can provide advice on extra steps that can be taken in framing or the creation of microclimates for particularly vulnerable items.

The American Institute for Conservation of Historic and Artistic Works (AIC)

- Temperature: 59–77°F (15–25°C)
- Relative humidity: 45–55 percent with no more than ±5 points (no frequency specified) within this range.

The Australian Institute for the Conservation of Cultural Materials (AICCM)

- Temperature: 59–77°F (15–25°C)
- Relative humidity: 45–55 percent with no more than ±5 points per twenty-four hours within this range.

The International Group of Organizers of Large-Scale Exhibitions (The Bizot Group)

- Temperature: 61–77°F (16–25°C)
- Relative humidity: 40–60 percent with no more than ±10 points per twenty-four hours within this range.[18]

Quantitative standards deemed to be "correct" can be misleading if they are adopted without consideration to other factors. If, in attempting to maintain "ideal" conditions, organizations destroy the fabric of their historic buildings, spend scarce resources on energy rather than security or maintenance, constantly turn on air-conditioners or humidifiers, or resort to makeshift and ineffective solutions, such as trays of water on radiators, it is better to accept wider but gradual shifts of relative humidity in either direction. Spending scarce resources on the item-level enclosures described in chapter 5 can mediate climate extremes to some degree as well.

Mold

Molds and mildew are terms used to describe a fungus that may appear as a fuzzy-looking growth on the surface of organic materials in damp conditions, both outdoors and indoors. Molds may be gray, black, green, yellow, orange, or various colors, and may have a velvety or wooly texture. Like other fungi, molds release tiny spores in order to reproduce. Mold spores continually waft through the air, both indoors and out-of-doors. Molds are a natural part of

the environment, but mold growth indoors is an abnormal condition resulting when there is excessive moisture infiltration and accumulation, particularly if the moisture problem remains undiscovered or unaddressed.

Controlling moisture can prevent indoor mold growth. In galleries and storage areas, concern should be registered and actions taken when the relative humidity approaches 68 percent. At that point, fans and portable dehumidifiers should be activated, since above 68 percent relative humidity the danger of mold growth is great. Inspect all framed prints and drawings and make sure that air is circulating around them. Check for condensation along shelving. Move all artworks away from the source of the dampness, for example, along outside walls, up from floors, or away from leaky pipes. Like "hot spots," pockets of high humidity can occur in confined spaces, for example, condensation and subsequent mold growth is often observed in framed works on paper installed on exterior walls or kept in unheated storage units. Keep in mind that microclimates are easily formed and maintained by water-loving paper. In most cases, no further treatment is required to deactivate mold spores, other than lowering the humidity to a percentage in which they cannot survive. The use of fungicides, such as thymol, to kill active or suspected mold growth is no longer recommended due to health concerns and questions of effectiveness. Exposure to fungicides does not provide protection against future mold growth. Whenever working in an environment where a mold outbreak is suspected, personal protection, particularly a HEPA face mask, if not more, must be used (see OSHA https://www.osha.gov).

Light

The effects of overexposure to light or radiant energy on paper are drastic and irreversible. Cellulose deteriorates and certain colors fade or change hue completely. Light-sensitive media include watercolor, the ink in Japanese prints, iron gall ink, pastel, and the brilliantly colored dye-based ink of a porous-point pen. Papers can become dark brown or change color entirely depending upon their constituents.

When controlling radiant energy, it is useful to consider three factors that will determine the degree of damage from exposure to it: type, intensity, and exposure time.

Type of Light

While all light is dangerous, certain wavelengths of radiant energy are more harmful to paper (including other organic materials such as textiles, basketry, feathers, leather, papyrus, and parchment) and colorants than others. Firstly, it is important to keep in mind that the human eye detects only a narrow band of the spectrum of electromagnetic energy, ranging from violet at one end of

the spectrum (400 nanometers) to red (700 nanometers), and all the colors in between for which the human eye has receptors. UV radiation (below 400 nanometers) is invisible to humans, but is especially destructive to both paper and organic media. UV radiation is found in high proportions in daylight and in smaller amounts in fluorescent lighting. Incandescent (tungsten) light bulbs do not produce appreciable amounts of UV light. Tungsten halogen fixtures for use in track lights for spotlighting or "wall washing" contain more UV light than tungsten incandescent lamps. The rule of thumb is, the bluer or "cooler the temperature" of light, the more UV it contains. The amount of UV radiation produced by energy-efficient CFLs varies depending on their color temperature. LEDs do not emit appreciable UV radiation.

Because UV radiation is invisible and harmful, there is no reason *not* to remove it as much as possible. Methods of removing UV radiation from rooms where works of art on paper are exhibited are straightforward. Physically blocking out all daylight with curtains, or removing fluorescent tubes and substituting incandescent light bulbs or LEDs are straightforward approaches. Filtration is another method. Filtration is accomplished by the use of plastic filters, which are available in many forms. Exterior windows and skylights can be treated with UV-filtering film applied directly to the glass. Flexible blinds made from clear UV-filtering plastic can be hung in windows. Cylinders of similar filtering material can be slipped around fluorescent tubes. Finally, prints and drawings can be framed behind rigid UV-filtering acrylic sheet. Because the use of UV-filtering acrylic is one of the most effective ways of protecting prints and drawing from UV radiation, many collecting institutions do so routinely. Nonetheless, unfiltered sunlight is usually prohibited from entering galleries via windows and skylights, because its direction and intensity cannot be controlled. Fortunately, UV-filtering glazing products are now available in a static-free type (see chapter 5). The presence of UV radiation is detected and measured using a handheld light monitor (see Appendix 2). The upper limit of allowable UV radiation is 75 microwatts per lumen, the amount of UV permitted by a typical incandescent lamp, which was the most common light source when lighting standards were established. Like other lighting recommendations, such as light intensity and duration of exposure, the percentage of UV "allowed" in gallery lighting is based on a workable standard and is not the point below which conditions are "safe."

Intensity of Light

The intensity or brightness of visible light should also be considered when displaying prints and drawings. In the United States light intensity is usually measured in footcandles; in Europe it is measured in lux units; one

footcandle equals approximately ten lux. The proper level of illumination for works of art on paper has been much debated. No amount of visible light is "safe," since even low visible light levels for a long duration will add up to same total amount of radiant energy striking the artwork as higher visible light levels for a short duration. It is generally agreed that 5 to 8 footcandles (50 to 80 lux) of incandescent light with no UV present from other sources is acceptable for limited exposure times. This figure represents an uneasy compromise between the ability to see an artwork and the desire to protect it. Again, like type of light and duration of exposure, it is a range in which the average human eye can differentiate colors and detect details at a fairly close range. There is no point in reducing light intensity to three footcandles in the name of preservation, since no one will be able to see the work in question. As people age, their eyes' ability to discern colors lessens and brighter lighting is needed. This has led to the suggestion that museums establish special viewing opportunities during which light levels are raised. Light intensity is also measured using a handheld light monitor (see Appendix 2). Fortunately, advances in lighting technology and design have resulted in the ability to make pictures look more brightly illuminated under lower intensities. Lighting specialists often can transform a gallery without raising light levels.

Exposure Time to Light

The effects of exposing a print or drawing to radiant energy of any wavelength or of any intensity are cumulative. For this reason, prints and drawings should never be permanently displayed. Three months of exposure time per year per drawing is a prudent policy adopted by many museums. For private collectors, regular and frequent rotation of prints and drawings is advisable or the use of individual opaque covers for them. Three months represent the duration of a typical museum exhibition or traveling show. It is not a magic number, below which light damage is prevented; rather, it is an acknowledgment that the public requires at least three months to see a show and a museum needs to justify the effort and expense for mounting it. Traveling shows simply add to the cumulative exposure time for each item; the extra months can be deducted from its exposure "dosage" for the following year.

Once again, these recommendations are based upon the conditions that can reasonably be met and maintained. Remember the three factors of light: type, intensity, and exposure time. Control any one factor and damage to paper will be reduced. Better yet, control all three! If these lighting restrictions seem excessive, it is for good reason – light damage is irreversible, and when its toll has been taken, it is too late to lower the lights.

The perceptive reader will have noted from previous chapters that not all works of art on paper are equally vulnerable to damage from light. So why should a "one-size-fits-all" lighting policy be applied to all prints and drawings? It is a fact that a sketch done using a felt-tipped marker on an optically brightened paper is far more susceptible to rapid and irreversible light damage than a Rembrandt etching. Because of the validity of this observation, many institutions classify their works of art on paper into three categories of decreasing vulnerability to light exposure. Each category corresponds to a "British Blue Wool" standard, a dyed fabric that is calibrated to fade at a predetermined rate. The International Standards Organization (ISO) classifies these rates of change into categories, each of which represents various media and supports (excluding photographs and textiles). Each category is as follows[19]:

Category 1: Works of sensitivity levels ISO 1, 2, or 3
Pastels (any sensitive colors, inexpensive, or unknown palettes); watercolors (any sensitive colors, inexpensive, or unknown palettes); opaque water colors (any sensitive colors, inexpensive, or unknown palettes); colored printing inks, including oil-based (any sensitive colors or unknown palettes, e.g., lithographs, screen prints, commercial printing, etc.); multicolored tempera images of unidentified pigments (e.g., illuminated manuscripts, Asian opaque watercolor on paper or silk); most tinted papers, e.g., blue gray, green gray; felt tip pen drawings; all brown inks; complex black inks; unknown yellows and reds in Japanese *ukiyo-e* prints; unknown yellows and reds in European manuscripts; low-grade ephemera used in collages.
Category 2: Works of sensitivity levels ISO 4, 5, or 6
Wood pulp and other low-grade paper or card supports.
Category 3: Works of sensitivity levels ISO 7, 8, or above
Good-quality rag papers; carbon-based inks; graphite, charcoal; metalpoint drawings (coatings for metalpoint papers are probably acceptable if white, but not if colored); earth pigments, ochres, umbers, etc.; natural chalks, red, brown, black, white (conte crayons).

It is important to note that these categories apply only to the duration or the cumulative light exposure before what is called the "just noticeable fade"; low light levels with no UV radiation present are assumed.[20] While it is easier to track and evaluate past and future light exposures according to one rule that applies to every item, some institutions make allowances for slightly more robust works on paper when making lending decisions. The motto of "less exposure; more preservation" should prevail, however, since we cannot predict what demands for access to our collections await them.

Integrated Pest Management Program

An improperly maintained environment may also prove inviting to insects and rodents. Figures 2.27–2.29 illustrate the damage they can cause. The most common insect enemies of paper are termites, cockroaches, silverfish, book lice, and bookworms. They are attracted not only to the paper, but also to adhesives, sizes, and certain media. Insects can cause damage very quickly and infestations should be dealt with promptly. Once that is done, regular, thorough good housekeeping procedures can help keep collection areas free of such pests by eliminating the damp, dark places they love as habitats and by keeping the area clear of any organic matter on which they might feed. Humidity control and regular cleaning of storerooms, closets, and cabinets are essential. Obviously no food should be permitted in these areas. Only if the problem persists are more serious measures, such as the use of insecticides, warranted.

Insecticides are not new. Pliny the Elder (23–79) described rolls of papyrus entombed for over 500 years with citrus leaves in excellent condition. During the Ming and Ching dynasties in China, sheets of paper coated with lead compounds were bound into books to protect them from moths. A traditional Japanese yellow dye made from the bark of the *kihada* tree has been proved effective in warding off insects. In the past, arsenic has been used to disinfect the rags used to make paper pulp and textiles – with deadly effects. Exposure to artifacts treated with arsenic and cyanide, especially taxidermy specimens, is still too frequent in natural history collections. Exposure of artifacts to an anoxic environment is one current approach to insect elimination, which avoids the use and aftereffects of toxic pesticides.

Many collecting institutions are beset with cyclical bouts of pests, including insects, rodents, bats, and birds, entering and damaging collection areas. While one's immediate inclination might be to call an exterminator, the establishment of an IPM program is ultimately a more cost-effective solution to a complex problem. An IPM program focuses on utilizing nonpesticide-based prevention and response procedures in order to minimize health risks for personnel as well as damages to the collection itself. The routine use of naphthalene (moth balls) as an insecticide and pest repellent is no longer recommended; other pyrethrum-based insecticides are under review. Typical aspects of an IPM program include creating and implementing policies for the routine inspection of the entire facility in which artifacts are housed, authorized trapping procedures, and documentation of the results of all inspections or trapping programs. Practical steps, which can be taken immediately, include:

• The thorough inspection of all materials brought into any area where collections are displayed, studied, or stored, looking not only for the pests themselves, but also traces of their activities;

- Detailed instructions for daily maintenance and general housekeeping of collection spaces; chapter 5 describes the brightly lit and noncluttered storage spaces that will aid in this step;
- Restrictions on areas within the building where food and drinks may be consumed;
- Careful monitoring of landscaping around the outside of the building, with special attention paid to the proximity of live plants and vines, and clear drainage patterns;
- The monitoring and enforcement of a Collections Care Program, in particular the adherence to appropriate temperature and relative humidity parameters.

Some institutions prohibit live floral arrangements and decorative plantings entirely, but this is a difficult policy to enforce. All living plants should be regularly inspected for insect infestations. An excellent resource for establishing and maintaining an IPM program is Museum Pests.net (http://museumpests.net), a product of the IPM Working Group.

Disaster Preparedness and Emergency Response

A Disaster Preparedness and Emergency Response plan is considered as critical as an institution's Mission Statement, Code of Ethics, Strategic Plan, and Collections Management Policy. A comprehensive plan will incorporate plans for evacuation of staff and visitors, responses to bomb threats or active shooters, and other potential emergencies. For our purposes, the discussion is limited to the consequences of a disaster for collections of paper-based materials. Like risk assessment, because the nature of every collection and the facility that houses it differs, every plan is unique. One constant, however, is keeping the Disaster Preparedness and Emergency Response plan current and easily accessible to everyone. For example, failing to note that a historic slate roof leaked during a recent downpour, a designated fire warden has retired, or a salvage company has relocated, makes the best plan useless when emergencies occur.

A thorough risk assessment will have noted disasters – natural, mechanical, and human-made – that could potentially strike an institution depending on its age, location, and function. Based on their relative probability, ideally steps will have been taken to reduce disasters from happening and to lessen their impact if and when they occur. An Emergency Response team on stand-by will insure a rapid response, but only if telephone numbers and e-mails are kept up to date and the plan has been rehearsed. In addition, if storage rooms are located underground, it is reasonable that water alarms be installed and emergency supply carts be equipped with appropriate supplies. The National

Park Service has published an excellent guide, *An Emergency Cart for Salvaging Water-Damaged Objects*, which describes in detail what such a cart should contain. This list is reproduced below:

General Supplies

- Copy of the Emergency Response Plan
- List of response staff phone numbers and e-mails
- List of general emergency phone numbers and websites
- List of phone numbers and websites for rental equipment and refrigerated trucks
- List of key locations or key codes for affected rooms and exhibit/storage cases
- Disposable cameras, tablets, or smart phones with built-in flash to document the emergency and objects in situ before recovery activities
- Clipboard with notepads
- Pencils, pens, and permanent ink markers
- Preprinted Object Record Sheets to track the movement of collection items; the Object Record Sheet should include: accession number, type of object, type of damage, treatment needed, new location
- Scissors (4–6 pairs)
- Object tags (several sizes)
- Door wedges (large size to secure heavy stairway and storeroom doors in an open position)

Safety Supplies

- CAUTION barrier tape and signs
- First Aid kit
- Boxes of premoistened, antibacterial towelettes
- Single-use respirators approved for protection against dusts and mists (respirators may be necessary if mold has already developed)
- Disposable Tyvek® protective clothing (available in small, medium, and large sizes) or aprons
- Stretchy, pull-on boots with nonskid bottoms
- Gloves (work gloves with leather palms, disposable latex gloves in several sizes)
- Plastic safety goggles

Supplies for Removing Excess Water

- Large cellulose sponges

- Squeegee with a long handle (to move water toward drains)
- Sponge mops (cotton mops can be used but are heavy and require a wringer bucket)
- Plastic buckets
- Broom
- Dust pan and brush
- Rags (boxes of cotton painters rags or toweling to dry individual objects)
- Terrycloth toweling
- Paper towels
- Blotting paper (white, photographic type for interleaving paper objects)
- Unprinted newsprint
- Disposable baby diapers (excellent for quickly absorbing large quantities of water from soaked textiles and other porous materials)
- Flexible tubes of super-absorbent cellulose to act as dams

Lights and Power

- Flashlights and extra batteries
- Work lights (the type in plastic cages that can be hung) and extra bulbs
- Heavy-duty electrical cords with multiple heads
- Power strips
- String for securing electrical cords up out of the water

Tools

- Tool kit containing: hammer, small and large flat-head screwdriver, small and large Phillips-head screwdriver, specialized tools for opening exhibit cases, pliers, crowbar, vice grips, utility knives with retractable blades (with extra blades), nails, and hatchet

Containers, Supports, Wrapping Materials

- Polyethylene sheeting (large roll of 4 mil) for tenting areas if leaks are still a problem, cut sheets – about 4' × 8' for wrapping objects and covering smaller surfaces
- Duct tape (several rolls to seal bags or splice together sheets of polyethylene)
- Corrugated high-density polypropylene boxes (for transporting wet objects); cut several holes in the bottom for drainage
- Plastic bags (clear food grade, both lightweight and heavy duty, in a variety of sizes for objects; heavy-duty garbage bags for disposal of soiled recovery supplies and trash)
- Nylon cable ties for closing bags
- Wood blocks (2–3 dozen 12-inch blocks cut from 2" × 4" lumber (or Etha-foam® blocks) to raise objects off the floors)

General salvage and cleanup supplies available in the facility should include powerful floor fans, wet/dry vacuums, dehumidifiers, and carts for moving collection items.

Usually, an Emergency Response Plan is organized into steps: Documentation and Assessment of Damage, Setting Priorities for Recovery (Triage), and Recovery Activities. These are summarized below; more detailed response procedures may be found under Further Reading.

Documentation and Assessment of Damage

While rapid response is key, aided considerably by supplies close at hand and a rehearsed plan of action, documentation and assessment of damage must commence immediately. In this way, the causes of the disaster are recorded as are the original location of items, which may be key in their subsequent identification, tracking, and treatment. Nothing takes the place of visual evidence when it comes to insurance settlements and photographic documentation has clarified many claims. Fortunately, most people have personal cellphones these days that can quickly capture and document the situation as well as the condition of individual collection items. Most important is to track the movement of collection items, since in the chaos following a disaster, items can be easily lost.

Setting Priorities for Recovery (Triage)

As an emergency situation evolves, it is necessary to divide collection items according to their degree of damage. In some collections, certain accessioned works have been designated as having salvage priority due to their value and significance. These items are usually located in one area, have unique identifiers, or have been assigned to one member of the response team. It should be noted that this policy is highly controversial and not universally adopted by collecting institutions. While theoretically logical and very appealing, disaster situations are highly variable and individual heroics not advisable. If this institutional policy is in place, salvage priority items should be examined first and directed accordingly.

As items are distributed into categories according to the degree of damage, their locations should be noted whether on the Object Record Sheets found in the emergency response cart or by taking pictures of them. Different disasters will result in different kinds of damage, that is, soot from a furnace "puff back," breakage from earthquakes, and contamination from sewage (not to be dealt with in-house). The references found at the end of this chapter can help in planning for these emergencies.

Water damage is one of the most common and extreme consequences of a disaster. When prints and drawings are involved in a flood or accidental leak,

the highest priority must be to remove them from their wet surroundings and to sort them according to their degree of wetness. Depending upon the quantities involved and the staff and facilities available, specific recovery activities will vary.

Recovery Activities

The most important aspects of recovery activities are speed and organization, which are much more likely to occur if an Emergency Response Plan has been rehearsed and supplies are available. For large-scale disasters involving archives or other large quantities of loose sheets of paper, the services of a commercial salvage and recovery company should be retained. A preexisting relationship with a professional paper conservator who is acquainted with the collection is also enormously helpful when emergencies occur.

Air-drying is the most typical activity undertaken when works on paper are wet; however, air-drying is labor and space intensive.[21] Framed works on paper should be removed to a dry location and unframed as soon as possible, after their condition has been documented for insurance purposes. Individual sheets of wet paper should be spread out on clean tables that have been covered with blotting paper or unprinted newsprint. Fans should keep the air moving as much as possible without directly disturbing fragile papers. New plastic window screening placed on top of loose papers will help restrain their movement. As the paper towels absorb moisture, they should be replaced. Keep in mind that wet paper is especially fragile, so handling must be kept to a minimum. As the individual sheets of paper begin to dry, they will curl. At this point, sheets of nonwoven polyester and blotting paper can be gently placed over them, with no additional weight, however. Regularly rotate the blotting paper until the works are completely dry at which point they can be rehoused in temporary folders and boxes until further examination and treatment if necessary.

Other recovery options for sodden papers, usually in larger quantities, are freezing, vacuum freeze-drying, and vacuum thermal-drying, services provided by commercial vendors. These salvage methods are more applicable for nonunique books and records; however, they may be in order for large-scale disasters.

NOTES

1. A suggested Table of Contents for a Collections Care Management Policy is given by Nicola Ladkin, "Collections Management," 19, in *Running a Museum: A Practical Handbook*, ICOM, 2004. http://icom.museum/uploads/tx_hpoindexbdd/practical_handbook.pdf.

2. The Code of Ethics for Museums of the American Alliance of Museums, which included this allowance for the spending of deaccessioning profits, was approved 1993. In 2015 a survey to clarify to scope of "direct care," was commissioned, http://aam-us.org/resources/ethics-standards-and-best-practices/direct-care.

3. American Institute for Conservation of Historic and Artistic Works, *About Conservation: Definitions of Conservation Terminology* (2015). Retrieved from http://www.conservation-us.org/about-conservation/related-organizations/definitions#.VoFgf8ArLpB.

4. American Institute for Conservation of Historic and Artistic Works, "Commentary 20 – Preventive Conservation," *Commentaries to the Guidelines for Practice* (2008). Retrieved from http://www.conservation-us.org/docs/default-source/governance/commentaries-to-the-guidelines.pdf.

5. Gloves should be worn when directly handling objects made from metals or absorbent materials, such as textiles, ivory, and basketry. Glove-wearing policies will vary from institution to institution.

6. The RC-AAM is a membership group within the American Alliance of Museums of those responsible for, or interested in, the management of cultural heritage collections and exhibitions. The Registrar's Committee was formally established in 1976. http://www.aam-us.org/.

7. National Park Service, https://www.nps.gov/museum/publications/MHII/mh2ch5.pdf.

8. Print Council of America, www.printcouncil.org.

9. Because the processing of loan requests requires considerable time and expense, particularly for conservation and registrarial staff, the potential impact of work loads must be considered before a loan request is approved.

10. A downloadable World verison of the AAM *General Facility Report* can be purchased from https://aam-us.org/ProductCatalog/Product?ID=891.

11. *General Facility Report,* American Alliance of Museums, 2011, Preface.

12. Print Council of America, Guidelines for Lending Works of Art on Paper, 2015 digital edition, section 3.1. www.printcouncill.org. (accessed 11/27/2015).

13. Paul Marcon. *Six Steps to Safe Shipment.* Canadian Conservation Institute, 2015. Available from http://canada.pch.gc.ca/eng/1444920450433.

14. Halon, an inert gas for suffocating fires, was banned in 1994.

15. The 2015 Handbook of the American Society of Heating, Refrigerating, and Airconditioning Engineers is available from https://www.asahre.org/resources–publications/handbook.

16. The NPS Museum Handbook is available from https://www.nps.gov/museum/publications/handbook.html.

17. Charles L. Eastlake, Michael Faraday, and William S. Russell, *Report on the Subject of the Protection of the Pictures of the National Gallery by Glass.* House of Commons, 24 May 1850, Appendix A, 67–69. Reproduced in *Historical Perspectives on Preventive Conservation*, ed. Sarah Staniforth (Los Angeles: Getty Conservation Institute, 2013), 270.

18. Marjorie B. Cohn, *Wash and Gouache: A Study of the Development of the Materials of Watercolor* (Cambridge, MA: Fogg Art Museum, 1977), 61, n. 2.

19. The author disagrees with the upper range of allowable RH, which could reach 70 percent, when the possibility of mold growth is greater.

20. Colby, Karen M. *A Suggested Exhibition/Exposure Policy for Works of Art on Paper.* 1993. Unpublished. http://www.lighresource.com/policy1.html (accessed 3/14/2016).

21. https://www.nedcc.org/free-resources/preservation-leaflets/3.-emergency-management/3.6-emergency-salvage-of-wet-books-and-records (accessed 3/13/2016), 2.

FURTHER READING

Adams-Graf, Diane, and Claudia J. Nicholson. "Museum Security: Thinking Ahead about Museum Protection: An Ounce of Prevention is Worth a Pound of Cure." *TechTalk. Minnesota Histrical Society.* March 2000. https://sustainingplaces.files.wordpress.com/2014/03/mnhstechtalkmarch2000.pdf (accessed 3/14/2016).

American Alliance for Museums. *Developing a Collections Management Policy.* 2012. http://www.aam-us.org/continuum/developing-a-cmo-final.pdf?sfvrsn=2 (accessed 3/14/2016).

———. *National Standards and Best Practices for U.S. Museums.* 2008. http://www.aam-us.org/resources/ethics-standards-and-best-practices (accessed 3/14/2016).

———. *Developing a Disaster Preparedness/Emergency Response Plan.* 2012. http://www.aam-us.org/docs/default-source/continuum/developing-a-disaster-plan-final.pdf?sfvrsn=4 (accessed 3/14/2016).

American Institute for Conservation (AIC) and International Institute for Conservation of Historic and Artistic Works (IIC). "The Plus/Minus Dilemma: The Way Forward in Environmental Guidelines." *International Institute for Conservation of Historic and Artistic Works (IIC).* 2010. www.iiconservation.org/dialogues/plus_minus_trans.pdf (accessed 3/14/2016).

American Museum of Natural History. *Museum SOS.* http://www.museum-sos.org/htm/res_menu_docs.html (accessed 3/14/2016).

American Society of Heating, Refrigerating and Air-Conditioning Engineers (ASHRAE). *2015 ASHRAE Handbook–HVAC Applications. Chapter 23: Museums, Galleries, Libraries, and Archives.* Atlanta, GA: ASHRAE, 2015.

Appelbaum, Barbara. *Guide to Environmental Protection of Collections.* Madison, CT: Sound View Press, 1991.

Ashley-Smith, Jonathan. *Risk Assessment for Object Conservation.* Oxford: Butterworth-Heinemann, 1999.

British Library. *Collection Care.* http://www.bl.uk/aboutus/stratpolprog/collection-care/conservetreat/ (accessed 3/14/2016).

Broderick, James. "Can Museums Measure Up?" *Illuminating Engineering Society's Gateway Roundup.* July 2011. http://apps1.eere.energy.gov/buildings/publications/pdfs/ssl/gateway-roundup_7-11.pdf (accessed 3/14/2016).

Brommelle, Norman. "The Russell and Abney Report on the Action of Light on Watercolours." *Studies in Conservation* 9, no. 4 (1964): 140–145.

Canadian Conservation Institute (CCI). *CCI Notes.* http://www.cci-icc.gc.ca/ (accessed 3/14/2016).

———. "A Light Damage Slide Rule." *CCI Notes,* 1989. http://www.cci-icc.gc.ca/ (accessed 3/14/2016).

———. *Preserving My Heritage.* www.preservation.gc.ca (accessed 3/14/2016).

Canadian Heritage Information Network (CHIN). *Canadian Heritage Information Network (CHIN).* http://www/chin.gc.ca (accessed 3/14/2016).

Cassar, M. *Environmental Management: Guidelines for Museums and Galleries.* London: Routledge, 1995.

Cassar, May, and Jeremy Hutchings. *Relative Humidity and Temperature Pattern Book: A Guide to Understanding and Using Data on the Museum Environment.* London: Museums and Galleries Commission, 2000.

Colby, Karen M. *A Suggested Exhibition/Exposure Policy for Works of Art on Paper.* 1993. Unpublished. http://www.lightresource.com/policy1.html (accessed 3/14/2016).

Collections Trust. "Benchmarks in Collections Care." *Collections Trust.* Collections Trust. www.collectionstrust.org.uk/collections-link/collections-management/benchmarks-in-collections-care (accessed 3/14/2016).

Cuttle, Christopher. *Light for Art's Sake: Lighting of Artworks and Museum Displays.* Amsterdam: Butterworth-Heinemann, 2007.

Druzik, James, and Stefan Michalski. *Guidelines for Selecting Solid-State Lighting for Museums.* Ottawa, Los Angeles: Canadian Conservation Institute, Getty Conservation Institute, 2011.

Florian, Mary Lou. *Heritage Eaters: Insects and Fungi in Heritage Collections.* London: James and James, 1997.

Foundation of the American Institute for Conservation of Historic and Artistic Works. *Connecting to Collections Care Online Community.* www.connectingtocollections.org (accessed 3/14/2016).

Grattan, David, and Stefan Michalski. "Environmental Guidelines for Museums." *Canadian Conservation Institute.* 1/9/2014. http://www.cci-icc.gc.ca/resources-ressources/carepreventivecons-soinsconspreventive/enviro-eng.aspx. (accessed 3/14/2016).

Hatchfield, Pamela. *Pollutants in the Museum Environment: Practical Strategies for Problem Solving in Design, Exhibition and Storage.* London: Archetype, 2002.

———. "A New Look at Conservation Standards." *American Alliance for Museums.* January/February 2011. http://aam-us.org/publications/museum-magazine/archive/a-new-look-at-conservation-standards (accessed 3/14/2016).

Hatchfield, Pamela, and Jane Carpenter. *Formaldehyde: How Great Is the Danger to Museum Collections?* Cambridge, MA: Center for Conservation and Technical Studies, Harvard University Art Museums, 1987.

Havermans, Johannes. *Environmental Influences on the Deterioration of Paper.* Rotterdam: Barjesteh, Meeuwes & Co., 1995.

Humphrey, Vicki, and Julian Bickersteth. "Museum Environmental Standards in a Changing Environment." *Papyrus: A Publication of the International Association of Museum Facility Administrators.* 12 (3): 38–39. http://newiamfa.org/ (accessed 3/14/2016).

Leister Readers in Museum Studies. *Preventive Conservation in Museums.* Edited by Chris Caple. London: Routledge, 2011.

Library of Congress. *Emergency Preparedness.* http://loc.gov/preservation/emergprep (accessed 3/14/2016).

Lull, William. *Conservation Environment Guidelines for Libraries and Archives.* Albany, NY: State Education Department, New York State Library, 1990.

Massachusetts Institute of Technology. *Collections Manual.* http://web.mit.edu/museum/collections/manual.html (accessed 3/14/2016).

Merritt, Elizabeth E. *Covering Your Assets: Facilities and Risk Management in Museums.* Washington, DC: American Association of Museums, 2005.

Minnesota Historical Society. *Minnesota Historical Society (MNHS).* http://www.mnhs.org/preserve/conservation/ (accessed 3/14/2016).

Muller, Chris. "Air-Quality Standards for Preservation Environments: Considerations for Monitoring and Classification of Gaseous Pollutants." *Papyrus: A Publication of the International Association of Museum Facility Administrators,* 11 (2): 45–50. www.newiamfa.org/ (accessed 3/14/2016).

National Archives and Records Administration. *National Archives and Records Administration.* http://www.archives.gov/preservation/formats/ (accessed 3/14/2016).

National Archives of Australia. *National Archives of Australia.* http://www.naa.gov.au/collection/family-history/family-archive/indes.aspx (accessed 3/14/2016).

National Center for Preservation Technology and Training. *National Center for Preservation Technology and Training.* http://www.ncptt.nps.gov (accessed 3/14/2016).

National Committee to Save America's Cultural Collections. *Caring for your Collections.* New York: Harry N. Abrams, 1992.

National Park Service. *Conserve-O-Gram.* http://www.nps.gov/museum/publications/conserveogram/cons_toc.html (accessed 3/14/2016).

National Park Service. *Museum Handbook, Part I: Museum Collections.* Washington, DC: National Park Service, 2006.

National Trust for Historic Preservation. *National Trust for Historic Preservation.* http://www.preservationnation.org (accessed 3/14/2016).

Northeast Document Conservation Center. "1.6 Priority Actions for Preservation." *Northeast Document Conservation Center Preservation Leaflets.* https://www.nedcc.org/free-resources/preservation-leaflets/1.-planning-and-prioritizing/1.6-priority-actions-for-preservation (accessed 3/14/2016).

———. "2.2 Monitoring Temperature and Relative Humidity." *Northeast Document Conservation Center Preservation Leaflets.* 2012. https://www.nedcc.org/free-resources/preservation-leaflets/2.-the-environment/2.2-monitoring-temperature-and-relative-humidity (accessed 3/14/2016).

———. "2.4 Protection from Light Damage." *Northeast Document Conservation Center Preservation Leaflets.* Edited by Donia Conn. 2012. https://www/nedcc.org/free-resources/preservation-leaflets/2.-the-environment/2.4-protection-from-light-damage (accessed 3/14/2016).

———. "4.9 Storage Solutions for Oversized Paper Artifacts." *Northeast Document Conservation Center Preservation Leaflets.* https://www.nedcc.org/free-resources/preservation-leaflets/4.-storage-and-handling/4.9-storage-solutions-for-oversized-paper-artifacts (accessed 3/14/2016).

Perrin, T.E., J.R. Druzik, and N.J. Miller. *SSL Adoption by Museums: Survey Results, Analysis, and Recommendations.* Richland, WA: Pacific Northwest National Laboratory, 2014.

Person-Harm, Angela, and Judie Cooper. *The Care and Keeping of Cultural Facilities: A Best Practice Guidebook for Museum Facility Management.* Lanham, MD: Rowman and Littlefield, 2014.

Pinneger, David. *Integrated Pest Management for Cultural Heritage.* London: Archetype Publications, 2015.

Print Council of America. *Guidelines for Lending Works of Art on Paper.* Print Council of America. 2015. www.printcouncil.org (accessed 3/14/2016).

Rose, C.L., and A.R. de Torres. *Storage of Natural History Collections: Ideas and Practical Solutions.* New York, NY: Society for the Preservation of Natural History Collections, 1992 (2002).

Saving Your Treasures. *Saving Your Treasures.* http://www.netnebraska.org/extras/treasures/index.htm (accessed 3/14/2016).

Shelley, Marjorie. *The Care and Handling of Art Objects: Practices in the Metropolitan Museum of Art.* New York: Metropolitan Museum of Art, 1987.

Simmons, John. *Things Great and Small: Collections Management Policies.* Washington, DC: American Association of Museums, 2006.

Staniforth, Sarah, ed. *Historical Perspectives on Preventive Conservation. Readings in Conservation.* Los Angeles: The Getty Conservation Institute, 2013.

STASH (Storage Techniques for Art, Science & History Collections). 2014. http://stashc.com/ (accessed 3/14/2016).

Tétreault, J. *Airborne Pollutants in Museums, Galleries and Archives: Risk Assessment, Control Strategies, and Preservation Management.* Ottawa: Canadian Conservation Institute, 2003.

University of Illinois. *Preservation Self-Assessment Program (PSAP).* https://psap.library/illinois.edu (accessed 3/14/2016).

Waller, Robert. "A Risk Model for Collection Preservation." *13th Triennial Meeting Rio de Janeiro Preprints.* 102–107. International Council of Museums, Committee for Conservation. 2002. http://www.museum-sos.org/docs/WallerICOMCC2002.pdf (accessed 3/14/2016).

———. "Conservation Risk Assessment: A Strategy for Managing Resources for Preventive Conservation." *Preprints of the Ottawa Congress, September 1994.* London: International Institute for Conservation, 1994: 244.

———. "Risk Management Applied to Preventive Conservation." In *Storage of Natural History Collections: A Preventive Conservation Approach,* by H.H., Hawks, C.A. and Caroline Rose Genoways. Iowa City, IO: Society for the Preservation of Natural History Collections, (1995): 21–27.

Waller, Robert, and Stefan Michalski. "Effective Preservation: From Reaction to Prevention." *Getty Conservation Institute.* Spring 2004. http://www.getty.edu/conservation/publications_resources/newsletters/19_1/features.html (accessed 3/14/2016).

Wilcox, U.V. "Facility Management." In *Storage of Natural History Collections: A Preventive Conservation Approach,* edited by C.A. Hawks, and H.H. Genoways and Caroline Rose. York, PA: Society for the Preservation of Natural History Collections, (1995): 29–41.

Chapter 7

Basic Paper Conservation Procedures

EXAMINATION OF PRINTS AND DRAWINGS

There are several benchmarks in the life of a print or drawing, which require its close examination. The first of these ideally occurs even before the piece enters a collection. Many Collections Management Policies have stringent acquisition rules concerning the condition of items donated to or purchased for a collection, due to the fact that caring for collections is a long-term and expensive commitment. If a print or drawing is in poor condition, has been badly restored, or has no study value relative to other collection materials, it will most likely languish in storage using up valuable supplies, space, labor, and, of increasing concern, energy. On occasion, an item will require time-consuming and expensive item-level conservation treatment, which is also an important consideration prior to acquisition. Will the costs associated with its treatment be made up by the value that the piece adds to the collection? Whenever possible, items under consideration for acquisition should be examined for present and potential future conservation issues and their potential costs. Some works on paper, due to their size or materials, will necessitate special conditions for their storage, travel, or exhibition – these requirements, too, are better to predict before their acquisition, rather than confronting unexpected demands on your budget and space.

Each newly acquired work on paper should be promptly examined upon arrival to determine the nature of any existing condition problems, to identify and eliminate, if possible, their causes, and to stabilize or repair any existing damage to the extent necessary to safely catalog and prepare the work for rehousing and storage. Detailed incoming examination reports will provide points of reference in the future should the condition of the piece change.

Other occasions when prints and drawings need to be examined are loan requests, periodic condition surveys, and item-level conservation treatment. In this book, directions for treatment are confined to the minor remedial steps that may be required for stabilization prior to storage or safer processing and handling. These routine procedures can be performed by a paper conservator or by someone, typically a collections care specialist, conservation technician, or preparator, who has been trained to carry out basic treatments and preventive conservation activities and who works in conjunction with or under the supervision of a conservator. Other instances in which examination is in order are study or photography requests. On a day-to-day basis, examination reports are useful for quick reference. For example, if an item is requested for loan, a look at its examination report will indicate any ongoing conservation problems, for example, active flaking, or if unusual requirements are needed that might affect its travel or exhibition. As mentioned in chapter 6, all incoming works need to be inspected for insect pests, as well, which can be hidden in old frames and backing boards and in packing and shipping materials. If possible, the area for this preliminary inspection, which is often undertaken by registrarial or collections care staff, should be segregated and away from collection storage areas.

Every collection item should be examined periodically, with notes documenting its ongoing condition. Examination reports and condition surveys of collections should be conducted periodically and are considered an important aspect of responsible collection stewardship. This insures that expensive and time-consuming conservation treatment priorities are maintained, undetected damages resulting from poor handling practices are discovered, cataloging records are corrected or updated, and policy decisions and financial predictions are based upon reliable information. Examination reports can play a critical role in answering the insurance company's questions if damages occur in transit or while an artwork is on loan. Properly described, the details of an artifact's condition are at your fingertips. Examination reports are tremendously helpful for conservators, who are eager to learn about any past damages, treatments, and repairs to an artwork. For all of these reasons, many grant-making agencies will not fund item-level treatments until a condition assessment of the collection as a whole – and the conditions under which it is held – has been completed.

EXAMINATION AREA AND PROCEDURE

The area in which works of art on paper are examined should be well lit, uncluttered, and scrupulously clean. A large working surface is essential. The surface should be covered with clean white blotters, with ready replacements

at hand, or it can be a nonporous "cleanable" material such as glass, composite, or laminate countertop material. In addition to a laptop or tablet computer into which you will enter your observations, you should have a ruler (either a twenty-inch or a forty-inch one, whichever is appropriate), calibrated in centimeters and in inches. If a tape measure is used, it should be made from lightweight flexible plastic or fabric and have a locking mechanism to prevent unexpected retractions. A sharpened graphite pencil and notepad are always advisable (no uncapped pens should be allowed in proximity to an unprotected work of art). A magnifying glass or a headband magnifying *loupe* (Optivisor®), a stainless steel microspatula, and a scalpel with Number 10 or Number 15 blades are also needed. Small craft knives (X-Acto®) can also be used for cutting away old hinges and framing materials.

Remove the print or drawing from the temporary protective enclosure in which it was placed after unframing together with any labels and notations. If you have been unable to separate the artwork from its mat or mount, include that information in your report. Record your observations, while keeping the actual manipulation of the work to a minimum. Measure the artwork's greatest dimensions, height before width – and *do not rest the ruler on the art*. If the shape of the piece is irregular, note that fact and illustrate its outline by a small diagram for clarity; depending on what collections management software is used, this may not be possible. Also note the dimensions of any platemarks on intaglio prints. Transcribe all the information from any labels and unframing notes. Set labels aside to either be scanned and/or encapsulated. The microspatula can be used to gently lift a corner of the sheet so that you do not need to pull it up with your fingers. Always turn the print or drawing over while using proper support, instead of just one corner. If it is brittle or weak, it should be examined in its temporary enclosure. To turn it face down, close the folder and turn the entire package over. The folder will provide the piece with overall support.

The surface of charcoal, chalk, graphite, and pastel drawings should be protected by glassine during the examination of their versos. Obviously, works in unfixed pastel or with active flaking should not be turned over at all.

Describe the piece and its condition as accurately as possible, so that future examiners will be able to focus on what you have observed and make an assessment of any changes. You may find the term "discoloration" sufficient, but subsequent readers will not know exactly where the discoloration is, how severe it is, or what may have caused it. A matrix system, whereby the artwork is divided into quadrants, is useful for indicating location. If you do not recognize what the problem is or what caused it – for example, foxing – describe what it looks like and its symptoms. A magnifying glass and adjustable light may be useful for examining defects, as well as for determining the work's medium and technique.

When handling the work of art, avoid touching it with your fingers as much as possible, especially within the design area, and – as mentioned in chapter 6 – wash your hands frequently.

EXAMINATION FORMS AND TEMPLATES

Examination reports vary a great deal in format and data entry and can be more or less detailed. Today, condition can be recorded using customized software on computer tablets. Primarily, the report should describe the characteristics that distinguish one particular item from any other one either in your collection or known to exist, in the case of multiples. For example, the work may be one of an edition of ten prints by Picasso, but yours is signed, *P. Picasso*, and dated, *1954*, in graphite pencil in the lower right corner and numbered, *2/10*, in graphite pencil in the lower left corner with a collector's stamp on the center of the verso in blue ink. When making the determination of distinguishing marks, ask yourself if the item were lost or stolen, how would you identify it as coming from your collection? Details of the printed image are not unique, nor are any printed titles, which would be exactly repeated, in another impression of the same print.

The following information should be included at a minimum:

1. Identification of the item and location of distinguishing marks (artist, title, date, accession number, signature, stamps, seals, inscriptions).
2. Description of the work and its components (greatest outside dimensions, platemark dimensions, paper type, color, texture, thickness, medium and technique, frame, framing materials, unframing notations, mat, hinges).
3. Description of condition and location of damages (paper losses, flaking of medium, tears, creases, discoloration, fading, accretions, etc.).
4. Evidence of past treatment (repairs, lining, dry-mounting, fixatives, cosmetic restorations).
5. Date and name of examiner.

The above description of information to be included in a standard examination report is based on Guidelines 24 and 25, *Documentation*, in the American Institute for Conservation of Historic and Artistic Artifacts (AIC) *Guidelines for Practice* (revised 1994). If the same form is to be used to propose and record subsequent item-level treatment, sections need to be included for the treatment proposal, name of conservator, signature of custodian acknowledging the proposed treatment, a general description of the treatment, including date, materials used, as described in Guidelines 26 and 27. Routine maintenance procedures (e.g., dusting, refoldering documents) may not require additional documentation.

PHOTOGRAPHIC DOCUMENTATION

According to Commentary 27 of the AIC *Guidelines for Practice*, it is important that information regarding the treatment of a print or drawing be documented. In addition to completing the forms described above this can also include before, during, and after photographs. While it can be argued that certain procedures taken during processing of acquisitions are exempt from photographic documentation, it can equally be argued that photographically recording the visual appearance of all items will be useful in many additional ways besides treatment documentation, for example, grant applications, photography requests, and study. Best practice dictates that all items be photographically documented before and after treatment, and such images include: information that uniquely identifies the cultural property that is, accession number; date; size scale; color and gray scales; and a light direction indicator. Once an area has been set up, photographic documentation will become fast and efficient, especially if readers follow the advice provided in the Second Edition of *The AIC Guide to Digital Photography and Conservation Documentation* (see Further Reading).

SURFACE CLEANING

After examining the artwork thoroughly, you will have a good idea of whether it will require item-level conservation treatment or if it simply needs some further preparation for safe processing or before going into storage. One of the most routine procedures performed on prints and drawings is "surface cleaning," sometimes called "dry cleaning."

Unframed prints and drawings often enter collections covered with a thin all-over layer of accumulated grime from poor storage or handling. Dust, soot, and accidental marks are deposited inevitably on their surfaces from air pollution and human contact. Such surface dirt should be removed not only for aesthetic reasons, but also to eliminate it as a source of further damage to the artwork itself or others around it. Dirt is abrasive, can harbor insect eggs or larvae, or, in the case of greasy urban soot, can attract more dirt.

Tools and Materials

To begin the surface cleaning procedure, place the artwork on a spotlessly clean surface and assemble the tools needed: a very soft-bristled brush; an air bulb, available from photographic supply stores; a drafting brush; a good supply of precut 3 × 3 inches blotter squares, the same as used for hinging; small weights; a stainless steel microspatula; and white vinyl eraser powder. Commercial drafting powders and architect's cleaning pads, used with decreasing frequency these days of computer-aided design (CAD), can

contain pumice, which is too abrasive for softer papers. Rubber-based eraser powder contains sulfur, to be avoided around photographic materials. Rubber dries out and becomes gritty as it ages. An eraser powder, available in fine or medium coarseness, made from grated sulfur-free white vinyl erasers, is more gentle and is available from conservation material supply companies. If the powder comes in cloth pouches, the fabric should be cut and the eraser powder applied directly with the fingertips.

Procedure

Before you begin, you must ascertain whether the artwork can tolerate the mechanical action of surface cleaning. Brittle papers that cannot easily be handled should not be surface cleaned. Heavy-handed cleaning can make tears and fold lines worse. Design areas are generally to be avoided in this procedure. Powdery media and heavily printed areas must plainly also not be subjected to overall surface cleaning.

It is also important, before you begin, to determine if surface cleaning will alter the character of the paper. With unsized papers and extremely soft papers – most tissues, for example – even slight rubbing will pull up fibers and roughen the surface. Rubbing can dull highly polished "parchment" papers and colors sometimes offset easily. Always test the effects of any erasing technique in an inconspicuous corner of the artwork before proceeding. Permanent damage in the form of mottling and haloing can result from a too-vigorous surface cleaning.

Begin the surface cleaning procedure by gently blowing away any loose surface dirt on the face of the artwork with the photographer's bulb blower. Follow that by going over the surface with a soft brush – a soft *hake* Japanese brush about three inches wide is ideal. Brush from the center of the item out toward the edges. Use very light pressure and be especially cautious near powdery design areas. Brushing should be so light that the paper does not move. Very thin papers can be held into place under a blotter square secured with one's fingers. As dirt accumulates around the working surface, whisk it way with the drafting brush. Do not use the drafting brush on the artwork; its bristles are too stiff.

If the artwork remains dirty, after its surface has been lightly brushed, the next step is to use powdered white vinyl eraser crumbs. Sprinkle a small amount of the eraser crumbs onto the area to be cleaned. Working around sensitive design areas, lightly roll the crumbs in a circular motion with your clean fingertips (some conservators wear latex or nitrile rubber finger cots, especially for large-scale surface cleaning operations). As the eraser powder turns gray, blow or gently brush it away and apply more fresh crumbs. In order that your hands remain free, secure the artwork in place with a small weight placed over

a blotter square. Work systematically from the center of the work outward, replacing the eraser powder as it becomes soiled. As you approach the edges or corners of the artwork, use less pressure to avoid crimps and creases. Work carefully around areas of heavily colored inks or drawing media. Be especially mindful of existing tears and creases, which can be made worse by surface cleaning. Always work in the direction of the tear – never against it.

As you reduce surface dirt, keep in mind that any marks that are potentially meaningful in any way should be left alone. Such marks may reflect an artist's working process or an event that happened in the life of the work. Even a footprint on the verso of a drawing may not be accidental. While it is not likely that the gentle surface cleaning described here will remove any written inscriptions, it must be mentioned that even nonsensical words and numbers can be meaningful. One exception may be framer's marks or "carets," and calculations, which so often deface works on paper. When in doubt, it is prudent to leave all written marks until consultation with a curator.

If you appear to be picking up anything other than loosely adhered surface dirt – anything that resembles pigment or paper fibers – stop at once and reassess your cleaning procedure. Your powdered eraser may be too abrasive, your motion too vigorous, or the pressure applied by your fingertips too heavy. The goal is not to remove all the dirt on the surface of the artwork, leaving it spick-and-span but clearly for the worse for the cleaning; rather, surface cleaning is done to remove the surface dirt that may be transferred to other works and storage enclosures.

As you work, carefully brush away accumulated eraser particles with the soft-bristled brush. Eraser crumbs inadvertently left on the surface of a print or drawing can themselves attract dirt and dust, so they must be completely removed as well. Clean the surrounding working surface and – again it bears repeating – wash your hands frequently. Clean both the front or recto and the back or verso of the artwork with the eraser powder, being careful to never turn the artwork face down onto used eraser crumbs. Use the spatula to lift a corner of the artwork – gently – before grasping the entire sheet to turn it over.

When you have completed the above procedure, record your work in full on the examination report. Also, note any changes in the item's appearance.

REPAIRING TEARS

Old and new tears, ruptured folds and creases, and skinned patches of paper require repairing and reinforcement, work that can be performed by following or modifying the procedures described below. The goal of this process should be one of stabilization in order that the work can be more safely handled and prepared for storage.

Tools and Materials

Assemble the necessary tools and materials: a white vinyl eraser (Magic Rub®
by Sanford, Mars Plastic® by Staedtler); an assortment of different weights
of Japanese tissue; strained starch paste or methyl cellulose adhesive; a flat
firm-bristled brush one-fourth to a half-inch wide; brushes with pointed tips
in several small sizes; distilled, deionized, or filtered water; blotter squares;
polyester web squares; a bone folder or burnisher; pointed forceps; cotton
swabs; a sharp scalpel with Number 10 or Number 15 blades; a stainless steel
microspatula; small plate glass squares; and small weights. Useful sizes for
the blotter, polyester, and glass squares are 3 × 3 inches and 3 × 6 inches.

Procedure

First, examine the tear carefully. Are the edges worn and dirty, or are they
fresh? Do they come back together to join neatly, or is there a gap, show-
ing that the edges have been worn down? Are the edges of the tear beveled?
Proceed only after determining the configuration of the tear. Is it simple or
branched?

The next step is to clean and align the edges of the tear. To some extent, the
tear will already have been cleaned, following the surface cleaning described
above. Carefully brush away any eraser crumbs that may have become lodged
in the tear. Place a polyester web square below the tear. With the artwork
remaining face-up on a clean white blotter, very gently clean the edges of the
tear using a white vinyl eraser that has either a pencil or rectangular shape,
taking care not to disturb the exposed fibers. Remember, tub- or surface-sized
papers will have a tougher exterior than interior. Do not use colored erasers
or erasers containing pumice. Slide the eraser in the direction of the extended
fibers, not against them. The idea is not only to clean the fibers but also to
extend and realign them as much as possible for a strong and unobtrusive
repair. Then turn the artwork over and clean the other side of the tear. Always
remember that torn prints and drawings should be given extra overall support
when turning them over.

Align the edges of the tear, overlapping the fibers in their original ori-
entation as much as possible. The better the edge of a tear meshes with its
opposite edge, the better the repair will be both structurally and aesthetically.
Gently rolling a dampened swab in the direction of the fibers will help to both
clean and extend them. If the tear spreads apart easily, hold the edges in align-
ment by weighting the artwork on either side of the tear. Do not remove the
weights until the repair has fully dried, or the tear will pull apart.

Place a small amount of strained paste (see Appendix 1) in a shallow
dish and tamp it briskly with the flat brush, to eliminate any lumps. Mix it

thoroughly with a few drops of water until it has the consistency of yogurt or heavy cream; paste that is too thick will constrict as it dries, while paste that is too dilute may penetrate through to the front of the paper and be too weak. Starch paste does tend to retain its strength, however, even when diluted. Methyl cellulose adhesive can also be used, but without dilution.

Next, choose the tissue needed for the repair. The actual name or type of the tissue is not as important as its compatibility with the paper of the print or drawing. If the mending tissue is too thin, the tear will not be sufficiently reinforced, so that, if the artwork is flexed or curled, the tear is liable to tent, reopen, or spread. If the mending tissue is too thick, it will produce an embossed opaque stiff area behind the tear. Long multiple repairs that are too heavy will cause deformation of the entire sheet and furthermore, while the repair may remain intact, the weaker area to either side of it will tear when subjected to sudden stress. Generally speaking, the mending tissue should be slightly lighter in weight and color than the paper of the print or drawing. For lightweight paper, *tengujo* or *chumino* papers can be used; for papers of medium weight, *sekishu*; and for heavy papers, *okiwara*. Although today more generic, the names of Japanese tissues often describe their original place of manufacture and not weight, so the final selection must be done by feel, not by name. For example, *sekishu* is available in several weights. If reinforcing a thinned, not actually torn paper, select a very lightweight tissue. Tear off narrow strips of the tissue – one-eighth to one-fourth of an inch wide. The repair should be made with several shorter strips of tissue laid down slightly overlapping each other, rather than one long continuous strip of tissue.

After the edges of the tear have been cleaned and aligned, use a small brush with a pointed tip to apply starch paste or methyl cellulose adhesive just along the tear line. Starting at the innermost terminal end of the tear, with the brush tip, carefully stroke out the fibers of both torn edges, working to deposit the adhesive between the areas that overlap. Do not let the adhesive seep through to the front of the artwork if possible. The polyester web square will prevent the artwork from sticking to the blotter below if adhesive does reach the front. Rub the joined edges of the tear lightly with the bone folder through a polyester web square placed on top of the provisional mend. If you wish, the tear can be dried at this point by using a polyester web square, a blotter square, and a glass plate and a weight placed over it. Or you can continue to the next step.

Apply the thinned starch paste or methyl cellulose adhesive to the mending tissue strip while grasping its end with the forceps. Hold the strip of tissue against a piece of glass and brush along and outward as much as possible to extend the fibers of the mending tissue for better holding power. Pick up one end of the tissue with the forceps and quickly apply it, adhesive side down, to the innermost end of the tear. Using a brush or bone folder through polyester to tamp the repair into place. Cover it with a polyester web square and

lightly burnish to insure complete, overall contact. Working quickly, apply more sections of pasted-up tissue strips until the tear has been completely mended. A long branched tear may require mending in separate stages, one section being allowed to dry before tackling the next. To insure that the tear remains properly aligned as it dries, cover each section with polyester web squares, blotter squares, glass, and weights. Change blotters after 5 minutes and allow the repaired tear to dry thoroughly under pressure, even after it is apparently dry to the touch. Tissue mends extending beyond the edges of the sheet should be trimmed off with a sharp scalpel. Record what you have done on the examination report.

By modifying the mending technique just described you can repair a variety of tears and cracks or reinforce skinned areas in art on paper. If you misalign a tear or use the wrong tissue, remove it immediately by lightly rolling over it with a swab that has been dampened – not soaked – with water. Work in only one small area at a time, about an inch long. As soon as the repair and its adhesive are sufficiently softened, start to push or roll the tissue back upon itself, using a blunt knife, scalpel, or the tips of the forceps. Do not simply pull the repair off. To do this would exert too much stress on the back of the artwork, which is already somewhat softened from moisture. As you push the repair tissue back against itself, also gently scrape up the adhesive. Clean your knife often with a tissue to prevent the sticky paste from accumulating on it. Work along the entire area that has been moistened – do not stop in the middle of this operation. If the going is slow, the artwork may become saturated by the time you reach the end of the repair or, conversely, it may have dried out and curled. For these reasons, work on only small portions at a time and be especially cautious when ending the work in each area, since that is where the paper will have been exposed to moisture for the longest time.

When you have successfully removed the tissue used for the repair and as much of the adhesive as possible, you may notice that some of the adhesive remains embedded in the paper. This residue should be removed or reduced as much as possible, because if it remains, it will shrink as it dries and that will cause the paper to curl. To remove the residue of adhesive, lightly roll a dampened swab over it once or twice. Blot quickly and repeatedly to pick up the dissolved adhesive and to prevent it from penetrating farther into the paper. Use a fresh swab as often as necessary. When you feel that all of the paste has been removed, cover the area, front and back, with polyester web squares followed by blotter squares, glass plates, and weights. Change the blotters after 5 minutes and allow a total drying time of at least 30 minutes. More time will be needed if the paper of the artwork was penetrated by water in the process.

As you remove incorrectly applied repairs, keep in mind that you are working above an area that has already been damaged and be aware that its earlier problems can be easily aggravated by your actions.

Please note that the above procedure is intended only for removing tissue repairs recently applied using starch paste or methyl cellulose adhesive. Do not attempt to remove old repairs applied with aged, unknown adhesives. Tidelines, skinning, and additional damage can easily occur. A paper conservator should repair tears in works having sensitive media or tears that interfere with the design area of a print or drawing. Sometimes a sheet is so extensively torn or weakened by thinned areas that an overall lining with a Japanese tissue is advisable for auxiliary support. This, also, is a job for a paper conservator.

SPOT TESTING FOR WATER SENSITIVITY

Water should never by applied to a work of art in any form – liquid or vapor – until all the components of the work have been tested for sensitivity to water – including the paper itself. This is ascertained by a procedure known as "spot testing."

Procedure

To test for water sensitivity, use distilled, deionized, or filtered water, which is free from impurities. Using a tiny brush or even a toothpick, place a tiny droplet of the water – no more than one-sixteenth inch in diameter – on the surface on the paper in an inconspicuous area. Observe the droplet carefully, through a magnifying glass or a head loupe, noting saturation time. Allow the droplet to saturate the paper and then immediately press a small precut blotter square against the area. Inspect the blotter square to see if any color or impurities have transferred from the paper itself. If a brown ring forms around the perimeter of the wetted area, the paper contains substances that can move during wetting and cause staining. If this happens, do not proceed. Cover the spot test area with a blotter square, a glass square, and weight and allow the piece to dry thoroughly.

Next apply a tiny droplet of water to one color used in the design of the piece, again in an inconspicuous location. Again, observe the droplet carefully, noting saturation time, color changes, and softening or feathering of the medium's edges. Before the droplet dries or the very moment it saturates the medium, press firmly with a blotter square. Immediately lift the blotter square away and examine the test area to see if any trace of color has been picked up. It is a good idea to promptly draw a circle around the test area on the blotter square with a pencil and label which color was just tested. In this way, a record is kept of which colors have been tested and which are yet to be done. Examine the test area on the artwork itself for any changes in appearance – textural differences, color shifts, shininess, or dullness. If the artwork is affected by the application of water, do not proceed.

Repeat the spot testing on every color and type of medium used. Record the results on your examination report. They will inform any further actions you may elect to take and will be of interest to a conservator should further treatment be needed.

FLATTENING ROLLED ITEMS

Rolled-up objects, such as family documents, broadsides, and architectural drawings, frequently pose special problems in the process of cataloging and preparing items for storage. Often the materials used to make these kinds of objects were of poor quality to begin with, or the objects may have been handled roughly during their use. It is not unusual to find such works crushed and torn at either or both ends of the roll. Rolled-up tubes make cozy nests for animals and are often filled with nesting materials, seeds, or worse. To complicate matters, such items are often quite large, making handling difficult in general. Attempts to unroll or open the item up simply for processing can often produce more damage. Prints and drawings that have been rolled up for many years must be unrolled very slowly.

Tools and Materials

You will need a device that produces a fine even mist of water (air brush, spray gun, canned pressurized air with sprayer attachment, a plant (dahlia) mister, a sprayer with an adjustable nozzle, ultrasonic humidifier with flexible hose), distilled, deionized, or filtered water; white blotters; plate glass with beveled edges, one-quarter to one-inch thick; lens tissue or lightweight polyester web (Reemay® or Hollytex®); wool printer's felts, a quarter-inch to half-inch thick; heavy weights (felt-covered bricks, scuba diver weights, the unabridged *Oxford English Dictionary*, jars of shot, and other found objects).

It is useful to have one or two "flattening stations" permanently set up, with two sets of plate glass, blotters, and felt sheets cut to match. One set, for smaller items, could measure 20 × 26 inches; the other set, for items such as posters and large-scale drawings, could measure 30 × 36 inches. Since no two artworks are identical, the number of blotters and felts used below the glass should vary accordingly, but their dimensions should match those of the plate glass.

Each flattening station, or "press" as it is sometimes called, consists of printer's felt, six to eight blotters, and a sheet of plate glass. Printer's felt is different from ordinary felt, being made of pure wool fibers and as much as a quarter-inch to a half-inch in thickness. Weights and a few sheets of lens

tissue or fine polyester web should be readily available nearby, to protect sensitive surfaces during flattening.

Procedure

Examine the rolled-up item as thoroughly as possible without unrolling it, in order to identify the medium and to note any colors, which may be water soluble. Remove any insect or animal droppings and heavy dirt as much as possible using soft brushes.

The Humidity Chamber

Place the item in a humidity chamber. Such a device can be very simply constructed from a plastic garbage can with a tight fitting lid or a deep tray covered with a sheet of rigid acrylic. In the bottom of the container place a tray filled with hot water. Over the tray of water, invert a plastic crate, dish drainer, silkscreen frame, or plastic window screen, to prevent the artwork from falling into the water in the tray. Place the rolled-up item in the chamber and close the lid tightly. After a few hours, check on its progress. The humidity level within the chamber should have risen by this time; a small paper gauge or dial hygrometer placed inside the chamber will indicate the level of humidity present. The paper of the rolled work should feel softer and its "curl" less tight. If the humidity of the container has not risen significantly, add some hot water to the tray, or very lightly mist the interior of the container with a fine dahlia sprayer or use the vapor emitted by an ultrasonic humidifier before closing the chamber again. It may be necessary to keep the item in the container overnight. Double-check to insure that, when unfurled, the item cannot accidentally come into contact with the water at the bottom of the chamber.

When the artwork feels most relaxed, remove it and place it first on polyester webbing and then on an impermeable surface, such as a countertop or glass. This will slow down the evaporation of water. Using long, thin strips of mat board or blotter, weight down the outermost edge of the piece. Small glass squares may be placed on top of these to provide a better anchor. Slowly start to unroll the artwork, inserting long, thin strips of mat board parallel to the roll as you go. These will help to gently hold the paper flat and will prevent the item from rolling up again. If the paper is sufficiently relaxed, no more weight is necessary at this time. A sheet of blotting paper can be placed on top of the item while it slowly air-dries. If the artwork begins to resist your efforts to unroll it, lightly and indirectly mist it with water or, better, with the vapor emitted from an ultrasonic humidifier, so that it again relaxes. The piece can also be covered with lightweight plastic sheeting to delay drying. It is important that water droplets do not actually form on the paper or be

absorbed by it – they could easily cause staining if they penetrate the paper and dry. Also, water-sensitive media may be affected by direct application of water. When the work has been completely unrolled, proceed as you would in routine overall flattening, but remember that more relaxation in the paper will be needed before the artwork is placed under weight. Premature flattening under weight will cause the paper to crack along its undulations.

OVERALL FLATTENING

As has been observed repeatedly through this book, paper is not two-dimensional. It readily reacts to the environment around it or responds to the materials and techniques used on it. Thus, the deformation that results in paper may be unintentional or intentional. The purpose of the overall flattening procedure described below is simply to increase the safety with which a print or drawing can be handled and stored. For example, a letter that has been folded for years can be difficult to insert into a storage folder and the process can endanger the letter as well by cracking its stiffened fold lines. The steps involved – relaxation of the paper fibers and drying under pressure – may sound simple, but they require a concomitant sensitivity to the properties of the paper and aesthetics of the artwork. Extreme measures that have been taken in the past to flatten paper, such as mounting to stiff cardboard or even ironing, can easily and permanently destroy the subtle topography of prints and drawings.

Platemarks are valued characteristic of intaglio prints and must never be reduced. Moisture should never be applied directly to their embossed lines; if mending tears in their vicinity work carefully around them. The moisture and weight involved in any flattening technique should never exceed that produced by an intaglio press.

Procedure

Place the item to be flattened face down on one half of a clean white blotter folder, large enough to completely cover the piece when closed. The piece should have already undergone surface cleaning and any mending needed. Also, the paper and the medium in all its colors should have been tested for water sensitivity beforehand. If the piece is nonetheless still quite soiled, do not proceed – excessive surface dirt can cause tidelines from the movement of the water and can become more deeply embedded in the paper pores as they swell up and then constrict. If the work is reasonably clean, however, begin by holding the water sprayer at least two feet away from the object and spraying its verso. (*It is a good habit to always first test the sprayer by pointing*

away from the artwork, in case the device spurts or to ascertain the forceful-ness of its spray.) The paper may darken as it absorbs the water mist. If it is nonabsorbent, droplets may form on its surface. If they do not penetrate the paper in a few seconds, gently close the blotter folder and flip the entire piece. The paper will probably begin to move as the cellulose molecules expand with their intake of water. Short-fibered wood pulp papers like newsprint will move quite a bit and may even begin to curl up into a tube. If the paper starts to react vigorously, quickly and firmly close the blotter folder and flip the entire piece over. Slowly open the folder with your sprayer readily at hand. Lightly spray the front of the artwork, again from about two feet away. This will counteract the expansion of the other side and the paper will soon relax. Repeat these steps until the artwork is limp and evenly relaxed overall. Some nonabsorbent papers will require time and repeated applications of mist.

Carry the dampened artwork in the closed blotter folder to the flattening station. It is a good idea to have lifted up the glass and several layers of blot-ters beforehand, so that the press is ready to receive the dampened artwork. Place a sheet of lens tissue or lightweight polyester web onto the bottom blotter, the one onto which the artwork will be placed. Open the blotter folder slowly. The dampened artwork can be transferred onto the press either by grasping it by its "shortest" corners – those at the end of the piece's shortest width – or by its diagonal corners. If the piece has repaired tears, the tears should always hang vertically when the artwork is lifted and placed onto the blotters for flattening. After the piece has been placed onto the bottom blot-ter, cover it with a piece of thin polyester web or lens tissue. It is especially important to use either one of these materials to cover repaired tears whose adhesive may have been reactivated and could otherwise stick to the blotter. Place several blotters – four or five – over the protected piece followed by plate glass. Distribute heavy weights evenly across the surface of the glass. While there is no specific weight required, 30 to 50 pounds is the typical range used.

After 30 minutes, flip the blotters above and below the artwork, while keeping the lens tissue or polyester web in place, and continue drying under the same weights. The item should remain in the press for several days. After-ward, remove it, place it on a blotter in the open, and observe it. During the next few hours its deformation may return.

FLATTENING WORKS IN WATER-SENSITIVE MEDIA

Prints and drawings made with water-sensitive media can usually be relaxed in this way for flattening because only a small amount of moisture is involved and it is indirectly applied. Certain dyes, however, especially those found in

water-based felt-tipped markers, or the aniline purple in copy or indelible pencils, popular office supplies used well into the mid-twentieth century, will feather and bleed with even the slightest wetting (see Figure 4.1). Therefore, before attempting to flatten any artwork, it is essential to test carefully under good light and magnification if possible, not just the design media, but the inks used in signatures or collectors marks, as well. If the work does contain water-sensitive areas, and if they are discrete and small in size, simply mask them with paper scraps or a small tent of folded blotter during spraying, so that they are protected from direct moisture. Remember their location when spraying up the verso in order to avoid that area. If the color in question is used extensively throughout the piece, do not proceed. Common sense dictates that a tiny date written in a water-sensitive felt-tipped pen can be adequately masked during spraying and sufficiently relaxed prior to flattening, while a sheet of paper covered in writing using the same pen cannot.

FLATTENING REPAIRED ITEMS

The same indirect means of dampening paper should be used for works in which tears have been repaired using starch paste or methyl cellulose adhesive, particularly when spraying their versos. A small tent of folded blotter can be placed over the repaired tear while spraying above it. Remember the adhesives are reactivated when they become damp so always use a sheet of lens tissue or thin polyester web between them and the blotters used in flattening.

KEYS TO SUCCESSFUL FLATTENING

The success or failure of the flattening operation depends on the absorbency of the paper, its drying speed, the cause of the deformation, and the ambient temperature and relative humidity of the room. A general rule of thumb is to never rush any step of the procedure from the initial relaxation to the final drying under weight. Because of the many variables involved in flattening, stubborn paper deformations that defy initial attempts to flatten them may require several tries or modified drying techniques. More weight is usually not the solution. More frequent blotter changes, softer or thicker blotters, less absorbent "hard" packs, or more time in the press may be needed. Remember that the goal of the flattening procedures described here is simply to provide safer handling conditions for routine handling and storage of prints and drawings. If complicated manipulation is required to flatten an item in order to catalog it and wrestle it into its storage enclosure, better to contact a paper conservator.

A Word about Deacidification

In chapter 2 we saw how the internal and external sources of deterioration caused darkening of paper accompanied by its embrittlement, notable by a decrease in its ability to be flexed or curled. The piece – a newspaper clipping, an artist's sketch, or child's drawing – easily tears around the edges or shatters into jagged fragments. Surely, everyone has seen such a paper. Papers displaying these chronic all-over, all-out symptoms are sometimes recommended as candidates for aqueous or nonaqueous deacidification, whereby an alkaline reserve is precipitated within the structure of the paper. A pH indicator reading of below 7 or 6.6, the pH of pure cellulose, proves that the paper is acidic. But should deacidification, or acid neutralization or buffering as it is sometimes called, be the next step?

How to accurately measure and properly interpret the pH of paper are contentious issues for conservators. Superseding the debate on the best way to measure and interpret pH, however, is the pragmatic decision of what course of action to take next. Despite a long-standing scientific justification for deacidification, paper conservators have not wholeheartedly embraced the various alkalization processes that have been developed and widely advertised. Several theories can be advanced for this reluctance. First of all, many items do not come under the jurisdiction of conservation until their problems of darkening and embrittlement are manifest. At this point little can be done to reverse the damage since, to be effective, deacidification must occur before acid hydrolysis produces such symptoms. Secondly, conservators are wary of the unpredictable visual changes brought about by deacidification.

On the marketplace are several products available for nonaqueous spray deacidification, which are marketed specifically to scrapbooking enthusiasts who often incorporate ephemera into their creations. These products are not recommended for use on prints and drawings.

FINDING AND WORKING WITH A PROFESSIONAL PAPER CONSERVATOR OR COLLECTIONS CARE SPECIALIST

In North America, two national professional associations are excellent resources for locating and selecting a qualified paper conservator or collections care specialist who will provide sound, ethical preservation services for prints and drawings. As with other important decisions, a little time and effort to become an informed consumer will lead to optimal results.

A professional paper conservator or collections care specialist working in the United States today should be a member of the AIC, a national membership organization (501 c.6). Members having the peer-reviewed status of Professional Associate and Fellow have demonstrated their adherence to the

Institute's *Code of Ethics* and *Guidelines for Practice* and are permitted to include their membership status in advertising. The AIC maintains an online referral service, *Find a Conservator*, whereby its Professional Associates and Fellows, who have agreed to be listed, can be identified according to their geographical location, area of specialization, and type of services provided (http://www.conservation-us.org). It is important to realize that conservators and collections care specialists are not licensed or accredited in the United States. Accreditation is in place in Europe and Canada. The AIC website also has informative guidelines, *How to Choose a Conservator*, which suggest that the following preliminary questions be asked of each candidate:

1. What is your background?
2. What are your educational and training credentials?
3. How long have you been a practicing professional?
4. What is the scope of your practice? Is conservation your primary activity?
5. What is your experience in working with works of art on paper?
6. What is your involvement in conservation organizations?
7. What is your availability?
8. Who are your references and previous clients?

For single-item conservation treatments, you can expect the following practices:

1. Procedures: A conservator will want to examine the item before suggesting a treatment. Prior to beginning a treatment, the conservator should provide for your review and approve a written preliminary examination report with a description of the proposed treatment, expected results, and estimated cost. You may be asked to initial a statement allowing the conservator to modify the proposed treatment if unforeseen developments make that advisable. Often, in the course of treatment, it is necessary to resort to procedures not specified in the proposal in order to address unexpected deviations.
2. Cost and schedule: The conservator should be willing to discuss the basis for all charges. Determine if there are separate rates for preliminary examination and evaluation and if these preliminary charges are separate or will be deducted from a subsequent contract. Paper conservators do not ordinarily mat and frame prints and drawings following treatment, but may be able to do so. Acquaint yourself thoroughly with the limits of your insurance coverage before letting a work of art leave the collection for treatment. Ask questions about the conservator's facility, security, insurance, payment terms, shipping, and any additional charges. Conservators often have a backlog of work; inquire if a waiting period is necessary before new work can be accepted.

3. Documentation: The conservator should provide a treatment report when treatment is completed. Such reports may vary in length and format but should list materials and procedures used. The final report may, if appropriate, include photographic records documenting condition before and after treatment. Recommendations for continued care and maintenance may also be provided. Both written and photographic records should be clear and understandable to a layperson. All records should be retained for reference in case the object requires treatment in the future or changes ownership.

Preventive conservation activities, such as condition surveys, rehousing projects, digitization preparation, or relocation of collections, will involve different procedures and require different staffing, but should still reflect the professional standards of the AIC.

In Canada, two related national organizations are the Canadian Association for Conservation of Cultural Property (CAC/ACCR) www.cac-accr.ca/home and the Canadian Association of Professional Conservators (CAPC) http:// capc-acrp.ca/index.asp, the latter conferring accreditation. Together they have published *Selecting and Employing a Conservator in Canada*, which is available on their websites.

The Foundation of the AIC (FAIC) is a nonprofit entity (501 c.3) that supports conservation education, research, and outreach activities. It maintains valuable resources for anyone with an interest in preserving cultural heritage.

The importance of establishing and maintaining a solid working relationship with a paper conservator or collections care specialist cannot be overstated. It requires direct (never via a business representative), ongoing communication, and trust on both sides. The conservator should be sensitive to your concerns and willing to discuss all procedures and their rationale in detail and you, in turn, should be willing to modify expectations in deference to the conservator's expertise. If you are not pleased with the results of the treatment or confused by the terminology used in the report, talk it over with the conservator, immediately. Only through honest communication can a satisfactory working relationship between conservator and caretaker, owner, or curator be maintained.

FURTHER READING

American Institute for Conservation of Historic and Artistic Works. www.conservation-us.org (accessed 3/14/2016).
———. *Code of Ethics and Standards for Practice*. 1994. http://www.conservation-us.org/about-us/core-documents/code-of-ethics-and-guidelines-for-practice#. Vu7hBxIrK3U (accessed 3/14/2016).

Appelbaum, Barbara. *Conservation Treatment Methodology*. Oxford: Butterworth-Heinemann, 2007.

Art and Archaeology Technical Abstracts. http://www.aata.getty.edu (accessed 3/14/2016).

Australian Institute for Conservation of Cultural Property. http://aiccm.org.au/ (accessed 3/14/2016).

Baker, Cathleen. *From the Hand to the Machine: Nineteenth-century American Paper and Mediums: Technologies, Materials, and Conservation.* Ann Arbor: Legacy Press, 2010.

Banik, Gerhard, and Irene Brückle. *Paper and Water: A Guide for Conservators.* Oxford: Butterworth-Heinemann, Elsevier, Ltd., 2011.

Bearman, Frederick. "Conservation Principles and Ethics: Their Origins and Development." In *IPC Conference Papers London 1997: Proceedings from the Fourth International Conference of the Institute of Paper Conservation, 6–9 April 1997,* edited by Jane Eagan Leigh. Leigh: Institute of Paper Conservation, 83–89.

Bewer, Francesca. *A Laboratory for Art: Harvard's Fogg Museum and the Emergence of Conservation in America.* Cambridge, New Haven, MA: Harvard Art Museum, Yale University Press, 2010.

Boston Museum of Fine Arts. *Conservation and Art Materials Encyclopedia Online (CAMEO)*. http://cameo.mfa.org/wiki/Main_Page (accessed 3/14/2016).

British Library. *Collection Care.* http://www.bl.uk/aboutus/stratpolprog/collection-care/conservetreat/ (accessed 3/14/2016).

Canadian Conservation Institute. http://www.cci-icc.gc.ca/ (accessed 3/14/2016).

———. *Preserving My Heritage.* www.preservation.gc.ca (accessed 3/14/2016).

Canadian Heritage Information Network. http://www/chin.gc.ca (accessed 3/14/2016).

Clapp, Anne. *Curatorial Care of Works of Art on Paper.* New York: Nick Lyons, 1987.

Collections Trust. "Benchmarks in Collections Care." *Collections Trust.* www.collectionstrust.org.uk/collections-link/collections-management/benchmarks-in-collections-care (accessed 3/14/2016).

Conservation OnLine. www.cool.conservation-us.org (accessed 3/14/2016).

Donnithorne, Alan. "Early Approaches to the Conservation of Works of Art on Paper: Cleaning, Repair and Restoration." In *Early Advances in Conservation, British Museum Occasional Paper No. 65,* edited by Vincent Daniels, (1988): 15–25.

Ellis, Margaret Holben, ed. *Historical Perspectives in the Conservation of Works of Art on Paper. Readings in Conservation.* Los Angeles: The Getty Conservation Institute, 2014.

Foundation of the American Institute for Conservation of Historic and Artistic Works. *Connecting to Collections Care Online Community.* www.connectingtocollections.org (accessed 3/14/2016).

Hicks, Catherine. "Early Approaches to the Conservation of Works of Art on Paper." In *Early Advances in Conservation, British Museum Occasional Paper No. 65,* edited by Vincent Daniels, (1988): 7–12.

International Institute for Conservation of Historic and Artistic Works. https://www.iiconservation.org/ (accessed 3/14/2016).

Institute for Conservation. http://icon.org.uk/ (accessed 3/14/2016).

Kosek, Joanna M. "Restoration of Art on Paper in the West: A Consideration of Changing Attitudes and Values." In *Restoration: Is It Acceptable? British Museum Occasional Paper No. 99*, edited by Andrew Oddy, (1994): 41–50.

Library of Congress. http://www.loc.gov/preserv/ (accessed 3/14/2016).

National Archives and Records Administration. http://www.archives.gov/preservation/formats/ (accessed 3/14/2016).

National Archives of Australia. http://www.naa.gov.au/collection/family-history/family-archive/indes.aspx (accessed 3/14/2016).

National Center for Preservation Technology and Training. http://www.ncptt.nps.gov (accessed 3/14/2016).

National Park Service. *Conserve-O-Gram.* http://www.nps.gov/museum/publications/conserveogram/cons_toc.html (accessed 3/14/2016).

National Trust for Historic Preservation. http://www.preservationnation.org (accessed 3/14/2016).

Northeast Document Conservation Center. http://www.nedcc.org (accessed 3/14/2016).

Saving Your Treasures. *Saving Your Treasures.* http://www.netnebraska.org/extras/treasures/index.htm (accessed 3/14/2016).

University of Illinois. *Preservation Self-Assessment Program (PSAP).* https://psap.library/illinois.edu (accessed 3/14/2016).

Warda, Jeffrey, Franziska Frey, Dawn Heller, Dan Kushel, Timothy Vitale, and Gawain Weaver. *The AIC Guide to Digital Photography and Conservation Documentation.* 2nd. 2011. Washington, DC: American Institute for Conservation of Historic and Artistic Works. http://www.conservation-us.org/publications-resources/special-projects/the-aic-guide#.Vu8q8BIrK3U (accessed 3/14/2016).

Glossary

This Glossary is intended to define terminology used throughout *The Care of Prints and Drawings* in order to encourage consistency of usage and foster clearer communication. Each definition is limited to the term's conservation parlance and does not include other possible meanings. Popular brand names of some products have been included; inclusion does not constitute endorsement.

À l'essence A pigment diluted only with a solvent with a minimum of binder added, which allows it to be used in a saturated form.

À la poupée Localized coloring applied with a dauber or brush to a printing matrix by hand, sometimes through stencils.

Abaca tissue An unbuffered long-fibered thin paper made from hemp fibers, which is soft and strong; used mostly as a packing and cushioning material.

Abbey pH Pen® See pH indicator/pencil/meter/pen.

Abrasion Rubbing, scraping, or wearing away of the medium or roughing up of the paper support of a print or drawing, usually noticed along the highpoints of the medium, creases in the paper, or where the window mat touches the image's perimeter.

Absorbent Capable of taking in liquids or gases or energy, such as light and heat.

Absorption Penetration of a substance into the structure of another, such as through capillary action or the retention of energy, such as heat or light.

Accelerated aging Induced aging under laboratory conditions intended to hasten chemical reactions typically by exposure to high temperature and/or light. Accelerated aging does not replicate natural aging but some correlation has been suggested.

Accretions Small bits of accidental foreign matter adhered to the surface of a print or drawing; flyspecks are common accretions.

Acetate See Cellulose acetate.

Acid A substance capable of forming hydrogen ions when dissolved in water. Acids measure less than 7 on the pH scale. Acids may be introduced during the

manufacture of paper, as with certain sizing formulations, or afterwards, by migration from other materials or from atmospheric pollution.

Acid burn See Burn.

Acid deterioration The weakening of paper by acidity through hydrolysis, resulting in a reduction in the degree of polymerization (length of structural chains) and bringing about a drop in paper strength. Acids may be internal, that is, a result of the papermaking process, or external, that is, introduced by migration from other acidic materials or atmospheric pollution.

Acid-etched A method of making nonreflective glass whereby one side of the glass is etched by acids. To be effective the artwork must be in direct contact with the glass. This type of nonreflective glass has largely been supplanted by optically coated acrylic sheets.

Acid hydrolysis A chemical reaction in which an acid reacts with water or moisture in the air, causing organic chain breakage. In paper, it is characterized by embrittlement.

Acid ink See Iron gall ink.

Acid migration The movement of acidity from one substance, typically poor-quality matting and framing materials, into an absorbent, less acidic material when the two are in close proximity. Mat burn is a common example of localized acid migration.

Acid neutralization A term often incorrectly used for deacidification, in which an alkaline substance is precipitated within the structure of paper; may also mean simply a reduction of acidity.

Acid-free A popular and loosely applied term referring to matting, framing, and storage materials having at the time of their manufacture a neutral pH; sometimes used inaccurately as a synonym for alkaline or buffered.

Acid-free corrugated cardboard (Blueboard) Single- or double-walled corrugated cardboard, commonly colored blue or gray, that has been rendered acid-free; may be lignin-free, and/or buffered to raise the pH to 7.0 or above.

Acid-free foamboard A board made of foamed plastic (polystyrene) material sandwiched between coated paper from which the acids have been removed or have been chemically neutralized to raise the pH above 7.0.

Acidic Characterized by having a pH measurement of less than 7.0.

Acidity A condition in which the concentration of hydrogen ions in an aqueous solution exceeds that of hydroxyl ions as determined by a pH value of less than 7.0.

Acrylic General term used to describe a large family of polymers and copolymers where at least one principal structural unit or monomer is derived from acrylic or methylacrylic acids or their esters. Polymethyl methacrylate is the most important of the group. Valued for their strength and flexibility, acrylic resins are typically employed as consolidants, fixatives, adhesives, and surface coatings. The resins have also been marketed as solid sheets available in various thicknesses.

Acrylic resin emulsion/dispersion Synthetic acrylic resin suspended as tiny droplets in water; the resulting solution can be used as a painting medium, coating, or adhesive.

Acrylic sheet A solid thermoplastic sheet made from acrylic polymers. Noted for its lightweight, transparency, weather resistance, color fastness, rigidity, high optical

clarity, and impact resistance. It is inherently stable and resistant to chemical changes that may cause yellowing or increased haziness.

Acryloid B-72® Before 1997, an ethyl methacrylate/methyl acrylate copolymer manufactured by Rohn and Haas Company; now Paraloid B-72®.

Activated charcoal/carbon Amorphous carbon produced from charcoal, which has been subjected to high heat (800–900°C) with steam or CO_2 to produce porous, high surface area particles capable of efficient adsorption of gases and vapors.

Adhesive Any substance, that is capable of bonding materials to each other by chemical or mechanical action or both.

Adhesive tape A thin, narrow paper, plastic, or fabric carrier coated with an adhesive, which may be water, solvent, or heat-activated, or is pressure-sensitive. Tapes are usually classified by the way they are affixed or by the nature of their carrier, that is, pressure-sensitive tape or linen tape.

Adsorption The adherence of atoms, ions, or molecules of a gas, or a mixture of gases, a liquid, or material dissolved in a liquid, to the surface of another material.

Agar-agar A dried mucilaginous substance extracted from marine algae or seaweed. When mixed with water it swells into a hygroscopic gel, which is used in conservation as a carrier for enzymes or as a poultice.

Aigami Also called dayflower blue, a plant-derived dye used in *ukiyo-e* printing. It is extremely sensitive to light.

Air brush An instrument, powered by compressed air, used to spray liquids through a controllable nozzle with great precision.

Air-drying The drying of wet paper in a current of air at room temperature, as distinguished from drying by contact with heat or by putting between blotters under weight.

Air space The space between the work of art and the glazing in a frame.

AKD See Alkyl ketene dimer.

ALARA As Low As Reasonably Achievable; used as a measurement for levels of human exposure to radiation.

Albumin The proteinaceous white of an egg occasionally used as a binder or as a transparent coating.

Alcohol Commonly used to indicate ethyl, methyl, or isopropyl alcohol. A generic term used to describe organic compounds whose primary functional group is a hydroxyl (OH^-).

Alizarin A natural or synthesized organic red compound, traditionally used to dye textiles.

Alkali A compound that dissolves in water and releases hydroxyl ions (OH^-), thereby forming a basic solution with a pH greater than 7.0. Because an alkali neutralizes acid (H+), which promotes the breakdown of paper, an alkaline reserve is sometimes introduced into paper, which impedes the process of degradation.

Alkaline Characterized by having a pH of more than 7.0.

Alkaline bath 1. A water bath with an alkaline solution added to swell the paper fibers and flush out more dirt or to raise the pH of the sheet after washing. **2.** In the case of calcium or magnesium additives, to render deionized water less "ion hungry," thus not diminishing already existing alkaline reserves in the sheet.

Alkaline reserve 1. The amount of alkaline precipitates that form in deacidified paper upon exposure to air. A reserve of 2–3 percent of precipitates is considered a reasonable level for permanence. **2.** In accordance with ANSI Z39.48-1984, the compound, typically calcium carbonate, in mat board and other paper-based storage materials, deliberately introduced in order to impede acid degradation, by acting as a buffer to maintain a pH greater than 7.0. A 2–3 percent reserve is generally recommended.

Alkalinity The condition of a solution or material in which hydroxyl ions (OH^-) exceed hydrogen ions (H^+) above pH 7.

Alkyl ketene dimer (AKD) A synthetic internal sizing agent for paper that is more chemically stable than alum/rosin sizing.

Alpha cellulose The portion of a cellulosic material that is insoluble in 9.45 percent sodium hydroxide solution, after the material has been previously swollen with 17.5 percent sodium hydroxide. This portion is considered to be the highest molecular weight, that is, the longest fibers, and purest form of cellulose. Traditional Western papermaking fibers such as linen and cotton have naturally high percentages of alpha cellulose.

Alum (Common alum, Potash alum) Aluminum potassium sulfate; colorless crystals. $AlK(SO_4)_2$ $12H_2O$ (CAS 11043-67-1) Refers to the traditional substance used to harden gelatin tub sizing.

Alum/rosin sizing A type of sizing having as its primary constituent rosin derived from pine trees. Untreated rosin dissolves in water and is chemically very reactive. During the wet stages of papermaking, the rosin is combined with aluminum sulfate, confusingly called papermaker's alum, and forms an insoluble precipitate, which is especially attracted to unrefined wood pulp.

Aluminum sulfate A sizing substance, $2AlS_3O_{12}$ also called papermaker's alum, used to form and precipitate insoluble rosin within the structure of usually wood pulp paper during the wet stages of papermaking (CAS 10043-01-3).

Amate/Amatyl A type of felted bark paper made in pre-Hispanic Mexico.

Amorphous silica Pure, chemically inert silicon dioxide typically used as a dehumidifying or humidity buffering agent (CAS 63231-67-4).

Amylopectin The primary component of starch.

Amylose The secondary component of starch.

Anaerobic Living, active, or occurring in an oxygen-free environment.

Angstrom (Å) A unit of wavelength; 10 Å = 1 nanometer.

Aniline dye A dyestuff prepared from the distillation products of coal-tar, a byproduct of coke and coal gas manufacture, consisting mainly of carbon, hydrogen, nitrogen, and sometimes sulfur. Classes of aniline dyes include acid dyes, basic dyes, and direct dyes (based upon the method of application). The term originally applied to dyes derived from aniline, but today is used broadly for synthetic organic dyes and pigments, whether or not they are derived from the aniline dyestuff.

Animal glue See Glue.

Animal membrane A term occasionally used instead of parchment or vellum.

Anodized Coated with a protective oxide film by an electrolytic process; typically applied to aluminum or other light metal to make the surface harder.

Anoxic An environment having insufficient oxygen to sustain plant or animal life.

ANSI American National Standards Institute. http://www.ansi.org

Antireflective See Nonreflective.

Antistat See Antistatic agent.

Antistatic agent (Antistat) A solution that prevents or minimizes the formation of static electricity, typically applied to acrylic glazing.

Aquarelle pencil See Watercolor pencil.

Aquatint A type of intaglio print produced by melting powdered rosin onto a metal plate and then etching the plate in an acid. By varying the densities of the rosin and time in the etching bath characteristic tonal effects resembling watercolors are produced.

Aqueous Containing water.

Archival (Archivally sound) A nontechnical qualitative term that describes a material or product that is permanent, durable, or chemically stable, and can therefore be safely used for preservation purposes.

Archive One or several historical records or documents deemed to be significant and worthy of preservation.

Art-Sorb® Amorphous silica.

Aspirating Drawing or sucking in; usually applies to a psychrometer, which pulls in air via a small electric fan.

Assemblage The term assemblage refers to works made with three-dimensional objects mounted or joined together, sometimes free standing; assemblage can also refer to the technique of collage, which employs two-dimensional objects adhered onto a flat surface.

Assembly The package, consisting of the glazing, window mat, artwork, back mat board, and backing board, which is inserted into a frame.

ASTM American Society for Testing and Materials. http://www.astm.org

Atomizer A device for creating small droplets of a liquid, generally used prior to the invention of the aerosol spray can.

Attachments Hinges, labels, stamps, or other extraneous material adhered to a print or drawing; they may or may not be significant.

Auxiliary support An additional paper, cardboard, or fabric, potentially of historic or aesthetic significance, provided to physically support a print or drawing.

Back mat board (Bottom mat) The mat in direct contact with the verso of the artwork and to which the artwork is typically attached.

Back paper See Dust cover.

Backboard See Backing board.

Backing board The stiff foamboard, corrugated paper, or plastic board inserted into the frame to protect its contents from physical and atmospheric damage.

Backing See Lining.

Ballpoint pen A handwriting instrument having as its distinguishing feature a writing tip containing a rotating ball for contacting the writing surface for the purpose of depositing the writing fluid onto the writing surface.

Baren A smooth burnishing tool used in the production of *ukiyo-e* prints.

Barrier A sheet of heavy neutral or alkaline paper or clear polyester film inserted into a frame package to prevent acid migration or to retard the penetration of humidity.

Basic dyes A family of dyes having an affinity for ground wood, thus, used in the coloring of poor-quality papers such as construction paper. Basic dyes are brightest tinctorially, but have generally poor lightfastness.

Bast fiber A strong woody fiber obtained chiefly from plants such as hemp and flax used in the manufacture of cordage, matting, fabrics, and paper.

Beater A machine designed to cut and fibrillate papermaking rag fibers as part of pulp preparation.

Beni An organic pink colorant derived from the safflower used in *ukiyo-e* print production.

Beta (β) radiography A process for imaging watermarks and other variations in paper density by the use of a methyl methacrylate sheet impregnated with carbon-14. Carbon-14 emits beta particles, which can penetrate average thicknesses of paper. A sheet of x-ray film, placed on the opposite side of the paper being examined, is thus selectively exposed according to the degree to which the beta rays are able to pass through the sheet.

Beva® A thermoplastic adhesive.

Bevel The angled (usually 45°) cut edge of the opening of a window mat.

Binder A substance that causes particles to adhere to one another, as in dry media, or holds them in suspension, as in wet media.

Biro See Ballpoint pen.

Bister (Bistre) 1. A rich brown drawing ink extracted from the organic deposits of soluble tars and resinous soot that accumulate in the chimneys of wood-burning fireplaces. **2.** The color associated with this pigment.

Bistre See Bister.

Black chalk A form of natural carbon, having slaty impurities that allow it to be carved into rods and used for drawing.

Black lead See Graphite.

Black light Long-wave ultraviolet radiation.

Blackened lead white The gradual conversion of lead carbonate (and also other lead-based pigments such as red lead or vermilion) to lead sulfide when exposed to hydrogen sulfide, a common ingredient in air pollution. The reaction causes the white pigment to turn a deep gray, metallic color.

Blanching A lightening or clouding over of aged paint or varnish films.

Blankets See Felts.

Bleach The act of, or agent used in, lessening discoloration or staining of paper or medium.

Bleaching The lessening of localized or overall discoloration by the use of an oxidizing or reducing agent.

Bleeding (Running) The migration of nonfast colorants caused by water, water vapor, or other solvent, resulting in a blurred or feathery edge of the medium or mottling of the paper support. Movement of medium may occur laterally, called feathering, or may penetrate to the verso, called sinking.

Blending stump See Stump.

Blind stamp An uninked, embossed symbol created by die stamping or intaglio printing, used by collectors and for commercial purposes by print publishers and printmakers since the nineteenth century.

Blocking The tendency of a film to adhere to itself.

Bloom A whitish haze seen in varnishes resulting from either excessive humidity or inherent factors, sometimes called blush; a similar effect caused by the saponification of fatty or waxy media, such as crayons, oil pastel, and paint stick, sometimes called efflorescence.

Blotting paper Unsized, porous paper having little wet strength. Intended to absorb water and/or ink. It can be made of rags, cotton linters, chemical or mechanical wood pulps, or a mixture of these. The traditional color of blotting paper in the early nineteenth century was pink because it was originally made from turkey red-dyed cotton rags, which could not be bleached.

Blueboard See Acid-free corrugated cardboard.

Blush See Bloom.

Board See Fiberboard, Pressboard, or Solid board.

Bone folder (Paper knife) A thin narrow tool made from polished bone used for smoothing window mat bevels, burnishing repairs or tapes, and creasing.

Borax (Sodium borate) A white powder added as a suspension agent to India ink; also used as a detergent. $Na_2B_4O_7 10H_2O$ (CAS 1303-96-4).

Bottom mat See Back mat board.

Brad A short, thin nail with a small head typically used to secure a backing board into a frame.

Brad setter (Fitting tool, Driver, Pusher) A device designed to firmly insert brads into the molding of a frame using pressure, thus minimizing shock and vibration as would result from a hammer. Usually one face is cushioned to prevent damage to the frame molding.

Brayer A cylindrical tool made of rubber, wood, or plastic that can be rolled across the surface of an item delivering smooth even pressure; also used for applying an even coat of ink to a surface to be printed, that is, a woodblock.

Break An abrupt rupture in paper.

Bristol board A general term for a solid or laminated heavyweight paper made in thicknesses of one to four 0.006 inch plies, and in several finishes. The name is derived from the original product manufactured in Bristol, England.

Brushing out See Fibrillation.

Bubblewrap® Plastic film incorporating compartments of air, used for cushioning purposes; the air will eventually escape and the plastic deteriorate; not for long-term storage.

Buckling See Cockling.

Buffer In chemistry, a solution or material that contains both a weak acid and its conjugate weak base such that the addition of other acid or alkali causes only slight changes in the pH; also, the alkaline reserve contained in paper-based materials in order to counteract acids that may form in the future.

Buffered tissue Thin paper, typically used as interleaving sheets, containing an alkaline reserve.

Buffering agent The substance added usually as a precipitate to maintain or raise pH; in paper-based boards, it is typically calcium carbonate ($CaCO_3$).

Bulge A localized distortion.

Bumpers Small rubber, plastic, or cork circles or hemispheres affixed to the bottom corners of the back of a frame molding in order to keep it away from the wall, hence reducing marking of the wall and increasing air circulation behind the frame.

Burin An engraving tool used to cut grooves of differing profiles into a metal plate for intaglio printing.

Burn (Acid burn) Discoloration and embrittlement of paper typically resulting from acid migration.

Burnished An area of the paper or design made shiny and lustrous by rubbing or by flattening out the paper fibers.

Burnisher A smooth agate or bone polisher; in printmaking a steel polisher used to smooth mezzotint or aquatint passages for highlights.

Burr The raised line of metal above the surface of a metal plate, which has been incised, as in engraving or dry point. It is particularly characteristic of drypoints, where the burr produces a soft, velvety halo until it is worn down from repeated printing.

CP See Cold press.

CAD See Computer-aided design.

Calcium carbonate A white odorless compound occurring in nature as the minerals calcite, aragonite, and vaterite; limestone, marble, and chalk are natural calcium carbonate. Also in plant ashes, bones, and shells. Often used as a buffering agent in paper and boards; also a white acid-sensitive pigment. $CaCO_3$ (CAS 471-34-1).

Calendering A finishing process in papermaking whereby the sheet of paper is heated or chilled under pressure in order to create a smooth, burnished surface.

Caliper 1. The thickness of a material measured under specific conditions. Caliper is usually measured in thousandths of an inch (mils or points) or, under the metric system, in millimeters. **2.** A device having two curved arms joined at one end, used for measuring the thickness of a paper or board.

Capillary action The tendency of absorbent materials, such as paper, to pull liquids and vapors into their interstices.

Capillary matting A nonwoven synthetic fiber material that is designed to absorb moisture in one direction.

Carbon black ink A true black drawing or writing ink containing as a pigment finely divided particles of carbon, usually derived from the incomplete combustion of hydrocarbons, called lampblack.

Card Thin, flexible, usually laminated and highly calendered cardboard.

Cardboard A generic term describing a laminated or filled board of varying thicknesses all stiffer than paper.

Caret A V-shaped framer's mark indicating the placement of the work or the location of the corner of a window mat opening.

Carrier See Support; see Vehicle. Also, in adhesive tape, the paper, plastic, or fabric surface that has been coated with an adhesive.

Cartoon The final, full-scale preparatory drawing intended for transfer to the working surface by scribing, or pouncing; usually for an easel painting, fresco, stained glass, or tapestry of large size. Cartoons are often in poor condition owing to their original function.

Cartouche A decorative motif usually containing the name of the artist, date, or collector found either on the artwork itself or on its mat or frame.

Casein A milk-derived protein used as a vehicle in paints, coatings, and adhesives.

Catalyst A substance that initiates a chemical change or reaction.

Cellulose A polysaccharide (glucose) polymer $(C_6H_{10}O_5)_n$ that is the chief constituent of the cell walls of all plants and, hence, often the chief constituent of paper.

Cellulose acetate A thermoplastic resin produced from wood pulp or cotton linters, soluble in acetone. In conservation it is used for lamination, a process largely discontinued.

Cellulose ether (Cellulose gum, Sodium carboxymethyl cellulose, Methyl cellulose, Hydroxypropyl cellulose, Hydroxyethyl cellulose) A family of white, bulky solids made by the action of acid and alkali on wood pulp, having extremely hygroscopic properties; used in conservation as adhesives, poultices, cleansing agents, consolidants, and coatings. Solubilities and aging characteristics vary widely.

Cellulose gum See Cellulose ether.

Cellulose nitrate (Nitrocellulose) The polynitrate ester of natural cellulose. It is the principal ingredient of lacquers and various plastics and films, and was used in conservation as an adhesive for ceramics and as a coating for metals. Nitrocellulose decomposes rapidly and is highly flammable.

Cellulose powder Pulverized alpha cellulose used in conservation procedures for making fills or for poulticing.

Centipoise A unit for measuring viscosity; in conservation typically used to differentiate cellulose ethers at standard percentages.

Chain line The regularly spaced straight marks in laid paper formed by the stitching wire in a papermaking mold.

Chalk See Black chalk, Red chalk, White chalk.

Chamois A soft, cloth-like leather material from suede finished sheep or lamb skin used for blending tones in works made with most dry drawing media or for erasing; originally made from the skin of a chamois, a small antelope.

Charcoal A drawing medium derived from the carbonization of wood or vine twigs with no added or naturally occurring binder.

Charge See Furnish.

Chemical pulp See Pulp.

Chemical stability Not easily decomposed or otherwise modified chemically. This is a desirable characteristic for materials used in conservation since it suggests an ability to resist chemical degradation over time and/or upon exposure to various conditions during use or storage.

China clay See Kaolin.

China grass See Ramie.

China paper (India paper) 1. A soft, waterleaf paper made in China from bamboo fiber. The absorbency of the paper allows very fine impressions to be pulled from a plate; however, the flimsy paper is usually supported by a plate paper (*Chine collé*). China paper is also referred to as India (proof) paper, as a result of the eighteenth-century tendency to describe as Indian anything that came from Asia. **2.** Also, an extremely smooth paper made opaque by the addition of a clay filler.

Chine appliqué See India proof print.

Chine collé See India proof print.

Chipboard An inexpensive board made entirely from recycled paper products, containing a variety of impurities.

Chop mark (Printer's chop) An inked or uninked symbol stamped or embossed onto a print by the printer or publisher.

Chumino A lightweight Japanese paper.

Clam shell box A protective storage container consisting of two side-by-side attached trays that fit into one another.

Clear glass Glass having a smooth or polished surface on both sides.

Cleavage Separation of paint layers from each other or from their support.

Climate control The ability to maintain temperature and relative humidity at constant levels.

Coated paper Paper that has received a coating of clay or other pigment and adhesive materials in order to improve its finish in terms of printability, smoothness, and opacity.

Cockling (Waving, Buckling, Warping, Curling, Undulation, Gondolage) Localized deformation or a repeating and regular pattern of deformation in paper, usually across the sheet or around the edges due to irregular drying or fluctuating relative humidity. Cockling is sometimes considered to be more closely and regularly spaced than buckling.

Code of Ethics A set of rules or standards describing professional behavior and practices, usually set up by an organized group or association. The first Code of Ethics for conservators was proposed and approved in 1963.

Codex A handwritten manuscript constructed of a number of sheets of paper, parchment, or papyrus joined along one side only that are turned to be read.

Cold press (CP) Smooth-surfaced paper finished by placing between metal plates and running between heavy rollers; its texture is not as smooth as hot pressed. See also Not.

Collage A work of art comprised of cut, torn, and pasted papers, fabrics, and other ephemera, often drawn upon or otherwise decorated.

Collections Care Program An institutional policy that specifically describes how preventive conservation is incorporated into all practices involving collection items.

Collections care specialist An individual who is trained and experienced in specific preventive care activities and who works in conjunction with, or under the supervision of, a conservator.

Collections Management Policy A written document that specifies an institution's policies concerning all collections-related activities.

Collector's mark A stamped or embossed monogram, name, or symbol designating ownership of an artwork.

Collograph An embossed intaglio print pulled from a plate onto which are affixed textured elements such as fabric, lace, wire, or cardboard.

Collotype A photomechanical reproductive process involving the use of photosensitized gelatin; under magnification, the print is characterized by a reticulated tonal pattern.

Colophony See Rosin.

Color print A print in which the colors are entirely produced through an indirect method of application, that is, one of various printing techniques using colored inks.

Color shift Fading or darkening.

Color transfer The migration of certain colors contained in a dye mixture from one drawing to materials found in close proximity to the drawing for extended periods of time, possibly caused by high boiling point solvents and/or oil-soluble dyes susceptible to sublimation.

Colorant A generic term for an inorganic or organic pigment or a natural or synthetic dye.

Colored pencil A drawing or writing implement containing a lead composed of pigmented or dyed marking material.

Colored print See Hand-colored print.

Common alum See Alum.

Compensation (Inpainting, Retouching) Replacement of design or support only in areas of loss.

Compound/Composite support A support composed of joined papers or cardboards.

Computer-aided design (CAD) is the use of computer programs to create two- or three-dimensional (2D or 3D) graphical representations of physical objects.

Condition The physical state of an object as determined by visual, analytical, and chemical analysis.

Condition report A written description of the physical state of an object that may include photographs, sketches, or diagrams.

Conservation The profession devoted to the preservation of cultural property. Conservation activities include examination, documentation, treatment, and preventive care, supported by research and education.

Conservation administrator A professional with substantial knowledge of conservation who is responsible for the administrative aspects and implementation of conservation activities in accordance with an ethical code such as the AIC *Code of Ethics* and *Guidelines for Practice*.

Conservation Clear®️ Acrylic UV-filtering rigid acrylic sheet manufactured by Tru Vue.

Conservation educator A professional with substantial knowledge and experience in the theory and techniques of conservation whose primary occupation is to teach the principles, methodology, and/or technical aspects of the profession in accordance with an ethical code such as the AIC *Code of Ethics* and *Guidelines for Practice*.

Conservation scientist A professional scientist whose primary focus is the application of specialized knowledge and skills to support the activities of conservation in accordance with an ethical code such as the AIC *Code of Ethics* and *Guidelines for Practice*.

Conservation technician (Preservator) An individual who is trained to carry out routine conservation treatment and preventive conservation activities and who works in conjunction with or under the supervision of a conservator.

Conservator A professional whose primary occupation is the practice of conservation and who, through specialized education, knowledge, training, and

experience, formulates and implements all the activities of conservation in accordance with an ethical code such as the AIC *Code of Ethics* and *Guidelines for Practice*.

Consolidant A substance used to strengthen a friable medium or weakened support, usually applied as a liquid or vapor.

Consolidation The reinforcement of paper in a weakened condition or the strengthening of friable media with a suitable substance, such as gelatin, cellulose ether, or a synthetic resin in solution, in such a way that color and reflectance are not changed.

Consumed whites When the white highlighting of a drawing is made with chalk (calcium carbonate) on an acidic paper, over time, the alkaline white neutralizes the acid, and is itself consumed or used up, often leaving only a lighter area of paper where it had been.

Contamination Exposure to or absorption of potentially harmful impurities.

Conte crayon A proprietary, but now generic term, used to describe a square rod of a compressed compound of pigment and greaseless binder. They are available in red, brown, white, and black. Named after its inventor, Nicholas Jacques Conté (1755–1805), the scientist who was also responsible for the modern graphite pencil.

Continuous paper See Machine-made paper.

Continuously manufactured acrylic A solid sheet manufactured by extruding acrylic monomer, resulting in low stress levels, but not the highest optical quality.

Copper resinate See Verdigris.

Copy pencil (Indelible pencil) A pencil composed mainly of aniline dye, gum arabic or tragacanth, and graphite. Copy pencils are similar in manufacture and appearance (when dry) to regular graphite pencils. However, their lines develop an intense color when wetted and may penetrate and strain the paper, depending on its absorbency. Copy pencils are light-sensitive.

Core The central portion of a filled or plied mat board.

Corner rounder A sharp cutting tool with a curved blade used to cut and round off sharp corners, especially in encapsulation.

Coroplast® Polyethylene or polypropylene corrugated board.

Corrosion 1. Damage, usually through oxidation mechanisms, to the surface of a metallic compound. **2.** Iron gall ink damage to paper.

Corrugated cardboard A single- or double-walled board consisting of two face papers separated by heavy paper with alternating ridges and grooves; also available in polyethylene and polypropylene.

Cotton linters See Linters.

Couch To transfer a newly formed sheet of paper from the mold onto a felt for pressing.

Countermount To affix a paper of similar weight and size of the artwork to the verso of the board to which an artwork is adhered overall, in order to prevent or minimize warping.

Counterproof A sheet of paper placed over a dampened drawing done in a water-soluble medium drawing or freshly pulled print in order to create a second reversed

image. In printmaking, counterproofs are used to make corrections in the plate or block.

Courier A person designated to accompany a work of art in transit to insure its safe arrival, unpacking, and installation.

CP See Cold press.

Crack A fissure formed in the medium by flexing the underlying support or by excessive stress or force; a similar defect in coated papers.

Crackle (Craquelure) The pattern of cracks in a thick paint layer or a coating caused by drying and shrinkage of the binder in the paint or by flexing the support; it can be a precursor to flaking.

Craquelure See Crackle.

Crayon A generic term for a handheld stick of drawing medium; today often accepted as a wax-based drawing medium.

Crazing The reticulated pattern of minute fissures that can sometimes develop in glass, rigid acrylic sheets, and paint layers from internal stresses, chemical exposure, or mechanical impact.

Crease A sharp, straight deformation caused by folding or crushing the paper support often resulting in breakage of the paper fibers.

Crepe square A drafting tool composed of hard porous rubber used to pick up sticky adhesive residue.

Crimp A sharp deformation in paper resulting from bending it against its grain.

Crinkle A sharp-edged buckle in paper.

Cross direction The direction crosswise to the orientation, or grain, of the fibers in a sheet of paper.

Cultural property Objects, collections, specimens, structures, or sites identified as having artistic, historic, scientific, religious, or social significance.

Cupping A condition characterized by concave flakes of medium, such as opaque watercolor or tempera, which curl up around their edges.

Curl The deformation of paper along a join resulting from incompatible dimensional changes; that is, the repair tissue is too thick.

Cut An accidental or deliberate severing by a blade.

Cutting mat A resilient, usually self-healing, surface usually having a grid pattern on which to measure and cut polyester film and mat board.

Darkening The change from a lighter hue to a darker hue.

Data logger An electronic device having sensors, data storage, and a microprocessor that records environmental conditions over time. Data can be downloaded to a computer or transmitted wirelessly; often called a HOBO.

Day-Glo® paint A commercial daylight fluorescent opaque watercolor.

Daylight fluorescence The characteristic of reflecting a greater percentage of visible light than absorbed visible light.

Deacidification A process for removing or neutralizing acids in a sheet of paper and, at the same time, leaving an alkaline residue in the sheet to protect it against further acid attacks. The process can be water- or solvent-based and delivered via a liquid or vapor phase.

Deckle The removable wooden frame placed over a papermaking mold to prevent the pulp from running off during sheet formation.

Deckle edge The rough, uneven edge naturally occurring on handmade paper. It forms where the pulp flows against or under the deckle of the papermaking mold. It can be simulated in machine-made paper.

Decomposition Chemical or physical deterioration.

Deformation A condition characterized by three-dimensional change, buckling or cockling.

Degradation A reduction in chemical or physical strength; in chemistry the conversion of an organic compound into one containing fewer carbon atoms.

Dehumidification The removal of moisture, usually from the environment, by mechanical and/or chemical means.

Deionized water Tap water that has passed through tanks containing resins, which remove some minerals, such as copper, iron, and chlorine. The water is thus rendered "ion hungry."

Delamination The separation of paper into plies or, as a treatment procedure, the separation of a print or drawing from the mount to which it has been adhered overall.

Denatured alcohol Ethyl alcohol rendered unfit for human consumption by the addition of a noxious substance.

Dent A localized, typically C-shaped depression caused by the impact of a hard object or by curling the paper against its grain.

Desiccant/Desiccation A substance or process used to remove moisture from the environment.

Deterioration The gradual aging and ultimate destruction of materials due to the action of chemical, biological, and physical processes.

Détrempe (Glue tempera, Distemper) A mixture of colorant and glue used as a paint.

Dextrin A carbohydrate produced from wheat starch by hydrolysis with dilute acids, enzymes, or heat. It is manufactured in a number of grades, from a white to yellowish powder, and is used as an adhesive in envelopes, gummed papers, and tapes, and in printing and in inks and watercolors as a binder.

Diamond point See Glazier's point.

Diffuse Hazy in appearance; to break up and scatter incident light.

Diffusion The act or process of scattering incident light or other energy such as heat.

Dimensional stability The measure of a paper's response to changes in temperature and humidity or repeated wetting.

Dimpling Scattered, random indentations or depressions.

Ding A sharp, small deformation in paper usually caused by a hard object striking the paper.

Dip pen A writing implement having no reservoir to hold ink. The nib must be periodically charged using an external source of writing fluid.

Disaster response plan A contingency plan for cultural institutions outlining response and recovery procedures in case of fire, flood, or other natural or human-made emergencies.

Discoloration A change of color, as in staining.

Disinfection The destruction of harmful microorganisms or the inhibition of their activities.

Disintegration Breaking down physically, chemically, or visually.

Dispersion An apparently homogenous substance that is made up of two or more finely divided solids, liquids, or gases; milk is a liquid/liquid dispersion; smoke is a gas/solid dispersion.

Distemper See Détrempe.

Distilled water Water that has been heated until vaporized and then condensed and collected, resulting in absolute purity.

Distortions Undulations and deformations in a sheet of paper, which may be inherent, as a platemark, or caused by tension, such as improper mounting.

Documentation The recording in a permanent format of information derived from examination and conservation activities.

Dog ear The corner of a sheet turned down like the clipped ear of a fox terrier.

Double-sided tape A carrier with pressure-sensitive adhesive on both sides.

Drafting powder A granular erasing compound usually composed of pulverized rubber or vinyl eraser sometimes containing pumice as an ingredient.

Draw A diagonal deformation emanating from the corners of a print or drawing usually the result of the work being adhered to a secondary support around all four edges. See Tipped down.

Drier (Drying agent, Siccative) A substance, usually a metal compound that catalyzes the oxidation of oil-based paints and printing inks, hastening drying times.

Drip A discrete stain caused by a liquid or the liquid itself.

Drop out (Fall out) That portion of a mat that is cut away to form the window.

Dr. Ph. Martin's Synchromatic Transparent Watercolors® A popular brand of dye-based, brilliantly colored inks introduced in the mid-twentieth century.

Droppings Animal or insect feces.

Drumming Extreme flatness and tautness of a sheet of paper usually resulting from tipping it down to a secondary support; see Tipped down.

Dry bulb In a psychrometer, the tip of the thermometer that is not wetted before use.

Dry clean See Surface clean.

Dry cleaning pad A soft cloth bag filled with drafting powder used for removing loosely adhered surface grime from paper; not all dry cleaning pads are appropriate for use on prints and drawings.

Dry mount To mount a print, drawing, or document to a secondary support using a nonaqueous adhesive alone or a thin tissue coated with the adhesive, usually accomplished by applying heat and pressure; the mount itself.

Drying agent See Drier.

Drying oil A usually seed-derived oil that dries slowly by oxidation rather than evaporation.

Drying rack Tiered shelves of metal or plastic screening on which damp papers are placed to air-dry; generally used in printmaking and conservation facilities.

Drypoint An intaglio process using a needle-like tool to scratch a design into the printing plate. The burrs that are raised on both sides of the line also form part of the finished design, resulting in soft velvety lines; the print itself.

Dulling A decrease of reflectivity typically due to repeated rubbing.

Durability The degree to which a material retains its physical properties while used for its intended purpose.

Dust cover A heavy paper covering the entire back of a frame and adhered to the molding in order to prevent penetration of particulate air pollution.

Dye A natural or synthetic colorant used in solution to stain materials, as opposed to pigment particles, which are held in suspension.

Edition The total number of authorized impressions, excluding proofs, of a print.

Efflorescence (Bloom) Hazy, irregular patches of crystalline particles on the surface of the art work resulting from the migration of free fatty acids in the medium.

Egg tempera See Tempera.

Electrostatic printing (Xerography, Xerox®) A dry method of reproduction of graphic matter, by which an image is produced in the form of electrostatic charges by reflecting the image onto the surface of a charged photoconductor, which holds its charges in the dark, but dissipates them when exposed to light. The image on the photoconductor is developed by bringing it into contact with an ink powder, called a toner, which consists of a thermoplastic resin and colorant. The powder image is then transferred to copy paper and fixed to the sheet by heat fusion.

Embossed/Embossing An intentional design or accidental defect in paper, which is consequently molded or in relief.

Embrittlement To make or become brittle through the action of heat, light, acidity, or natural or artificial aging, which act to shorten the cellulose polymers contained in the fibers that make up the paper.

Emery paper An extremely hard and fine abrasive paper made by spraying pulverized emery (aluminum oxide, Al_2O_3) onto a strong backing paper coated with an adhesive.

Emulsion A mixture of two normally immiscible liquids, such as oil and water, in which minute droplets of one are suspended in the other; mayonnaise is an emulsion.

Encapsulation (Polyester encapsulation) A protective enclosure for paper-based artifacts. The item is placed between two sheets of transparent polyester film that are subsequently sealed around all edges using double-faced tape or welding.

Encaustic A technique of painting with colors in hot wax not generally used on paper until the twentieth century when interest in the medium was revived.

Enclosure A mat, folder, envelope, portfolio, or box used to protect works of art during storage.

Engine sized Internally sized paper.

Engraving A type of intaglio print whereby a design is cut into a metal plate with a burin.

Enzymes Biological agents used under controlled temperature and pH to render complex, insoluble molecules into smaller, more soluble components. Amylase converts starches into sugars, which are quite readily soluble. Protease does the same thing for proteins. Conservation applications of enzymes include the removal of aged animal glue and starch paste.

Ephemera Printed materials not originally thought to be of literary or historical importance nor intended to be permanent, for example, labels, advertisements, greeting cards, and brochures.

Epoxy coated Sealed and often heat-cured with an epoxy resin.

Eraser An implement, that is, a piece of rubber or soft plastic, used for eradicating marks on paper.

Erosion See Grazing.

Etching An intaglio method of printing using a needle to incise a design on a metal plate that has been coated with an acid-resistant ground. The plate is then subjected to an acid bath, which "bites" into the exposed areas.

Ethafoam® A polyethylene closed-cell foam with excellent aging characteristics used for support and cushioning in storage and shipping. It is easily carve-able and is available in a wide variety of densities and thicknesses.

Examination The investigation of the structure, materials, and condition of cultural property including the identification of the extent and causes of alteration and deterioration.

Examination report A written description of all aspects of an artwork including its materials, techniques, components, and condition, and may include photographs, sketches, or diagrams.

Extender An inert material added to a substance in order to increase its bulk, either as a necessary ingredient or as an adulterant.

Face See Recto.

Face/Facing paper In a multiply or filled paperboard, the exterior paper; the face paper is often of better quality or is decorative.

Facing A temporary protective tissue applied to the surface of a work of art, often to secure flaking paint.

Facsimile 1. An exact reproduction or copy of an original. **2.** An electronically transmitted and printed out document, often on unstable sensitized or coated papers.

Fading The gradual loss of color of a pigment or dye, typically by the action of light although other degradative factors, such as air pollution, may be involved.

Fall out See Drop out.

False margins The deliberate extension, permanently or temporarily, of the dimensions of a sheet of paper for either treatment or aesthetic reasons.

Fe⁺⁺ (Iron two ion) A charged form of iron whose presence indicates actively deteriorating iron gall ink.

Feathering The degree to which the ink spreads laterally to either side of a written line; see Bleeding.

Felt side The smoother side of a paper that has not been in direct contact with the wire mold or screen during manufacture; it is considered the "top" side.

Felts (Blankets) Thick woolen mats used in Western papermaking for pressing newly formed sheets of paper and also by printers in intaglio printing to sandwich the inked plate and dampened paper before they are pulled through the press. Used with blotters for flattening prints and drawings by conservators to provide resilience and cushioning.

Ferrous sulfate With gallic and tannic acid, an ingredient in iron gall ink, which produces a color upon exposure to oxygen; $FeSO_4$ (CAS 7720-78-7).

Ferrule The band or tube usually metal that holds the bristles of a brush together and attaches them to the handle.

Fiber The main constituent of paper pulp, made of thread-like filaments many times longer than wide. Most fibers in paper are made of cellulose, but fibers of animal, mineral, or synthetic origin are also utilized.

Fiber analysis The identification of the fibrous constituents of a paper sheet or paper pulp usually through microchemical examination and testing.

Fiber board Paperboard made of laminated sheets of heavily pressed fiber.

Fiber content A statement of the types and percentages of fibers used in the manufacture of a paper, board, or cloth. Important because the quality of the fiber significantly affects both the durability and chemical stability of the material.

Fiber optics A system for transmitting an intense beam of light through a narrow flexible cable made up of fine glass fibers.

Fibrilla(e) Cellulosic microfiber(s).

Fibrillation (Brushing out) In papermaking, fibers are beaten to loosen and separate the fibrillae, the thread-like elements that form the fibers. Fibrillation creates more surface for establishing fiber-to-fiber bonds in the paper, more interlacing of fibrillae for a strong sheet of paper, and more water retention so that the fibers are held better in suspension on the wire to form a close and even sheet.

Filament (Strapping) tape A pressure-sensitive tape whose carrier is reinforced with continuous strong threads to increase breaking strength.

Fill (Insert) Paper or pulp usually toned and used to compensate for a loss in the support of a print or drawing.

Filler 1. The materials added to the fiber furnish of paper in order to obtain printability, opacity, color, etc., of the final product. **2.** The inert substance, such as clay or titanium dioxide, added to pigments and dyes in order to bulk up the final drawing or painting medium.

Fillet (Spacer) The thin narrow band used to create or increase the air space between the work of art and the glazing in a frame.

Filmoplast SH® A cloth-backed pressure-sensitive tape having an acrylic-based adhesive.

Finger cot A small latex or nitrile rubber sheath for protecting individual fingertips.

Fingerprints Visible traces of contact with fingers; sometimes caused by a substance on the fingers or due to the oils naturally contained in them, which oxidize over time.

Fissure A break or rupture.

Fitting The process of assembling and inserting all the components of a frame package, that is, glazing, window mat, artwork, back mat board, and backing board, as well as completing the framing process by attaching bumpers, hanging wires, and a dust cover.

Fitting allowance The difference between the frame molding dimensions and the size of the glazing, window mat, back mat board, and backing board. Normally frames are made 1/8 inch larger all around in order to allow for the expansion of paper-based materials.

Fitting tool See Brad setter.

Fixative (Fixatif) 1. A clear solution, such as a natural or synthetic resin in an organic solvent, applied to a drawing in order to adhere powdery pigment particles to the support. **2.** A substance sprayed or locally applied to water-soluble media in order to "fix" the image prior to washing or spraying with water.

Flaking Bits of medium, which have become detached from the design layer.

Flattening The elimination or lessening of distortions in paper by overall or localized treatment.

Flax Bast fibers gathered from the plant, *Linum usitatissimum*, of the family Linaceae, or recycled from linen fabric. Flax has a fiber length of approximately 33 millimeters and produces a strong, durable paper.

Float A means of displaying prints and drawings so that the edges of the sheet are visible, usually desirable when the design extends to or goes beyond the paper's borders or when the edges of its secondary support or mount are decorative or historically significant.

Float glass Sheet glass made since 1959 by a process of floating a continuous layer of molten glass on the surface of a bath of molten tin. The sheet is fire-polished and annealed without grinding or polishing. Float glass has a nearly true optical surface and few irregularities and distortions.

Float wash To place a humidified print or drawing sheet onto the surface of a water bath. The surface tension of the water and the air trapped in the porous paper will make the sheet float on the water. Through capillary action, water contained in the sheet will be slowly exchanged with water in the tray, leaching out water-soluble discoloration.

Fluorescence The property of certain materials, including certain pigments, adhesives, and papers, when illuminated with ultraviolet light to radiate unpolarized light of a different wavelength, thus allowing them to be identified.

Fluorescent lamp An electric lighting fixture usually comprised of a cathode ray tube containing a gas or vapor, which produces light when electric current is introduced. Some types of tubes produce high levels of ultraviolet radiation and should be fitted with filters.

Fly specks Small raised, crusty accretions of insect excrement.

Foamboard (Fomecore®) A rigid sheet of polystyrene foam sandwiched between two heavy facing papers.

Fold The deliberate bending of a sheet of paper with little or no breaking of the paper fibers.

Folded hinge (V-hinge) A narrow strip of paper, typically Japanese tissue, folded lengthwise with one side adhered to the artwork and the other to the back mat board.

Folding endurance A standardized test showing the number of double folds a paper will endure before it ruptures.

Folio A flat, sturdy folder for holding or storing prints and drawings.

Fomecore® See Foamboard.

Footcandle A measurement of visible light equal to a unit of illuminance on a surface that is everywhere one foot from a uniform point source of light of one candle and equal to one lumen per square foot. One footcandle equals approximately 10 lux.

Forceps A pincer-like instrument for grasping or manipulating small objects.

Formaldehyde A volatile organic compound, CH_2O, exuded by many paints, wood products, sealants, and insulation (CAS 50-00-0).

Fountain pen A writing implement having a self-contained reservoir for the ink.

Foxing A term used to describe distinctive rusty stains and spots formed within paper over time, often having a characteristic reddish-brown color from which the name is derived. The exact mechanism by which foxing develops is not understood, but

almost certainly involves fungal activity, elevated humidity, and, possibly, the presence of catalytic metal inclusions.

Fracture An angular break in paper.

Fragility Weakness or vulnerability to damage.

Fraktur A form of German Gothic calligraphy ornamented with colorful flowers, birds, and other decorative motifs, used in certificates, papercuts, and illuminations created by the Dutch and German Pennsylvanians.

Frame A physical enclosure for the purpose of protecting and presenting works of art. The frame package usually includes the glazing, window mat, artwork, back mat board, and backing board all inserted into the frame molding.

Framespace® An S-shaped clear plastic strip used as a spacer or fillet in framing.

Frass Excrement, shell casings, or other insect detritus.

French mat A mat decorated with thin lines and panels of watercolor wash, sometimes incorporating strips of marbled paper, foil, or a cartouche.

Friable To be or about to become powdery; often a precursor to flaking.

Fugitive The tendency of a colorant to fade over time usually induced and accelerated by exposure to light, although other factors such as air pollution may contribute.

Fume hood (cupboard) An enclosed chamber with a sliding sash or door and a mechanical means for extracting noxious gases, such as toxic solvent fumes.

Fumigant A substance, typically in the vapor phase, employed to destroy insects, animals, or fungal growth.

Fumigation The process by which works of art are exposed typically to a noxious gas, which destroys animal and plant life.

Fungicide A substance that destroys mold spores.

Fungus (Fungi) A main division of Thallophyta, or primitive plants, including the molds, yeasts, mushrooms, and bacteria.

Furnish (Charge) The ingredients contained in the stock suspension from which the paper or board is made. These include fibers, sizing materials, fillers, dyes, and other additives.

Gall nuts (Oak apples) The spherical excrescences appearing on certain trees, typically oaks, produced by the deposited eggs of a type of stinging insect. Galls (galla) contain tannic and gallic acids and are used in the manufacture of iron gall ink.

Gallic acid A component of oak galls used in making iron gall ink; $C_7H_6O_5$ (CAS 149-91-7).

Gamboge A gummy resin derived from *Garcinia hanburii* and refined into a brilliant yellow pigment.

Gampi A bast fiber gathered from the inner bark of the branches of a shrub, *Wikstoemia canescens*, of the family Thymelaeceae. Gampi features fibers of approximately 3 millimeters and produces a thin and lustrous Eastern paper. It is said to be naturally resistant to insect attack.

Gap A space, typically used to describe a tear in paper that has spread apart.

Gauffrage Blind printing without ink and usually forming an embossed design, typically found in some types of Japanese woodblock prints.

Gelatin (Gelatine) A proteinaceous material produced by the prolonging boiling of animal connective tissue and bones, typically used as an adhesive or sizing agent.

Genre scene A depiction of a popular scene, often with moralistic or sentimental overtones.

Gesso A material made from a mixture of chalk or whiting and gelatin or casein, usually applied as a coating or ground.

Giclée® A fine art print created using an ink-jet printer.

Glare Bright reflected light that is usually distracting.

Glass A mixture of natural silica sand and two or more alkaline salts such as soda, lime, or potash that solidifies from a molten state without crystallization. It may be colorless or tinted, transparent or opaque. Glass is a common glazing material in picture framing.

Glassine A translucent and smooth-surfaced paper super-calendered to make it impervious to the passage of water, grease, and air. So-called "neutral" glassine is not chemically processed to produce translucency.

Glassine tape A thin, translucent tape of a water-activated adhesive coated on one side of a glassine carrier; often used on philatelic collections.

Glaze 1. The substance itself or the action of applying a clear coating, usually a natural gum, to a hand-colored print or watercolor in order to saturate one color, usually red or brown. **2.** To insert glass or an acrylic sheet into a frame package in order to protect its contents; **3.** The quality of polish or high gloss on the surface of paper created either during the manufacture as in machine glaze or after the sheet is formed. The latter processes include friction glazing, calendering, plating, or drying on a Yankee drier.

Glazier's point (Diamond point) Small lozenge- or triangular-shaped piece of flat metal used to secure a matted work of art and a backboard into a frame instead of brads; usually "shot" into the frame molding with a specially designed "gun."

Glazing 1. The glass or rigid acrylic sheet used in a frame as a protective interface between the environment and the work of art. **2.** The craft of the glazier, one who cuts and fits glass; **3.** A thin coat of clear color applied over a lighter, painted surface.

Gloss A luster or shine.

Glue A proteinaceous gelatin-based adhesive derived from the collagen in animal hides and bones, such as rabbit skin, horses' hooves, and fish bones.

Glue gun A handheld device for applying hot-melt adhesives whereby a solid rod of the adhesive is pushed through a hollow heated metal tip.

Glue tempera See Détrempe.

Gluten A brown, sticky mixture in the seeds of cereals, which remains after washing out the starch from wheat and rice. It must be removed in order to make starch paste.

Glycerin (Glycerol) Colorless, sweet, hygroscopic syrup added to certain media, such as watercolors, to promote their wetting up.

Glycerol See Glycerin.

Gondolage See Cockling.

Gore-Tex® A gas permeable nonwoven polyester/polytetrafluoroethylene laminate.

Gouache See Opaque watercolor.

Gouge A groove or cavity scooped out of the paper support, often caused by broken glass.

Grain 1. The orientation of fibers within a sheet of paper resulting from its method of manufacture. In machine-made paper the grain results from the orientation of fibers along the direction of travel on the papermaking machine, called machine direction. The direction crosswise to the grain is the cross direction. The grain determines the direction of the paper's expansion and contraction. Generally paper expands across the grain and tears with the grain. **2.** In wood, the direction of growth.

Graphite (Black lead, Wad) A mineral form of carbon, characterized by a metallic gray color and soft flaky semicrystalline structure. A baked graphite and clay mixture comprises what is commonly called a "lead" pencil, a misnomer resulting from a misunderstanding of the chemical composition of graphite.

Gray scale A series of achromatic tones extending from white to black through a regular progression of successively darker grays. In black and white photography to assess color balance and as a measure of the relative differences in depth, hue, or brightness of similar colors.

Grazing Damage to the surface of paper caused by feeding insects.

Grime Dirt either superficially resting on the surface of a print or drawing or embedded in its medium or support.

Ground 1. A mixture of calcium carbonate, gypsum, or powdered bone, with water, glue, and sometimes a colorant added, painted onto paper or parchment and then burnished in preparation for a metalpoint drawing, chiaroscuro drawing, or to make a smoother working surface. **2.** In the etching process, the waxy, acid-resistant coating applied to a metal plate prior to creating the design by scratching through it with an etching needle and immersing the plate in an acid bath.

Ground wood A form of mechanical wood pulp containing a wide range of celluloses, lignin, and other impurities.

Gum Any of a number of naturally occuring colloidal polysaccharides of high molecular weight, which can be dispersed in cold or hot water to produce various solutions typically used as binders, adhesives, and consolidants.

Gum arabic The hardened sap extruded from trees of the genus *Acacia*. The best grades of gum arabic are obtained in North Africa and are sometimes called gum Senegal. Gum arabic can be used as a binder in watercolors, pastels, and tempera. When boiled and thinned it becomes common mucilage.

Gum tragacanth The gummy exudation from the stems of *Astragalus gummifer* found in Asia Minor; used as a binder, traditionally in the manufacture of pastels.

Gypsum See Calcium sulfate.

Hair silk An extremely fine strand of natural silk.

Hake brush A flat oriental-style brush having very soft bristles used in calligraphy and painting to apply broad washes.

Halogen A group of high melting point transition metals, used in electrical lamps.

Haloing The darkening of a paper or medium usually surrounding an oil-containing or corrosive substance.

Hand The relative feel of a sheet of paper, especially its weight and density.

Hand-colored Transparent washes of watercolor, occasionally opaque watercolor, applied by hand to black-and-white prints.

Handmade paper Eastern or Western paper formed by hand, although machines may be used in pulp preparation.

Hanging hinge See Pendant hinge.

Hardware On a framed item, the wire, screw eyes, D-rings, or bumpers needed for hanging.

Heat-set tissue Thin, lightweight tissue coated on one or both sides with an adhesive activated by high temperatures and pressure.

Heightening White accents added to drawings in either wet or dry media in order to suggest relief or to make corrections.

Hemicellulose An important constituent of the fibers found in plant cell walls in addition to cellulose and lignin. Softwoods contain lesser amounts of hemicelluloses than hardwoods. Hemicellulose is mostly removed from wood fibers during pulping. Hemicellulose is differentiated from cellulose by its lower degree of polymerization and its greater chemical sensitivity to alkalis and acids.

Hemp A bast fiber gathered from the annual herb or perennial weed, *Cannabis sativa*, of the family Moraceae. Hemp features a fiber length of approximately 25 millimeters and is used mainly in Asian papermaking.

HEPA High Efficiency Particulate Arrestance or Air.

Highlighter Typically a daylight fluorescent porous-point pen.

Hinge A folded or flat strip of tape or paper, usually Japanese tissue, designed to attach a print or drawing to a back mat board or other secondary support.

HOBO® A brand of data logger.

Hole Any kind of opening through the support with a corresponding loss of support or design material.

Holland tape See Linen tape.

Hollytex® Nonwoven polyester web.

Honeycomb panel A solid auxiliary support constructed from lightweight paperboard.

Hook A slight curve at one end of a mat cut resulting from decreased pressure on the blade.

Hot-melt adhesive A thermoplastic adhesive that is applied in the molten state and forms a bond upon cooling and solidifying, typically applied with a glue gun.

Hot press A paper or board with a smooth, slick surface produced by pressing the sheet between preheated metal plates and passing it between heavy metal rollers.

Hue The relative gradation of a color.

Humectant A substance that attracts and retains moisture.

Humidification The relaxation of a sheet of paper by the gentle application of moisture, sometimes by spraying with a fine mist of water, suspending over a enclosed tray of water (humidity chamber), or sandwiching between dampened sheets of Gore-Tex®, capillary matting, or microfiber toweling.

Humidity chamber A container capable of providing sustained levels of high humidity.

Humidity indicator card A paper-based card or strip impregnated with an adsorbing desiccant that changes color with differing levels of relative humidity.

HVAC Heating, ventilation, and air-conditioning.

Hydrogen bonding The intermolecular attraction between hydrogen atoms and negatively charged atoms. It accounts for the enormous strength of cellulose-to-cellulose bonds.

Hydrogen sulfide A colorless flammable gas with an offensive odor; a common ingredient of smog. H_2S (CAS 7783-06-04).

Hydrolysis A chemical reaction in which water reacts with another substance to form two or more new substances.

Hydrophilic/Hydrophobic Terms used to describe a substance's response to water or water vapor. Hydrophilic materials attract water; hydrophobic materials repel water.

Hygrometer An instrument used to measure moisture content.

Hygroscopic A term used to describe substances that attract and absorb water or water vapor without liquefying. Desiccants used to reduce relative humidity are strongly hygroscopic.

Hygrothermograph A recording device used to monitor both relative humidity and temperature.

Illumination 1. The decoration of a manuscript or book with painted pictures, ornamented letters, designs, or a combination thereof, in tempera or gouache colors and usually burnished in gold or silver. Sometimes inaccurately called miniature painting. **2.** Visible light; radiant energy.

Illustration board A sheet of rigid cardboard with a sheet of drawing paper mounted to or wrapped around one side, often used by commercial artists.

Image size (Work size) The area of a drawn or printed composition on the paper or within the platemark.

Impact (Dot matrix) One form of direct contact digital printing.

Impasto A thick, textured application of paint.

Impression One of several images pulled from the same printing surface.

In situ In the actual location of the work.

Incident light The total amount of light striking the surface of an artwork; it can be reflected transmitted, or absorbed.

Incising A method of transferring a design by tracing the major outlines with a stylus or other sharp instrument with the drawing whose verso has been covered with charcoal or using a copying paper, such as carbon paper. The incised lines are often visible on the surface of the original drawing in raking light.

Incision A sharp cut into paper.

Inclusion A stray piece of foreign material held within the matrix of the paper sheet usually occurring during its manufacture.

Indelible pencil See Copy pencil.

India ink Historically, a suspension of carbon black particles in water and a binder, such as gum arabic; also known as lampblack, Chinese, or India, ink. The ink was developed by the Chinese circa 1200 B.C.E. Modern India ink has shellac added to render it waterproof and borax as a suspension agent.

India laid print See India proof print.

India paper See China paper.

India proof print (Chine collé, India laid print, Chine appliqué) An image printed on China paper adhered to plate paper either with paste or solely by the action of the printing press. The absorbency of the China paper allows finer impressions to be pulled from the plate. However, it must be supported by a heavier paper in order to withstand the pressure of the press. Traditionally, India proof prints were made

by intaglio processes, but have more recently been produced by lithography and other printing techniques.

Indian yellow A bright yellow organic pigment derived from the urine of cows fed mango leaves and containing euxanic acid as its principal ingredient; no longer manufactured.

Inert Having little or no ability to react to chemical or environmental changes.

Infrared radiation (IR) Electromagnetic radiation in the wavelength range of 760–1,000 nanometers; it is characterized by its radiant heat.

Inherent vice A source of deterioration directly resulting from the materials or techniques used to create a work of art, as opposed to external causes of damage or deterioration.

Ink A descriptive word for a fluid composed of a pigment or dye in a suitable vehicle, used for writing, printing, and drawing.

Ink jet (IRIS®) The process (thermal or piezoelectric) or the print produced from a steady emission of water-based dyes through a tiny nozzle in the manner of an airbrush. The image is composed of minute, digitally predetermined drops of ink sprayed onto paper wrapped around a rotating drum. As with computer hardcopy, prints are produced on demand, rather than in full editions.

Inlay, Inlaid The process of surrounding a print or drawing with a continuous margin of a lighter weight paper attached only around the verso edges of the artwork. The method is intended to provide auxiliary support for the artwork and to prevent touching it while its verso is examined.

Inorganic Chemically characterized as not derived from biological matter, that is, not containing carbon as a dominant element.

Inpainting See Compensation.

Inscription A significant word or phrase, usually written by the artist, on a print or drawing.

Insect damage Losses, thinning, staining, or accretions resulting from insect activity.

Insecticide A type of pesticide, generally either a natural or synthetic organic compound, designed to kill insect life.

Insert See Fill.

Instability Having a tendency to break down either chemically or physically.

Intaglio A method of printmaking whereby the design is incised below a metal plate surface either mechanically or chemically through the use of acid. Examples include engravings, drypoints, etchings, and aquatints.

Integrated Pest Management (IPM) A program designed for collecting institutions for preventing or controlling insect and animal infestations that combines various prevention and response procedures.

Interleaving (Slip) sheet pH neutral or buffered paper inserted between the bound leaves of a book or used to separate a group of prints and drawings; intended to slow down the deterioration of the object and prevent abrasion; also used in matted items to protect the surface of the artwork exposed by the window mat.

Internally sized Paper having the sizing added during pulp preparation not after sheet formation.

Interventive treatment A conservation action that physically or chemically affects a print or drawing.

IR See Infrared radiation.

IRIS® See Ink jet.

Iron gall ink A brown-black writing and drawing ink made from a suspension of iron salts in gallic/tannic acids derived from gall nuts. When first applied, it can be black, but brown, or yellow. Its corrosiveness and tendency to fade seem to be related to the relative amounts of iron and acids present.

Iron⁺⁺ (Iron two ion) See Fe^{++}.

Jade 403® Polyvinyl acetate emulsion adhesive.

Japan (Japon) Originally Japanese but later a Western paper, typically buff-colored and smooth surfaced, made in imitation of Japanese vellum paper, *torinoko*, and particularly prized for printmaking.

Japanese paper/tissue Hand- or machine-made bast fiber paper, typically made in Japan or East Asia, used in conservation because of its strength, suppleness, and stability; in printmaking because of its softness, absorbency, and dimensional stability. It is often erroneously called "rice paper" or "mulberry paper."

Japon See Japan.

Jute A bast fiber gathered from the stems of the *Corchorus capsularis*, of the family Tiliaceae. Jute features a fiber length of 1–5 millimeters and is used in both Eastern and Western papermaking.

Kaolin (China clay) A fine, white clay.

Kappa (κ) number The amount of lignin remaining in a pulp after processing.

Ketubah A Hebrew marriage contract.

Kneadable eraser A pliable eraser that can be shaped for more controlled erasing or tamped gently onto the surface of delicate papers to remove loosely adhered surface grime.

Knot In papermaking, a dense mass of fiber.

Kozo (Paper mulberry) A bast fiber gathered from the inner bark of the branches of the paper mulberry tree, *Broussonetia papyrifera*, of the family Moraceae. Kozo features fiber lengths of 6–20 millimeters and is the primary constituent of Eastern papers.

Kraft paper A paper made by a modified sulfate process using only wood pulp. It is relatively coarse and known for its strength. Its natural unbleached color is brown, but lighter shades can be obtained by using semibleached or fully bleached sulfate pulps.

Lacuna(e) Small missing part(s); the term traditionally described wormholes but can also refer to losses in a single sheet.

Laid down Attached overall to a secondary support using an adhesive.

Laid line See Wire line/mark.

Laid paper A paper characterized by closely spaced watermarked lines produced by the wires of the mold held together by interlaced "chain" wires.

Laminated Composed of many fused or bonded layers.

Lamination The action of uniting layers of material by means of heat and/or pressure, by adhesive or solvent. The three main classes of lamination include: "heat seal" in which no auxiliary adhesive is used; the document is placed between thermoplastic film and then heat and pressure are applied. Second, "dry mounting" in which a plastic film or tissue with adhesive is used with heat and pressure. Third,

"hand lamination" in which a solvent is applied to dissolve a film over a tissue causing it to adhere to a document. Once used widely as a preservation method for archival material, lamination has been generally replaced by encapsulation, preferable for its reversibility. Some forms of lamination are considered unacceptable as conservation methods because of potential damage from high heat and pressure during application, instability of the lamination materials, or difficulty in removing the lamination from the item, especially long after the treatment was performed.

Lampblack A type of nearly pure (99 percent) amorphous carbon black pigment produced by the incomplete combustion of hydrocarbons, historically, the soot collected from burning mineral oil, pitch, tar, or resin.

Landscape A horizontal format.

Latex Non-vulcanized, natural rubber.

Lay down A qualitative term used to describe a wax-based crayon line; ideally it should be consistent and smooth.

Layman In papermaking, the person responsible for removing each freshly pressed paper from between the felts and forming another pile for further pressing and drying.

Lead A thin rod of compressed graphite or other marking material typically encased in a wood cylinder, as in a pencil, or intended to be inserted into a mechanical pencil.

Lead carbonate See White lead.

Lead pencil See Graphite pencil.

Lead point A stylus or the drawing made from one, composed of lead usually also containing tin used for secondary ruling and mechanical purposes. Lead can make faint marks on ungrounded papers.

Lead white A pigment, lead carbonate, $PbCO_3$, used in liquid form for heightening drawings or for coloring grounds for prepared or coated papers. Oxidizes and turns brown or black when exposed to hydrogen sulfide, a common ingredient in smog (CAS 598-63-0).

LED See Light-emitting diode.

Lens tissue A lightweight lint-free nonabrasive tissue often used as an interleaving paper during drying under weight.

Letterpress printing A form of relief printing using movable type.

Light damage The alteration of medium or support from exposure to light; may be indicated by fading, darkening, or other color shifts.

Light-emitting diode (LED) A device that emits visible light from an electrical current running through it characterized by low-power requirements, little heat production, and long life.

Light staining The darkening of a sheet of paper due to overexposure to light; colloquially called "sunburn" or "time toning."

Lightening Becoming less saturated in color.

Lightfast A material not visually or chemically affected by exposure to visible radiant energy, that is, light.

Lignin A chemically amorphous organic component of the cell walls of plants that occurs naturally, along with cellulose. Lignin is largely responsible for the strength and rigidity of plants, but its presence in paper contributes to chemical degradation.

Lignin-free Containing less than 1 percent lignin or having a kappa number of five or less. It does not mean that the product does not contain ground wood, nor does it mean that the product is of conservation quality.

Limpness A condition of paper resulting from little sizing or deterioration of sizing from age or humidity.

Lineco pH testing pen® See pH indicator/pencil/meter/pen.

Linen A fabric woven from flax fibers.

Linen tape (Holland tape) Typically a tape with a sturdy fabric carrier and a water-soluble adhesive, although pressure-sensitive adhesives may be used.

Lining (Backing) To affix another sheet of paper to the verso of a print or drawing. The secondary support can help an embrittled sheet hold together. In modern conservation, fine-weight Japanese tissues are adhered using a thinned starch paste, but only when auxiliary support is required.

Linocut See Linoleum block.

Linoleum block (Linocut) A relief printing method using linoleum adhered to a block or fabric backing into which the design is cut.

Linseed oil A drying oil typically used as a binder in oil paints.

Linters The fleecy fibers that adhere to cottonseed after it has been through a cotton gin. Linters can be removed from the seed, cooked, and made into paper pulp.

Lite One unit or piece of glass.

Lithography A planographic process of printing using a fine-grained limestone or prepared metal plate, a greasy pencil or ink, a weak acid solution, and water. The image drawn or transferred with a hydrophobic medium will attract the oil-based printing ink; the hydrophilic stone or plate, wetted up with water, repels the ink.

Loaded paper Paper containing a large amount of filler, usually clay, added for weight or smoothness.

Loss A missing portion of either medium or support.

Loup(e) A small handheld or head-mounted magnifier.

Low iron glass See Water white/Water clear glass.

Lucite® Polymethyl methacrylate sheet.

Lumen A unit of measurement of light intensity; one footcandle equals ten lumens.

Lux A unit of measurement of light intensity; one footcandle equals ten lux.

Machine direction In a sheet of paper, the orientation, or grain, of fibers along the direction of travel on the papermaking machine.

Machine-made paper (Continuous paper) Paper formed by a machine in contrast to handmade paper.

Madder An organic red colorant containing natural alizarin, derived from the *Rubia tinctorum* plant, replaced by synthetic alizarin.

Marker See porous-point pen.

Marvelseal® A laminated film incorporating aluminum foil; used as a barrier film.

Masking tape Crepe paper coated on one or both sides with a rubber-based adhesive; originally used as a mask when spray painting automobiles. See also Pressure-sensitive tape.

Mat A protective, but often decorative, enclosure for prints and drawings constructed from two sheets of mat board hinged along one side. An opening is cut into the

outer sheet (window mat) through which the artwork is viewed. The lower sheet (back mat board) supports the artwork.

Mat board A sturdy paperboard comprised of laminated plies or a filled core between face papers used to protect and present works of art on paper.

Mat burn The continuous brown stain usually surrounding the image of a print or drawing caused by its intimate contact with a window mat composed of unrefined ground wood pulp.

Mat cutter A devise for cutting mats that can range from a simple utility knife to a sophisticated table- or wall-mounted machine.

Material Safety Data Sheet (MSDS) Information designed to provide workers and emergency personnel with proper procedures for handling or working with chemicals. The MSDS will include information such as physical data, toxicity, health effects, first aid, reactivity, storage, disposal, protective equipment, and spill/leak procedures. MSDS are available directly from the manufacturer and via a wide range of sites on the Internet.

Matrix system In documentation, a plotting system using a grid and coordinates for locating and recording defects or damages in a print or drawing.

Matte Dull, not shiny.

MDF See Medium-density fiberboard.

Mechanical wood pulp Pulp obtained by grinding logs or wood chips and used for inexpensive grades of paper such as newsprint.

Medium-density fiberboard (MDF) A wood product made by combining wood fibers with a resin under high temperature and pressure. It is not suitable for enclosed storage or display furniture.

Medium/Media The substance that has been used to create a print or drawing; in a narrower sense, the material that holds together pigment particles.

Melinex® Clear polyester film.

Mend See Repair.

Metalpoint 1. A drawing created by a stylus made from metal, typically lead, silver, gold, copper, or their alloys, drawn across a paper prepared with a slightly abrasive ground. **2.** The drawing implement itself.

Methyl cellulose A chemically modified cellulose ether that has many uses in conservation as an adhesive, poultice, and sizing agent (CAS 9004-67-5).

Methyl methacrylate An acrylic resin monomer used to make plastics, such as a rigid sheet used as glazing.

Mezzotint (Manière noire, Manière Anglaise) An intaglio process created toward the end of the seventeenth century to produce tone in engraving. The process involves roughening the surface of the plate with a "rocker" to control the light and shade effects as desired. The rougher the surface of the plate, the more ink it will hold and the darker the print will be. The nonprinted areas are burnished so as not to hold any ink. Mezzotints are characterized by a rich, velvety ink layer with numerous tonal gradations.

Microclimate A self-contained, controlled environment, typically created within a frame, storage container, or display case.

Microbiological attack Deterioration resulting from fungal or animal attack.

Microfiber An extremely dense fiber designed to be soft, absorbent, and lint-free.

Microspatula A small metal tool with flattened and smoothly rounded ends.

Migration The movement of a substance such as oil, media, or acidity in paper.

Mil Unit of measurement equal to one thousandth of an inch (0.001 inch) usually used to describe paper or film thickness.

Mildew See Mold.

Miniature See Illumination.

Minium See Red lead.

Mirror plate A flat metal flange that extends from the back of a frame and secures it to the wall.

Miter (Mitre) An angled joint, typically in the corners of a frame molding.

Mitre See Miter.

Mitsumata A bast fiber gathered from the inner bark of the branches of the shrub, *Edgeworth papyrifera*, of the family Thymelaeaceae. Mitsumata is used in making a soft, absorbent, and slightly lustrous East Asian paper.

Mold (Mould) In Western papermaking, the mesh screen held in place by a wooden frame, which is dipped into the paper slurry and lifted up allowing the excess water to flow through it. In machine papermaking, the slurry is poured onto the mold.

Mold-made paper Paper produced by machine in a mold to resemble handmade paper. The deckle edge in mold-made paper is more sharply delineated than that of handmade paper.

Molding (Moulding) Contoured rigid wooden, metal, or plastic strips joined together to form a frame intended to protect and present a work of art.

Molecular trap/sieve A zeolite system having an open-network structure allowing it to selectively absorb gases and liquids.

Monoprint/Monotype A unique planographic print produced in a single impression.

Mothballs See Paradichlorobenzene.

Mould See Mold.

Moulding See Molding.

Mount An auxiliary support for a print or drawing that may or may not have artistic or historic significance.

Mounted Attached, either overall or partially, to an auxiliary support.

MSDS See Material Safety Data Sheet.

Mucilage An adhesive typically manufactured from a gum or dextrin.

Mulberry paper See Japanese paper.

Multispectral imaging The capture of the appearance of materials as they react under different wavelengths of electromagnetic radiation, for example, ultraviolet and infrared radiation.

Museum board (Conservation board, Archival board) A multiply board composed of rag or chemically purified wood pulp papers, which may contain an alkaline reserve.

Mylar® Polyester film; now Melinex®.

Nanometer (nm) One millionth part of a millimeter, commonly used to designate wavelengths on the spectrum of light.

Nanoparticle (Nanoparticulate) A microscopic unit measuring less than one-hundred nanometers in one dimension.

Naphthalene (Moth balls) A pungent and possibly carcinogenic insecticide. $C_{10}H_8$ (CAS 91-20-3).

Neutral Having a pH of 7.0, neither acid nor alkaline.

Neutralization A process whereby the pH is raised to 7.0, but no alkaline reserve is introduced into the sheet.

Newsprint A low-grade paper typically thin and smooth surfaced made from mechanical wood pulp, used chiefly for newspapers.

Nib The component of a pen used for the application of the writing or marking fluid.

Nick A small loss with sharp edges.

NISO National Information Standards Organization. http://www.niso.org

Nitrile rubber A synthetic rubber that is highly resistant to oils and solvents, typically used for gloves and containers.

Nitrocellulose See Cellulose nitrate.

Nonaqueous Containing no water.

Nonglare See Nonreflective.

Nonreflective (Antireflective) Glass or acrylic sheet used as glazing treated either by etching or optically coating its surface in order that it does not reflect incident light.

Not A descriptive term for a textured paper that has not been hot pressed; it is rougher than cold pressed paper.

Oak apples See Gall nuts.

OBA See Optical brightening agent.

Obverse See Recto.

Off-gassing The process of releasing, usually slowly, volatile organic compounds, including acids, from woods, sealants, and paints; many are harmful to paper.

Offset 1. An image formed from a medium that has been transferred onto another surface either while wet, as in a printing ink, or dry, as in charcoal. **2.** A type of printing process based on the transfer of ink from a cylinder onto paper.

Oil pastel A drawing stick composed of pigment particles or colorant, filler, and an oil binder.

Oil sketching paper Introduced in the early nineteenth century, heavy paper, smooth or textured, coated with a primer, traditionally lead white. Several sheets were compressed into a tablet to be later separated with a knife inserted around the edges.

Okiwara A heavy- or medium-weight Japanese paper.

Old Master An artist, usually European, working prior to 1800; the end date is debatable. The term has been generally replaced by Master, indicating degree of accomplishment, not period of activity.

Opaque watercolor (Gouache, Body color, Poster paint) A matte water-based paint with a binder of gum, glue, casein, or cellulose ether and a large quantity of filler for opacity. The opacity was traditionally achieved by the inclusion of lead white; however, in 1834, Chinese white and zinc oxide were introduced as substitutes. Also known, predominantly in Europe, as body color or, for the poorer quality product, poster paint.

Opaque, Opacity The inability of a substance to transmit radiation, such as light or x-rays.

Optical brightening agent (OBA) Certain organic compounds, which have short-wavelength fluorescence (blue or violet) in visible light, used to enhance the whiteness of paper.

Optical coating A microscopically thin layer deposited onto glass or acrylic sheet in order to give it certain properties, such as nonreflectivity.

Optium Museum® Acrylic UV-filtering, antireflective, antistatic rigid acrylic sheet manufactured by Tru Vue.

Optivisor® See Loup(e).

Organic Chemically characterized as derived from living or previously living organisms, having as its predominant element carbon with associated hydrogen and oxygen.

Overall size The greatest outside dimensions of the paper of a print or drawing.

Overlay See Overmat.

Overmat (Overlay) To cover the edges of a print or drawing by a mat in which a window is cut smaller than the artwork's outside dimensions. Overmatting can help to minimize buckling of the perimeter of the sheet.

Ox gall A surfactant derived from cow bile, typically combined with alcohol.

Oxidation Originally used to describe a reaction is which oxygen combined with another substance; now used to describe any reaction in which electrons are transferred. Oxidation generally results in chemical and physical deterioration.

Oxidizing agent A substance that yields oxygen readily, such as hypochlorites or hydrogen peroxide, used in some bleaching procedures.

Oxygen scavenger A material, typically a metal hydride, used to remove oxygen from the atmosphere by reacting with it to form water; in conservation it is often used to create anoxic environments intended to destroy insects.

Ozone An allotropic form of oxygen, O_3, produced by electrical discharges in the air, that is, copying machines or air purifiers or may be a component of urban air pollution. A powerful oxidizing agent it is harmful to organic materials (CAS 10028-15-6).

Pack The output from the first pressing of handmade paper.

Paint stick A solid rod of pigment, filler, and linseed oil.

Palimpsest An effaced area on a support that is subsequently used for writing, painting, or drawing.

Paper In general, all types and categories of matted or felted sheets of fiber formed on a fine screen from a water suspension.

Paper knife See Bone folder.

Paper mulberry See Kozo.

Paperboard A multiply board composed of laminated papers.

Papermaker's alum See Aluminum sulfate.

Papermaker's tear A thinner circular mark in mold-made paper caused by a drop of water falling on a freshly formed sheet.

Papier mâché Macerated paper combined with an adhesive used to form decorative objects and sculpture.

Papyrus A sheet-like material manufactured by the bonding of two cross-oriented layers of strips cut from the stems of the *Cyperus papyrus* plant indigenous to the Mediterranean area.

Paradichlorobenzene (Mothballs) White crystals with penetrating odor used as a fumigant, generally discontinued due to health hazards. $C_6H_4Cl_2$ (CAS 106-46-7).

Paraffin A refined mineral wax derived from petroleum distillates; can be synthesized to have specific properties.

Paraloid B-72® After 1997, the trade name given to an ethyl methacrylate/methyl acrylate copolymer by its manufacturer Rohn and Haas Company.

Parchment (Vellum) A translucent or opaque material made from the wet, limed, and dehaired skins of sheep, goats, or similar animals, by drying at room temperature under tension on frames. Vellum can imply a fine grade of parchment; the terms are today interchangeable.

Parchment size A sizing material or weak adhesive made from scraps of parchment boiled in water.

Particulate Of or relating to minute bits of material, especially when referring to a type of air pollution.

Pass-through hinge A pendant hinge that is not affixed to the recto of the back mat board, but is inserted into a slit and fastened on its verso.

Passe-partout To encase between two pieces of glass or acrylic sheet; (obsolete) a decorative, precut, often gilded cardboard, into which standard-sized printed reproductions or photographs were inserted.

Paste An adhesive derived from cooking vegetable starches, typically wheat or rice, until they gel and cool the hydrolyzed product.

Pasteboard A multiply board composed of laminated papers.

Pastel A drawing medium consisting of pigments or dyes mixed with a gum binder, typically gum tragacanth but today cellulose ether, and rolled or pressed into stick form. The amount of binder determines the stick's hardness.

Pasteprint (Sealprint) Medieval prints composed of laminated paper with an embossed design covered with thin tin foil typically depicting religious figures and scenes.

Patch See Repair.

PE See Polyethylene.

Pellon® Nonwoven polyester web.

Pen A writing or drawing implement characterized by delivering ink through a nib.

Pencil Today designates a writing or drawing implement comprised of a wood-encased lead of baked graphite and clay; the term previously referred to a fine pointed brush.

Pendant hinge (T-hinge, Hanging hinge) A narrow strip of paper, typically Japanese tissue, that is adhered to the verso of the artwork and its remaining portion fastened to the backboard directly above the piece, not folded behind it, generally resulting in a more secure attachment.

Perforation A small loss of paper.

Permalife® Paper containing purified alpha cellulose, cotton fiber, and calcium carbonate, and no optical brighteners; deemed to be "archival," and carries the infinity symbol watermark.

Permanence The ability of a material to resist chemical deterioration; not a quantifiable term.

Permanent Lasting indefinitely; when used by the industry to describe an ink or dye, the term only described resistance to water and laundering.

Peroxides Chemicals having the general formulation (R-O-O-R). Peroxides are oxidizing agents and, hence, capable of catalyzing oxidation reactions, such as bleaching.

Perspex® Polymethyl methacrylate sheet.

PET See Polyethylene terephthalate.

pH A value taken to represent the acidity or alkalinity of a aqueous solution in moles/liter. A logarithmic scale numbered from 0 to 14 is used with 7.0 as the neutral point. Numbers higher than 7.0 denote alkalinity while numbers lower than 7.0 denote acidity.

pH indicator/pencil/meter/pen A substance or device used to measure the hydrogen ion concentration, or pH, of an aqueous solution or the surface of a paper. It can be done colorimetrically with certain chemical indicators, such as special inks and pencils, or by potentiometric methods using electrodes, such as a pH meter.

Photo-oxidation A chemical reaction catalyzed and sustained by light.

Photochemical Visual or mechanical changes resulting from the action of radiant energy.

Photocorners Small triangular pouches of paper or plastic used to secure the corners of an artwork to secondary support, typically a mat or album page. Their versos may be pretreated with a water-activated or pressure-sensitive adhesive.

Photogravure A process for making prints from an intaglio plate prepared by photographic methods; the print itself.

Photomechanical The means of transferring an image to a printing surface by photographic methods; used to describe printed reproductions produced by a variety of methods, such as photogravure and collotype.

Pick-up A circular, less dense spot of medium at the terminal end of a crayon stroke resulting from excessive pressure and back-and-forth motion of the crayon. A bit of softened and sticky crayon is pulled from the paper as the crayon is lifted away.

Picture glass The traditional designation for glazing material that has a nominal thickness of 0.080 inch (1.7–2.5 millimeters). Picture glass is clearer and smoother than regular window glass.

Pigment A coloring agent having discrete particles that are mixed with a binder in order to create a wet or dry medium. A pigment is insoluble in water and forms a suspension, imparting color by spreading over the surface to which the solution is applied and depositing minute particles.

Piling Bits of crayon, which spall off a wax-based crayon and become adhered to the paper.

Pith paper (Rice paper) Thin sheets cut from the pith of a small tree, *Aralia papyrifera*, from China. Popular as a watercolor support for decorative export wares.

Pixel The smallest possible unit or point used in digital imaging.

Plain glass Noncoated, nonetched polished glass.

Planographic prints One of the three major categories of printmaking processes. Prints are produced by the transfer of an image from the flat surface of a smooth stone or metal plate, rather than an indented surface, as would occur in intaglio printing or a raised surface as would occur in relief printing. The term planographic

was originally coined in order to categorize lithography although other stencil processes may now be included.

Plastic eraser See Vinyl eraser.

Plasticizer A liquid or solid that dissolves in or is compatible with a resin, gum, or other substance and renders it flexible or easy to manipulate. Some plasticizers are chemically unstable.

Plate The surface, stone, metal, or other matrix, from which printed impressions are taken.

Platemark The physical impression or embossing made by a plate during the printing process, usually intaglio or, occasionally, lithography and relief prints.

Plate paper A thick, soft, high-quality printing paper, lightly sized, having a smooth surface without a high gloss, usually used for intaglio printing; also, the secondary support of chine collé prints.

Plate size The dimensions of the plate from which a print is pulled, often delineated by a platemark.

Pleat A sharp fold in paper.

Plexiglas® Polymethyl methacrylate sheet.

Ply One of several laminated layers.

Pochoir A highly refined type of stencil (planographic) printing process, used mainly for making multicolor prints, for tinting black-and-white prints, and book illustrations. The process was used especially in early twentieth-century French printmaking.

Point A unit of thickness of paper or board; one thousandth of an inch (0.001 inch). For example, 0.060 inch equals 60 points; see also Mil.

Polar Exhibiting a differential atomic charge.

Pollutant A gaseous or particulate, usually atmospheric, contaminant.

Polycarbonate Thermoplastic linear polyesters of carbonic acid, used to manufacture very clear and strong transparent plastic sheets used in glazing and vitrines.

Polyester A common name for the plastic polyethylene terephthalate. Its characteristics include transparency, colorlessness, and high tensile strength. In addition, it is useful in preservation because it is very chemically stable. Commonly used in sheet or film form to make folders, encapsulations, and book jackets. Its thickness is often measured in mils. Common trade names are Mylar® and Melinex®.

Polyester encapsulation See Encapsulation.

Polyester web A nonwoven fabric formed of matted spun-bonded polyester, typically used in paper conservation as a release sheet or for washing support.

Polyethylene (PE) A translucent thermoplastic material prepared by polymerizing ethylene at high pressure and temperature in the presence of oxygen. In sheet form it is used for lamination of documents in lieu of cellulose acetate or for encapsulation. It can also be used as a hot-melt adhesive or made into foams.

Polyethylene terephthalate (PET) A chemically stable, clear plastic available as a flexible film, frequently used in storage enclosures.

Polymer A substance composed of very large molecules consisting essentially of recurring long chain structural units that distinguish them from other types of organic molecules and confer on them tensile strength, deformity, elasticity, and

hardness. Monomers, derived largely from coal and oil, are used as the building blocks of polymers.

Polypropylene A clear, heat-resistant, chemically stable plastic available as a flexible film. Common uses include storage enclosures.

Polystyrene (PS) A thermoplastic material produced by the polymerization of styrene. Used in solution as an adhesive or formed into foams.

Polystyrene core board See Foamboard.

Polytetrafluoroethylene (PTFE, Teflon®, Fluon®) A resin formed from tetrafluoroethylene monomer; highly insoluble, extremely high melting point; highly inert with a very low coefficient of friction; often used to fabricate low friction folders or spatulas for use on conservation.

Polyurethane A polymer derived from the reaction of a polyisocyanate with a polyhydroxyl compound normally of polyester or polyether structure. Polyurethane foams and most varnishes are not stable on a long-term basis and should not be used for conservation purposes.

Polyvinyl acetate (PVA) A range of colorless, transparent, thermoplastic solids, usually used in adhesives; available in both resinous and emulsion forms. There are dozens of PVA adhesives, some are "internally plasticized" and are suitable for use in conservation because of their greater chemical stability, among other qualities.

Polyvinyl chloride (PVC, Vinyl) A range of thermoplastic materials produced by the polymerization of vinyl chloride, generally not recommended for conservation because they contain plasticizers and chlorine.

Porous-point/tip pen (Fiber-tip, Marker) A handwriting or handmarking instrument having as its distinguishing characteristic feature a nib made of porous material for contacting the writing or marking surface for the purpose of depositing the writing or marking fluid.

Porte crayon A metal or wooden holder for a rod of drawing or writing material, such as chalk or natural graphite.

Portfolio A stiff folder sometimes having separate or decorative covers used for storing or presenting prints and drawings.

Portrait Having a vertical format.

Post A stack of interleaved felts and freshly formed sheets of paper.

Post-irradiation effect The continuation of chemical reactions catalyzed by light; for example, in sun bleaching, the continued bleaching of paper after it has been put in the dark.

Poster paint See Opaque watercolor.

Potash alum See Alum.

Poultice A malleable substance carrying a liquid, that is, water or organic solvent, applied to the medium or support and intended to soften adhesives or reduce staining through absorption.

Pouncing An early method of transferring a drawn design by pricking the outlines and major lines of the image and forcing a fine powder, usually charcoal, through them onto the working surface.

Powder coating A coating made from spraying powdered thermosetting resins onto a metal substrate, which are then set by baking.

Preparator Typically, a person trained in hinging, matting, framing, and displaying works of art according to conservation standards. A preparator can sometimes assume the role of a conservation technician; see Conservation technician.

Prepared paper A paper with a ground applied to render it colored or smooth.

Preservation The protection of cultural property through activities that minimize chemical and physical deterioration and damage and that prevent loss of informational content. The primary goal of preservation is to prolong the existence of cultural property.

Preservator See Conservation technician.

Pressboard A tough, dense, highly glazed paperboard, used where strength and stiffness are required of a relatively thin (e.g., 0.030 inch) board. It is almost as hard as a sheet of fiberboard, and is commonly used for the covers of notebooks; see also Solid board, Fiberboard.

Pressure-sensitive tape Strips of paper, plastic, or other carrier coated on one or both sides with an adhesive, typically rubber- or acrylic-based that adheres when pressure is applied.

Preventive care (Preventive conservation) The mitigation of deterioration and damage to cultural property through the formulation and implementation of policies and procedures for the following: appropriate environmental conditions; handling and maintenance procedures for storage, exhibition, packing, transport, and use; integrated pest management, emergency preparedness and response; and reformatting/duplication.

Primary support The paper on which a print or drawing has been directly created.

Print The process or product of impressing or otherwise transferring an image from one surface to another.

Printer's chop See Chop mark.

Profile A frame molding as seen in cross-section, including its contour, rabbet, and exterior dimensions.

Protein Nitrogenous organic compounds of amino acids found in vegetable and animal matter. Animal glue contains proteins.

Prussian blue A blue precipitate formed from solutions of ferric salts and potassium hexacyanoferrate (II). The earliest synthetic mineral pigment (1704).

PS See Polystyrene.

Psychrometer A hand-whirled or electronically aspirating device for measuring relative humidity by comparing the temperatures obtained by two thermometers, one of which is covered with a moistened wick (wet bulb) and the other wick is dry (dry bulb); used to calibrate other humidity measuring instruments, such as hygrothermographs or as an independent measurement.

PTFE See Polytetrafluoroethylene.

Pucker A deformation in paper usually caused by tension.

Pull To make one impression of a print.

Pulp The mechanically and/or chemically prepared mixtures obtained from wood or vegetable fibers to be used in the manufacture of paper and board.

Pulpboard A board composed of a mass of compressed pulp.

Pumice A light, porous stone of volcanic origin used as an abrasive; occasionally found in erasers.

Puncture A hole in the support of a print or drawing with no actual loss of paper.

Puttying The uneven deposition of wax-based crayons due to heat produced by friction.

PVA See Polyvinyl acetate.

PVC See Polyvinyl chloride.

Pyrethrum An insecticide to be used cautiously, if at all, in storage areas due to health concerns (CAS 8003-34-7).

Quill pen A drawing or writing implement whose nib is formed by cutting the hardened flesh end of a feather first diagonally, slitting it down the middle and then narrowing it into a point.

Rabbet (Rebate) The space, including the protruding lip of a frame molding, designed to accommodate the glazing, matted artwork, and backing board. The rabbet has a depth and a width.

Radiant energy The spectrum of electromagnetic waves generated by the sun.

Rag paper/board Paper or board manufactured from pulp having a high cotton rag or linter content, which may or may not contain an alkaline reserve.

Raking light Light directed at an acute angle or parallel to the plane of the support in order to emphasize irregularities in the medium or distortions in the support.

Ramie (China grass, Rhea) A bast fiber gathered from the stems of the perennial herb, *Boehmeria nivea*, of the family Urticaceae. Ramie features a fiber length of approximately 120 millimeters and is used in both Eastern and Western papermaking.

Rattle The noise produced by a sheet of paper when it is shaken. Lack of rattle may indicate that the sizing has deteriorated or has been reduced by some treatments.

Ream A standardized quantity of paper having identical dimensions and properties.

Rebate See Rabbet.

Recto (Obverse, Face) The front or side of a sheet on which appears an image or printed text deemed to be of primary importance; the right-hand side of an open Western codex.

Recto/Verso mat An enclosure designed to show both sides of a single sheet.

Red chalk (Sanguine) A drawing medium derived from hematite (chemical source) in several shades of red to brown; because the medium is soluble in water, red chalk drawings were often made into counterproofs.

Red lead (Minium) A pigment, lead tetroxide, Pb_3O_4. Oxidizes and darkens upon exposure to hydrogen sulfide, a common ingredient in smog.

Reed pen A writing or drawing implement whose nib is carved from the stem of a variety of sturdy grasses first diagonally, then slit down the middle and narrowed to the desired width.

Reemay® Spun-bonded polyester web.

Refractive index The ratio of the velocities of light in a medium and in the air under the same conditions; typically used in conservation to refer to a visual change resulting from consolidation or coating.

Reinforcement A repair, patch, or lining applied to a print or drawing for additional physical support. Also, the intensification of an abraded drawing or weak printed impression by drawing or painting over it, which is no longer an accepted practice.

Relative humidity (RH) The ratio of the amount of water vapor in the air to the maximum possible at a given temperature, expressed as a percentage.

Relaxation The process of humidifying paper in order to reduce creases and cockling by subsequent flattening or to prepare it for washing or lining.

Release paper See Silicone release paper.

Relief print A category of prints whereby the image to be printed is raised above nonprinting areas, which are removed by tools.

Repair (Mend, Patch) A small piece of Japanese tissue or, more often in the past, Western paper, usually applied to the reverse of a sheet bridging a tear or cut and restores some strength to the sheet.

Reservoir The component in a writing implement in which the reserve ink supply is stored.

Residue of adhesive Adhesive remaining from a former treatment, which may cause distortions in the paper sheet by its different reaction to moisture.

Resin Naturally occurring secretions of plants, generally insoluble in water and soluble in alcohols, examples include the natural varnishes, such as copal and dammar. Also, synthetically manufactured compounds produced by polymerization of simpler substances, originally meant to have the properties of natural resins. Plastics are generally based on synthetic resins.

Resizing Treating a paper by applying or immersing the sheet into a solution containing a sizing agent such as gelatin or cellulose ether, in order to restore its original strength, rattle, or other characteristics.

Respirator A gas mask or screen of fine wire or gauze with or without absorbing or chemical reagents, worn over the mouth and nose to protect the wearer from dust, smoke, and poisonous or irritating vapors.

Restoration Treatment procedures intended to return cultural property to a known or assumed state, often through the addition of nonoriginal material.

Retouching 1. See Compensation. **2.** Also, in the printing industry, the changes made on a worn intaglio plate to allow more prints to be pulled.

Retted Soaked, as in flax, in order to loosen the fiber from the woody tissue for processing.

Reverse See Verso.

Reversibility The ability to undo a process or treatment with no change to the object. Reversibility is an important goal of conservation treatment, but it must be balanced with other treatment goals and options.

Reversion The return of a preexisting condition, especially the reappearance of stains after bleaching.

RH See Relative humidity.

Rhea See Ramie.

Rheostat A device used to regulate settings on electrical equipment, such as the temperature of a tacking iron.

Rhoplex AC-33® An acrylic resin emulsion adhesive.

Rice paper (Pith paper) See Pith paper; see Japanese paper.

Rip A tear in paper.

Risk assessment The systematic identification and prioritization of threats to collections according to the relative probability of their occurrence and the extent and degree of damage they could cause.

Rocker A convex toothed metal handheld device for creating small, regularly spaced pits in a metal printing matrix as part of the mezzotint printmaking process.

Roller-ball pen A roller-ball pen is differentiated from a ball point pen by the viscosity of its writing fluid, which does not exceed 1,000 centipoise. See Ballpoint pen.

Rosin (Colophony) The resin obtained after distilling turpentine from the secretions of the *Pinus palustris*.

Rosin size See Alum/rosin sizing.

Rot Damage to paper from excessive humidity.

Rubbing alcohol See Isopropyl alcohol.

Running See Bleeding.

Rupture A sharp break.

Rust 1. An oxidation product of iron-containing materials, such as staples and paper clips. **2.** An inaccurate term for foxing.

Sanguine See Red chalk.

Sap green A plant-derived green pigment used in watercolors.

Saponification The alkaline hydrolysis of esters into acids and alcohols, as in the conversion of fats into soaps by an alkali or the breakdown of printing inks when exposed to extreme alkalinity.

Scalpel A small knife with an extremely sharp, replaceable blade, available in several sizes and profiles.

Scar A damage to the surface of paper, typically a scrape.

Scission The breaking apart of chemical bonds.

Scotch Tape® A proprietary series of pressure-sensitive tapes manufactured by the 3M (Minnesota Mining and Manufacturing) Company. Originally (~1929), the tape consisted of a cellulose nitrate carrier coated with a natural rubber adhesive with wood resins as natural tackifiers and petroleum derivatives as softeners. Present-day Scotch Tape® consists of an acrylic-based synthetic adhesive on a cellulose acetate carrier.

Scrape (Scuff) An interruption of paper or media caused by rubbing against a harder material.

Scratch A linear scrape apparently caused by a sharp point.

Screenprint See Silkscreen.

Scriptorium (Scriptoria) A facility devoted to transcribing texts by copying by hand, typically prior to or concurrent with the invention of movable type in the fifteenth century.

Scuff See Scrape.

Sealprint See Pasteprint.

Secondary support An integral mount, lining, or auxiliary support, which may or may not have artistic or historic significance.

Seed hairs Fibers, which grow attached to the seed of a plant, such as cotton.

Sekishu A medium-weight Japanese paper.

Self-adhesive tape See Pressure-sensitive tape.

Separation Delamination of either paper or media.

Sepia 1. A semitransparent, dark brown-black organic pigment prepared from the defensive secretion of various species of *Cephalopoda*, especially the cuttlefish

and squid. **2.** The drawing ink or watercolor made from this pigment. **3.** The color of this pigment.

Sequestering agent A substance added to deactivate metal ions in a system, for example, the pretreatment of a paper containing iron-induced foxing or copper-based pigments prior to undertaking other procedures.

Serigraph See Silkscreen.

Sheet size The greatest outside dimensions of a sheet of paper.

Shellac A natural resin, *lac*, obtained from the scale insect, *Laccifer lacca (Coccus lacca)*, used in varnishes; often erroneously used to refer to any natural resin coating.

Shive In paper, a bit of incompletely processed papermaking fibers.

Shrink-wrapping A procedure involving the complete enclosure of an object using a clear plastic film that shrinks as it is heated with a hot air gun.

Siccative See Drier.

Sight size The dimensions of a print or drawing that are only visible within a mat or frame.

Silhouetting The darkening of the perimeter of a print or drawing from direct contact with an acidic window mat; also can refer to light staining.

Silica gel An inert but very hygroscopic granular form of amorphous silica, which can be conditioned to maintain a certain level of humidity. Commercially available in a wide range of particle size, absorption characteristics, and purity. Often contains a color indictor that changes from bright blue to faded pink when saturated with water vapor.

Silicone release paper A paper coated with a silicone-based polymer, usually polydimethyl siloxane, that repels adhesives, typically used as a barrier paper in mending procedures to prevent sticking of the artwork to the blotter.

Silk mat A window mat that has been covered with silk for decorative purposes.

Silking A process, no longer current, for reinforcing weakened paper through the application of a thin silk gauze to one or both sides of the paper sheet.

Silkscreen 1. A planographic method of printing using a hand-cut or photographically prepared stencil adhered to stretched silk or polyester fabric on a frame through which ink is forced using a squeegee. **2.** The print itself.

Silverpoint An implement or the drawing created using a stylus composed of silver; often incorrectly used to describe a metalpoint.

Single mat A mat having as a window one sheet of mat board.

Sink mat A mat whose backboard has been built up with strips of mat board or corrugated board around the perimeter of a particularly heavy or thick artwork in order to give it more support.

Sinking Penetration of a medium into the paper support.

Size, Sizing 1. A substance that inhibits the penetration of water into the internal structure of paper and therefore decreases the swelling of the paper fibers in response to moisture. Sizing affects the stiffness, strength, smoothness, and weight of the paper, as well as its aging characteristics. Sizing agents include rosin, gelatin, glue, starch, cellulose ethers, synthetic resins, etc. **2.** Chemicals added to paper and board that make it less absorbent, so that inks applied will not bleed. Acidic sizings can be harmful and can cause paper to deteriorate.

Skinning See Thinning.

Slat burn Characteristic pattern of discoloration often showing grain and knots on the verso of a print or drawing resulting from the use of wood, typically cedar shingles, as backing boards.

Slip sheet See Interleaving sheet.

Slip/Release agent In pressure-sensitive tapes, the substance applied to the exterior of the carrier in order that the tape not stick to itself or leave residual adhesive when it is unrolled.

Slit A straight cut in paper.

Slurry A free-flowing suspension of paper pulp.

Smear Blurring of medium caused by rubbing.

Smudge A random, accidental mark made by rubbing against another substance; also, the blurring of parts of a design by abrasion.

Solander box A sturdy storage box, which may or may not be constructed of acid-free materials, named after their inventor Daniel Charles Solander (1736–1782), a pupil of Carl Linnaeus (1707–1778).

Solid board A paperboard made of the same material throughout. Distinct from a combination board where two or more types of fiber stock are used, in layers; see Fiberboard, Pressboard.

Solid sketch book Developed in the mid-nineteenth century, a number of sheets of paper compressed to form a solid block with adhesive around the outer edge. Single sheets were separated using a knife. Evidence of the adhesive is frequently present.

Solubility The ability of one substance to be dissolved by another.

Solute The substance, usually a solid, dissolved by a solvent.

Solvent A liquid, which dissolves another substance, the solute, usually a solid, for example acetone is a solvent for a rubber-based adhesive, the solute.

Sonotube® Very strong tubes made of plastic or cardboard used for rolling oversized posters or wallpapers; not archival.

Spacer See Fillet.

Spalling The loss of bits of wax crayon due to the friction-induced heat.

Spectrophotometer A photometer for measuring the relative intensities of light in different parts of a spectrum.

Spectrum The band of electromagnetic radiation extending beyond the ultraviolet and infrared portions into the X-ray and microwave regions. Visible light occupies the middle portion of the spectrum; ultraviolet and infrared radiation are invisible.

Specular light Reflected light where the angle of reflection is equal to the angle of incidence causing a surface to appear smooth and highly polished, like a mirror.

Split A soft break made when a sheet ruptures along a previously weakened area.

Spot A discrete area of discoloration either on or in paper.

Spot test A chemical test, which involves placing a drop of reagent on the surface of a sheet, then reading the change in color to indicate the presence of such substances as lignin, rosin, starch, or proteins. More broadly, a preliminary step in treatment involving the replication, on a miniature scale, of the proposed treatment, that is, the effects of water on pigments or the effects of a consolidant on colors.

Sprung A distortion in a cut or tear that, due to age, climatic conditions, or other factors, prevents its rejoining in-plane.

Spur A gathering of freshly made papers taken from the press after partial drying and suspended in the air for further drying.

Stability See Chemical stability.

Stabilization Treatment procedures intended to maintain the integrity of cultural property and to minimize deterioration.

Stain A discrete area of discoloration characterized by its penetration into the fibers of the sheet. Stains are usually described by their origin, such as tape, light, or oil stains.

Standard Something set up and estimated by authority as a rule for the measure or quantity, weight, extent, value, or quality.

Stanley knife See Utility knife.

Starch Vegetable carbohydrate occurring in the granular form in certain plants and corresponding to a polymer composed almost exclusively of glucose groups; used as an adhesive, coating, and sizing agent.

Starch paste The most common adhesive used in paper conservation, made by cooking purified rice or wheat starch with filtered, distilled, or deionized water. This adhesive remains easily reversible and ages well over time.

Starving In a writing implement, an inadequate flow of marking fluid through the nib.

Static electricity Stationary charges of electricity often created by friction.

StaticShield® Acrylic UV-filtering, antistatic rigid acrylic sheet manufactured by Tru Vue.

Stearic acid A white, crystalline fatty acid obtained by saponifying tallow or other solid fats.

Stencil A sturdy paper or flexible metal sheet that is perforated or cut so that when ink, paint, etc. is applied, a design forms in the open areas and prints the paper below; see also Silkscreen, Pochoir.

Stereobinocular microscope A microscope with dual adjustable optics, one for each eye, resulting in the ability to see depth; frequently used in the examination and treatment of prints and drawings.

Stock Paper pulp, which has been beaten and refined, treated with sizing, color, filler, etc. and, which after dilution, is ready for sheet formation.

Strainer A simple nonadjustable frame made of wooden or metal strips, typically used in framing to secure the frame contents and backboard to the molding or by itself onto which is stretched a paper or fabric.

Straining A synonym for stretching. Engravings were often pasted onto a support of fine linen stretched over a wooden frame. As the moisture in the paste evaporated, the print would shrink and become perfectly flat, all disfiguring cockling eliminated. The print on its strainer would then be framed under glass in the usual way.

Strapping tape See Filament tape.

Stretcher An adjustable wooden or metal frame onto which is stretched canvas or paper.

Strike through The degree to which ink traverses vertically through paper so as to appear on the underside of the written line; also used to describe the degree of penetration of aged adhesives, in particular that of pressure-sensitive tape.

Strip lining The application of either cloth- or paper-extended margins to the perimeter of a print or drawing either temporarily or permanently.

Stump An artist's implement made from tightly wrapped paper or chamois used for blending dry drawing media.

Stylus A pointed metal implement used for ruling or transferring purposes, or when used on prepared papers, for making a metalpoint drawing.

Substrate See Support.

Sulfur dioxide A colorless gas with a pungent odor, SO_2, and a common urban atmospheric pollutant (CAS 7446-09-5).

Sumi ink The solid form of carbon black ink, traditionally associated with Asia, or more specifically Japan.

Sun burn See Light staining.

Support (Carrier, Substrate) The physical surface, usually paper, upon which a print or drawing appears.

Surface clean To remove or reduce loosely adhered surface grime from the surface of paper using a variety of erasers; sometimes called dry cleaning.

Surface pH The measure of acidity or alkalinity obtained through the use of a surface electrode or an indicator strip held against a wetted area of paper for a predetermined time; not necessarily an accurate measurement of the interior of the sheet or other areas on its surface.

Surface sized A paper that has had sizing applied to its surfaces either during its manufacture or as a separate operation; it differs from tub sizes in the equipment used and the lighter amount of sizing applied.

Surface tension The contractile surface force of a liquid that allows it to form a meniscus; surface tension varies from one liquid to another and can either be an advantage or a disadvantage depending on the conservation procedure.

Surfactant (Wetting agent) A substance that reduces the surface tension of water, including wetting agents, detergents, and emulsifiers. Surfactants fall into four classes depending upon the nature of the electric charge carried by their surface active ions in aqueous solutions: anionic, cationic, nonionic, and amphoteric.

Synthetic Human-made.

T-hinge See Pendant hinge.

Tacking iron A thermostatically controlled, handheld device, whose metal tip is used for locally applying heat; used primarily for activating heat-set tissues or hasten drying.

Tanned A chemical process typically applied to animal skin using tannic acid to prevent it from spoiling by converting it to leather.

Tannic acid Tannin $C_{76}H_{52}O_{46}$ (CAS 1401-55-4).

Tapa A coarse felted cloth or paper made in the Pacific Islands from the inner bark of the paper mulberry tree (*Broussonetia papyrifera*).

Tape Technically a thin, narrow, flexible strip of paper, plastic, or fabric; see Adhesive tape.

Tear A break in a sheet, severing paper fibers in an irregular pattern.

Tear resistance The measurement of the force required to tear a specimen of paper under specified controlled conditions in a laboratory.

Teflon® See Polytetrafluoroethylene.

Tempera A type of paint, or the technique associated with it, consisting of a dispersion of pigments in a water-miscible emulsion. The resulting paint layer is smooth

with a slight sheen. In the West, the traditional emulsifier was egg yolk; however, the broader use of the term includes gum and casein binders, typical of the binders used in opaque watercolor.

Temperature A measurement of hotness or coldness expressed in degrees Celsius and/or Fahrenheit.

Tenjugo A lightweight Japanese paper.

Tensile strength That property of a material, such as paper, which enables it to resist failure from a tensile or stretching force.

Tension Strain exerted on paper usually from incorrect mounting.

Textblock The compressed stack of paper, which makes up a book, not including its covers or case.

Texture The pattern on the surface of paper, which may be produced artificially for decorative or functional purposes or simply a result of the papermaking process, that is, the texture of wool fibers as a result of pressing between felts.

Thermal decomposition Degradative chemical reactions either initiated or exacerbated by heat.

Thermal energy Heat, which results in increased temperature of the work itself or its environment.

Thermographic A type of digital printing produced either by direct thermal transfer or dye diffusion.

Thermometer An instrument for measuring temperature; may be based upon the expansion of a liquid or electrical resistance.

Thermoplastic Having the repeatable property of being softened by heat and hardened by cooling.

Thermostat A device for measuring and regulating temperature.

Thinning (Skinning) Extreme abrasion of one side of a sheet resulting in a more or less uniform loss of a layer of paper; usually visible with transmitted light.

Thymol A fungicide no longer recommended due to health concerns; like naphthalene (moth balls) its crystals sublime (CAS 89-83-8).

Tide line A discolored ring or linear stain in paper resulting from the deposition of dissolved material by water or other solvents at the point where they have evaporated.

Time toning A euphemism referring to the gradual darkening of paper from either external (light, acidity) or internal (alum-rosin sizing) sources of degradation.

Tipped down Attached around all four edges, usually on the verso to a secondary support. Because the paper is not free to respond to changes in humidity and temperature, drumming, draws, and washboard buckling can result; see Drumming, Draw, and Washboard buckling.

Tissue paper A class of papers made in basic weights that are relatively light. They are machine or handmade from many types of pulp and are not all suitable for conservation purposes.

Toner A thermoplastic resin and a colorant mixture used to create electrographic prints. Additives can include release agents, surfactants, charge control agents, and waxes.

Tooth The degree of roughness of prepared or unprepared paper.

Torchon A tightly rolled rod of paper used for blending friable media, such as charcoal.

Torinoko See Japan.

Tortillon A tightly rolled rod of cloth or chamois used to blend dry drawing media, such as charcoal.

Toxicity The degree of poisonousness or noxiousness of a substance to its receptor via many channels of egress.

Trace An insignificant amount.

Tracing paper Translucent paper either chemically treated or impregnated with oils or resins for the purposes of copying or transferring images. Its surface must be receptive to graphite pencil or ink.

Translucent Admitting and diffusing light so that objects beyond cannot be clearly distinguished.

Transmitted light Light, which passes through a sheet of paper, glass, filter, or other material held before its source.

Travel frame A temporary, sturdy frame made specifically to protect a work of art during travel; also a frame in which a work of art is displayed in other venues usually because its usual or original frame is too fragile for travel.

Treatment The deliberate alteration of the chemical and/or physical aspects of cultural property, aimed primarily at prolonging its existence. Treatment may consist of stabilization and/or restoration.

Tub sized Paper, which has been surface sized by dipping it into a container typically holding a dilute solution of gelatin.

Tungsten A high melting point metal element used in electrical lamps; used as a standard in determining excessive UV radiation.

Turn buttons Small, rotatable fasteners screwed to the back of a frame molding and used in lieu of brads for securing the frame's contents; useful if items are frequently framed and unframed and also for preserving the molding.

Tusche A greasy liquid used to create liquid-like effects on a lithographic stone or plate.

Type high The height of a piece of standard type used in letterpress printing, or 0.918 inch (23.3 millimeters).

Tyvek® High-density polyethylene film often used as a vapor barrier.

Ukiyo-e print A type of Japanese woodblock print, which first appeared in the 1660s and depicted scenes from everyday life. *Ukiyo-e* means "floating world picture" and refers to the temporal nature of the genre's subject matter.

Ultrasonic welder A device used in polyester encapsulation, which fuses the edges of the enclosure by the use of heat produced by high-frequency sound waves.

Ultraviolet (UV) radiation Electromagnetic radiation not detectable by the human eye. Wavelengths 400–315 nm (near UV, UVA, or Black light) are present in sunlight, daylight, and most lamps. Wavelengths 315–200 nm (UVB or UVC) are only encountered indoors from unshielded lamps.

Ultraviolet filter A material used to filter the ultraviolet rays out of visible light.

Ultraviolet inhibitor Sacrificial chemicals added to some varnishes that absorb the energy of ultraviolet light, usually releasing it as heat.

Ultraviolet stabilizer Chemicals introduced into a material that serve to prolong the life of the material in which they are contained, for example, varnishes or protective coatings.

Unbuffered Containing no alkaline reserve.

Underdrawing The initial sketch or outline for a subsequent design usually executed in another medium.

Undulation See Cockling.

Utility knife (Stanley knife) A simple, handheld cutting device consisting of a sturdy blade in an adjustable handle, used for cutting mat board or corrugated board.

UV See Ultraviolet radiation.

V-hinge See Folded hinge.

Van dyke brown A golden warm brown pigment from soil and peat, sensitive to light due to its high percentage of organic constituents.

Vapor barrier A treated paper, synthetic film, or metal foil used behind a frame to protect its contents from high humidity.

Varnish A resin, synthetic or natural, dissolved in a solvent used as a transparent coating.

Vatman The person who forms a sheet of handmade paper by dipping and lifting the mold.

Vehicle (Carrier) The substance that holds pigment particles together in a medium.

Velcro® A fastening system composed of a fabric or plastic strip of fuzzy material, which firmly grips another strip of loop material, introduced in the mid-twentieth century.

Vellum See Parchment.

Verdigris (Copper resinate) A blue-green pigment of copper acetate widely used in the illuminations of manuscripts, books, and maps. Over time, it degrades the paper from the production of acidic acid. Green stains and brown halos penetrate to the verso and the paper becomes brittle in the areas of heaviest application.

Vermilion A pigment, mercuric sulfide, HgS, sometimes erroneously called minium.

Verso (Reverse, Obverse) 1. The back or opposite side of a sheet on which appears an image or printed text, usually characterized by having no image or printed text or one deemed to be of lesser importance. **2.** The left-hand page of an open Western codex.

Vinyl eraser (Plastic eraser) A white eraser introduced in 1965, containing polyvinyl chloride and having no pumice or other additives.

Vinyl See Polyvinyl chloride.

Visible light That portion of the electromagnetic spectrum detectable as colors by the human eye, extending from violet (400 nm) to red (700 nm).

Vitrine A type of exhibit furniture that typically consists of a transparent enclosure, sometimes called a "bonnet," which sets onto or into a base or pedestal.

VOC See Volatile organic compound.

Volara® A dense cross-linked polyolefin/polyethylene closed-cell foam with excellent aging properties used for cushioning.

Volatile A substance having a tendency to vaporize or evaporate rapidly.

Volatile organic compound A gas, especially formaldehyde and peroxides, emitted by decomposing materials; in the museum environment, refers specifically to gaseous pollution present in closed spaces, such as storage rooms, display furniture, or storage enclosures.

Wad Naturally occurring graphite, mainly found in Borrowdale, England; replaced by fabricated graphite rods by Nicolas Jacques Conté in 1794.

Warping See Cockling.

Wash To treat a work of art on paper by immersion in a tray of purified or chemically modified water to reduce water-soluble stains and discoloration.

Washboard buckling Directional, regularly spaced distortions in a paper sheet usually due to tension exerted by improper mounting to a secondary support.

Washi Handmade or machine-made Japanese paper typically containing kozo, mitsumata, or gampi fibers, although other lesser quality non-bast fibers may now be included.

Water white/Water clear glass (Low iron glass) Absolutely colorless glass containing no metallic impurities.

Watercolor A painting medium consisting of finely ground pigments dispersed in a water and gum solution, usually gum arabic. A small amount of hygroscope substance, that is, honey or glycerin, may be added in order to make the paint more readily dissolve in water; the artwork itself.

Watercolor pencil A colored pencil containing surfactants that cause drawn lines to dissolve when water is applied.

Waterleaf paper 1. A dried sheet of paper before it is sized. **2.** A general term for soft, unsized papers that are readily absorbent, including blotting paper.

Watermark A translucent mark in paper usually identifying the maker or type of paper. In handmade paper it is produced by wires sewn to the mold; in machine-made papers it is typically impressed in the newly formed sheet or produced through the application of waxy coatings.

Waving See Cockling.

Wax bloom See Efflorescence.

Wear Evidence of normal usage.

Web adhesive A low melting point thermoplastic adhesive not on a carrier sometimes used as a dry-mounting material.

Weeping glass Chemically unstable glass exuding hygroscopic salts, which attract water under conditions of elevated humidity resulting in the formation of droplets.

Wet bulb In a psychrometer, one of two thermometers having a dampened cloth-covered end, used for measuring relative humidity by comparison with a dry bulb.

Wetting agent See Surfactant.

Wetting up The ability of a medium to respond to water in order to be immediately available for use; that is, the addition of glycerin to watercolors to make them quickly soluble.

White chalk Naturally occurring calcium carbonate or levigated calcium carbonate mixed with varying amounts of gypsum (Plaster of Paris) to form sticks; typically used for heightening.

White glue (PVA) A generic term typically referring to a PVA emulsion adhesive.

White line woodcut See Wood engraving.

Whiting Naturally occurring calcium carbonate typically used as an inert filler or white pigment.

Window glass Sheet glass formed by a casting process in which molten glass is poured on an iron table covered with sand where it is rolled and flattened before being ground and polished on both sides with abrasive. This process, invented in the late seventeenth century, allowed for an economical means of glass production, which greatly increased the use of windows in buildings and the use of glass in framing art work. Iron, added to increase strength or contained in the sand gives window glass a greenish tint.

Window mat The outer portion of a mat into which a window is cut through which the image of a print or drawing is viewed.

Wire line/mark (Laid line) The shorter closely spaced linear pattern naturally occurring in handmade or mold-made papers resulting from the configuration of the mold. Laid lines are typical of handmade paper, although they are often simulated in machine-made paper.

Wire side The side of a mold- or machine-made paper adjacent to the screen, characterized by the mimicking of the screen's texture, including the watermarks, chain and laid lines, or weave pattern.

Wood cut A relief printing process in which the image or design is cut into a block of wood sawed parallel to its grain using knives, gouges, or chisels; the printed image itself.

Wood engraving (White line woodcuts) A type of relief print made by using a burin to engrave blocks of extremely hard, fine-grained wood, usually boxwood, sawn against the grain.

Wood pulp Papermaking fibers produced by the chemical or mechanical processing of a wide variety of softwoods and hardwoods. Fiber lengths, as well as hemicellulose and lignin content, can differ considerably depending on the refining method employed.

Work size See Image size.

Workable fixative (Fixatif) A dilute solution of typically cellulose nitrate applied during the course of building up layers of powdery medium, for example, charcoal; it is a poor film former but allows the layers to be gone over.

Worm holes Regularly shaped curvilinear tunnels and/or holes in paper caused by insect larvae.

Wove paper Handmade, introduced around 1750, or machine-made paper formed on a woven screen rather than on a laid patterned papermaking mold. The resulting paper has a uniform thickness and a smooth surface, which can sometimes have a faint fabric texture.

Wrapper A hinged protective cover on a matted object intended to protect the window mat. It usually can be swung around for storage and/or display.

Wrinkle A sharp deformation of paper, irregular and angular in configuration, often having broken fibers and going against the grain of the sheet, caused by folding or crushing.

X-radiography The technique of producing an image using the electromagnetic energy of short-wavelength (0.06–20 Å) radiation striking a sensitized film or digital plate.

Xerography (Xerox®) See Electrostatic printing.

Xerox® See Electrostatic printing.

Yellowing A gradual darkening of the original color of paper, due to internal or external sources of deterioration.

Zeolite An inert crystalline aluminosilicate (Na_2O Al_2O_5 $(SiO_2)x$ H_2O), added to paper-based framing products to absorb pollution and water vapor. It is found naturally, but is often manufactured to meet specific performance parameters.

Zone system In a building, areas of individually controlled environments typically determined by a facility's physical layout or its separate mechanical systems.

Information supplied for each chemical substance includes its commonly used name, synonyms, and empirical formula. Also provided is its American Chemical Society's Abstracts Service number (CAS), a numeric designation that uniquely identifies a specific chemical compound. This entry allows one to conclusively identify a material regardless of the naming system used.

Appendix 1

How to Make Starch Paste and Methyl Cellulose Adhesive

by Katherine Sanderson

STARCH PASTE

There are many methods for making traditional starch paste for use in paper conservation. Personal preferences can be strong and last for generations. Nonetheless, making paste need not be complicated or time-consuming.

Whether you are new to making paste or have decades of experience, it is important to understand how the chemical properties of starch act to transform a dry powder into a strong and stable adhesive. Starch is composed of small granules containing molecules of amylose and amylopectin. Starch does not dissolve in water at room temperature. Instead the starch granules are suspended and create a white opaque liquid. If left to soak overnight, a matter of individual preference, the starch would settle to the bottom of the container. When heated, the mixture goes through two distinct phases. First, the granules swell and the liquid becomes more translucent and slightly thicker. This happens at the gelatinization temperature, which varies depending on the type of starch (125–130°F for wheat starch and 154–167°F for rice starch). The second phase occurs once the temperature has risen to about 175–205°F, when the granules burst, releasing the amylose and amylopectin molecules. These molecules are then free to interact with the hot water to form a thicker, stickier gel.[1] If the starch is not allowed to reach this temperature range, the cooking process will be incomplete, resulting in a weak paste that feels slippery, rather than sticky, when pressed and released between the thumb and index finger.

A NOTE ABOUT MATERIALS

The most common type of starch used to make paste is wheat starch; however, some prefer rice starch, which produces paste with slightly different properties. These differences can be subtle and are debatable, but it is clear that rice starch produces a less rigid gel than wheat starch when cooled to room temperature. This variation is caused primarily by a different ratio of amylose to amylopectin in the two starches (1:4 in rice starch and 1:3 in wheat starch).[2] Pastes made with either kind of starch are effective adhesives for routine tasks, such as mending tears or applying hinges. As with most aspects of paste making, the choice to use wheat or rice starch usually rests upon convention rather than invention.

Paste should be free of impurities when used on works of art. For this reason, conservators typically use distilled, deionized, or filtered tap water. It is also strongly recommended that nonmetallic cooking implements and storage containers be used in order to avoid the possible inclusion of metallic impurities, which can then rust in the paste.

Although continuous stirring in a saucepan or double boiler is a tried and true technique, there are other approaches to cooking that can also produce great paste. To avoid constant stirring, an electric pot with an automatic stirring arm can be used (Le Saucier® by Tefal; Kitchenstir®). Paste can also be made in a microwave oven, which requires short bursts of cooking alternating with stirring.[3] Regardless of the exact procedure, attaining the correct temperature and thorough stirring are the keys to making a good starch paste.

INGREDIENTS AND EQUIPMENT

- 22 grams (3 tablespoons) of wheat starch[4] (or rice starch, if preferred)
- 250 milliliters (8 fluid ounces) distilled, deionized, or filtered tap water
- Scale for weighing out starch (or tablespoons if scale is not available)
- Beaker or liquid measuring cup
- Stove or electric hot plate
- Saucepan, enamel, or Teflon® coated; or double boiler made of glass or enamel
- Rubber or Teflon® spatula, or wooden spoon
- Glass, ceramic, or plastic storage container with a nonmetallic lid
- Strainer with fine nonmetallic mesh

DIRECTIONS

Combine the starch and water and stir until the starch is evenly dispersed in the water with no visible lumps. The starch will settle naturally to the bottom

of the water container, so be sure it has been thoroughly stirred before pouring it into the pot. Place the saucepan over medium heat and pour in the starch-water mixture (if using a double boiler, bring the water to a boil before pouring in the starch mixture). Once the starch-water mixture is overheated, stir constantly until the paste is fully cooked.

Within the first 10 minutes, the starch with reach the first phase mentioned above and become thicker and more translucent. As the paste cooks, it will thicken and air bubbles will develop and elongate. After about 25 to 30 minutes, depending on the heat below, the paste will take on a gelatinous or rubbery quality and become slightly more opaque. If using an electric pot, increase the setting to high. Once it has reached this point, the paste is done. It can continue to be cooked for a longer time, if a thicker paste is desired. Immediately transfer the hot paste into a clean storage container and let it cool completely before sealing.

STORAGE

Paste should always be stored at room temperature. Although refrigeration will preserve it longer, the cooler temperature also causes the paste to retrograde, becoming granular and watery. The simplest storage method for paste is a glass or plastic jar with a nonmetallic lid stored in a cool dark place. A layer of water on top of the paste also prolongs its usable life, but the water must be replaced daily. Some conservators prefer to store paste in large 30-milliliter polyethylene or neoprene syringes. When using this storage method, the syringes must be sterilized by immersing them in boiling water and then air-dried; the paste should be drawn into them immediately after cooking, when still hot, while avoiding air bubbles if possible. The caps and plungers also need to be sterilized to avoid spoilage.

Occasionally, ortho-phenyl phenol or eugenol (oil of cloves) is added as preservative; this practice has been largely discontinued.

Discard the paste when it becomes watery and develops a sour odor, or mold growth.

USING THE STARCH PASTE

Prior to use, force a small quantity of paste through a fine gauge nonmetallic mesh strainer using a rubber spatula or plastic spoon. If the paste is still lumpy, repeat this process until smooth. Using a clean, stiff-bristled brush, mix the strained paste with small amounts of deionized, distilled, or filtered water until it has reached the consistency of yogurt or heavy cream. There may be situations that call for a thicker or thinner paste, so adjust the amount of water accordingly.

METHYL CELLULOSE ADHESIVE

Methyl cellulose, the slippery and slow-drying ingredient in commercial wallpaper pastes, is acceptable for conservation purposes when used in its food-grade form. Methyl cellulose is industrially manufactured as a white powder in several formulations designed to produce a range of viscosities in a 2 percent standard solution at 20°C. For example, Methocel A15C® will produce a gel of approximately 1,500 centipoise in a 2 percent solution, while Methocel A4C® will produce a thin syrup of 400 centipoise in a 2 percent solution. Methocel A4M® will produce a stiffer gel of 4,000 centipoise in a 2 percent solution. Methyl cellulose gels can be used to modify the properties of starch paste or white glue (PVA emulsion) and to extend their drying times. Most conservation suppliers sell a generic high-viscosity (1,900–2,200 centipoise) methyl cellulose powder for use as an adhesive. Typically, it is used in a 3 or 4 percent mixture.

INGREDIENTS AND EQUIPMENT

- 2.5 grams (2 teaspoons) of Methocel A4M® high-viscosity methyl cellulose, food grade
- 125 milliliters (4 fluid ounces) (one half cup) distilled, deionized, or filtered tap water
- Scale for weighing out methyl cellulose powder (or tablespoons if scale is not available)
- Beaker or liquid measuring cup
- Small rubber or Teflon® spatula or stirrer
- Glass, ceramic, or plastic storage container with a nonmetallic lid

DIRECTIONS

To mix methyl cellulose for use as an adhesive, add 2.5 grams or 2 teaspoons of methyl cellulose powder to 62 milliliters or 2 fluid ounces (one quarter cup) of hot distilled, deionized, or filtered tap water and stir until blended. The powder will not dissolve but will evenly disperse. Slowly add a second quarter cup of cool or room temperature water, stir, and let stand for several hours or overnight. Do not continue to stir after the solution begins to thicken, as this will cause foaming. The final gel will have the consistency of mayonnaise.

STORAGE

Methyl cellulose adhesive needs to be stored in a clean, air tight container. It does not require refrigeration. Discard if it becomes cloudy, watery, changes color, or develops a strong musty odor.

USING METHYL CELLULOSE ADHESIVE

Methyl cellulose adhesive is not as strong as starch paste, but should be adequate for routine repairs and hinging. It is used directly as made and not diluted. Remember that this is a very slow-drying adhesive.

NOTES

1. McGee, Harold, *On Food and Cooking: The Science and Lore of the Kitchen.* New York: Collier Books, (1984): 335–338.
2. Horie, C. V., *Materials for Conservation: Organic Consolidants, Adhesives and Coatings.* Oxford: Butterworth-Heinemann, (1987): 135–140.
3. One microwave recipe calls for a 1:5 (weight:volume) wheat starch:water mixture soaked in a deep ceramic or glass container for one hour. Microwave on high setting for 20–30 seconds. Remove and stir. Repeat on high setting for 20–30 seconds. Remove and stir. Continue this pattern for a total cooking time of approximately 30 minutes or until desired consistency is achieved.
4. Purified or precipitated (*zen* or *jin shofu*) wheat starch should be used; not wheat flour, which still contains gluten.

FURTHER READING

Baker, Cathleen A., "Methylcellulose and Sodium Carboxymethylcellulose: An Evaluation for Use in Paper Conservation through Accelerated Aging," in *Preprints to the Contributions to the Paris Congress, 2–8 September 1984: Adhesives and Consolidants*, Norman S. Brommelle, Elizabeth M. Pye, Perry Smith, and Garry Thomsom, eds., London: International Institute for Conservation, (1984): 55–59.

Feller, Robert and Myron Wilt. *Evaluation of Cellulose Ethers for Conservation.* Marina del Rey, CA: Getty Conservation Institute, 1990.

Horie, C. V. *Materials for Conservation: Organic Consolidants, Adhesives, and Coatings.* Oxford: Butterworth-Heinemann, 2000.

McGee, Harold. *On Food and Cooking: The Science and Lore of the Kitchen.* New York: Collier Books, 1988.

Mills, John S., and Raymond White. *The Organic Chemistry of Museum Objects, Second Edition.* Oxford: Butterworth-Heinemann, 2003.

Miller, Bruce F., and William Root. "Long-Term Storage of Wheat Starch Paste." *Studies in Conservation,* Vol. 36, no. 2, (1991): 85–92.

Morse, Elizabeth A., and Janet L. Stone. "A Method for Storing Additive-Free Wheat Starch Paste." *Abbey Newsletter,* Vol. 13, no. 8, (1989). http://cool.conservation-us.org/byorg/abbey/an/an13/an13-8/an13-816.html.

Museums and Galleries Commission. *Science for Conservators, Volume 3: Adhesives and Coatings.* New York: Routledge, 2002.

Sanderson, Katherine. "Making it Stick: Paste on Paper." *The Book and Paper Group Annual,* Vol. 26, (2007): 155–159.

"Wheat Starch Paste - CCI Notes 11/4–Canadian Conservation Institute (CCI) Notes." Accessed November 16, 2015. http://canada.pch.gc.ca/eng/1439925170645. Available from: http://www.cci-icc.gc.ca/resources-ressources/ccinotesicc/11-4-eng.aspx.

Appendix 2

Suppliers of Paper Conservation Materials and Equipment

Compiled by Catherine Lukaszewski

More and more companies have created or have expanded their inventories to accommodate the needs of archivists, collections care specialists, registrars, paper and book conservators, framers, and individual collectors of prints and drawings. All major suppliers of conservation papers, boards, equipment, and supplies have websites or are represented through large distributors. Furthermore, many companies have in-house advisors who can guide you in making your selections.

Please note: inclusion does not constitute a blanket endorsement of all products offered.

MATTING, GLAZING, AND FRAMING MATERIALS

- **Crescent Pro** (RagMat and other matboard; mounting and presentation boards)
 (800) 323-1055
 www.crescentpro.com
- **Evonik Industries** (acrylic sheet)
 (800) 631-5384
 www.acrylite.net
- **Larson Juhl** (custom frames and framing materials)
 (800) 438-5031
 www.larsonjuhl.com
- **Legion Paper** (assorted papers)
 (212) 683-6990
 www.legionpaper.com

- **Light Impressions** (matting and framing; archival presentation and storage)
 (800) 975-6429
 www.lightimpressionsdirect.com
- **McMaster-Carr** (hardware and hand tools)
 (609) 259-8900
 www.mcmaster.com
 Nielsen Bainbridge Group (framing and framing products)
 (512) 506-8844
 www.nielsenbainbridgegroup.com
 Tru Vue (assorted glazing options)
 (800) 282-8788
 www.tru-vue.com
 United Mfrs. Supplies (matting, glazing and framing materials, incl. hardware)
 (800) 645-7260
 www.unitedmfrs.com

MATERIALS AND FURNITURE FOR
ORGANIZATION, STORAGE, AND DISPLAY

- **Archival Methods** (archival storage and presentation products)
 (866) 877-7050
 www.archivalmethods.com
- **Archival Products** (archival enclosures)
 (800) 526-5640
 www.archival.com
- **Archivart** (archival products for exhibition, storage, and general care)
 (888) 846-6847
 www.archivart.com
- **Brodart** (library supplies, equipment, and furnishings)
 (888) 820-4377
 www.shopbrodart.com
- **Crystalizations Systems, Inc.** (standard and custom storage systems)
 (631) 467-0090
 www.csistorage.com
- **Custom Manufacturing, Inc.** (custom-made archival boxes)
 (607) 569-2738
 www.archivalboxes.com
- **Delta Designs, Ltd.** (standard and custom storage solutions)
 (785) 234-2244

www.deltadesignsltd.com
- **Demco** (archival storage supplies; library supplies, and furniture)
(800) 356-1200
www.demco.com
- **Gaylord** (supplies and furniture for archival storage/installation/display)
(800) 448-6160
www.gaylord.com
- **Hollinger Metal Edge** (archival storage accessories and furniture; asstd. supplies)
West Coast: (800) 862-2228 or East Coast: (800) 634-0491
www.hollingermetaledge.com
- **Keep Filing** (archival storage accessories)
(618) 912-4466
www.keepfiling.com
- **The Library Store** (archival storage supplies; library supplies, and furniture)
(800) 548-7204
www.thelibrarystore.com
- **Print File** (archival accessories for storage and display)
(800) 508-8539
www.printfile.com
- **SmallCorp** (standard and custom products for display and storage)
(800) 392-9500
www.smallcorp.com

ENVIRONMENTAL CONTROL AND MONITORING

- **Art Preservation Services** (assorted equipment and supplies)
(718) 786-2400
www.apsnyc.com
- **The IMC Group Limited** (calibration, data logging and monitoring systems)
www.the-imcgroup.com
+44 (0) 1462 688078
U.S. Distributors:
 - ○ **Cascade Group Inc.**
 www.cascadegroupinc.com
 (800) 800-0588
 - ○ **Masy BioServices**
 www.masy.com
 (978) 433-6279

- **Keepsafe Microclimate Systems** (microclimate systems for storage and display)
 (800) 683-4696
 www.keepsafe.ca
- **MicroDAQ** (data loggers and other equipment)
 (877) 275-9606
 www.microdaq.com
- **NoUVIR** (ultraviolet- and infrared-free lighting)
 (302) 628-9933
 www.nouvir.com
- **Onset** (HOBO data loggers)
 (508) 759-9500
 www.onsetcomp.com
- **T & D Corporation** (data loggers)
 www.tandd.com
 North America distributors list (with telephone contacts):
 www.tandd.com/about_tandd/contactus/north_america.html
- **Test Equipment Depot** (new and used equipment)
 (800) 517-8431
 www.testequipmentdepot.com

DOCUMENTATION AND IMAGING

- **Adorama** (photography and lighting equipment and accessories)
 (800) 223-2500
 www.adorama.com
- **B&H** (photography and lighting equipment and accessories)
 (800) 606-6969
 www.bhphotovideo.com
- **Robin Myers Imaging** (color targets; gray cards)
 (925) 519-4122
 www.rmimaging.com
 General Supplies for Paper Conservation Procedures
- **Conservation by Design** (materials/tools/supplies; storage/display furniture)
 +44 (0) 1234 846300 [North America distributor: (770) 279-5302]
 www.conservation-by-design.com
- **Conservation Resources Int'l** (conservation tools and supplies; archival storage)
 (800) 634-6932
 www.conservationresources.com

- **Conservation Support Systems** (conservation and storage supplies; equipment)
 (800) 482-6299
 www.conservationsupportsystems.com
- **Dick Blick** (art supplies)
 (800) 828-4548
 www.dickblick.com
- **Electron Microscopy Sciences** (chemistry; laboratory supplies and equipment)
 (215) 412-8400
 www.emsdiasum.com/microscopy
- **Fisher Scientific** (chemistry; laboratory supplies and equipment)
 (800) 766-7000
 www.fishersci.com
- **Hiromi Paper International, Inc.** (assorted papers, specializing in Japanese)
 (866) 479-2744
 store.hiromipaper.com
- **Kremer Pigments, Inc.** (art and restoration materials and supplies)
 (800) 995-5501
 shop.kremerpigments.com
- **Micro-Mark** (small tools)
 (888) 263-7076
 www.micromark.com
- **MuseuM Services Corp.** (conservation supplies, chemicals, tools, equipment)
 (651) 450-8954
 www.museumservicescorporation.com
- **New York Central** (art supplies)
 (800) 950-6111
 www.nycentralart.com
- **Polistini Conservation Material LLC** (archival materials, tools, supplies)
 www.polistini.com (preferred method of contact: email, listed on website)
- **Preservation Technologies** (deacidification and digitization products/ services)
 (800) 416-2665
 www.ptlp.com
- **Schoolmasters Science** (chemistry; laboratory supplies and equipment)
 (800) 521-2832
 www.schoolmasters.com/science
- **Sigma-Aldrich** (chemistry and labware)
 (800) 325-3010

www.sigmaaldrich.com/united-states.html
- **Talas** (conservation and bookbinding supplies and tools; archival materials)
 (212) 219-0770
 www.talasonline.com
- **University of Iowa, Center for the Book** (repair papers, educational materials)
 (319) 335-0447
 www.book.grad.uiowa.edu/store
- **University Products**
 (materials, tools and equipment; archival storage and display; basic furniture)
 (800) 628-1912
 www.universityproducts.com
- **Utrecht** (art, presentation, and storage supplies)
 (800) 223-9132
 www.utrechtart.com
- **VWR International** (chemistry; laboratory supplies and equipment)
 (610) 386-1700
 us.vwr.com/store

Index

References to images appear in *italics*.

About the Author

Margaret Holben Ellis is the Eugene Thaw Professor of Paper Conservation, Institute of Fine Arts, New York University, where she teaches the conservation treatment of prints and drawings, as well as technical connoisseurship for art historians. She also serves as Director, Thaw Conservation Center, The Morgan Library & Museum. She is currently Vice President and Fellow of the American Institute for Conservation of Historic and Artistic Works of Art (AIC), Fellow of the International Institute for Conservation of Historic and Artistic Works (IIC), Accredited Conservator/Restorer of the International Institute of Conservation (ICON). Professional and academic awards have included the Caroline and Sheldon Keck Award (2003) for a sustained record of excellence in education, the Rutherford John Gettens Merit Award (1997) in recognition of outstanding service to the profession both conferred by the AIC, the Rome Prize, the first to be awarded to a conservator, from the American Academy in Rome (1994), and most recently (2015) a scholar's residency at the Getty Conservation Institute. She has published and lectured on artists ranging from Raphael and Titian to Pollock, Samaras, and Lichtenstein, and her research on artist materials is similarly far-ranging. Her most recent publication is *Historical Perspectives in the Conservation of Works of Art on Paper* (2015) published by the Getty Conservation Institute. She is a graduate of Barnard College (1975 B.A. art history, *magna cum laude, phi beta kappa*) and the Institute of Fine Arts, New York University (1979 M.A. art history; Advanced Certificate in Conservation).

Lightning Source UK Ltd.
Milton Keynes UK
UKHW04f2141071018
330112UK00001B/85/P

9 781442 239715